MEMORY

Bernadette Mayer

Memory © Siglio Press and Bernadette Mayer, 2020. Memory (original installation of images and audio) © Bernadette Mayer, 1971. Images from Memory appear courtesy of the Bernadette Mayer Papers, Special Collections & Archives, University of California, San Diego. Biography of Bernadette Mayer © Marie Warsh, 2020.

All rights reserved. No part of this book may be reproduced or transmitted in any manner without prior, written permission of the copyright holders.

The publisher thanks Philip Good, Richard Kraft, James Walsh, Max Warsh, and especially Marie Warsh, for their time and care in helping to bring this book to fruition.

Front and back photos: Bernadette Mayer (details from July 26 and July 5 of *Memory*) Cover, book design, and typesetting: Natalie Kraft
Installation photograph on pages 4-5 of *Memory* at CANADA Gallery, 2017: Joe DeNardo Proofreaders: Lisa Pearson, Vanessa Rosenbaum, James Walsh, and Marie Warsh

Second printing | ISBN: 978-1-938221-25-5 | Printed and bound in China

This second printing is made possible by a grant from the Literary Arts Emergency Fund, organized by the Academy of American Poets, Community of Literary Magazine and Presses (CLMP) and the National Book Foundation, and funded by the Andrew W. Mellon Foundation.

Siglio uncommon books at the intersection of art & literature
PO BOX 234, South Egremont, MA 01258 Tel: 310-857-6935 www.sigliopress.com

Available to the trade through D.A.P./Artbook.com 75 Broad Street, Suite 630, New York, NY 10004 Tel: 212-627-1999 Fax: 212-627-9484

About Memory

In July 1971, Bernadette Mayer embarked on an experiment: for one month she exposed a roll of 35mm slide film each day and kept a journal. Later, once she had the film developed, she projected the slides in order to revise and refine her textual record.

The project was funded by Holly Solomon to exhibit at her first art space, 98 Greene Street. For the exhibition, Mayer had snapshots made from the slides, which she mounted on boards in the sequence in which they were shot, using handwritten cards to denote each day's sequence. The installation of over 1100 snapshots measured fifty-two inches high and thirty-six feet long. A six-hour audio recording in her voice of the entire text also played in the gallery. Reviewing the exhibition in The Village Voice, critic A.D. Coleman wrote that Memory was an "enormous accumulation of data" that "explores photography not as an art but as a tool which has extended our vision in ways we have yet to comprehend."

Memory was shown later in 1972, in an abbreviated form (and by appointment), in Mayer's home, a loft on Grand Street. Mayer reworked the text for publication in 1975 by North Atlantic Books in an edition that has long been out of print. More than forty years later, the project was exhibited again at the Poetry Foundation in Chicago in 2016 (with new prints made from scans of the original slides) and at CANADA Gallery in New York City in 2017 which featured the original 1972 grid of photographs.

This publication was made from scans of the original slides that are housed at the Bernadette Mayer Papers, Special Collections & Archives, at the University of California, San Diego. This sequence of almost 1150 images varies slightly from the original installation as a few slides were lost in the intervening years, and other images are included that, due to over or under exposure, were not shown in 1972 or the subsequent 2017 exhibition.

The audio is available to listen to at the Bernadette Mayer Papers, Special Collections & Archives, at the University of California, San Diego: https://library.ucsd.edu/dc/object/bb3998174f

Next page: Installation photograph of Memory, exhibited at CANADA Gallery, 2017.

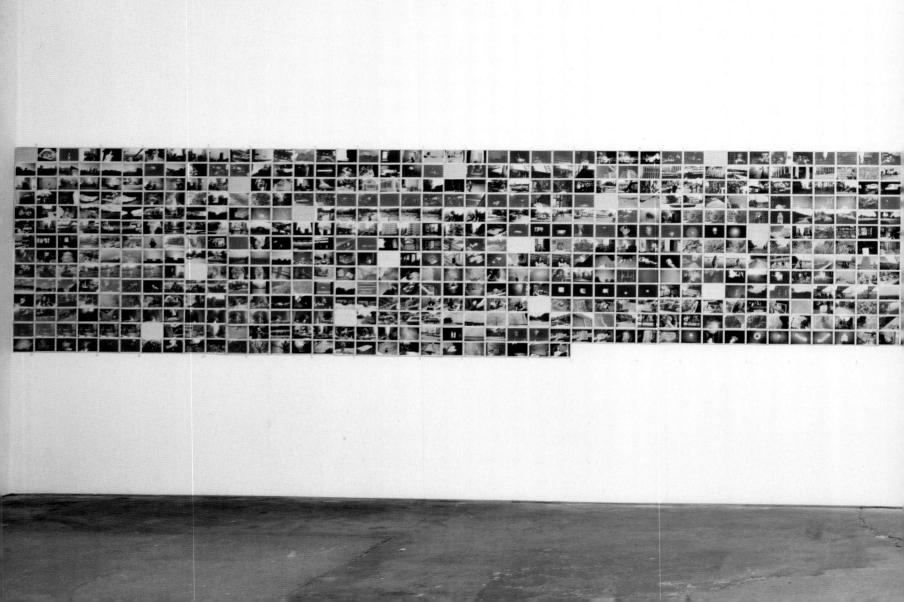

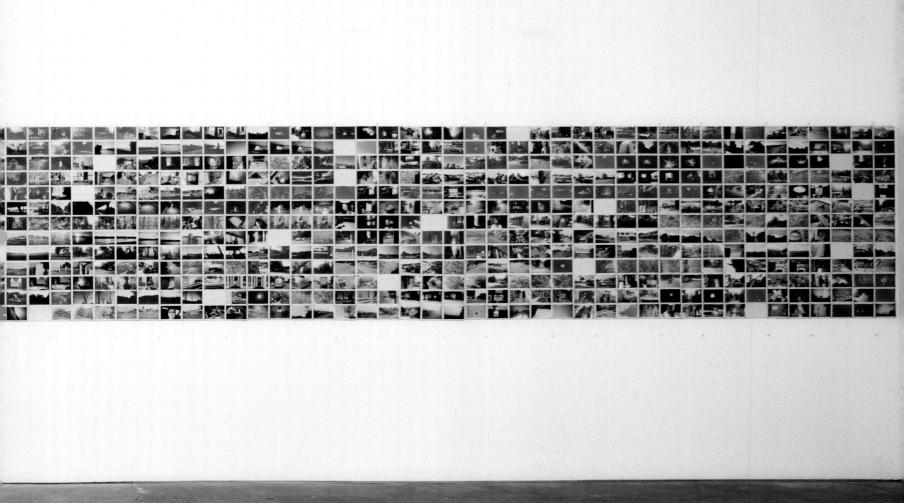

Time seemed to express itself in terms not of hours and minutes, but of shades and textures.

-Robert Macfarlane

Memory is made of a thousand snapshots and six hours of taped narration from a journal I kept and from the pictures. It encompasses the month of July 1971. I think it's a short space of time, but it takes up a lot of room, depending on how you store it.

Memory was first shown at Holly Solomon's gallery, 98 Greene Street, in New York City, then it was shown at my loft, and more recently at the Poetry Foundation in Chicago and at the CANADA Gallery in New York City. The text was published by Richard Grossinger's North Atlantic Books in 1975 including eight of the photographs on the cover of the book.

It's astonishing to me that there is so much in *Memory*, yet so much is left out: emotions, thoughts, sex, the relationship between poetry and light, storytelling, walking, and voyaging to name a few. I thought by using both sound and image, I could include everything, but so far, that is not so. Then and now, I thought that if there were a computer or device that could record everything you think or see, even for a single day, that would make an interesting piece of language/information, but it seems like we are walking backward since everything that becomes popular is a very small part of the experience of being human, as if it were all too much for us. Yet every enormity gets closer to the middles of the scientific sentences of which *Memory* is a loosening part. As a book, with all the photographs, maybe *Memory* will become the sentence in which science tells us what art is, or the other way around.

—Bernadette Mayer, November 2019

July 1

& the main thing is we begin with a white sink a whole new language is a temptation. Men on the wall in postures please take your foot by your hand & think that this is pictures, picture book & letters to everyone dash you tell what the story is once once when they were nearly ready thursday july first was a thursday: back windows across street i'm in sun out image windows & so on riverdale, did you know that, concentrated dash was all there was mind nothing sink . . . with my white pants in it. i dont remember this dont remember thinking one on one white & whiter the word pictures, sing on the wall in pictures did you get it right thought: yellow slat on the left side where are you? First on the roll comes first but what is growing backwards, motion growing backwards rocking back & forth or still one in a chair one lies in bed the tv is on out of boredom nothing soaking the clothes were still in the sink from the night before water & soap in the morning it's blue around & out the back windows of the blue room there's light of course light & the number six waking up with us crooked . . . under the windows other end under the street i look at myself in the mirror a painter in the side window that brings in the before noon light it was before that & so was i remembering what was somebody saying, tea, that this person was old could be a hundred years old that i could be a hundred years old my hair's back chin on knee, see, you drop a hair on the floor a long one it'll be there a long time floor as big as this we dont clean it too often like the parking lot near west broadway you crack walnuts one by one the one by the fire pump it was a hot day feel those people out, we are an image speed we are an image sound & by now i think it's speed sound by subway punched in the breast a drug bust ed dials the phone:

1. Ed.

he leans against the machine a fortune in tom's shirt he isnt talking he leans against the machine a fortune in t's shirt wasnt anyone home some song sing being sun we are reminding you: he isnt talking wasnt anyone home some song sing being sun we are now in an image, sound, his hair was pulled back mind too they're sons we are reminding you but now he leans against the machine, reels, & while it's on i've turned we are now in an image sound his hair was off the light a powerful light that was on it's off & outside pulled back they've turned the people working have turned the saw drill scooper off mine too but now he leans against the machine & it's lights off & ed rests in bed but i'm already dressed in a rubber reels & while it's on i've turned off the light a powerful light coat waiting to go out to the bookstore & now their machine is a drill that was on is off & outside they've turned the people working it starts up again to drive down. heroin-strychnine. will our teeth into rest start to hurt & rear window in the rain did i hear it: hurricane have turned the saw drill or scooper off & it's erica attica state prison & demands free

lights off ed rests in bed but i'm already dressed in a image in the window sound reels half. there's a bag with a rubber coat waiting to go out to the bookstore & now their container of coffee we drank it. i was sitting on my legs making phone machine a drill starts up again to drive down calls someone patted my head with shining eyes with eyes was working in downtown heroin & strychnine will our teeth start a room with a piano, in & out the door, i went to two record stores to hurt & rear window in the rain did i hear it: to get . . . we looked through catalogues of sounds i dont know but there hurricane erica attica state prison & demands free were always a lot of papers around if i had started coming over there image in & out the window sound reels half all the time i would have flunked out of school, why didnt he? there's a bag with a container of coffee for paper full of sounds on record, the index file with a girl we drank it. i was sitting on my legs making calls on a beach in color on it the calendar behind it big breasts plugged in someone pats you on the head with shining eyes with eyes what view i've also seen from eddie's window two e.b.'s was working in a room with a piano, in & out the door he was here tonight you can always tell the time, the view was i went to two record stores to get coronet vsq brandy & yellow yellow taxis down broadway, myself as

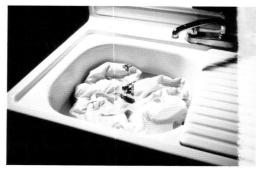

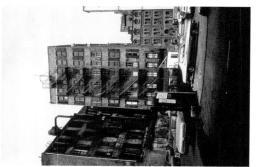

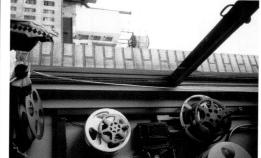

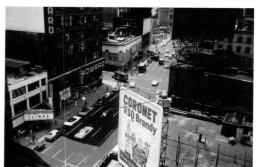

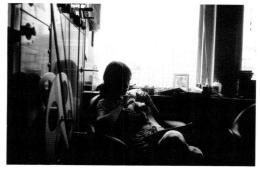

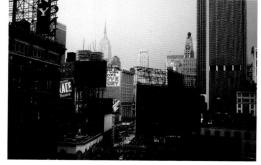

we looked through catalogues of sounds but there a whore, the circus theater climax i was bored that day listening to were always a lot of papers lying around working being done sounds, i was looking at our notebook more lists of sounds a bakery if i had started coming over there all the time i would a restaurant a bar a plane taking off cars going by the 20th century have flunked out of school fox fanfare many songs & musics a sign saying vertically howard and on for papers full of sounds on record that view again higher it looked threatening like rain & clock the index file with a girl on a beach in color on it reads 12:10 we were up early we did the light on me was morning light calendar behind it big breasts plugged in where i look old saying vertically sony this is the part of what view i've also seen from eddie's window two e.b.'s sky that cleared first blue an earlier blue a blue under people he was here tonight you can tell the time, the view was under people across crossing the street we were in a car we had corn yellow taxis taxi down broadway myself as a whore of some met a guy that lives in vito's building we had talked about sounds nationality the circus theater hitched a ride from a guy from colorado or wyoming figured he couldnt climax refuse us down fifth avenue under blue no turns ny public library i was bored sounds a bakery a restaurant a bar

want to go in no because the story goes a plane taking off cars going by by the 20th century fox tom met us at image tom & i went to hers to pick up fantasy fanfare many songs 7 musics a sign says vertically howard dope for the trip we had picked up money from his cashed it that view again at a first nation city skunks and, had a lot of cash on us, hitched & higher it's threatening like rain & clock reads ride to the right street in colorado i had a camera we stopped for 12:10 we were up early we did the light on me was morning light ice yellow & green ice the sun in the sun melting & smelting together where i look older saying vertically sign sony money melting in our pockets bought an ounce of grass for forty dollars this is the part of the sky that cleared first blue got two tabs of sunshine then we still have them frozen later an earlier blue a blue under people under people across crossing his check bounced but ours didnt that is till much later but not that one the street saying horizontally we are in a car we are the image sound went out on the streets a completely blue face moving we had met a guy we meet him he lives in v's bldg. continuing on he was living in the country where we . . . we talk about sounds hitch a ride from colorado or on some corner on another corner i mailed the letter we went wyoming figure he cant refuse us down fifth under blue no turns

back & skipping all the dishes we're in riverdale looking out the window ny public library lions want to go in no because the at two red cars with black tops was torn still with us no change that story goes to t how did we get there? tom met us at image we went to hers to pick up out all the windows we go wishing we could go out the windows dope for the trip we had money a check cash it at a first nation i explained, wonder under are are looking the whole story stop city skunk it's back it's cash a third red car passes under next to 2 red black tops we eat hitch to the right hitch to the left of colorado on & grey rain windows in the same place placed in the same some map i have a camera we stop for ice yellow & green ice where we had working & moving we had lived here ed had all in the sun melting & smelting together the money melting his left almost later we worked on windows i thought of stan brakhage in our pockets buy an ounce of grass for forty dollars get never had a baby here was pregnant in this room two icy tabs of sunshine freeze them back windows threatening but rain makes green or under brings later one check bounced but the other didnt a shady window & torn at the stove nikita khrushchev dies the image sound went out on the streets

elisha cook ir a completely blue face continuing on he was living in the i thought he had died how many times have you died in films country where we in humphrey bogart's suit? on some corner on another corner i mail the letters we go we think that t begrudges us fixes us cheeseburgers with a top back & skipping all the dishes we're in riverdale north on the pan his method we hasnt come to dinner i ate leftover chicken looking diagonally out across the window opening at two with gravy & a tomato with a saltshaker, t in the yellow curtain light red cars with black tops turns violet where does it come from i was resting on the top of the out all the windows let me explain wonder under are are looking refrigerator & white white hospital light on ed white rows of light the whole story a 3rd red car passes under next to rain makes green to purple come fluorescence i guess in the kitchen at 2 red black-tops we eat dinner least ed was watching tv & grey rain windows in the same place placed in the same

& grey rain windows in the same placed in the same inside the refrigerators lots of soda beer & invisible violet we had worked on moving here & windows back out the back is food more food hot & damp tracing my steps through the house threatening but rain makes green or brings it under looking around the hallway focus on dark chair & telephone table

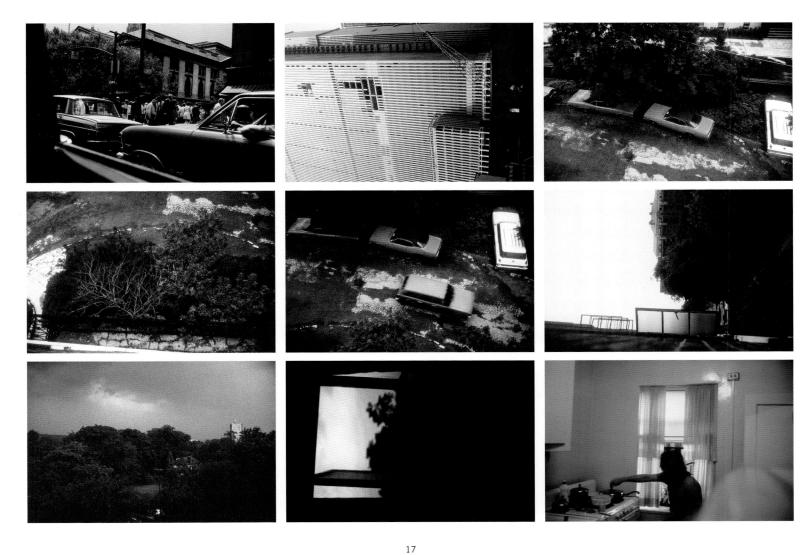

& a shady window with torn at the stove violet clear yellow light of the white door what looks so square in design nikita khrushchev dies elisha cook jr says how many times is everyone working involved no relation to anyone else's he had died in humphrey bogart's suit idea of projection image sound had come up with us a yellow & blue that we think that t fixes cheeseburgers with a top isnt there & two paler blues, it got darker night thunderstorms with on the pan his method is careful we hadnt come for dinner parents are swell they bring back old times when protected life fell i eat chicken & a tomato with saltshaker, t in the yellow curtain evenly over us at night if a thunderstorm ever breaks out again light turns violet where does it come from i am resting on (atomic bombs) someone's parents be there the top of the refrigerator light & white white hospital on ed white rows there's a new apartment across the way blocking view with only of light rain makes green to purple one light on i had guesses people meeting an encounter group the blinds what comes out of fluorescence i guess in the kitchen are up i sit up someone hunches his shoulders someone is erect at least ed was watching tv did you ever play football me? it was tennis someone reaches forward my cousin jane liked turquoise i hated jane things & out extends arms for soda a glass on the table a scotch grant's

exactly as they are sure she would say when she was ten scotch, someone is leaning forward we go downtown on the west side i fall asleep as soon as my head hits the pillow her mother highway we are slightly over green lights are blue red whites out said the same thing birth control rain majorska we get closer red stripes & i missed the moment of he played the piano by ear i felt thick a long distance red stripes at the moment of the flashing yellow signal's out stayed away in 18th st or canal east on grand st travels coming brighter over haze suns toward little italy rudolf bass reads brighter than it is red green & violet sky coffee shop coca cola grand & broadway flooded with rain or turquoise light green light red light out the back was smoke rising or cars passing or numbers letters lathes on scoops drill down my cousin jane liked turquoise I hated jane things exactly as they are she would say when she was ten i fall asleep as soon as machines in front of lathes official lathes you have it printed on glass DBH 14 scoop & a hole it makes in the ground my head hits the pillow her mother said the same thing they practiced birth control played the piano by ear i felt thick a long distance they've taken the pipes away & chain saw same construction crew they're on the outside now away

haze suns toward little italy rudolf bass reads green light red light they're gone tortured street & all its friends weeks & i'm the agent up in a normal room pretending 2 b a normal person out the back was smoke rising or cars passing or numbers letters lathes on scoops drill down machines in front of lathes official i spend my time looking at projections of weeks ago on the wall what was downstairs were they the same which are the lathes you have it printed on glass DBH 14 scoop & a hole in the ground they've just taken the pipes away and chain saw ones are the ones on the wall the same ones is the wall moving are the cracks moving is the earth rising is the tidal same construction crew they're outside now they're gone tortured street & all its friends weeks & i'm the fbi agent up in a normal wave coming or just an earthquake rising of violence coming right in my door what is an edge room pretending 2 b a normal person spending my time looking at projections of weeks ago, what was downstairs, were they the same they've found me out i'm in here i've exploded some ed is on the fire escape looking down same ones which are the ones are they the ones on the wall is the wall moving are the cracks moving is the earth rising is the tidal wave coming or same machines as before you start it all over this has happened before list the years just an earthquake of violence coming right in my door they've found me out i've exploded some bomb or other

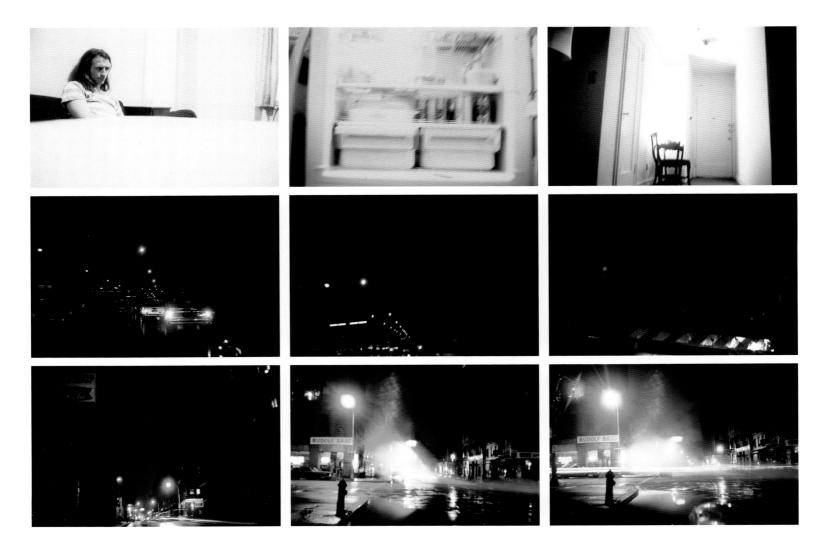

a whole you won a whole a continuous river running down the street garbage & smells on the wheel of the tire flowing ed is on the fire escape looking down, same ones same machines you start it all over this has happened before list the years pretty picture of memory noise technicolor sometimes memory is noise just parallel to canal & we know it's the telephone a whole, you won, a whole, a continuous river running down the street garbage & smells on the wheel of the tire flowing people a hundred fifty seven dollars worth though someone owes us a turn around the street & down & across the street the buildings (pretty picture of memory) noise, technicolor, sometimes memory is just noise, parallel to canal & we know it's the telephone people flood in the rain incidentally how long is my assignment here & the lights flicker on & off in both bldgs ours & theirs a hundred fifty seven dollars though havent heard from the one who owes us a turn around the street & down & across the street the thunderstorms are parents including the first floor you couldnt live there the plumbing's bad all brass pipes & brass buildings flood when it rains incidentally how long is my assignment here & the lights flicker on & off in both buildings ours & theirs containers cooking pots for the stew always eat the same thing with canned peas & carrots you became anemic thinking about & thunderstorms are parents including the first floor you couldnt live there the plumbing's bad all brass pipes & brass containers cooking pots

revolution come you went to the hospital are they fixing it july too just any part of no it's the phone co. residential they say or hurricane one & two flooding new jersey highways subways hurricanes in nova scotia they say no to everything anything goes on on between two or between say seventy foot waves in the bay of fundy according nuns in habits make obsessions rage strange color wheel to someone's father who likes geography & really likes rain do you reach me fern in new york where are we no one can avoid distractions i love you you are deer we dont hear images from you anymore what else can you remember nothing something else parents, come to the hurricane, it's on the first floor wheel color color wheel i ate colors in a dream what do bayaria & had to leave town was that us was that all you say anymore to someone who's a person i'll wheel colors tell me what you remember about the man who shot a deer in you like to your new location if you'll tell me what i'll wheel the colors you like to your new location if you'll you know about the man who shot a deer in bavaria & had to dream should i say anymore to someone who's a person leave town was that was that us was that all wheel color color wheel i ate colors in a dream what do you

parents, come to the hurricane, it's on the first floor can you remember nothing something else i love you you are deer we dont hear images from you fern in new york where are we no one can avoid distractions what else anymore do you reach me father who teaches geography & really likes rain nuns in habits make obsessions strange color wheel seventy foot waves in the bay of fundy according to someone's they say no, to everything anything goes on on between two flooding new jersey highways subways hurricanes in nova scotia or between one & two this month too just any part of

July 2

Lights. Lights all electric electric machines. This is an excuse. This is a prescription. The f/stop is the ratio between the length of the lens to the diameter of the opening it has less to do with you than with light. No dreams. Typewriter tensor light slide projector tape recorder holly in an electric red dress under electric light library light electric coffee cups from china, we sense the presence of something from china real ice july too do you do you know what I mean new ribbons roll into the library on ice to pick up film, daze fantasy patron with one roll shot, I put one in from the bag of film & shoot & still the ribbon with the hole in it talking to everything: will this be something: earlier later top bottom in out gertrude stein & emily dickinson on the stamp on heroin, ed working & going to toronto tomorrow, something to put together & more memory into a schedule of light: am I crazy & dont I want to fuck & manic's fucking everybody, putting together the past of so much information the same thing isnt it in numbers. Holly & portrait under electric light, smoke on a dime: strike anywhere go to the theater we did, hair still in knots since I was out of the state, street loft night lights I put the two together & came out with, just more: I aimed at the center of the bag & hit the rim none of that comb's necessary: I picked up the film & drove

down second ave late for anne point out. That's practical, parents, does it come with ego (parents) she would never leave me alone, ashes spill: whistling outside it's saturday night ed's gone out energy out of the room I'm misplaced. Letters to everyone: h her maid calls her solomon & two of aquarius, larry posing in a pink undershirt with breasts without them before a garbage can & trees church brick iron & cobblestones graveyard anne larry joan looking like me & anne is me, breasts larry arms up doesnt have his breasts anymore, hair. We loaded up the car with worlds & drove away. Ran out of gas. I ran over to 1st ave looking for a station, it seems to me later this day we drove to massachusetts or some other place, riverdale, I am sitting in the car saying to ed remind me to look up the cab driver in the queens phone book: I had written his address on the brown paper bag of film in the back of the car: no by this time it was in my leather bag, stuffed in because I thought the breeze of my running to look for gas would keep the film cool: the cab driver trying to pick me up wouldnt take me for free finally: well try to sit very close to me the hot seat & so that the meter wont turn on well it didnt work, I told him everything I could fit into the seat in the time we were together we had been drinking coffee. With holly with anne to a station, gas can, he waited & took me back 47th between park & lex, do you know where you are 57th between park & lex I took the subway to work & hurrying they're waiting at the barricade, lazy flesh, later anne

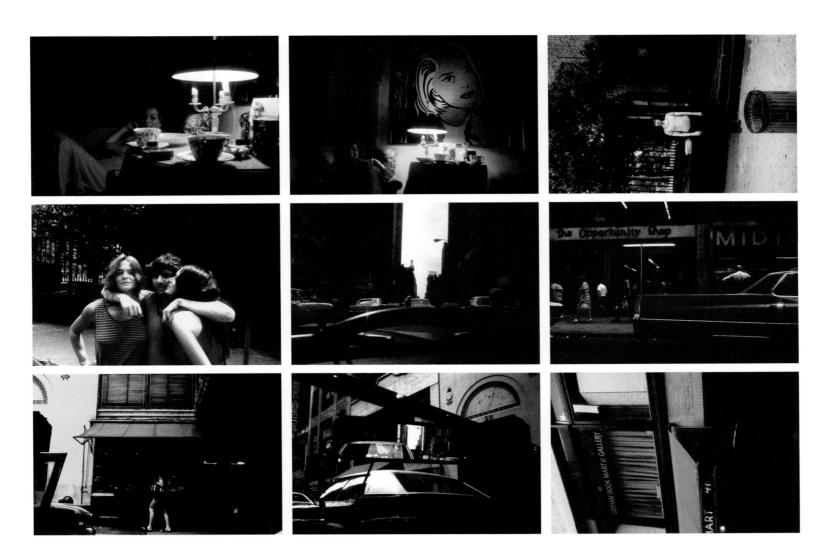

took a shower we exchange identities again, read each other book write talk look alike someone famous said so. Jasper johns his spoon the sonnets \$8.50 a ruler, later 0 TO 9 early, late day, food. I think I am thinking the opportunity shop is on 47th street under the gotham yes 47th street you tell them you're making a delivery with commercial plates, I tried that later they said mirrors, commercial plates fronts backs of cars which cars should I go up to the theater to meet ed where is he now still parked still on 47th street, how many times resting is the sky on 47th street waiting always threatening & that one tall building on the right bending over into the frame, we've stopped for that one we've stopped for a light we've stopped for a storm I'm going to call ed & go up to the theater I need glasses & the bel capri food company & ice & red light one way construction a strange & stranger light comes crashing through the sky in beams in new york clouds make up these dramas above bldgs nothing else. Numbers. Nos. At 6th ave near the west 4th street subway stop guys come by with pocketbooks tough guys shoeshine boy in front of the glass bank in sneakers a red foot rest & one man in shorts lying on the ground feet towards me shoes not shined write a mystery: anne's in the 5 & 10 getting glue comes out with a big straw bag too big to pay for I look around & motor on off the sun on the chrome of the bank disappears assuming anne talks to the guy in the phoenix & someone comes in to autograph their part their part in a

picture already filled with names one is di prima, collection, the boys, michael mcclure is on the wall so someone comes in a tall skinny guy, it was her & somebody & him, he was looking for a thin yellow volume on cornelia street here's the light on someone's federal savings & it's warm in here nine a's nina's mother drank stout & went to afghanistan, that light on the savings: gradually this strip a strip the color of old tarnished silver, gradually it narrowed & seemed to recede, then it was converted into an object that glistened like steel no bank, cheeseburgers & coffee in the riviera a girl passes by we meet frances on the street, I knew we would meet here converging irresistible, I'm on my way home no we are: julie called to bring ed to work the sound church bells tolled on the television pat pissed off, phone. I called the theater the moviola's broken ed said not to bother to come up but I didnt even talk to him talked to chris & john chris didnt show up last night to shoot the new movie because he cant go on with it & on west broadway in the late afternoon there's the truck full of pieces of material packed in cardboard truck that always crosses the street standing there on friday afternoon taking up most of the whole street so that cars have to go around one way cause the street goes two ways like going around driving crazy in the other lane & they do it fast just in case. We went home to do the proofs down on grand street under. I have, when I was about two or three years old I was taught the words of a hebrew prayer. I didnt understand

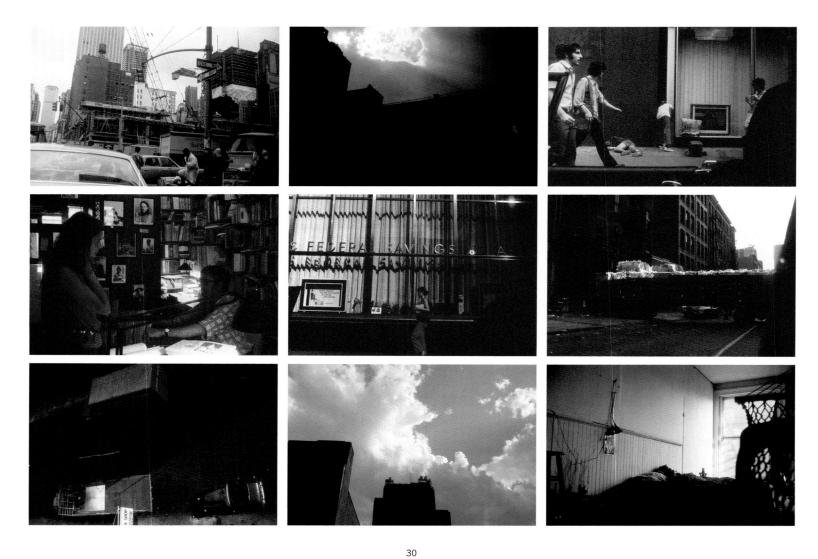

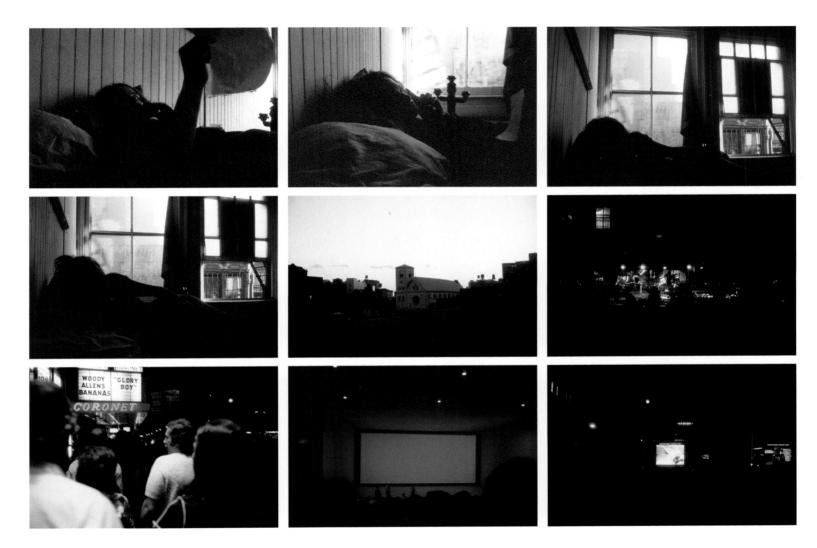

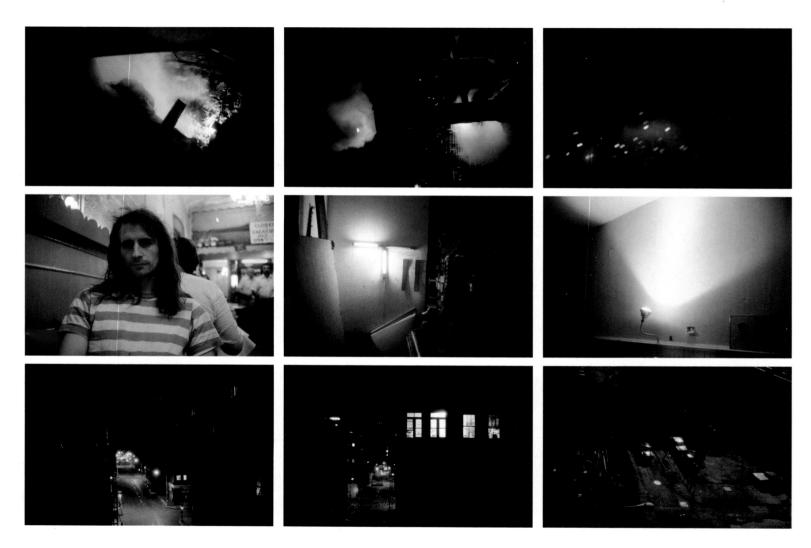

them & what happened was that the words settled in my mind as puffs of steam or splashes . . . even now I see these puffs or splashes when I hear certain sounds: I was looking out the window around at things anne took a shower lay down on the bed & made a phone call the sky looked like this: profiles anne on the bed holding up a piece of white paper the phone in her other hand, we worked, read through the book aloud violet revolution & all all in hoarse men's voices fast I massaged anne's neck. We decide to go to the movies, ed tells us we may have a room in a sound studio in massachusetts the next day we find out it's political, we are on contract, will take the book to the printer's ourselves, we drop off anne at prince street & drive up 1st ave to see carnal knowledge ed took this, we waited on a line to see it, we blended in to see it, when we saw how red the screen of the theater was, when we saw how red ann-margret was, it was worth it for ann-margret & a bank on lexington or park, we must've passed union square & driving down bway where at the time there were some extraordinary steam type construction sites, caverns, men at work, steam behind, in front of lights turns green & tracks all around in the middle of the forest we light the interiors with generators we light the forest with generators, and to set it straight if everybody thinks life is shit but me then isnt this writing shit & old, gulliver's travels, lord jim, the secret sharer heart of darkness marble faun scarlet letter moby dick vanity fair old man & the sea sun also rises great gatsby the red pony daisy miller pudd'nhead wilson spiller: I am happy for the occasion to send a note your way, always pleasant memories are attached to your name, we heard here that sister irmengard was anointed is it true? sister m felician must be worried, tell her that her friends here are praying for her & sister irmengard, please direct this big news to your school paper & if possible send me the copy that carries it may god reward you, happy lent: when tom would not speak to her she finally told him of his identity. This is another example of her pride. When she learned of tom's method of repaying his debts, she condoned the thefts & even helped him for which he sold her down the river, this, in her opinion, was the worst possible fate to which anyone could be doomed. Yet when she escaped to st. louis she forgave tom easily, everything was put aside for him even to the extent of murder quotes: the experience of each new age requires a new confusion & the world seems always waiting to be waiting for its poet. A spill ed's back & joe colombo had been shot long before this, still hanging on, we went to the luna for dinner at about 3am, we chose carnal knowledge over insects we wanted to see people in a movie, ann-margret annes eat luna 1st time see moon in month fear murder roaming rampaging gangs of black men coming to kill the italian men but we had dinner anyway next: blacks in little italy a little sunny, food: after coffee that again iced, cheeseburger & leaf (2), kathleen's rivers (naive) cheese pear beer burnt bread (luna: bread water wine priests of

nyu having a discussion & crazy people horrible sarcasm of veal with peppers lasagna (lights) asparagus (iron) & thank you very much) I thought this was one of the days we recorded sound all day ed was exhausted in tom's green & white striped shirt. In front of the city where the silver moon always shines & someone's always up, like the late show replaced by stars coming in thru your window, do they want us to stay up volunteer or get jobs, which is it, deserted streets exhaustion food & to finish last night one movie one more movie for the play ending up with a shot of scotch & breakfast & two cups coffee & drilling awake till 8am thinking of crystal clear, what pill should I take we get home two fluorescent lights are on & the door opens to a yellow house with books a light my painting joe's piece ed's picture: down the street green, up the street flags & eduardo a whole floor lit where the man, nevermind, I need boxes, & thank the simple art of murder: gas + can: 2.65 + 45 = 3.10& a neat nozzle for someone's dream: something that happened changed the lives of 10 people, a day you're not sure of there's no space for you:

So why dont you come over every saturday, why dont you teach us every monday: more than 30 years have passed since that moment when is anything permanently forgotten photograph: monday — a window of a factory, tuesday — a small white handkerchief with "a merry christmas" embroidered in red across one corner, wednesday — a man's black striped pants, thursday — a light brown earthenware jar, friday — an earthenware jar like thursday but darker in color, saturday — a saucer with a pattern of brown & gold squares round the edge, sunday — a metal cream pitcher. No I know we didnt know yet no & new: or: monday to friday — he described the fall of his native — at the hands of the — after a ten-year seige telling how the armed — had entered the city in the belly of a great wooden horse & how the - had fled from their burning city among them — & his father — & young — not long afterward - had advised setting sail for distant lands blown by varying winds we quickly — the next day — again on the shores finally they reached — again the — a hero — in a dream he —when — warned in a dream — decreed that the body — led his band — of the — world & the question was how to tell you in a way you'd remember: we still didnt know when we were going to massachusetts, I think jacques & kathleen had left already, vesterday with anne holly carnal knowledge & the day before collecting sound effects, so we got up early I think & went straight to grand union with the nagra, the door just banged so I locked it there was nobody there, ed put the nagra in a shopping cart put on his earphones & went to work, there was no musak in grand union because it was a holiday the day before fourth of july, everybody in the city had gone away with the sounds & the store was empty, cash registers sounded great & they were having a red tag cookie sale, the door banged again, there were people buying only a few things at the store, all the people in the store that day were buying only a few things, another thing, grand union used to sell cigarettes but now they've got a machine from joe colombo, what if I locked the door, then somebody came in thru the window, then when I rushed out the door, there was the original somebody standing there waiting, somebody's coming in's not that bad, grand union is right across the street from j&k's, I took a picture of the guys standing out in front of the drome social club on the first floor where j plays poker when he's in town, now the club's a bakery, we drive uptown to find a good department store, stop at macy's & gimbels, no good. I thought a fire pump next to a coke bottle looked good but the coke was in shade. I saw a lot of weird people hanging around 6th ave & 34th street on that holiday weekend paralyzed parked waiting for ed to get the sound out of the department store. Usually I wait for yellow

cabs to pass by, one of them stopped & somebody got out. They catch the sun. Imagine spending the day on your bicycle, I was parked in front of a discount drug store selling something called nodor or hodor no it was a furniture store a rip-off place but they had a 34 piece junior dinette. So I pulled up around the corner so ed could go to another store & a hotdog man was doing a big business & there was a sun tan ad that caught my eye: tan hawaiian. Ed went into korvettes or sonic arts I think steel buildings catch the sun like taxi cabs. We parked on a downtown street to stop another store maybe 5th ave this time I cant remember, no, we were just around the corner on 7th near pennsylvania station & I was looking at windows again. No luck. Just drifters so we went uptown to bloomingdale's to check that place out & record some street noise there it was a really clear day but there wasnt enough traffic to make the noise level boom & bloomingdale's noise was fine except they didnt have & neither did any of the other stores, they didnt have those bells you remember hearing, the bells called floorbells ringing like the bell at the end of the line but more resonant, so we stopped where we were at 3rd & 60th for quite some time recording cars passing with a long boom some time goes by in car, some guy thinks our boom's a geiger counter & we're at niagara falls waiting for the traffic to build up at the lights there's a big schlitz ad, it reads reach for the gusto in life & all the familiar pancake buildings, I wonder how carol that

fainted is she was nervous when I saw her & what the fuck somebody starts playing the drums so loud across the street it sounds like trashing & I see more people on bicycles & while I'm looking ed's answering questions about his machine, is it a three or a four, this guy really knows what he's talking about, it aint no geiger counter, the nagra is made in switzerland, yes, so we did all we could with department stores & traffic & then we went to daly's & daly's aint there anymore either to record some bar noise but they serve too much food & it's always crowded, turned out we couldn't use their noise at all cause you could hear the sound of frying in the background & the tv was on I think but we had a good beer & so & then went to a horn & hardart's lunch counter to see if we could get good restaurant noise musak & all, now this horn & hardart's noise turned out pretty well except, again, for the intermittent frying & sizzle noise but the musak was great & so was the clinking & I had iced coffee & ed had a coke & we shared a grilled cheese or maybe I ate the cheese sandwich & ed had a piece of pie. Anyway they treated us pretty well in there & didn't complain about the tape recorder & there were a lot of people eating dinner, a sort of dinner, including one priest who sat right down next to us, he aint afraid of no geiger counter & these people eating dinner again looked like the people in the market & seemed to me they must have had a regular schedule to live on which included dinner at horn & hardart's a place with an

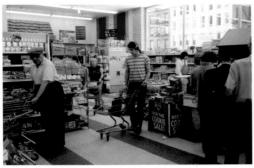

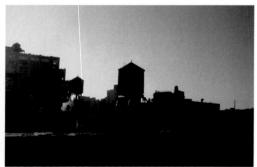

old reputation every day or at least every saturday or at least every july 3 & after that we came home & I went up on the roof to take some pictures. It was still a clear day. I took six or eight pictures looking out in every possible direction from the roof where the moon was already up, just a sliver still or approaching half & I didnt change exposures except when I shot directly at the sun & when I shot my own shadow. The house was a mess of machines that day tapes & cords lying all over doing nothing, we had been working so we cleaned up a little & ed used vito's tape recorder, the one he left there, v in toronto I think, to listen to the tapes we had gotten. I asked ed to take a picture of me from the back by the fluorescent light $\&\:I$ looked at the light itself which always comes out green on film & ed's desk, we had just set it up & tore down some shelves so he could have that corner, the desk was covered with tapes & lists of sounds, catalogs of equipment, tape cleaner & degausser, if I'm remembering it right a degausser is a machine that demagnetizes tape so you can re-record on it clean. We did the dishes too. I think we had been drinking a lot of espresso around that time, a lot of coffee of all kinds. I looked at all the lights in the room & the lights across the street, you can see them from the fire escape, they're always on twenty-four hours a day: impossible to take make pictures of this scene's not dull of white it down, we are recording sound listen supermarket department store bells no bells we move to a different turn spot tune gimbels to

corn at macy's looking 4 bells this is a girl who must take make pictures, she, not postpone, smoothly into focus comes foods notes sounds taken in the car taken while every one & every thing goes on moving in some experiment with isolation, is that what it is. Look around new spot small shirt white pants i'm inside not outside & cars & stares, to record, machines? stare? notes? stare? you? stare? where was I at that point — W34THST&7THAVE park double park park expose, goes on click, man in shades turns around he's a convict, joe colombo, go about observing & checking with a set of rules a certain set of rules in marked cars & uniforms the cops are too obvious in their observation & they these scraps are out of a need, this stuff is out of a need, I need a book two books, one for ed that's three, where are you a room & cereal -W35THST&7THAVE. Observation honk observation bleep there's always more there, traffic unit B unit B goes away, as long as I dont set up a 2546621 tripod on the streets they wont arrest me & I am the one taking notes mr. man & cars, a new vellow scrap, line the street. Colors & colors they're yellow blue brick grey white green pink words taxi lights my things tag \$2.19 people radio balloon baby chair bright blue car l'escargot the chimes the boardwalk 3rd ave el baronet & coronet king movies can move backwards diamond ice cubes co. maneuvering not able to maneuver true sea & ski & rheingold beer the woman drive defensively from the canadian

rockies up on the roof violins horn & hardart's black white up down shoes clothes rear view mirror love a guy gets out of his car, looks around a kid gets out he gets back in he parked in the middle of the street, flashers, all the way to texas if you want, stirring up dust, if any. Light blue delivery truck slams the door woman in yellow with a dress says take care & woman in a cadillac waiting & a guy in a suit on a bicycle & it's saturday & a guy in a cadillac going backwards from michigan the great lake state, glory boy bananas and a guy in an apron who is the poet. A woman talking to ed ed is not a woman, he doesnt wear sunglasses where is he & what's he looking for? Sound. Sound & carfare & gas & then the rest of the story goes: out in the open here & hot, trying to bite down trying to bite it down that's the trouble, we had a beer the bar was no good, reasons were frying, air conditioning, read about food poisoning in the new york post & put it down in case we die tomatoes from italy are good. I have no way of remembering a day. Rosemary calls & I talk her ear off we listen to tapes call tom not home call vito put scattered applause the appaloosa on to him & ed talks his ear off so we got rid of them, there's a house in maine for ten thousand dollars, we'll get a grant, we'll think of the mystery of the renovated barn, a house is for, a, protection and, b, insulation & we'll think of boys in the puglia, boys walking walking boys puglia walking edward & kathleen b b b bernadette mayer christophe cauchoix on a matchbook comma we'll think of this

& this is even older:

rte nine east between keene & brattleboro cinema theater motel, you watch thru the window of your room, drive in dont drive in & then nathaniel hawthorne college, antrim, new hampshire & stewartstown, new hampshire it's halfway between north pole & equator, the 200th anniversary of this.

asbestos canada asbestos cinema back in the ussr by chubby checker played on a jukebox in canada, well where have you been? all over. where have you been? all over. have you been to alaska? where do you want to go for xmas? have you been to greece? have you been to the bahamas? where do you want to go for christmas? the paname bistro make up ed for photo in sillery in racetrack in tv ed says, behind the scenes bus ride & a list of corporate injustices made up by a child if you indians are from china

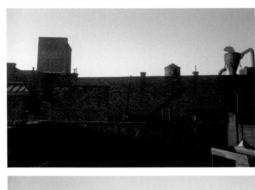

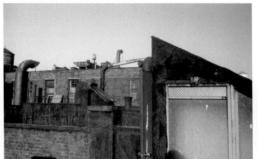

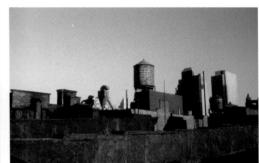

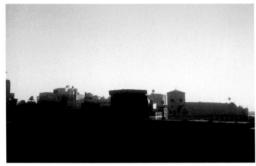

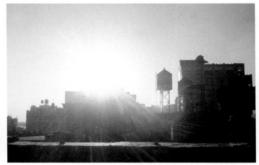

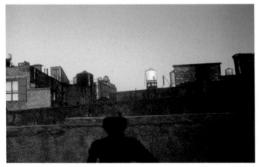

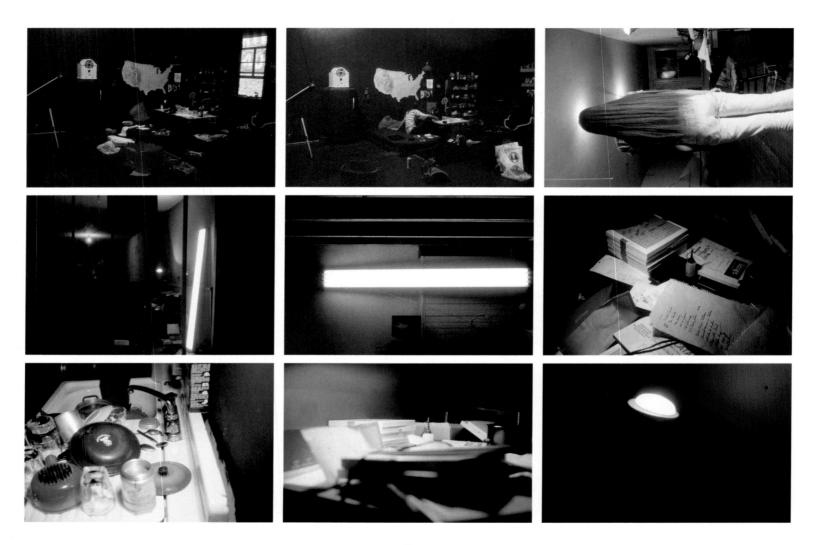

if you indians are from china why dont you call yourselves chinese? & something upside down & a cover & pictures & paint & something crossed out & something crossed out, it was done & an idea about transcription, off to the side & some numbers, a theater & service equipment & some long division & some copying & a face a tree a girl with her head down the sun, marks, a head an ax an ax-flag & food & a photo of m & a note: the negative's in the trunk, the key is mailed, will arrive at 33 tomorrow, signed.

We'll think of talking backwards, i'm talking backwards, i'm working more the way students in science are working in a lab, a movie is only the result of two to three months exploration of something, i tried to find a picture of karl marx when he was young but i found it only afterwards, he was very beautiful young just like warren beatty today every time you see a picture of marx you see him with a big beard & he was just like james dean when he was 20 years old, i used to like disney documentaries on animals, if john wayne played an animal perhaps i

would like him too, there is image & there is sound & i see no difference between a face being interviewed & just a picture of a word for example, they are just two shots, it doesnt bother me at all actually every time i see a film i sleep fifteen minutes there are two reproductions a matisse & a rembrandt & i very often sleep while looking at them, i can look like a business person or i can look like somebody in love, in love with that person for whom this piece is a personal message, from 19 to 20 i went to college & took easily about 150 examinations, then i got my degree which qualifies me to teach language &literature, i am talking backwards, but while i was going to college i was editing a literary magazine where we published the first translations of — the first dreams by — some — some — his experience with mescaline, the first — the first & so on, we also published the works of our own group, some of the things were really good, at the same time i made a series of pornographic . . . i'd give a year's wages for that gun/i'd give my left hand/to some unintelligible/i guess so/gunshots/this is july 3rd/you remember that dont you?/is that jacques & kathleen's?/yes/what's that?/that's the door to the roof/one dollar/ doesnt look like the roof does it?/dont worry joe'll be delighted to see you, he will, well of course he will, now where's your luggage, oh dont worry about me i'm gonna stay at the hotel, you're doing nothing of the sort you're staying right here with us, now you come along with me & we'll fix up the spare room,

nice little place you got here, i've got a great idea, let's you & i be honest with each other this isnt a nice little place & you know it, well it is kinda, yeah it is, why's he live in a place like this he's a millionaire if he'd only take it but he wont, so you've come up here to try to talk joe into going back to the ranch?, well not exactly, oh oh we're going to be honest remember?, well i would kinda like him to come back, so would i, you think you owe me that much, you would, i would, why donna, you've got a head on your shoulders, well maybe i better stay at the hotel, oh dont get nervous, we'll have this cleared up in no time, imagine a fellow like joe bein a teacher, teaching's for women that cant find husbands, now hold on partner teaching's a noble & important profession more noble & important than raising beef cattle for instance, now you hold on partner feeding the american people aint such a disgraceful occupation — i get an obscene phone call, a third steve, said he was coming just as i hung up the phone, pretty lucky — & it aint an easy one let me tell you, you let me tell you, we werent going to argue remember, we're buddies, i'm sorry daughter, sometimes i fly off the handle, so I heard, joe's sore at me eh?, well you're not exactly his favorite character, i couldnt let that boy grow up soft, all that land all that cattle, i had to toughen him up for the job ahead of him, & when you got too tough you tried to square things with your money, well now i didnt go for to hurt him, oh if joe had found understanding at home he would have had to try to find

it somewhere else, connie i want him back, what must i do, try a little humility, try controlling that temper of yours & above all keep that fucking bankroll in your pocket, connie there's joe remember, joe, yeah, joe look who's here, mmm, shit, hello pa, hello boy, had some business in the east yeah thought i'd drop by coming so close & all, well i'm glad you did, been a long time & all that shit, sure has, i know you two must have lots to talk about so why dont you go out on the porch where it's cool & i'll finish getting dinner ready, yes, come on pa, have a cigar boy, thanks pa i'll smoke it after dinner, still smokin those dollar cigars i see, why not son i can afford em, last year the best year we ever had down on the ranch, glad to hear it pa, oh yeah things are boomin down there, that's fine pa but how've you been, oh i've begun to creak a little bit at the joints i'm ready to step down & turn over the reins, anybody in particular?, well a man like to think his son . . . , pa let me put this as kindly as possible, i'm not coming back, doggone it why not that dont make sense not anymore, you run away from home cause you were sore at me, ok all right, you win your fight, here i am on my hands & knees beggin you to come back, what more you want, pa try to understand maybe i didn't take up teaching just to spite you, maybe that's how it was in the first place but since then i found out something, i love teaching, it's what i'm good at, you cant forgive me can you?, i have nothing against you pa, i'm tickled to death you're here honest i am, & as far as i'm

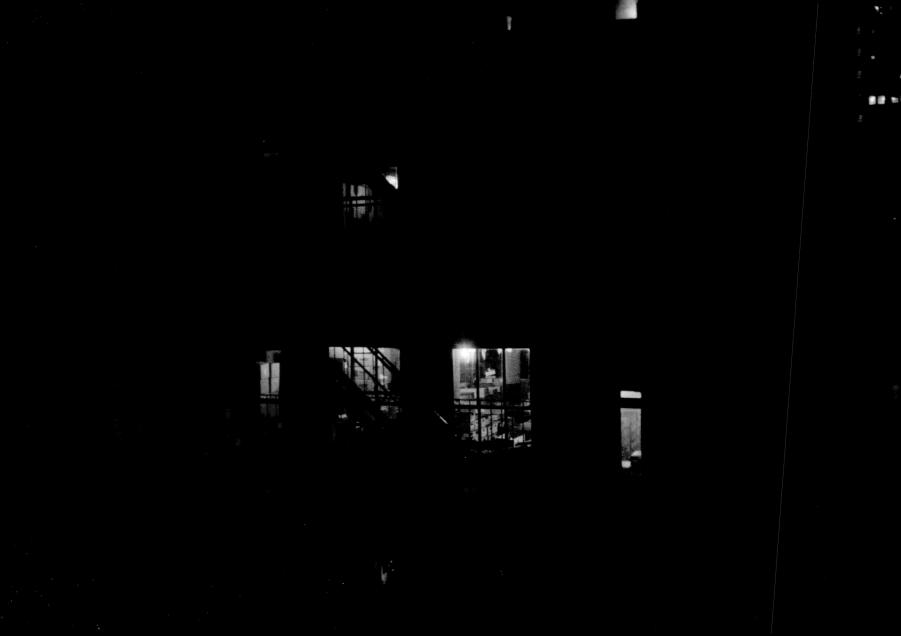

concerned bygones are bygones, i'm a teacher & i'm gonna stay a teacher, oh hi joe, hi, joe simmons, archy, come on & meet my father, how do you do sir, howdy boys, glad to know you etc, pa came out from texas to pay us a visit, oh are you connected with the university down there sir, i am connected with 20,000 head of white face cattle, well you're a lot better off you sure are, arent you gonna invite these fellas in to have a drink, oh sure, we'll have a . . . , thanks some other time we're late now, we'll take a raincheck on it, well so long joe etc, friends of yours?, teachers at the college, they seem like nice young fellas, well why're you so surprised, oh i dont know they just dont look like the teacher type that's all, well what is the teacher type pa, skinny sexless bald at 20, oh i didnt say that exactly, well you know the old saying joe them's can do & them's can teach, here's another one, feed a cold & starve a fever, well what's that got to do with it?, & here's another one, sing before breakfast & cry before supper . . .

Twelve seventeen & ten seconds bright day warms up, I warm up, I have little mats stapled into my nails, owning elephants, this space for a field, remember? Ed wet went "to get some cars," cigarettes & money flew, HC-110 at 7:1 dilute B at 68° straight-hypo, into cans, stop bath in beaker, take temp of HC-110, 68°, get time, lights off, roll & cover on, shake 30 seconds, lights off, stop bath one minute, cover, do cold running water 2 minutes, permawash solution, 2 minutes, agitate, cold 2 minutes, or cold one hour, photo flo, 2 minutes, hang & squeegee (in photo fib), hang one hour, then contact: shiny faces paper, prints dull. School: I'm going to take a picture of it, the only thing I feel like doing is looking at it, is looking at it in a picture, it is ducks in glass cases in poor light, it's hard to take a picture of it, james noeth has no prick, takes his clothes off, revival, all in kerchiefs & a movie of me in the room across the way, a movie out of the window, a blond girl running with flowers, she drops the flowers, she drops her wig, she isnt blond, we sing a song: trip to the moon: rocket ships on ringed trucks & families going like trailers, & finally high school gets out, we're going to massachusetts, rows of girls in golden coats marching, I call to someone, I say, "hey that made me think of you!" & he gets angry & we live in big rooms in hotels are

centers all is sex. & hotels are centers all is sex & ed swir a fish a frog a girl in pedalpushers a line the set, dropli stone couch the design. Dear dash, it could be me or you, you are sinking in the pillows currents, more specifically, red frequency: dreams #3 asleep & where's the coffee, the sun is coming through the library window, yes that one, it's against but cant come through the windows at my back, yours, at your back is a bed dont sneeze when you get up in the morning, white. Write: what where you get up it's afternoon dash I took the camera with me dash bye. Orzata hamburger chili sandals courvoisier scallops coffee cereal film tape piano pens candles matches mosquito netting gnocchi house in the country 8mm movie camera roller skates — the monster that was in here last night was the country, he was, still this is the sun still this is the city still the country was blue white & maroon with a long long tail, buzzing & making giant shadows by the light, feeding on the glue of a piece of tape on the ceiling, we put him in a box, country, slid a paper cover over it, threw the box out the window saving the picture we'd used as a cover, country, bye. One day I saw ed, eileen, barry, marinee, chaim, kay, denise, arnold, paul, susan, ed, hans, rufus, eileen, anne, harris, rosemary, harris, anne, larry, peter, dick, pat, wayne, paul m, gerard, steve, pablo, rufus, eric, frank, susan, rosemary c, ed, larry r, & david; we talked about bill, vito, kathy, moses, sticks, arlene, donna, randa, picasso, john, jack nicholson, ed, shelley, alice, rosemary

c, michael, nick, jerry, tom c, donald sutherland, alexander berkman, henry frick, fred margulies, lui, jack, emma goldman, gerard, jacques, janice, hilly, directors, holly, hannah, denise, steve r, grace, neil, malevich, max ernst, duchamp, mrs. ernst, michael, gerard, noxon, nader, peter hamill, tricia noxon, ed cox, harvey, ron, barry, jasper johns, john p, frank stella & ted. I still see ed, barry, chaim, arnold, paul, rufus, eileen, anne, harris is away, I dont see rosemary, harris is away, anne, larry, peter occasionally, who's dick?, pat, gerard is away, pablo is away, I still see steve, who're eric & frank?, I still see rosemary c, ed, & david is a different one. It's impossible to put things exactly as they happened or in their real order one by one but something happened that day in the middle of seeing some people & talking about some, something happened that day (look it up in stories) & what happened was what began this: and this came later, the day after that: "one two three people I saw, money we spent, gave out, the energy it took to get to the country, drinking three cups of coffee to talk about anarchy, to write a letter to anne about an old worn out subject, the destruction of the tapes, feel the breeze the generation gap, think about watching another person, then creating one for people to watch, understanding the desire to watch other people to understand them or just to watch them, not finding any place to set things down then save this for later & wait. I saw I talked about. No decision. No direction. That's good. & no thought.

Fans, the energy it takes to wave them. Flags. Get the pillow. The cake is in the oven. Get the beer. Why not talk about the energy of the weather in the city too, three describe it. Waiting toward something to come out of something. Placing something there. To think without thinking. Write without writing. Xyz, thoughts with fine edges. So many noises people places things points of view. Put something out in that field. Didnt understand. Now do. The do-nothing school. Against technology. Energy comes from somewhere. Pay. Some way. I feel terrible. Why. Race against time. All the dreams all the notes all the directions nothing comes from it. Need drink. Empty slot. Cant sit up. Cake. The leisure to go beyond the tree. The time. Did ed take a taxi? No, but he did get a ride home in j&k's 1964 cadillac convertible. & then I have something similar, I dont know when it happened, but first there's some time spent in a luncheonette: the answer box, answers any question, any yes or no question????? & lucky nos. for today, we're in everybody's luncheonette. I thought it was may 10, noon. It was june 5 noon. Vito & the roosters, the day that dash was sleeping, sinking into the pillows currents dreaming, you remember? The day I took the camera with me this was the same day: pick any rooster, my rooster's come a capon, raphael's question: what artists do you know? Film, black & white, slides, tv, movies, the american legion auxiliary box, what's the matter with r. Sign: how to succeed in business

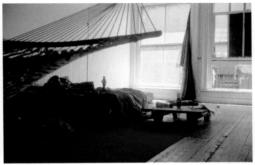

(cheat), viva & emma goldman. "Hi woody" & p lives near here. 10am (sam) & I am at 125THST, 74THST later nursing homes siring women screaming I scream a woman with short hair sipping a diet cola, straw, a kid says get outta here & gimme a glass of water what? Water what? Water pure water & kathleen pierre clementi christophe whatever-his-name-is & randa 302 elizabeth street. The kid runs out. A man makes a phone call it gets crowded, everybody's cheeseburger rare & a vanilla eggcream & a woman: "mikey stop around the store, something to show you, close for 2 minutes, minutes? That doesnt take care of it." Lose my mind like eeeeiiieeeeh & I found out when that happened but this still escapes me. This is something, something like: what's in quotes beginning with the people I saw, the money we spent & on through the fans & the energy it takes up to the convertible quotes. But now this interests me more: it is: it's charlie chaplin brought up to make lists STRANGE IDEAS LIKE TO STOP thinking about t dream am shot by hilly or jacques & how s everyone is & what you already know & shouldnt concern you & sudden mood & how h everything is & all of a sudden cant move feel stuck feel s the clear co. makes two by fours. So, drama is real is real in on a day & then some vision you are you are not so someone can know you are you are not the fleet the flight what kind of information is that going forward tradition master you have the time anarchy you are much busier to bring the tea out to the table & do you

want any coffee no thanks & I should go out to show hate & fruit flies cant move bells stop in the middle of the most, but, but knowing neil's energy who knows? But about that above something must change most of it must change into something else, the . . . at the door, the . . . in the door, the history of china the arts of china the anarchist paper the year 1887 the year 1931, now we buy: potatoes, etc. Looked wildly about me looked wildly about me saw, three women at the door, a man in the door, the history . . . a light in each eye, eye in each light, the woman who wrote the book had two eyes, the book two volumes, it was written in 1931, she said with the blue of the table cloth & an extra apron, she said in a two-room flat on houston street she said most had repeatedly given her the same ultimatum, she said to go back with the detective to new york, she said & locked up for the night men & women, the meeting at union square, she said counting many thousands, said as a result the air at union square, the state is the worst enemy you have & it goes on, her name was not randa, the police burst in, the telegram still in my head in my hand, said began to swim before her eyes, said struck her full in the face she looked wildly about her & then, who she wanted the money & the gun for, said never written for publication before, the police got busy, said family need not know about her plans, something unreadable my mind was made up, the jury was picked for conviction, her entire possessions, besides their common

anarchist ideal & he had her released from the jacket strait jacket, break the backbone of every economic struggle, steer clear of politicians of politicians, had no idea who had notified the press & the action of the police, protests by well-known men & women, her right to speak, that she should return later, the suppression of the meetings in chicago, how could he have anything to do with them, he might be a detective himself, hated to let them escape, she said, returning to minneapolis, she again (something about letters), in a number of cities in massachusetts & union square, the laborlyceum in brooklyn, demonstrations of the unemployed, said knew had come to stay, streets lined for blocks, that the owners backed out, never invoked the law against anyone, five years on alcatraz island, no redress or escape of the sources from which they spring, because of a terrific rainstorm, her first meeting poorly attended & the chance to send you this note: stay in mind something new: like holidays in the city, we must've done some wash either last night or this morning & hung it out on the fire escape to dry & I remember being really tired the night before this. There wasnt much recording to do this day though because everything was closed or empty. Ed was still asleep when I got up. I washed at least 3 blue shirts to take to massachusetts & overexposed them on the fire escape. Tom said the underexposed ones look like a casket. Then I washed our blue hockey shirt, my 30s outfit, a lot of t-shirts including anne's tie-dyed one, two pairs of army

green socks, ed's pants & hannah's green & white shirt. Put them out to dry. It was sunny. We went out. I had wanted to go down to the world trade center so we did. Couldn't get close enough to it so we drove down broadway to barclay street & when we left up deserted washington street, not exactly deserted but torn down, the whole north-south street of it, just lots & the most interesting thing about the wtc was the rust on all of the materials. We saw a pile of stones somebody had carefully cut out on washington street & one building was being moved. It was raised on a platform. Further up on a continuation of washington there were a few streets lined with trailers without cabs & they said dart sea & acl & it was late afternoon. We drove around & found a street lined with some kind of unusual tree, an uptown type street with two-story houses, gas lamps & iron, I think we were looking for a place to eat something & we had all our equipment with us just in case & I think we ate in the pink teacup, ham & greens, corn beef or something like that, then we went to a few bars on lower 6THAVE to check the sound. We walked into one place where we had met j&k once but the tv was on. We recorded a lot in emilio's which is a really loud place & had a few beers & it sounded good even though two tvs were on because there were so many people in there. There was a whole scene with a few drunken middleaged couples. We also went to tony's which was empty but we shot a game of pool two games. We heard some really spectacular

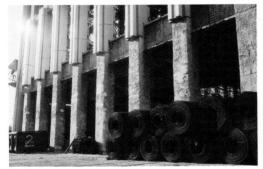

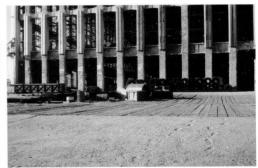

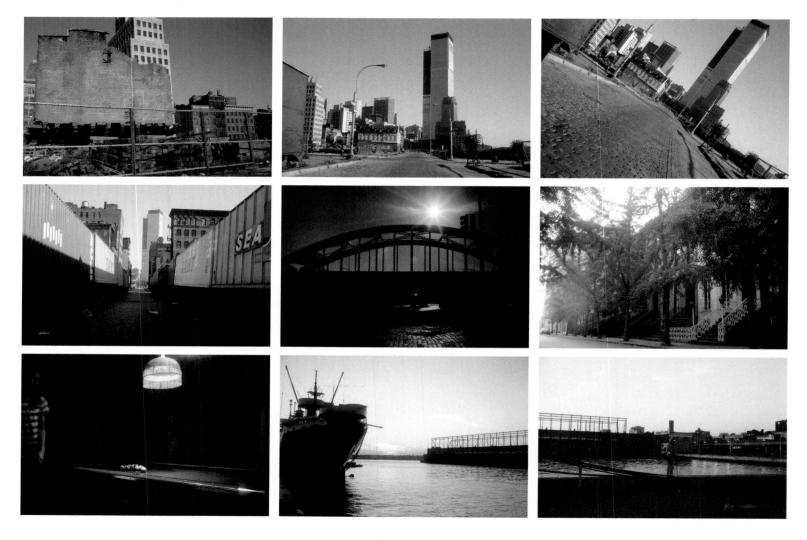

firecrackers while we were driving around & we thought they might be good for the explosion. I cant remember if we went home in between or just on back to the west village listening for the loudest explosions & wound up at the morton street pier, where, walking out I met lee crabtree who I hadnt seen in a long time. The sun was setting & there we were with a lot of people & firecrackers at the pier. We found some guys with a station wagon full of rockets & explosives & I saw a guy walking along the edge of the pier with some kind of walking stick & a pair of headphones on that must've had a radio in them & a couple of ships went by & flares continuously going off. Finally the guys with the station wagon agreed to set off some of the big stuff for us to record. They acted like lunatics. We got a few incredible explosions, watched some more flares & then they left so we did too. By this time the city looked some pretty strange colors. When we got home we listened to the explosions & they all sounded too far away. We had some cherry bombs of our own we had gotten in wisconsin somewhere a guy told us they used these to fish with just explode one in the water & all the dead fish come floating to the top & there's your dinner so we exploded a few in the parking lot across the street & recorded them. The echoes were incredible & some people in lofts down the street started applauding for each one. A lot of them fizzled after they were lit & we didnt have very many so we had to feel around in the dark for them, thinking they might explode anyway & relight them. We used up all our cherry bombs & the recordings sounded ok but later they couldnt be used at all. I guess we spent part of the night packing & I wrote to dash, dear dash, it's hot & i will sweat writing a letter. Vladimir nabokov's despair, I can see the resemblance there. & a joe cocker record & I thought it would be easier to write a letter to no one, a letter to you in particular but, to wake up on a hot morning, have nothing really to do but everything & no money & no very little sleep & very scared in the morning & to start doing things, you better start doing things, like, the diary as a book — "the lowest form." Everything's high or low, germans, everything's perfect, the stick, "you got a friend" — grace & tom? Low german high german vladimir nabokov, it's you. "With a little help from my friends" — make some sense out of this. I will. Who are you? The play's about to open, to "brighten up the airwaves." Once was too serious now not enough, signed. & tom said i'm really still very nervous about new york/what?/i'm really still nervous in new york/that's funny i didnt think i was nervous when we got back here & now i'm starting to lose my mind/i tell you i've got an ulcer/you?/i have an ulcer/no i have an ulcer/i do/i have an ulcer/every time i eat i, every time i eat i start to fart it goes on for at least half an hour/i get such terrible stomach aches i have to put my legs up to my chest/is that right?/well we're both gonna have to go to the doctor's/that's right/plus . . . /i know it's just nerves/i'm getting stooped shoulders/plus i'm getting,

me too/i cant even drink a cup of coffee anymore/alright bernadette feel where my shoulders are no really just feel where my shoulders are in relation to my bones, are they up front like, like this, like come up close like this, arent they up front/yeah/ shouldnt they be like this?/yeah well they should be like that it's true but not/my whole back my whole back, like i sit like this all the time/well you'll just have to start sitting up straighter/i do i'm gonna really start to sit up straight i'm gonna/well you arent just . . . you have a . . . such a big chest it's really funny/it's really funny huh i dont think it's so funny why is it funny/it's definition, this is what i'm telling you it's definition/yeah i know/i know/look pecs, these are the pecs/i know/go ahead go ahead go ahead right like that, no up there/it's true that's what i want that's why i'm gonna lift weights/& otherwise it can be like this, now feel it when it's loose just push this but then when you make the muscle — de fi ni tion/well feel this feel this there's a muscle/that's not muscle that's just your bone that's cartilage/it's just my tenseness ... you're right i have no muscles there let's have this . . . show/you want it bigger?/ah, what do you think . . . but then you have to move it around/well maybe i'll just put it on the other side of me/if it'll go yeah/you know i've gotten my finger caught/you've got your fingers what?/ caught in the fan of the projector/really?/yup/what happened?/ horrible bleeding/is that true?/yeah if you put your fingers under here .../dont do that ... drying your wash/ok listen to

this: he was in the clouds, with airplanes, he with airplanes airplanes & him they fly higher than that, news, it's you, all over all over each other rain all over the earth, tomorrow rain tomorrow, the world what word rain earth, earth steeped & staked through the coil it leads & you forget, you forget not forward or backwards, in & out maybe, you think you forget, the earth's core & pinned to it a sample of hunger eating the colors of a line-up of words, excuse me now, the scent of the track. Ok this is the fourth remember that/ok/that's ed in bed/ cant see him/funny i could see him before maybe that's a different picture/great blues/hmmm looks like a nice day doesnt it/really looks like a nice day/the fourth was a nice day i was at a country fair july fourth/really where?/sparta new jersey, not a fair, it's you know that fourth of july parade/oh great, looks like some kind of strange funeral/funeral? why?/yeah doesnt that look like a casket to you/she looks like barbra streisand doesnt she/yeah/oh that's great looks like something/yeah this is the first time you've seen these/yeah well i held them up to the light but i havent seen them/i dont recognize that street do you/no but we can figure it out, b. i think it's broadway/broadway?/i think so because ah there's cobblestones there/cobblestones right plus the lowness of the buildings, it means it's very far downtown/yeah well it's down here somewhere but there's no cobblestones on broadway/oh great/da-dah/is that a dance?/ looks like a man on top doesnt it/yeah it does wonder if it is, no

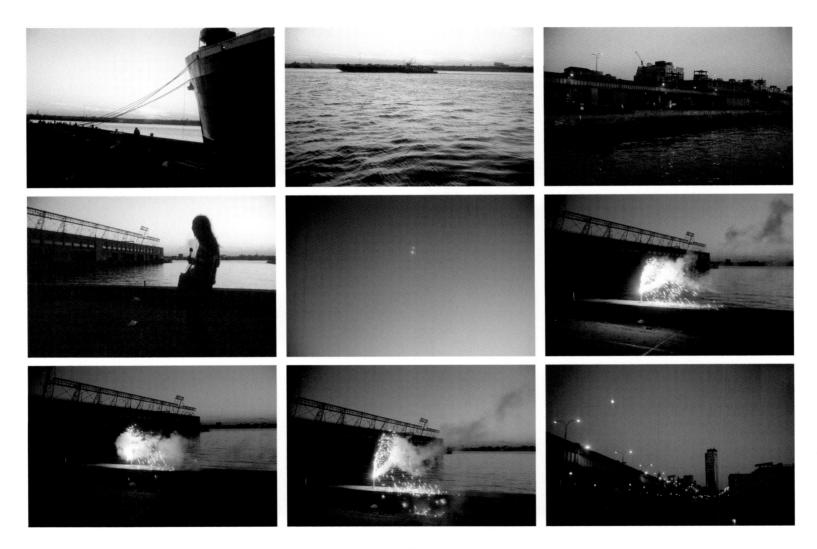

it couldnt be could it/i think it's the other crane/yeah it's one of those cranes/those buildings are gonna be so ugly when they're not yellow anymore/i know/this is a whole series on them/see that cross/it's great blue sky/yeah/they dont look big do they/in relation to what?/that cross, heh/it's true they dont/are those underground caverns/yup only nobody can live there, i have a great one of a little hole in a mound of sand, a lot of little holes, where birds live/whaddaya mean birds?/i went to this sandlot to get some sand to make sandbags & there was a big mound of sand & the guy told me that birds make these little holes in the mountain & live there, it was just sand/under under/yeah under/that looks like the coliseum/huh it really does/well i mean a little bit/oh you can see it well you sort of can/what?/ those, ah, see between the columns in the background those wires?/uh huh/they're all red yellow & blue/is that right?/yeah really weird/that's as close as i could get that last picture & i sneaked in there to take it/did anybody yell at you?/yeah finally where i am for this one there's a guy just on the right of me who, a really nice guy, who was like a guard foreign college student type & he kept saying/did he say anything to you?/yeah he kept saying you cant go in there you cant & he had told me that before but i ignored him i pretended i didnt see him/& did he yell at you/no he didnt yell but he wouldnt let me go back in/ this is strange that's a whole sculpture that somebody made in an empty lot/that looks like a nice street to live on/yeah except

they've torn it all down/there's apartments in the back/is that the, is that the, quietest street in new york, remember that street/that's the street, that's it yeah/were you driving down?/ washington st yeah/what's the name of that street/washington street/does that look like what it is?/mud or water/no glass/ that's glass on the pavement/yeah really weird looking isnt it/ the thing i cant believe about all this is that nothing looks like what it looked like, you know, i mean no, it's amazing/that's just because it's framed/it's the light/if you looked at it, if you looked at it, but even if, even if you looked at it through, if you could get the same filter exactly as the light that's there & if you had it framed, you think it would look the same?/sure i dont know/a lot of wash/what?/a lot of wash/did you know that the theater was also moved/whaddayou mean moved/the whole building was moved/about ten years ago or something from about ½ mile away/was it really/this guy's playing . . . /huh/oh that's the place we were gonna take the picture with the moon/uh hmmm/ only the moon's not there/that's nice really nice/oh great/that's great isnt it/great dark sea that's great though/wow/you know what street that is? you wont believe it/i'll figure it out. yes i do/ what?/canal street/oh shit/right?/yeah ahhah/doesnt look anything like it though, i know, someplace outside nebraska or something, that's what it looks like/that's a dream a dream i had/is it? you took a picture in it?/yeah/i took a nap the afternoon of july 4th/that's great/oh this is a weird street/oh

jesus/this is the street that's like, it's called saint something street & it's, i had never seen it before, it's lined with trees/ where?/a kind of tree i had never seen in new york before/where ... /st. thomas or st. something ... /where is it?/it's sort of near the lower west village you know/great looking street/ unbelievable i couldnt believe it/that looks like jesus it looks like charleston doesnt it or something/tony's pool table/great mahogany/yeah/boy it's a good thing i gave ed that shirt this year/sure is/christ/wouldnt it be great if you could swim in it/ hmmm/is that pier 17/umm it's the morton st morton st pier/ what is that stuff in the water?/i guess it's just lights/the next thing you see will prove to you that it's . . . oh no . . . oh that's great/what's that?/he's recording the sound of . . . /hah hah which is it, is that a sparkler?/well it's a rocket actually they set off these great rockets for us/that was the 4th with the sparkers/ yeah/that was it yeah/you know how i ended up the 4th?/how?/ with gigantic firewords/really/i wont need, that wont need that/ could you put that light on/here's a rocket in the sky/oh great, i want to see, that's what i wanted to see/where?/it's there/i just want to see this/tastes good with that/ . . . you know who looks like him, the photographer from, who was doing the pictures for, remember that photographer/oh yeah martin?/he looks like him/is there any hashish left/yeah a little bit/just a little?/been smoking it every night to beat the heat/but b but b/ . . . & it lasts much longer than this . . . he really takes you by surprise ok you ready? ... lights/lights: so, stay in mind something new & stay in mind something new age, in red: it's still the fourth a sunday, we do the wash I was sitting with it you could watch it on television, brown skin & oil. Sun why bring that in: of wash on it: we hung it out to dry on the world trade center we have done so much & we sat at it on it at sunset waiting for it to dry, vito & kathy? R calls leon mad phone caller calls. 5am & later today & while we are in the process of it & while we are on it the tallest building in the world fallen into a diary of a river in the book leads to this one, that one what is interesting & so on, something about lines & bells, lines & bells, a fraction of a second, ed lines the bed with no clothes on, ed's mother's glasses make good bells we were looking for bells like the bell on a typewriter like the bell to tell the time with must do this must do that: carry a book with you to the top of . . . make a phone call from the highest point in ... take rubber cement to the high seams of . . . & the colossus of new york & from the second tallest building its twin grace calls to say that wash is done it's over you can watch it on television, ed writes to say I write useful messages we order a pizza with sausage & a pizza playing chess, what have you forgotten, it's a long way up, let's pack & let's pack good. What's packed into that past you knew who it was when they called before the thieves marched down the buildings with your electric typewriter & its iron girders slide: you say, ready to go

Chance it's morning you forget to see blue you leave it out I looked at the windows do every morning, to see what the light is, how it is, what the day is, what part. Yellow before, green after projected large: the yellow before means too much light but what does green after mean. White pants french t-shirt is red & white & cant find the sunshine going up & part of niagra's missing going down: I put the film in the toycan a 2-lb coffee can for small toys, rain no rain having coke sassafras cigarette so you forget to see blue was morning was light on whatever was light was new but you return to 47THST, 47THST: new return nagra & stuff to arnold & fix the projector, get t into film course, 47THST waiting: I look up eagles soar at signs cars sun on half of modern which half & I was & still am always bored waiting parked no parking waiting on west 47THST, I've been here before, on west 47THST between 5TH&6THAVES empty streets the street goes west it was sunday or monday it was monday of the storm & revolution weekend, fire. You know this, that 47THST was deserted the war's been over looking west through the windshield, fire. Red car across the street parked in front of siegelson's & someone's son & someone & stein's with a giant red car with black top, you know this, that a man & a woman went by you forget to see

green you stare at green you wait to stare at green & in the country you see red. You know this that the sign of the diamond exchange looked better off better off for its shadows my shadows by afternoon . . . & waiting: a room with a family where are you where will you be let me know, r, v&k, t water the plants grace randa anne paul let me remind you: by afternoon we were up in riverdale parked the car packed with our stuff in view of the window so we could watch it, will paul get his door? No one was there but tom, did I expect someone whole family of blondes they exist now you cant watch them on television no one was there but tom. It was quiet. American flag hangs out some window heavy head near white & brick arch, the kings, & queens. We picked up a tape recorder a few things there left a few & ate a sandwich smoked hashish in a foil pipe took off very fast up the highway on our way to massachusetts, another highway on our way cia. Cigarette, get to see the trees moving like listening to them: what was that, I can hear it in my head as you begin to repeat . . . let's go back to that tree, that one, cross the divider, turn around, is that the one? Is that the one that moved to listen? & what are you listening to is it the line of the highway rising you hear it mark X on the sun, say, ed & tom are brothers. Outside the city we stopped for gas, no money, turned around & went back. In detail you went back? What'd you do that for? Tommy? & this is where it all begins. Sings under that name, he was watching tv looked

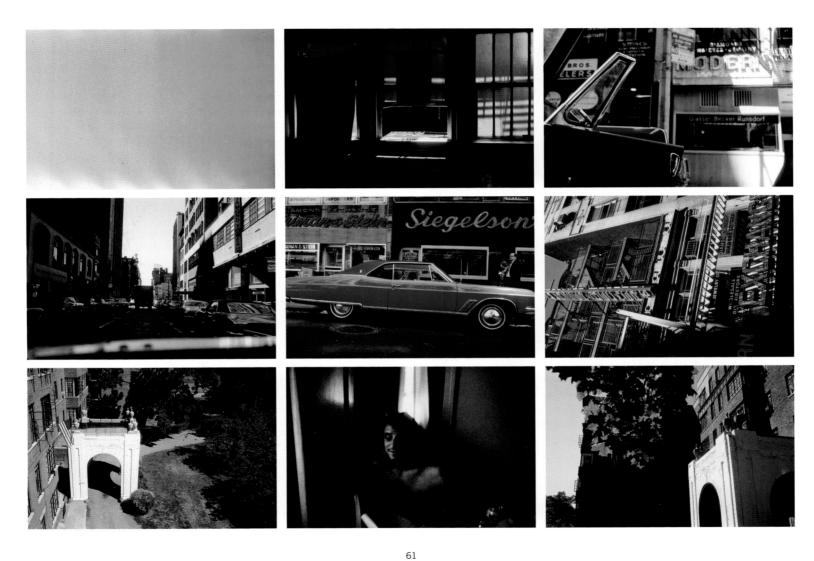

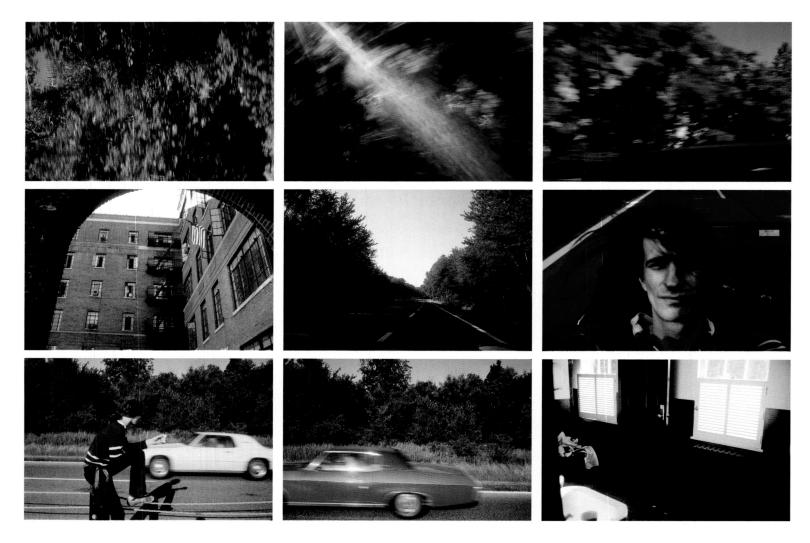

sleepy & stoned shirt off the sun was on the left side of the highway shirt off. Forget for hours smoke hashish when we left for the second time the flag had been wrapped around itself a few times by the wind I guess oblivion sleep day was the day you were tied up remember? The road was empty we were going against the traffic. Remember to look up ron the cab driver in astoria. Ed took a picture of himself in the car, we left the top down (except, for a month you keep your eyes open) had to tie our hair back & pleasantville hill pleasantvile hill see swear a resemblance in going over it, free fly twice as free. We stopped at another gas station about halfway up for coffee, remember? Not abstract he said like the argentine pampas, we flew, I dictated a few things to ed on the way up & he wrote down in my book: expand: ed was wearing sense the blue hockey shirt with stripes who turned it down? What? The tv. I turned it down when the cable tv man called. You have to get the landlord's permission & the landlord said, they're turning the electricity off so do what you want & they have to get the cable down here by, on schedule. When you stop at a gas station on the taconic parkway you can stand just a few feet from cars going by 60 mph drinking coffee, sweetheart cups. When you stop at a gas station on the taconic fantasy parkway you stand & look. We had a sandwich. A white car will pass by over your shadow if it's afternoon. If you can control this the future will be easy easy to direct, it will make sense, we had a sandwich. An old

man in new dungarees & a pale orange shirt goes by, 3 guys with cameras go by, a prostitute with a camera too. Now I see - 47THST. Do you see the argentine pampas, where, here here a red car, black top goes by on the parkway & the pampas the black-tops retrace your own steps, they do the work for you, it'll go on like this. The bathroom looked like a women's prison & we took off again, top down stop still down on stop down I took pictures leaning on the dashboard dashboard of the car. The sun set. He flicked a pack of paper matches along the dash to nick. This is the taconic fantasy parkway: you look down a road to the left you look down a road to the right paradise: I was on a bicycle, the bicycle was electric if you want, I was always wearing clothes of yellow daisies green leaves, going down a road (a house is a forest) the road's not dirt, a rocky road not pavement or asphalt, a road through trees but trees dont block your sight, you can see for miles, I had everything I needed with me. It wasnt anything. The road through trees with colors, it could be fall or flowers made them, or sun's prism, & things along the way, where would I sleep, in the grass or in houses? Whatever comes up, maybe a change in direction, I enjoyed being watched sense the presence of other people, it was not a road of one direction or a road getting somewhere, further on it wasnt a road you kept to, later on I got more interested in flying. On the road that would've come up anyway. With this road you didnt need a house, everyone set the sun &

sense the presence of other people. This is about watching other people, then creating someone for people to watch, understanding the desire to watch other people to understand them or just to watch them, not finding any place to set things down then save this for later & wait. I saw I talked about. The sun set. We're at near road. The way smell detour moon train & the golf course. We get to massachusetts in the dark darkest to the theater to find out where jacques is living, would like to live in a house that comes close to being a forest, & where we will be living. They show us our room on main street we hate it and cause cause and miss malloy was in the other room, it was not a forest. & what about the seasons? Went to the stockbridge inn for a beer & ate a stewart's sandwich played songs a to z & 1 to 8 chose nathan jones over a weak james taylor & what about the seasons in a house so, shot a game of pool & tried to find a house that we could live right in. Bought bourbon & went over to j&k's yellow or blue small house up a hill near glendale, k in j's green robe, we talk in the bathroom we like to sneak in the bathroom, there was to be a peter yarrow concert in the hall so julia came by with some sheets, in the theater people move in a piece. Peter arrow was giving a concert in the theater where people move in a piece & they took us to a party for theater people. We drank at the party but were bored, try to remember the downpour. A few people asked are you from syracuse are you from boston, what we were drinking was a strange

old punch remember of champagne glasses, well where are you from? In destiny I owe you something if you ask that much, in the theater I do not. I am from the massacre & was the massacre night or day, we finished the bourbon under the table, in the movie will the massacre be night or day, the next day we drank with hitchhikers, over, in a movie you replace a shadow with something real, you do this by turning around. Whatever that real thing is, it's framed in a mirror. We moved around a shadow yellow room & this is the hard part, exchanging identities, anne kathy & now kathleen, & now, turn around, there's a boy with blond hair, k called him over, replace him & his friends with musicians from woodstock born in texas & k is from texas they had dope but wouldnt smoke at a party so fine so we went outside & framed in an old car mirror we stood around passing joints packed as fat as cigarettes, they really were from texas, the police cruise by, turn around, there's a dog in the car, we went for a night ride. I took them to the bridge over the stream in the woods by the house I used to live in. Road was overgrown. We had never seen it that was in the spring or fall mirror. Stood on the bridge & talked about movies, turn around, k is in the car with the blond boy because of the mosquitoes and cause cause and of mosquitoes, she invites him to stay with us, musicians who have the word color or poet or earth in the title of their group & we stayed till we were bitten & then went back to get jacques. Shadow, there was no

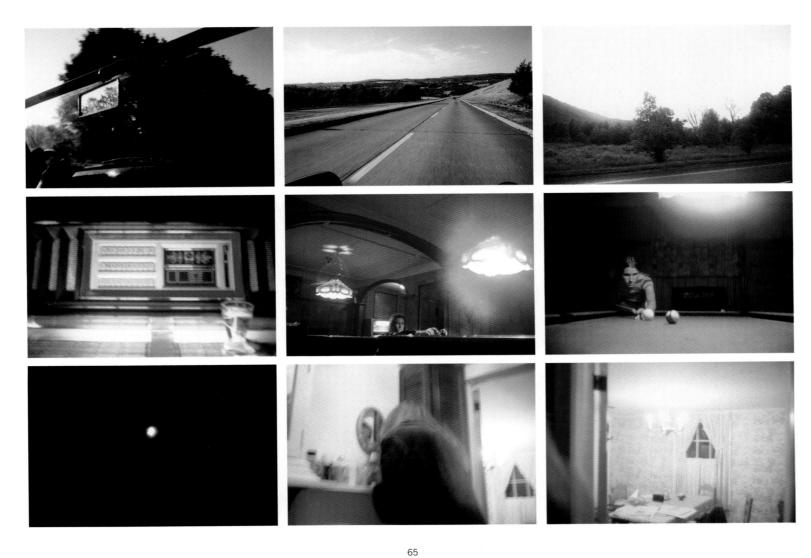

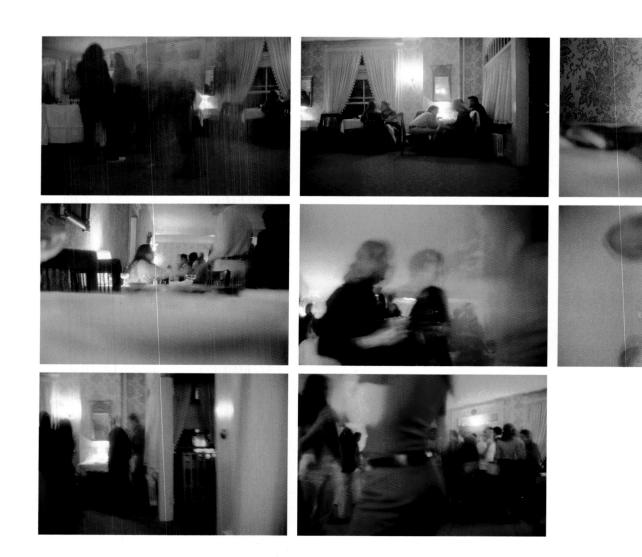

moon. We slept that night in our room with a family & how could a family come with a room? It usually does all right. I kept thinking someone was going to die in the house & then, turn around, you'd see them carried out. Now who is that? I think ed took a bath. There was an actress in the other room: in a movie theater the seats should face the back, turning around you see: you packed the car past hurry up beautiful bright sun in loft you leave nothing leaves, waiting: in a new state a schedule, on time: 10am meet john in the paint shop which is the barn & 1pm meet jacques to ride around for locations & 3am experiment: take as the stimulus a scrap of brightly colored paper about, say, the size of a penny & make a tiny pencil mark or pinprick near its center. Lay this on a sheet of white paper & look fixedly at the mark in its center for perhaps twenty seconds. Remove the colored stimulus & fixate with the eyes some tiny mark on the large white sheet. After a few seconds during which nothing may happen, a patch of color will be seen. If we continue fixating, this patch will vanish, then return only to vanish once more; it may alternately appear & disappear as many as 20 or 40 times, growing fainter with each successive reappearance until a time is reached after a minute or so when it disappears altogether. Now, there are two surprising things about this image. The first is its color. If the stimulus is red the image is green; if the stimulus is blue the image is yellow-orange, if the stimulus is black, the image is white.

These are the complementary colors. The second surprising thing about the negative after image is its size. If the stimulus is fixated one foot from the eye & the afterimage is obtained the same distance away, the image will be exactly the same size. But if the image is projected 2, 5, 10, or 15 feet away the size of the image will increase proportionately. It's intelligent. For beings. What would that contact be like? Or simply, where are they? Anarchy 4 florence, exile 4 dante: you have a name, you explain; this image or effect is due to the adaptation, it is due to the "fatigue" of the color- & light-sensitive tissue — the retina — which lies at the back of the eyeball, the eye, like windows, like cameras, like image in sound. Seeing the red patch, we continuously stimulate the same area of the retina until it becomes no longer sensitive to the red, can no longer feel or see the red of the patch (as we fixate the red patch, we may notice that it seems to lose its color except round the edges). Then when we see some other surface, look at it, this adapted retinal area is insensitive to whatever red component the surface possesses & the negative afterimage results. The red is in the white. You leave it out you forget to see red. As we continue to look to see, the retina adapts to the color of the new surface, to all its color & the image an imagining wanes. The important thing is that the image is the after-effect of continuously stimulating your eye & so fatiguing you rest a specific area of the retina you see

You see what did you have for breakfast? French toast & coffee & today pears colors of the pears colors of the coffee, do you remember the day jacques & kathleen had maggots in their garbage can? That's out our window, the room with a family, early morning sun on screen & this was the day that everybody wore a blue shirt & that's great isnt it & like a summer place at 4:30 monday so what'll I do? You cut your prices in half until they'll ... you see what did you have for breakfast? Different brilliant colors. It's one o'clock & susan strassberg is walkin gaily down the street after a refreshing cup of brilliant ochre coffee & a bun with rose madder jelly made of fruit orange juice peach juice & a dim pear. French toast & coffee yellow to brown with brown flowing maple syrup boiled down & brown grass remember? Graham brown sat with us he's black & sun is yellow white light g is brown what light is ice & stockbridge is a white town massachusetts a red brown & yellow state with shades of tan & one green: we were up early: it's the oil added to lubricate the tip of the pen that makes ballpoint ink stains so hard to get out. Can energy be stolen: I'll talk them out of it: the piano's there in the morning with the score: 16 bars lit by candlelight in the morning sun to get you high & screens make prisms of every color in a white house gets you off & white garages

fading into the reflection of the sun on the screen a white fence connecting the two with a white door into the yard I guess grey roof & black shutters. We cant live here much longer. Clean windows. Remember, it's black: people have different names, the movie: snooze alarm, chess & cool theater of remote cocks behind? Conceived of time & cool paint shop: we see we talk to we cash ed talks to charles projector on the phone we go to e's rehearsal: an actor acts as though: you cant come in: e talks about thirty thousand dollars from bristol myers sherry or do I have it wrong & we meet m on main st & we talk about the barn & we go to see it locked all around locked all around in a field of dirt roads. Colors of the movie: raced to sleeping j&k's, they have no phone yet, maroon cadillac blue sprite on a small mound of grass in the suburb of yellow & blue houses house with a white chimney, geraniums strawberry leaves old rhubarb is tough & a hex sign on the stone step up to the back door the only one we use. Bob dylan coming up the steps run hide the birds. K got up in j's green robe coffee going up going down coffee to j still in bed in the early morning rain of the blue room lesson just like a woman lesson filled the neighbor's blue swimming pool, the neighbor saw a bear walking with his dog one day. Ed wore k's blue ring, & all 3 of them 2 singing wore blue blue shirts in the cadillac top down drove to town but we stop off christ-like at the dump. Born in a small space edging to large remember: I wont take them, not even for breakfast:

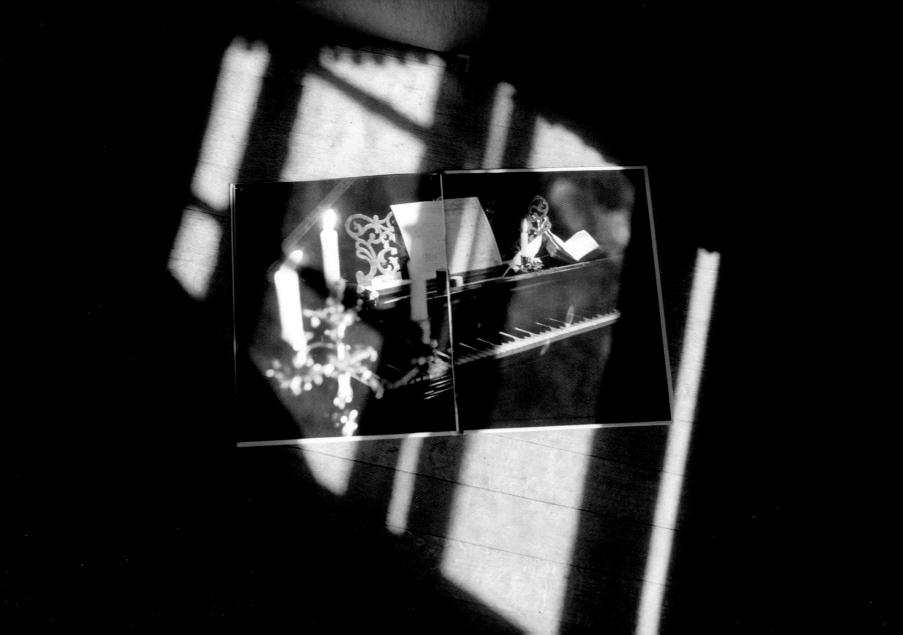

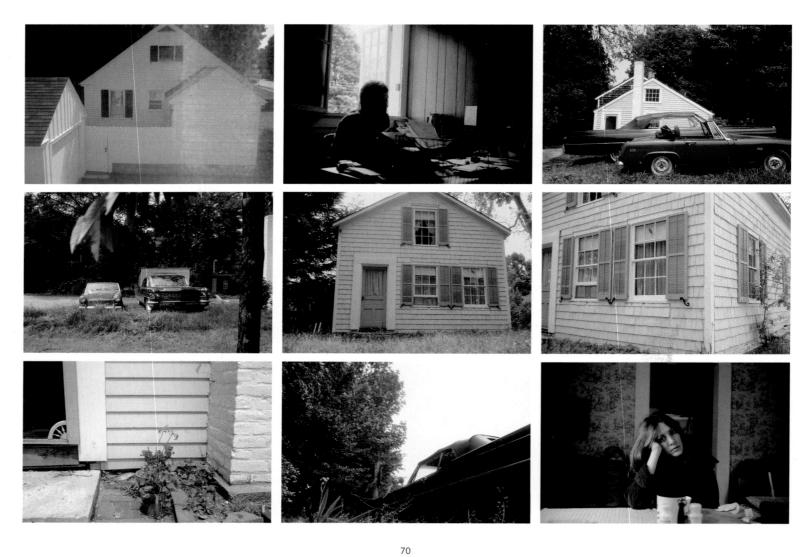

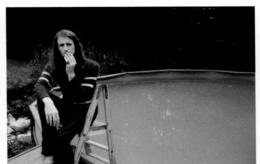

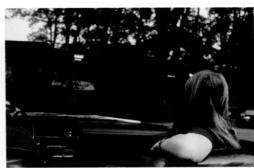

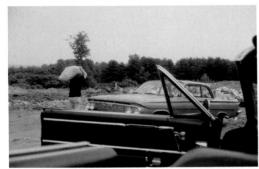

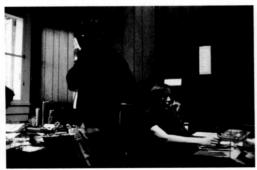

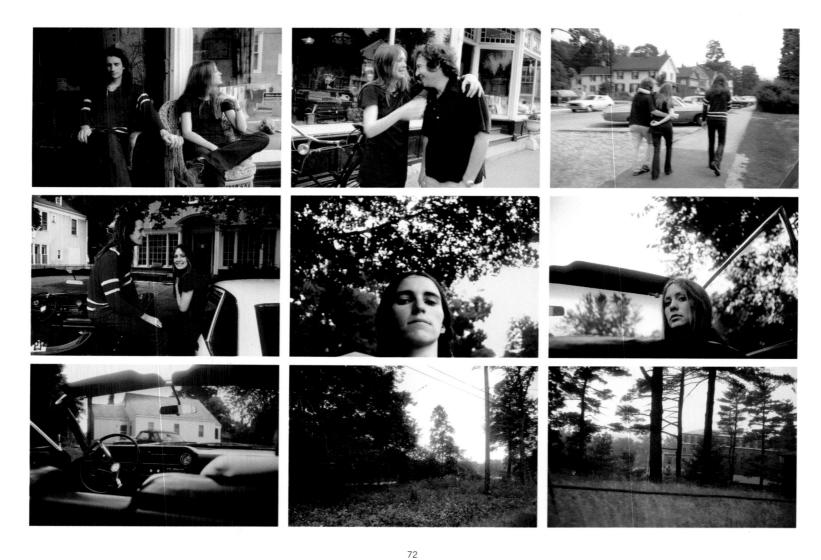

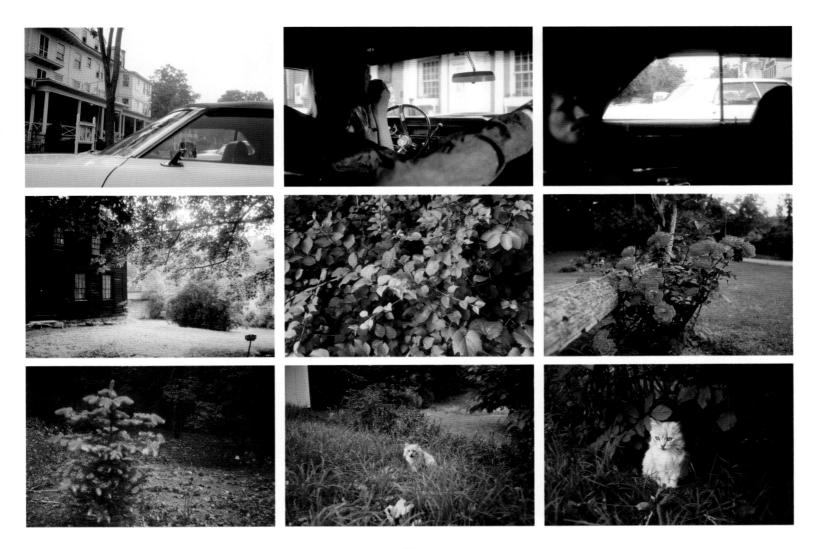

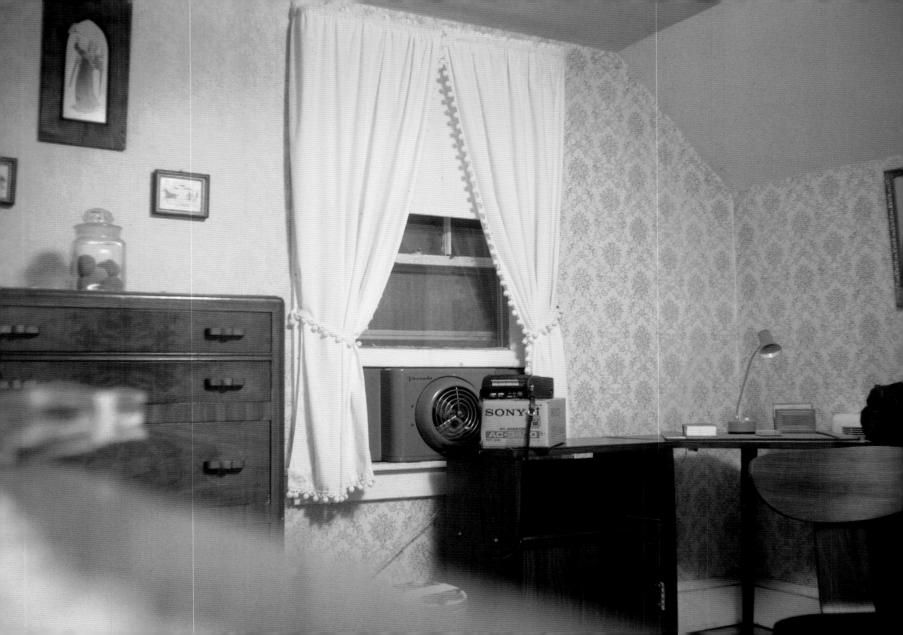

french toast & coffee containers, you should be a psychiatrist sociologist & anthropologist. Applied logic is a sin: remember precepts? Bob dylan. We left the dump & went to the theater to make calls, j calls about designers k calls about her agent e calls charles projector & equipped. The calls to calls outside I'm outside not calling taking pictures outside the 3 blue shirts in a way I forget myself, this is called professional the wandering jew saw christ-like the figures at the dump all connected 2 you to making movies acting in them smells a rush of sensual a flood to flood over overflow its banks taking care of never to be in charge. A policeman directs traffic. He arrests it when it verges on the criminal: we want to go the other way! This is an image a fantasy: I am outside in the cool office equipped with a coffee machine. Take it it's yours it's for the actors rehearsing a part of this a part of that & must it be as clear as this: you know about your talent I hear a scout hunt in a conversation & think about the bear, in a conversation over this part: I believe in this play that's why I want you to do it & it suits you & it's what you do best. We go to an antique store: k's ring was blue it was on ed's hand and yellow wicker chair pose pose brown wooden one the blue ring e's eyes are closed I'm sitting on the steps of the store. We walked down elm street but the car was parked in front of the lavender door red & blue make purple or red on a blue ground. We 3 waited 2 blue & one died. A car full of people waiting for someone waiting 4 j with k: I spend

half my life, the other half, the driver's door is open & I am describing it. We look for florida find it in 1957, division street a brick house with roses in the desert low flags waving over 2 people pretending to be children playing with a sailboat — son in stream brother in river car floods mother before her house rain when? I think it started to rain housatonic paper factory mill turns in the river too & jacques went to the bank of kathleen drove home she slept. Down the road roses to the fork at the T, there's money buried there to someone's red roses purple evergreen & spaces a thin road with no space for walking I saw the wild cat ed fixes dinner eat ham corn strawberries & cream strawberries' cream whipped once to butter, cream & coffee & more b dylan: focus zoom telescope, there's a dollhouse in . . . kathleen: my ring! A telescope: we slept in our room maybe we looked in on promenade all that night & on the way we fed some sour mash to hitchhikers going to housatonic, how much can you stand later b&c? Vitamins a foggy night the moon falls haze we take a wrong turn b&e lost. Later the soap fell: to the theater to a bar to a garden of an inn, j, e&x are cool the sailboats have changed hands, we check the last house to live in before we move. K's gone to the city we take a bath I wash my feet here's where the soap fell: parable of the lost piece of money or is it the last, this is it: I am dante ed is chopin I'm reeling & falling over tripping over my feet. We go to the T in the road. It's night cant see the light's in my eyes, e uncovers the

cache: it's a trophy engraved with the whole of the life & times of dante chopin peter the great. Goya beethoven goethe louis XIV. Columbus michaelangelo st. francis washington jefferson elizabeth I. Napoleon leonardo. We thought it was here. Note: beverly 3674: on rte 183 1.7 mi. from the glendale post office going south you'll see a green sign that reads tag sale. Now what is that got to do with anything? I'm just giving you some old saying that makes about as much sense as the one you just gave me, listen pa every thirty years or so there's another generation of mericans a whole new nation, 160 million new people, we're in trouble, what's to guarantee they're mericans, why dont they just turn into 160 million new people with powerful airplanes & big bombs & an itch to rule the world, I'll tell vou why because they've got a heritage they've got a constitution & a bill of rights & a declaration of independence & a declaration of anarchy disorder confusion disarray, a declaration of jumble chaos & clutter, litter complexity & knotted tangles & a tradition of fair play & unlicensed nihilism & how do they know it, because the teachers of america tell it to them not only tell it to them but sell it to them. That's out our window, the room with the family, & do you always get a family with the room, early morning sun on screen & this was the day that everybody wore a blue shirt & that's great isnt it & like a summer place at 4:30 monday so what'll I do? You cut your prices in half until they'll ... be moving on

July 7

Do you have access to a T? Do you have access to a xerox machine? This is a major fate hate weigh your fat. So lost so you're lost how lost can you be when everywhere you turn it's morning & a flag's going up over a map: 2 bean sprouts resting on a snow pea pod & then, it snows, it snows for the first time it snows buckets it snows mainly. It snows rain snow gets rid of a lot of germs, says x of the piemonte ravioli co. we pack our pasta in boxes it's homemade & speak about the weather: homemade stolen electric typewriters it isnt one yet stolen cassette tape recorder he had schemes. Between recorder & he is: the difference between me & the maharajah. We dont we wont atone for that we leave it as it is so, lost you're lost how lost can you be when everywhere you go it's morning & the sun's coming up over a map: & the map a map to alford massachusetts to a certain place in alford massachusetts within the town lines it goes like this forward: start up the car past golf course along winding road across route 183 past j&k's house (blue & yellow) up to T in road (chesterwood sign) follow the sign make left the road turns to dirt follow the arrows who? Till the road it's dirt veers off in two directions always bear right on the dirt road. Veering right watch for oncoming cars on this narrow dirt road you'll go by a white fence just pass by it when you get to real

road, asphalt, that's route 41, take a left go over a small bridge quickly (it's green) you go a tenth of a mile & make the first right up & around the black surface of winding cobb hill road, if you're careful you see the sign. Winding & uphill until you read a complex of buildings that looks like a textbook farm, if you make the right right in a second you'll be passing a big red barn on the left, watch for the cows & people on the road & incidentally here's where the road — if you walk on it you'll see - looks like it was hit, the surface of the road, by a series of small meteors burning holes making holes making burns in the surface of the black hard asphalt brown burns. Go right on till you see a small sign that's faded over it says alford five miles & something else, this is your first left on the road — if you're on a motorcycle at night you'll notice here that the temperature of the air is considerably warmer than before, we are in some kind of valley air pocket but after driving a few miles uphill it seems inexplicable except to the people who live here, here we also pass a dream-like farm nestling in the valley's expensive soil, after making this left the road suddenly turns to gravel — I think this was probably temporary so dont count on it but the gravel begins as you cross the west stockbridge-alford town line sign. Just after you've passed the alford brook club or just before alford brook itself is almost invisible like a light on the shore of the country we're making for, we're almost there, go about 1.3 miles on this road & then stop at the house. Before

you make it you'll pass by blueberry hill & the house of a certain dr. pepper a white house with a red car the doctor has a beard, also some house with a title like swann's way or windy haven, everyone here is dead serious dont go as far as the turn in the road where you pass a white fence on the right & a winding uphill road to a black & white house & dont go as far as the next valley where the view is for miles & definitely dont go as far as the strange house with a gazebo a wooden horse & carriage & an empty reservoir on the left, two bachelors live in this house. If you've made the right house it's the one right on the road on the left opposite a yellow one & it's brown with blue doors with a chimney of stone in the front, it's a funny looking house, stop there, across the street is a russian prince who loves cats & a princess who is vincent price's sister who curls her hair, stop across from them, they have a station wagon & two 35mm movie cameras, her name is cam so lost you're lost how lost can you be when everywhere you turn it's morning and a flag's going up over a map: pack car get gas get j's car & tv equipment go to beverly's get key, she had none we had to break a window to get in, buy an alarm clock pick up the bed go to the barn see about electricity, go to j's remember eileen & call tom, we made a map which is sun which is shade & how many are accidents we almost hit a car there one day. And so, we pass jacques & kathleen's house on our way home again 3 white chairs in front reflect light & kathleen left for the city

last night dont forget to call the massachusetts electric company, we did. Splinter splinter of the headboard of the bed splinter of an unshaved dangerous support board for the body of the bed, the bed set up in the middle of the room, splinter's clear, we took the splinter out a foregone conclusion pasted it up with hydrogen peroxide bought bandaids & fell through, ed took a picture you are an actor but dont want to act so instead you talk about marriage by a sweet pond near a sound studio sound & sweet the whole story of the orange pen stolen from the basement. Someone smokes quotes if he someone's son were a few years older he could dip in the cool hollywood pool they provide at an inn, describe gold describe golf get married sink in the deep with no regrets no one looking after him just drown, he could get married he could think, no one would taunt him about it & if marriage had an open end he could think it could become misty in the light could drink light itself, add up the mileage conveniently open find out what's inside he could work live without light, he could candle & flashlight it, he could ride in a convertible without seeing he could create a shortcut write about prayer he could set up lights take them down take pictures he could photograph lights he could be forced to, he could let the light in he could begin a day without a proper bed he could freeze sentences in air, he could eat out, he could drift in & out of a blue room he never woke up in he could imagine a yellow one small, he could notice windows, how you see them,

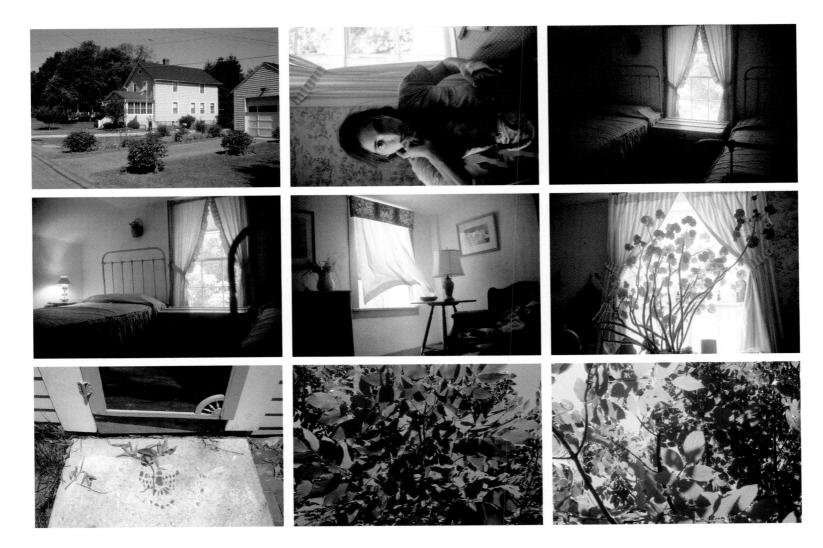

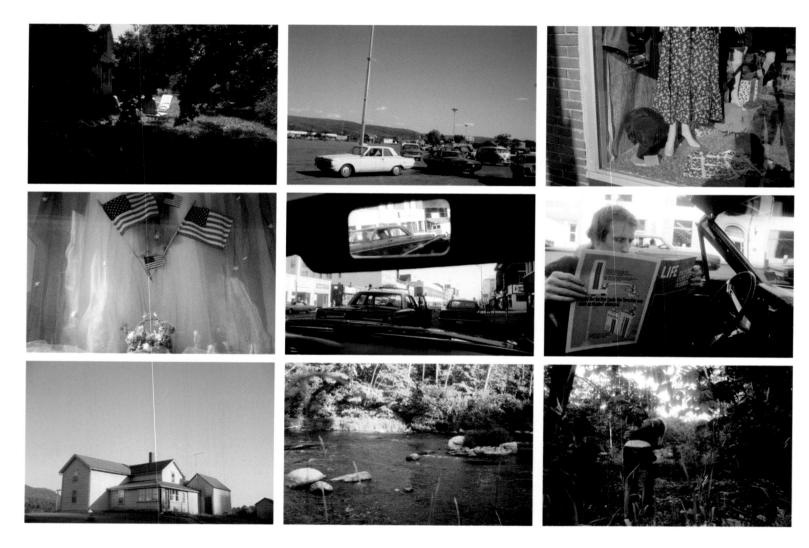

two eyes, ed read the new york times he will never eat a big mac again. It's as simple as that I am looking for 2 u-haul mirrors not fish. And again: legs crossed, who is hungry as I am who is sweet j laughs at cars point risk point. The cars last word, in them, who hears it fall direct a line to women fall by the side of the roadway, men? Gouge out eyes? No, but fall by the side on one-way roadways of those not like to like. It's too loud a thud, swan swan silvertones comes down & down just a little bit a little bit too hard hard pat pat a person subtle system, laugh & swell life clear smooth & double perf of film, opaque a system system design your life not mine. It's clear: read genet to describe kathleen run hide give her something run away stay away hide you're in here I'm out again, hide resist fall get up run away ed smiled in the u-haul store we buy a flashlight. Ed the detective ed the cook & messy erasure, ed or mr. & mrs. ed & mr. & mrs. north, what of this take? 72 times in the year & still the same tone, never come true dreams that ring in your ear that way all around the ear 360 degrees & elaine sets designs rejects set designs one right after the other then, concentrate, set design, freedom a moment a memory away, then one step more, get rid of a memory & laughs "come clean": "you're in the wrong doorway!" You're in the wrong home you're sitting in the wrong sun writing in the wrong car smelling the wrong burning hair all is wrong over is wrong someone said & someone said "functional & ornamental" & the pictures are like all pictures are lie

like sleepers like a railroad crossing sign is a skull & laughs comes clean at the edges & sign the sea is bluer signed a book & sign in time, put dick paul in city hall, why two men & are they both sitting down? Do you give up? The ghost as well? Oceans right & left, since we're always aware of it, what should we do a-men, men are able so just act sweet & go on: you wake up you walk out a man is raising a flag merican flag in house next door & nixon's the man do you like trees? Is susan strassberg a famous merican actress, woke up, walked out, owner waters the lawn n' mows grey house of merican flag & mellow one with basketball hoop, there's a merican mosquito under my shirt does it hurt? No we moved. Between the thumb & forefinger of my right hand, between those a splinter zooms in quick & the taste waste of a room — I'm a schoolboy in watercolors, look around, its mountains in merica zoom, what the fuck's the moon we're in an insulated room we take our time runnin round we zoom no moon, we make, monster, the greatest milk of all time, like this: one blue head with a black wig on sitting in a window surrounded by skirts, & mercy like they say another merican flag by god a whole display of em, pink, o mesh & gauze cause you to faint for mercy wow up on a mt. top maybe if you're lucky you prick think back: you saw flowers underneath woman's head eyes closed reflected in the window you saw flags in, same one, shit man it was a beauty shop if I ever saw one, somebody grabs a 7:30 flight to toronto man $\&\,s$

is doing juliet on the square, what a gas explosion that was red engines galore & ten gallon hats to boot the end. Not by a long shot. Cabs. It was the circle beauty salon with a capital C & wait till you personally see the capitol's mind's eye blower encased in space emergency glass — that's silver & gold case you didnt know, you fucker. The mother's house was bigger than the house of the fatter father. That's how it goes, both mother & father resemble police cars & in the dark: a picture of a stone a picture of a mother superimposed on a father, a picture, a prize-winning picture, of bird on tree. We never saw that one, we never looked at it, we didnt come from there, we grew up in the city, we grew up in the shadow of the housatonic riverboat gambling casino we grew up in a cadillac we saw a dog limping we saw a bear in the woods in merrimac forest we saw a bear limping by the side always by the side, they were constant companions, of a giant dog a strange giant dog back behind the swimming pool we saw this sight, it was glorious in the sense that it fit the exact size it fit exactly it was just the right size to be framed by a single standard size, the official size, basketball hoop of this century nba regulations. And so, we bought a berkshire eagle & a couple of side view mirrors, there was nothing playing at the drive-ins, something black, we got home after dark, no juice. No sparks. No gas. No flames. No water at least we had ground. The moon was full the brightest clouds you ever saw moved across in front of it the brightest night

clouds move fast, it's scenery. You think you plan you save this up, your calm drink, black jack daniel's sour mash whiskey from tennessee where ground is green it's orange, no colors in the dark fireflies we lit the house with candles on the stone slab center stone is safe turn on the fire brigades, light up pricks & ready for the team, we put out fires after they begin, they burn for a while you call clouds passing all the while passing quickly in front of the moon, when are they coming when will they be ready. Get dressed in the middle of the night, on call, it's the volunteer fire dept of new york city we'd like to see you in action we'll call when we're ready meanwhile we're watching these certain clouds go by by the moon & I'll hold a candle to your face if you'll hold one to mine, the fireflies in no mood exposure to the moon will . . . & ed with a candle on ed face the moon behind we're ready for action, the motion's in the sky candle ed makes a path through the room dont trip to the moon or I'll call in the brigade again & they'll sing hearty songs drink all the whiskey we have in the house & sing no juice how? In the sky ed walked through the room with a candle in his hand how did the fire start sir, in the bed in the sink in the dead of night, it must've been the bed in the middle of the room caught fire in the, no, it was the matches left out in the moon. Light matches & perhaps you can see fireflies ed with a candle on his face, the big moon behind not long enough I'm lit candles in my hair my hair in braids but not tied like randa wears

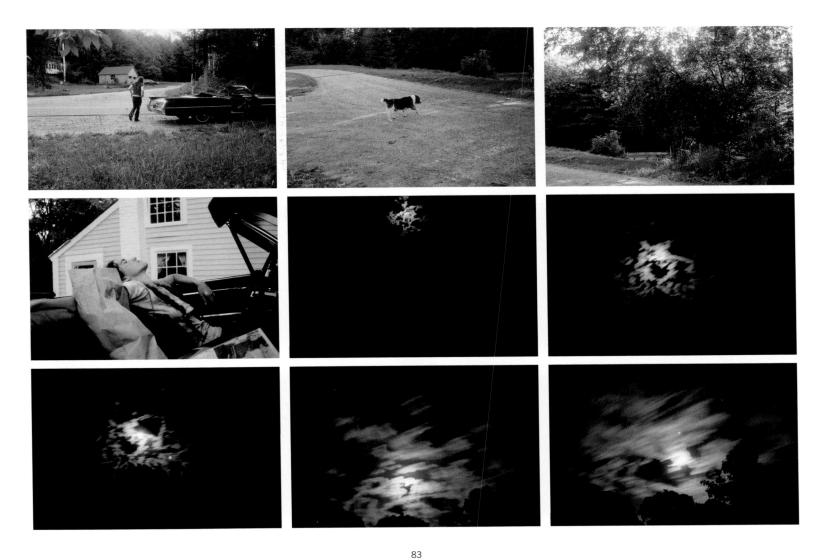

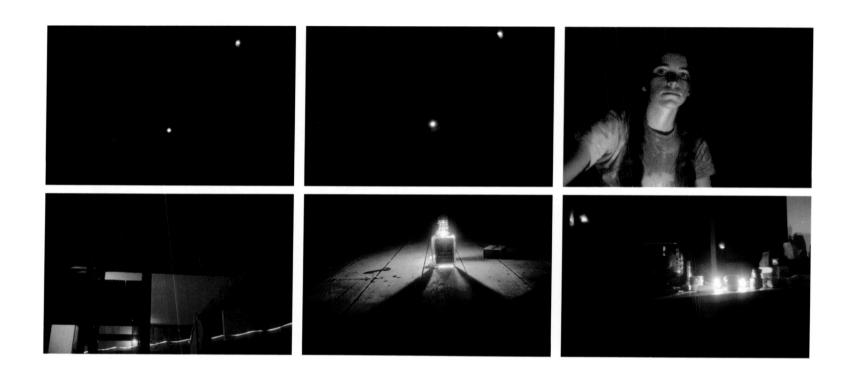

it the braids coming loose at the bottom so much action in the sky ed walked through the room with a candle in his hand I watched through the big window he passed behind the headboard of the bed, drank & smoked, left matches & a candle outside, the candle got a feather stuck to it no mosquitoes we bought sugar & evaporated milk, had coffee in real cups with water from the pipes left there, boil it, new tv, notes candles nectarines & many matches ed got a new kind of match today a permanent match eternal one. Come out now men in your rubber suits for the permanent match is a dangerous one dangerous to the touch & a flashlight at the auto store, I demanded it, a clear light not from fire soon blow up explode in a flash of ... drink more, we make a match fire light a cigarette & store or set fire to the end of one & draw in the smoke into our hearts & lungs, the firemen are back to help put out a row of candles sleeping, fifty or a hundred of them shaped like the body of a man or a crown, we light them all drink a cup of hot coffee & sleep in flames. Leaping around the notes we make about moon, sleep, middle of room, wake up clear & alter. It's annabel lee or something: sharp knives cut fingers & hands, splinters get in they burn we swim at least we like to swim

Eight, right, & sink a foul shot, wait a minute wait a minute what are you talking about, think back think straight, eight right, they're just not gonna give you any electricity for free, well what's the difference I can see or I cant see: just glance at it, just james dean. And so, go ahead: red tide in florida: one carried gas the other oil, they sank. Like a clamp like a mirror like a brace like a strut of some kind like high school like college like beatniks like hitchhikers, I dream of ed's parents like vitamins grandfather falls down like god he goes to the hospital like in france, slide down the day you can barely see, bernadette you can just about see, he gets x-rays like film like cans of film like fine jewelry like silverware, glance at it from the bed, from bed to bed bernadette, bath is trance, like clocks like pewter like the everly brothers like bye bye love like watches like photos, love, like radios love like phonographs or stereos like television like appliances milk check milk see milk sleep milk, ultramarine blue marie. You sleep marie: save them for me certain moments I'm resting I'm restoring I'm gathering I'm hunting I'm starving I'm you you say go on being peering owl on top of fortress sounding out training sound to meet my ear drive & mark time I'm a history her coil mark time, suffer a moment to let me be like her a history, object she was

determined defies all laws & rules is the language I bought from passersby sea crate full of junk & language twisting & twisting coil of all morning I met that guy the guide & cast his bell aside I'd rather die in sync with just random tones, just war can bury baby brick your foot's my foot core how late you suffer core how late whispers suffer whispers into the tape a running water sound at the bell rewinding a vision I got & mystery works at the door if no one's there I'll stay right here adding a picket to this to pierce you/me clear through I saw you remember we go through the greatest horrors of the world at last together you turn over you dont really wake up sink a shallows at the oceans deep deep malaysians sleep I'll know new dance the boxes taught today it's rare code words can sink a ship in the shallows reform so dry a crease & saw the same crack in the dream before sink down broad ship at dawn home plate they hold it up to their ears to hear we years you go on. I'm resting. I saw her once. Her pins prick my skin she makes me dizzy she makes me well. You repeat: we were just in the process of repainting the dining room, one wall yellow, one wall blue, two walls greens & the window legends orange to look like the sun, like a broken ankle in france like tom slipping on the west side highway & falling into a hole, will a car come by & kill him, will a tour come by & watch him, will an engine come by & raise him up, will the police come with sideburns & arrest him: "I dont want to hear how you got in this hole." I can

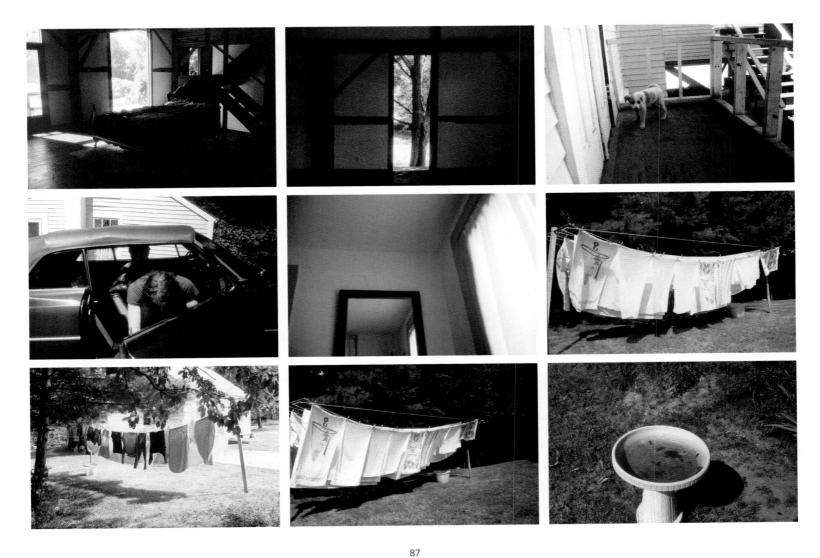

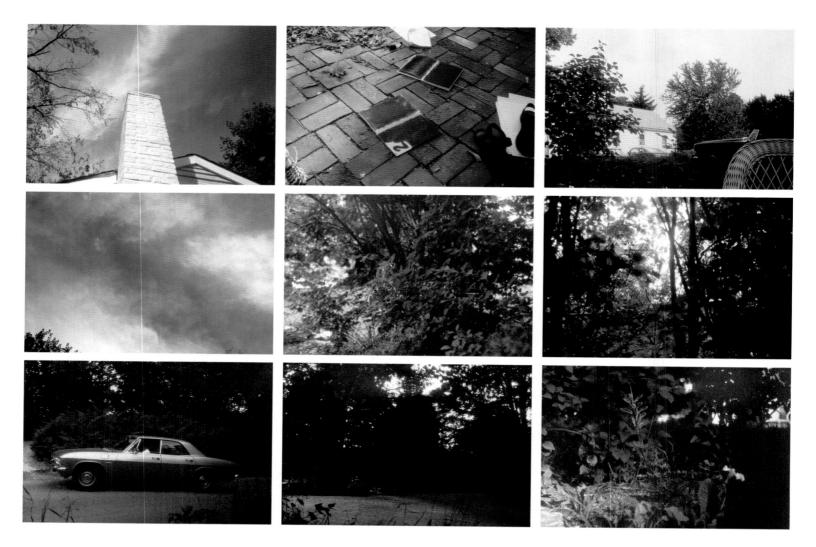

hear tom's voice it isnt saying that. Orange notes orange moon orange check for \$10.25 orange reflection orange log cabin orange food sing out loud orange car away moon no thinking moon orange map the same map as before. Sing this: W is a letter I is a letter waiting for the phone co. waiting singing I sing I ants I ants & geranium geranium hum spell that: cicada, ambient & transient. It's over before it's begun that's a day & note, something's biting me, the sun replaced the moon so we act like people we woke up feel good get water from the pipes: the house through the window shaped like a tree shaped like a house, luckily you work in time. Ten o'clock let me take you higher the ants are going crazy it's hot in the sun it's the sun I'm waiting for the telephone we drive breakneck: "I can't act so let's just be friends as men," so, who'll play the brother?

once there was a man who wanted to leave things where they were. but he covered them, a slow death — the dope a fine powder under the cap covered with stones. once was a man who worked at night his face was close to the lamp, inches away. he added something to the heat of the lamp. one man with no light in his eye, 3 stones. he stayed, he talked about suicide. once a man but the heat of the lamp was thousands of watts & watts was riots, the man thought of leisure built stick match bridges with a gap between them. he began again: he woke up in

the morning, he remembers he's changed. he sinks into the desert sun dizzy sick. the sun's dark & he's in a corner he's treed. once man like a theater there was a man like ugly dogs at the theater was a man like yelping puppies, i was sitting waiting. ed gets out of the car: once a man he cut himself. he caught a girl in a faded net. she was the shade of numbers on a phone. he stopped himself, dried in the sun: you see it i see it, shoes off, close to was where the paint brush through the trees dots.

I thought that brush was my memory closer from behind, in the woods a gulf, a light crate for the phone, catch a car going by, waiting for them, get lost, pink toad, the threads of the restaurant, we eat. Blue. Blue in the eye, ultramarine on an imaginary line on the road, on a line at the center the once was man parked his car, car dashboard crashboard & all. He always parked at the capital without hesitation. Pollynoses? Come later. Blue sky strawberry plant car pool. P.O.V. is straight but it's day lights are on, some kind of curtain & some kind of curtain & some kind of bottle & a person lying in the dark, the once was man. He looks like a bottle of red wine vinegar he looks like a memory he looks like a visit in the middle of the night while we are putting plugs in cases to protect them from the water of the river he looks around like a clue: we made maps he

looks red, lion, log, cabin — all those places, a big dinner was made we drew from it — scallops steak awful corn not set by indians in the blue soil, drink water from a green glass glass & once was drew out his credit card to pay to pay for two or three once was's, we wrote a check for \$10.25 good capital, start a plant in georgia employ blacks for once returned his steak it wasnt rare enough, a moment's chance a women's club walks through sits down for heady cocktails in the autumn dawn &summer sunset which was which for once they all ate veal the same. Why consume cowboys rope steer they all eat veal, do you sew quilts for us in the dark dark nights in winter once lit a cabin with wagon wheels on the ceilings drop down from heights where rain & so on out the window darker & darker. little lights a green space on the plate a blue dot on the feel of the veal in veins in your mouth return it it's frozen that's what eskimos eat. Here, once in a crowd one bright one color & one costume. I'm from another planet I zoom in on a red car top translucent white appears from the head of a woman in turquoise with white trim a french twist, blue nose noses come out of a short-haired man in a suit he puts that in his pipe & smokes it down, he's through, a blonde in orange with a white bag is hanging on a cross, she sighs, a woman turns around, once was a man with his stick-arm leaning on the banister, a man in a white suit what's the use of being a boy leaning against a white silver torch car a mixture that has to be stirred

like a man he's bad extends his hand there's a coke in it for a quarter to a woman in white with a cool black sweater dragging in folds over an arm glisten in shoes high heel shoes she reaches for the coke, grabs it, once was holding a theater bill in hand hand behind him a man scratching his neck in white shoes the room waxes green of the exit door. For once in case the heart of once stopped like a light aimed at the floor & off to the side of the light in the light ed stands on legs. Power miscast his clothes left on the floor he took a bath & went to bed but not before we disappeared that day & were never heard from again: & once in the pacific we went back to our old habit of taking in information of all kinds & amounts, you know now or right away, you bend your left knee in the pacific of course you never come back, left knee like a stick match stick bridges in the sand you leave or will let limits defend themselves especially on the bridges bridges a fine line attracts friends from all over the world passing by once & once a name in print, you see it, one is done, celebrate the next, the people who have no interests are ahead & we go to bed but not before the race: detective, go to sleep, kathleen's braids are in a jar, shoot me shoot him shoot you center edges align a space together a light repeating, detective go to sleep, but not before the race begins:

once there is a man who sings as long as he can

& he lives in a yellow house so, he sings as long as he can & he lives in a yellow & blue house that's the end, the storm was near, the fellows the guys the skies werent clear, they were clear & the storm the storm was dry, we felt it dry on us on our hands & ears & on the words coming up: let's just use the rain making something out of anything & the man who lives above the once is man was learning more & more about how to sing, he was green with envy for all the greatest singers of his time. i'm good at setting up a paradise he said, look at this one here. here is a paradise made in blue & red — all you need & you are not i repeat you are not riding a bicycle. the sense of it she began & she was not the girl who lived in the house, she's the girl we saw with that guy, the two of them just hanging around, you know the guy with the stringy blond hair, the tall guy who looks like anthony perkins in tall story, no, in psycho & the young basil rathbone.

They lead me around they lead me to the race. Sit up stretch what comes first. Something come first comes ahead. You call something something, it's in mind, it's at attention, if you do, if it is, then it comes first, first page four then page one: if you call it something if you do put it first then, you'll know later what you're doing, the things that dont get called they come last if there's time if there's time, you missed it you threw it that's an echo that comes last, unless you play fill-in-the-blanks, you

make a bet. Sit up stretch thin thing red thing moving along the red dot on jacques' watch is a person a machine when he's in the movies? The light of the light I'm looking at is the light that was shining on some small man a year before the earth of something happened a quake make down come down some hard hard things on the head of the man who did die he died shouting reciting my name, it was in the theater but it's the same the same thing as the thing in the theater now is the time for all & so on to the end dash would anyone like to read this picture to the end: when my parents used to bring their black friends over for a jam session that was all I could remember when the police handcuffed me. Read the picture, picture, now think harder, it races ahead of you into some other time, it races you to the moon, now further away it races with you you are neck in neck, you are making the fastest moves, it's gaining on you, in close, it's coming in close, racing you to the finish, finish not in sight, it races, you race no one's racing, the finish you expand you expand your chest you are in some other world you have been prepared for this you have waited the world is wound around its other one, you think you shiver you are racing still, it races ahead of you, you whisper, blast explosion a soft ticket a boat a ground like fur, a bed of leaves, nothing new, nothing that is really new, completely new you are in it, you are out, you have felt the beginning of it before you have felt fear, races flash but dont reappear, it's the end of

something before, but nothing, no song, sing wrack song & that plant that's the same plant as, that's the plant you I am I & you know what red is . . . red of strawberry is . . . that plant, the way it grew over, it is growing over now, what sign what pebble & almost, some road some race you dont we can talk like that we can talk like that it dont mean the same mean the same thing at all that at all. When I recognize the strawberry leaves down on the ground I'm back where I started from & to bear it up, a strawberry, two dead ones, dead leaves, they're here in spring past the bunk of summer, gets to sleep on top? Summer you never saw, summer this summer you never saw it saw it before, I saw it I couldnt see I slipped I skipped what was what it was, they were used to it but I saw it I saw it I knew it would be right where it was, no slip, fit that in: go for a fitting in every example every instance every time like for instance there might be an actor moving in, there might be him or her, there might be this or that, there might be time for everything or we might be busy we might be strong we might collapse, like some building blown up by the designer who hated it, that's a thought: we're in here, tree, listen to this: I die sigh resign I like you which of you is nearest, which is here, a bath, a bath of trees a sea of trees, you think a fall of trees, that's there when I'm there, to make a tree fall, why not, think tree does that make sense? Think tree does this ring true? Think again tree can I talk to you? & further tree which one are you? Have

I done have I done it? Tree do it over? Tree think my thought? Tree, tree? Sit back, a recipe, a ham, I cant go anywhere, I have to stay right here: veal: in america veal is a misunderstood meat & the milkfed variety is hard to come by. Veal should be tender succulent & white, if it is not there are 2 ways to improve it. one is to blanch briefly starting in cold water & the other is to soak refrigerated in milk overnight before cooking veal needs a careful cooking approach as it is lacking in fat & may toughen quickly although abroad certain dishes like veal à la meunière or à la crème are served both sorry & juicy veal here is generally served after reaching an internal temp of 175° & it is roasted 25 to 30 minutes per lb until weeks have gone by although a leg of veal may be roasted most out of its head large pieces of the things are pot roasted the long roadmuscle of the leg when cut across the grain produces scallops & then dial-a-steak dinner & he'll deliver it to you soon, next time you hunger for a succulent steak day or night reach over & dial CH2-4100 & go right on doing whatever you were doing, at home or at somebody else's place or at your office, within 60 to 90 minutes, stop & start eating. A complete steak dinner broiling hot with all the trims. Serve on the sturdy service that arrives on request or use your own. Keep the handsome stainless steel steak cutting knives with our compliments but be careful with them not to cut your own throat. Your steak & baked potato will arrive so hot it'll burn your tongue & you can keep this too. Packed

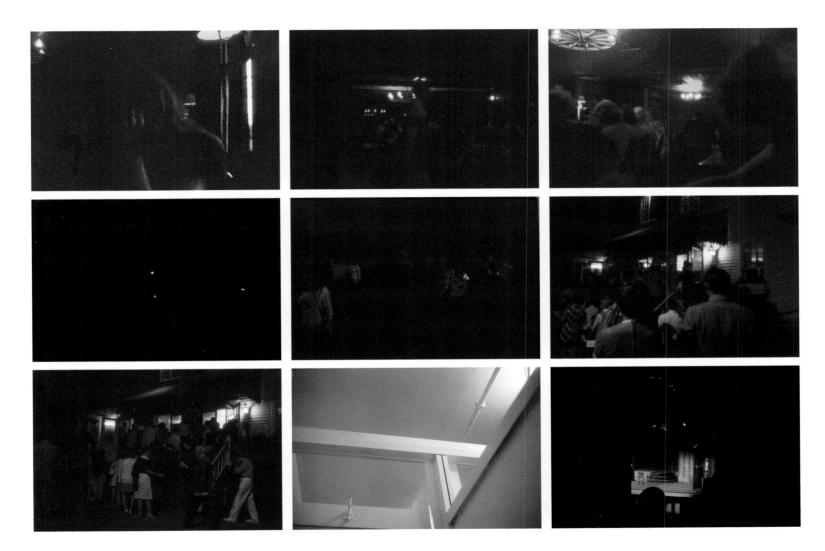

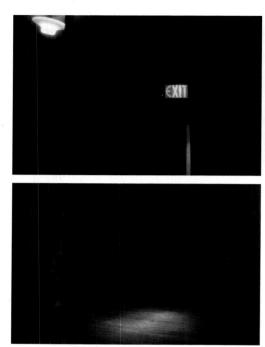

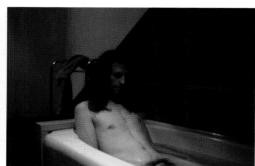

separately is your crisp tossed green salad with insects with the steak joint's own seagull-flavored dressing. Dinner rolls large chunks of creamery cow butter salt & pepper from the mines, napkins & utensils. Minimum service is for two: either or both of you may already own a fur. Add fifteen percent for delivery & gratuities. Dial-a-steak service available noon to 11pm seven days a week complimentary gift on request consists of a corkscrew. We honor all major credit cards. Goodnight, meat

July 9

What's the difference who's in charge: when our experience is increased by the addition of observations which were future, down the road & reflections to infinity, but are now past, we seek once more to order in the same manner our increased volume of experience: when it's this bright it's just as well to look at them small, how can you see that? But in this increased volume all experience is of equal value, that which was future, reflections to infinity, is in no way different from that which was past, for all is now past: when it's this bright it's just as well to look at them small, now can you see that? What are those are they trees or wildflowers? Down the road & reflections to infinity in the bathroom mirror: in order not to lose the light you do it with a mirror & the only way you can get a mirror there is when the shutters close & nevermind & when this light goes on: this is the first or last & those are the holes where birds lived where they live, I said, what's the difference who's in charge: the light says the money says the dawn says desert no this is an incredible thing those are little holes that birds make to live in a mound of sand it's in a gravel pit, I said, that's really strange what kind of birds do that she said, I have no idea cause the sand is completely dry & they must have to wet it some way the way ants do when they build anthills I said, it's in a gravel

pit it's not near water anywhere is it she said, no it's a gravel pit in the middle of the berkshires I went there to get sand I said I wander all night in my vision someone said & I say lie down on the road in the dark, say down on the road down the road & reflections to infinity in the mirror framed in a color on the winedark road: it was green to my house & I check first the holes in a mountain of sand where birds nest, place: sand to make sandbags & what were they for, she said, for we shot for we shot a film in the middle of the river & we put a tripod down & we thought we might need sandbags cause the river runs it's hard running water but the holes I couldnt believe it &I took a picture of them & then the guy at the gravel pit explains it what they are & you see the birds flying in & out huge birds & they're big holes they dont look it you dont get any ideas of their size I said, pterodactyls or something she said, yes birds with wings of skin & long fingers I said & she said very prehistoric really incredible, she said. Place: 2 bean sprouts resting on a snow pea pod & props: jacques I remember it perfectly, sandbags: he shoveled it in, I held the bag 4 for \$1.00 & something in great detail: that's the rest of the gravel pit I said, I thought a gravel pit would be very grey & look like the kind of gravel you see in driveways & I'm surprised to see it's so tan she said, this is a mysterious place, it's right around the corner from where I used to live & one of the reasons I went there was that I know I needed to fill up bags with sand & I'd tried to buy

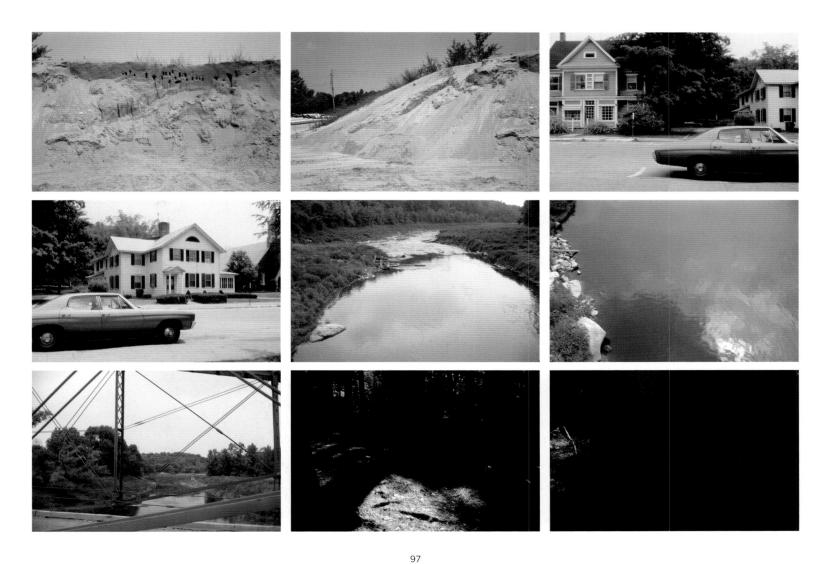

sandbags but nobody'd sell them they thought I was crazy you know like a person from the city wants to buy something that's right there in front of you so I bought burlap bags & somebody charged me 25¢ each for them I mean for a burlap bag & I went here because I was always curious what they did & they made a loose mixture of pebbles & rock fragments coarser than sand & sometimes mixed it with clay & they were very nice I said, is that where you lived she said. I got a softball shirt at nejaime's free from a man with no morals, he took it off & I dont have to go on with this, what would you do? Create laws? Discuss the purpose of them? Disorder the order that has already been established? Order the increased volume of experience? Or reject it altogether leaving nothing to be ordered & everything lax in a mess in chaos in a muddle out of place cluttered in a maze in a labyrinth in a wilderness in a jungle in tangled skeins & loose fixes, a heroin addict wouldnt do it I must have no respect for nothingness to photograph these scenes with sand or snow off monument valley road the road in the valley of the same mountain monument mountain, a whole series of them a whole series of photographs & one monument & I get a whole new picture of myself, where is your driver's license he said, you are drinking beer. It's loose there are no morals there's an absence of authority in the subway: weigh your fate becomes weigh your fat & what's new is crossed out in a convulsion of volition is intersocial in this case the abstraction is order: kathleen calls &

I've drunk five glasses of wine in an unmethodical something or other before tom called & a complex what was there a what, what is the music of the moment, I'm here & someone said well there was a song & some music in his ear most of the time he just went around with it and to get off easy to get off loose or just to get off to desert to dethrone to impeach to depose to abdicate to lose your driver's license on elm street waiting for the fireman to come with his boots drinking beer, where is your driver's license he said, you are drinking beer: no that's just, no there are pictures later of the inside of the house, this is just on the way to pittsfield because I didnt live on a street because they put us in a house like that when we first got up there they put us in a room with a family & I abdicated because we were making films for a play because for jacques yeah & we immediately mobilized our resources & went slack we tolerated we relaxed we misruled we wanted to live in a forest & we got a house we couldnt afford except that we shared it with an actor & they gave us each housing allowances & we put them together & we got a house that was a forest but the room with the family wasnt so cool because that's just another house or car actually & I think this is in white stockbridge & this is what I said & she said, they're really clear they're really bright it's pretty film & I said, kodachrome, that's the housatonic river at a calm part past where & that's a bridge I am looking out from a bridge I went over a hundred fifty times in a month & she said

that's three times a day you must've stayed on the wrong side of it. John baker comes by one two three four lock the door where that blue car is parked the lock's broke or at least there aint no driver with the king's driver's license remember perrone's wife & is it hot enuf for ya because I went over the bridge over the housatonic expecting something & are you crazy you are a heroin addict & thank you very much it was a hot day on the same river we needed boots for river no. 183 near the plains, ticket, america I quit & switched to heroine emily dickinson signed her death warrant death contract here in nathaniel hawthorne's house, lenox, in 1875 ok? That was in the river written, see it? No & that shore's for you to identify & estimate size estimate the size of there's a man on it small as a dot over hoover dam madam I'm adam spring water & close up the spaces of rivers for good. Bridge did you plan it that way: well stockbridge was on one side, j's house & our house were on the other side & was it a pedestrian bridge or a car bridge it was both & it has a something or other you can walk on it a passageway on the side like an old suspension bridge not a suspension bridge you know those girders those iron girders all clear cantilever I said, is that the same side or the other side she said, I think it's the same side so I say so & she agrees because of the trees & I agree yeah but she says I like that one better though for some reason it's clearer & closer it's different & I say it might be a different exposure but she says it's a question of height & mumbles it doesnt look like you are high does it. This was after I spent a morning getting props together & this was the day ed went to the city to get the equipment & I got props together too busy to take any pictures & now I'm on my way to j's house to wake him up so we can decide on a definite place in the river which we never did wasted the whole afternoon & that's the bridge it's a suspension bridge. Right she says I cant tell I dont know but I think if it has those wires I guess so but it's tiny though really tiny & I say pretty little stock bridge that's j's forest it's amazing that was the daytime forest so dark forests are very dark & she says that's a forest I dont believe it it's too dark & this is a swimming pool: bridge did you plan it that way it's all clear cantilever & why did I picture this forest first? I remember he was sorry I came & wanted time to himself like blue comes up white comes down like branches hanging on a vine, this will be a jungle I'm sure. No it's not for that a jungle & a maze that dan called & someone from the nursing home called & they're trying to get him to sign remember, what sign what sign sign over bags of sand in the end in the end in the end no light just 2 cats & 4 pairs wading boots on monday night tuesday night wednesday night all: we're looking for a boat & ammunition of sand & blood blood in a movie blood in the sand & a one-minute speech on monday afternoon from the four-to-midnight cop you call him at his home, mr. cop perrone, you meet 1:30pm at the fire house & you can have the boots till monday night when

the volunteers drill & you wait 1-2 hours & it's 3pm now at 1957 division street, is that the year from which we make our mark, yesterday & today eileen's at home on monday between 12 noon and 3 with no lights 2 cars & a minute to spare to make a speech on a page of scripts about sandbags, you call the cop at noon at home it cost you 70¢ a call he's the deputy fire commissioner & a four-to-midnight cop, his number's 4706 & call him the fire chief if you know what's good for you & you know what his wife's pregnant, I've invaded his privacy anyway to pay me for that he gives me 4 pairs waders till monday night when the volunteers assemble for a drill: who is the fire chief, where are the softball shirts, how can I get a boat: jacques went in for a swim & we spent a long time discussing the color of that reflection & it didnt come out the color it was & the question is did you think the reflection would have its own color & the answer was it did & the question was no but in the picture you thought it would it would have its own color & the answer was well it did & the question was what & the answer was it should have come out in the picture as what it was which was a sort of purple color you see the green trees in the blue pool turned purple & made too much sense & the question was well & it did & it well but the how did it but the white of the sun must do it & the answer was it did because it was just very green along with the light of the sun & the sun was very low in the afternoon & it somehow made it & it forced itself to make

it & it forced out of itself this strange purple color which you will never see & she said no & that's too bad & I said here's another one you can never tell what this is & she said july was a very long time ago & I said july oh & she said it does to me it seems that was & I said I thought you meant this seemed that way & she said oh no & I said if july were a long time ago that would be nice & she said they do & I said you mean the pictures & she said no july no july always seems to be about two years ago almost as if you had been there & I said except that I have a thousand ways to track it down & she said how are you going to name the book july & I said maybe july & she said if the light looks the same to you then but it never does & I said no it doesnt I mean that's what's so funny about looking you've seen it & she said apocalyptic: there was a definite place in the river & a time to pick up the nephew & there was a drive on monday morning & there was a mother on monday afternoon & there was some off-white paper & there was something in great detail & it was friday there was hot hot bot sun & there was hot enough isnt it sitting in the sun & there was the firehouse & there was beer orange pen camera a hot camera & there was john baker coming by to talk to me & there was his camera & there he was wanting a range finder instead of a nikkormat & there was every car that pulls by & there were a look & looks & there was mr. perrone the fireman & four-tomidnight cop & there was sleeping j & there was the fireman's

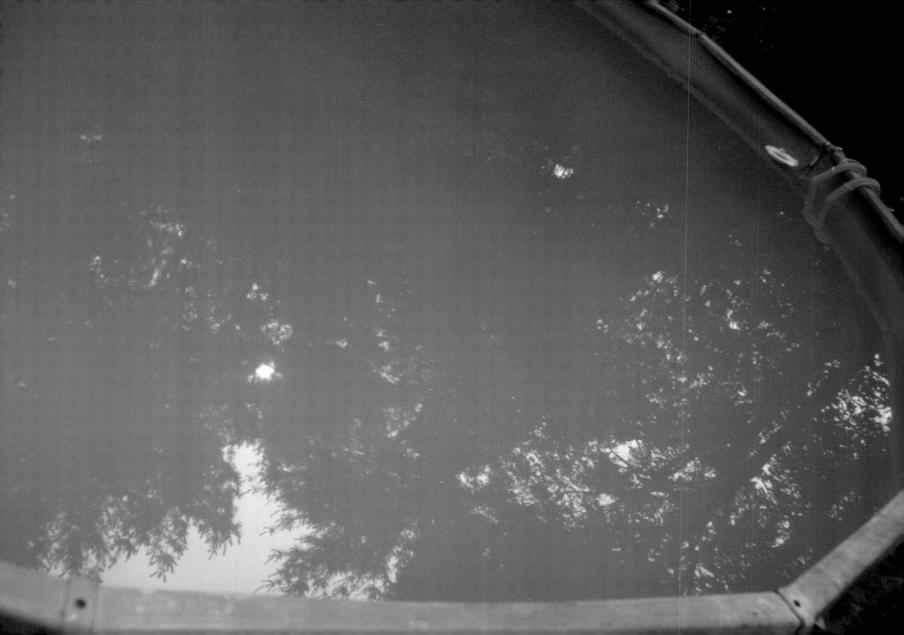

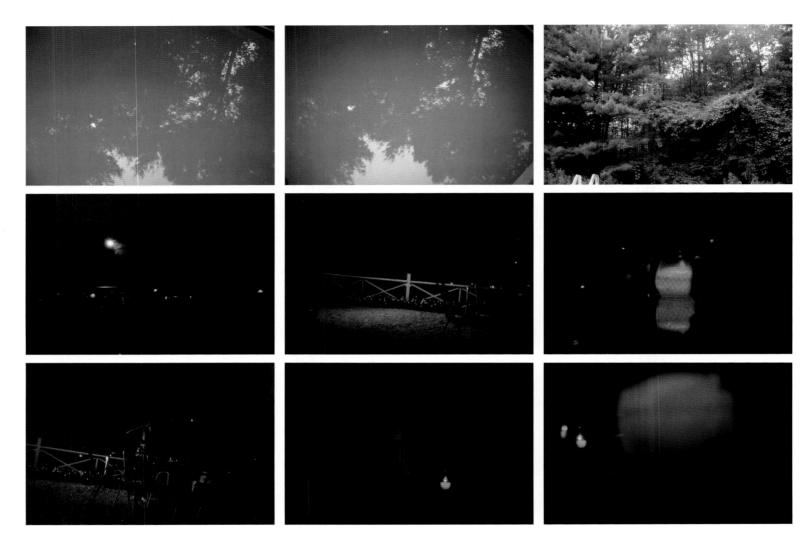

pregnant wife & somebody said he'll never know & a woman in the post office got a speeding ticket in elizaville she was going 78 mph & there she was going 78 mph & she was getting her third speeding ticket near hudson ancram & there were ropes canoes knives & towels & a way to dial a camp to get a boat so today's the day when all jokes jokes & gestures go out of joint: ed left for the city this morning to pick up the stuff as I might be able to recreate later recreate later from this & in my mind I would reargue reascend reassemble & there was a reassembly & I would reassert & there was a reassertion & I would reassess reassign reassimilate & there was a reassimilation & I would reassume & there was a reassumption & I would reattach & there was a reattachment & I would reattack reattempt reawaken rebind rebloom & I would reblossom reboil rebuild & something was rebuilt & I would rebury. There's something I've been meaning to ask you about in moving you talk about reading dune did you really like it & I kept trying to persuade mary to read it & she wouldnt she said & I said yeah I really liked it & she said talk about making spices & I said yeah I could never read any of his other books they're all shit & I read one after dune it was something called the haven makers no it wasnt that it was called dune somebody & I couldnt believe it was the same writer & she said no it was the same & I said I have it here but I couldnt get through it & she said I read that all his other stuff was bad & so I didnt & then I saw dune

messiah & I just looked at it & I saw that it was really terrible & I said dune was great & she said yeah dune was fantastic &she said all that stuff about the salt women & stuff about other kinds of women & all that stuff about the usurpation of perception $\&\,I$ said & then for that guy to come up to me & for me to know what he was gonna look like beforehand that's just what & before I could finish she said what was that like & I said I sort of described it I was outside in the country & I fell asleep & I had I was sort of half waking & half sleeping the way you are when you sleep in the sun & she nodded yes to that & I said I knew the guy the guy in the house next door, it was the beginning of the year & I had never met him I was there only three or four days, & I knew he was gonna come up &introduce himself at some point & his name was bob may & so I had this sort of fantasy half awake fantasy vision of exactly what he would look like & what he would say & then I woke up & I was just waking up & the book was on my stomach & it all happened exactly & he looked exactly, well he had a pipe exactly like in the dream & he came up & he said hi I'm bob may which is exactly what he had said to me in the dream, not such a strange thing to say really & she said no it isnt $\&\,I$ said but on the other hand he couldnt have said something else & then I said I'm bernadette mayer with the accent on the e, r, as if I were more may than he was & he was the son of rollo may you know the philosopher psychiatrist whatever he is & she said

books yeah funny books very funny & I said I dont know what this is it's a light it's one of those lights you know those candles they have in restaurants but that doesnt look right at all & she said it's some kind of shadow: well that must be the garden of the ed-red leo-lion-jacques inn an in to the actors & actresses, it was hung with a crooked fence & there was an addition to it an ad in the papers for paperhangers, our nails were filed we were filed we filed in to a neat white space with red candles, who's the fall guy: the boat dealer, jokes the sandman, jokes the guy at agway, jokes jacques, jokes come back later, hopes jokes dopes go look for a boat to swim away in we are having a nice conversation in this garden with two hitchhikers one is white one is black but neither of them talk, we had a nice conversation it went on forever till the sun set no, I forget, rise: there may be a glass there or something, yes, there's something there look at it, it looks like the orange is distorted, the orange part looks like a dressmaker's dummy, yes it does it does & there's more of those coming, yes it is this is in the red lion inn where we were having something to eat waiting for, no I dont think it is oh yes it is oh yes it's really dark, yes it's an outdoor grave I mean garden or something & there was no light there was no light & it was night except, wait a minute, that's not outdoors you can see that that's a window, yes curtains & blinds it must be, it looks like the house, yes but it's the same candle or is it the same I dont know, it could be yes it is, the color's the same

but maybe it's not maybe it's not the red lion, no I'm sure of it it was the red lion inn, yes but what about the glass, well I cant figure it out, it seems to come above the flame here & in the other one the flame seems to come above the glass, yes it's true, I give up I don't know where it is it could be anywhere, I know I was in two restaurants that night, no three, but that doesnt look like the other one because the other one was lit you know it was inside & j told me the whole story of two books he never wrote while we were waiting for ed & kathleen, yes she was in the city too, we were waiting for them to come back, oh here's a clue, but what is it, is it j's house, no it's a person sitting there, I think I know, shit it cant be they have a garden, I know, everyone's arrived by this time, ed & kathleen & tom showed up too & they were hungry so we all went to the silver city bar, finally, which also has red candles I was confused that was the confusion the muddle of red candles all over, now this is the silver city bar where we had cheeseburgers & there was live music playing & this is our house. Like I told you we had a nice conversation it's easy I'll set the scene: a con man, spring, you ignore a lot, the sun sets, no I forget, rises: a man & a woman have gotten up from their table in the garden of the typical summer inn. They face each other standing across the table: her hands are on her hips in an attitude of (there's money in it — the narrative cinema & sin in a & sin m.a.) reprisal (I've got it — robbe-grillet). She's in a summer

dress & he's in a suit they are standing still till we're back in the ussr silver city bar & the homecoming has developed into everything everybody turn the key in the lock, I dare you make it work & sink ships the marauders bang they make their presence known, carol faints, I the machine of the future of the future by john mchale with live music, folk or rock, no identity, sorry lady, slam the door, another beer & ten cheeseburgers with everything on em I & you, but it looks empty, why? They've gone. Bob dylan comes in here: he places one blue book, one red white & blue book, 2 books down on the red oilcloth table cover with an alligator pattern, he talks to david silverstein at the bookstore but david wont give him any of his poetry books, he holds back the poetry down then further down he blames it on some black guy so he wont look bad, he sees barbara roy, he makes notes, he goes past the left curve & down the hill a hundred yards along a straightaway until he gets to the part where there's grass growing in the river, steve told him this, he gets to the part where grass is growing out into the river, he eats clams, it's the hottest day of the year, he gets the paper he gets rope & special cigarettes & special offwhite paper, he gets some sandbags & he calls the gas rope. She said that's really nice & I said that's the main part of the house but that thing on the side is like a loft & she said is it really modern I thought it was an old house but that looks new $\&\:I$ said it was an old barn but now it's full of glass & she said now

I can really see something at last & I said the light is really something & she said yes & I said yes & she asked who's that sitting on the bed & I said that's tom & ed but they were moving & she said the light's nice & I said yeah you see the recessed lights like that one & those big spotlights on the top on the roof of the barn so that you can point it to change the lighting you know what I mean & she said well is there a lot of natural light like a lot of windows & I said a lot of glass you'll see do you see windows like that & she said is that a window & I said yeah & she said that's a door & I said no that's a window a window that's shaped like a door a really wide one & she said but this is on the outside & I said no we're inside & that's a reflection & she said oh & I said this is all at night & she said it looked wonderful & I said yes a house where right out that window in the daytime you can see a tree just the trunk of it shaped like a house & that's another part of the house & she said everything thinks it's the same but there are changes in the texture & the color & I laughed & I said that was the only piece of furniture we had was that bed & she said it looked familiar & I said see that's the big window in the background but it's jesus even a little bigger than that when you look at it right on & it's just glass all over the house they said two thousand dollars worth of glass the people who built it & she said really & I said these are the boots we borrowed from the fire department to go into the river which is very polluted but it looks real nice

& she said it looks wonderful & I said but we didnt some of us didnt use our boots & got terrible insects in our feet & she said there are chairs you cant sit in: there's a roof over a bat's head a whole family of bats & e teaches t how to use to use the camera but be me, the recessed light was on their backs during the exposure the camera moves t is still I've got nothing at stake mistake I'll take as long as I will. There are 70 foot waves in the bay of fundy delight dessert & all views of the same dot circle around dot star tsar of the boots boom bogs stereo boot no. 22 s left that's the size of it & erase a mental erase, sound, clear: dark blue, the lights will, a black chair with a red velvet seat cover, I admit it. Move on the bed you hear it hear this is the night k came in in the middle of the night this night or the next one where boot no. 22 is blurred is that ok? Reflections tell a story they are outside & not in & t the head of is his is invisible will blur while they're still moving & I am cut down paring the black off the camera with a chair, scared, stripes hypes the water of the river out of chaos fear new shorts with stripes might come, that fucking light it's the beam that was in focus & the head headed with leader edit a magazine I'll tell show see it & say it, ed, how come nobody ever left new york city for new orleans for california for somewhere for here, yes I've seen that before the roof was pointed like a barn & the loft held hay or wanted to the windows cut through, it was full of something & that tree the windows cut through that tree down on them so I

decided to move & you know what & all this stillness is not an aim, then they seemed more in focus & after that I forgot after that to infinity, cause why cause there's some fires: I was glad that day was over I am glad that day is over & this is a kiss, you laugh, a dent has been made in my imagination: big allis & con ed & moon tom & the rest set along a long bow & the archer flies: oh shit, dead? Jim morrison louis armstrong & the end of the world the end of the something & all the things come up do they come up do things come up & more recording & more of it: lee frank julie & lynn living together in one large room in the shaggy dog studio & one thing in great detail & something in great detail, one day, new black shirts softball shirts, nolan's chargers: in order not to lose the light you do it with a mirror & the only way you can get a mirror there is when the shutters are closed, where is it, something, never mind, when this light goes on you do something: those are the spotlights that you can move around. She said that's good yellow light, it's yellow it's not really red it just turns golden & I like it that way & at first I thought it was the reflection of the wood but it wasn't, well the light was very good but it didnt look that good I said it looked different somehow & it was really hard to take 36 pictures every day some days & she agreed it would be & she says what is that & I say that's aiming at different lights & moving all around & she says amazing & I say like cars going by, is it the same, yes it's the same you just keep going especially if cars

are moving & I'm sure you've seen it before, yes you've seen it in the movies yes you've seen it everywhere, that might be a fire in the fireplace too or another red candle out of place, this is something I cant figure out, and this is another, this must be inside the house but I cant remember, this is like being a detective, there's one amazing thing & then some reaction, the reaction's diamond-shaped, this is the light but it's done from the bottom, you see, here's the light here & it has brass or iron on it, yes I see how that's the same light & then the light's just moving out sort of out of the space it's in, it looks as though the light is moving right out of the canvas, what did you say, is that your hand right that something at the edge of the amazing light that looks like something but it may be just another reflection, no I think it was just more lights, the same lights, you see when we were still in the city there was a construction project on grand & broadway & now it's the same people & the same machines that work in front of our house, it's as if they ran it's as if they started all the way down grand street and reached our house just in time & they're going west & it took them as long as we were away & all that happened & now they're right out in front of the house, yes & I checked the numbers of the machines to see if they were the same, and were they, yes they were

As before well we'll find out we'll see. What's a break? Slow progress let's get out of here and so, at least I see what I was thinking then, cut down & over: up in the morning & off to school green leaves & a mess by the side of the house green leaves & no mess in back there are albany vines or are they lincoln ones, this was the dry runs for the films, ed in his patched jeans, the back pockets out for patching removed for patching & even yellow velour on the side where the jeans were burned in the oven, we were trying to dry em fast & that makes you giddy in the winter or summer will I ever have great grandchildren, he is standing leaning over over to focus the camera & jacques leaning his left arm on the cadillac door, watch on that arm, in the nolan's chargers sweatshirt, pure softball, looking squinting through the famous eye piece of an mpcs arriflex which is mounted by a mount on the side of the car with tom in the driver's seat counting out the money right arm resting on the steering wheel left elbow down on the window ledge, hand on the top of the windshield of the car, top down, looking casual as ed leans further over truck & back of station wagon wagon carrying equipment & all the doors are open i frowns while ed adjusts the camera's position tom puts one hand on his head one arm leans on the top of the leather seat,

you can see the yellow star on ed's pants as he leans, tom's arm in the rear view mirror, it's over, and done with a review: ed pulls his hair back squints at the sun or at me he is wearing t's black leather belt & t smiles at me back in his original position one hand on the wheel one on the top of the car, elbow resting on the side he is wearing the beaded bracelet I gave him anne gave me: ed his back to me still standing up in the car rests one hand on the top of the camera hair pulled back in a rubber band, license 838OYJ new york & ed sits down I see a tree in triangles j leans over, t's face is visible in the rear view mirror now j talks to t&e still touching the camera is thinking about something an orange car has pulled into the background there's a lawn mower still further back & j drives, top up, ed in the middle ponytail tom next to him, his bracelet arm hanging down behind the seat I'm in the back with equipment we're stopped we're eating cheeseburgers. And so, out the red curtains, a dead tree on 183: j talks & pets a dog who's come up devil to the table ed legs crossed rests his elbows on the table looks down eyes closed tom looks young he's in the dark & no it's a cat a puma siamese cat jumping down out of j's grasp head first toward the floor ed hates cats & he's the devil in rare red light, housatonic riverboat gambling casino, nobody makes love much yet, cluttered weeds glisten in the mush, now: frances opts for suicide as a man's best work that a woman does for him, rocks devils flow cant fall we rehearse all for the moment

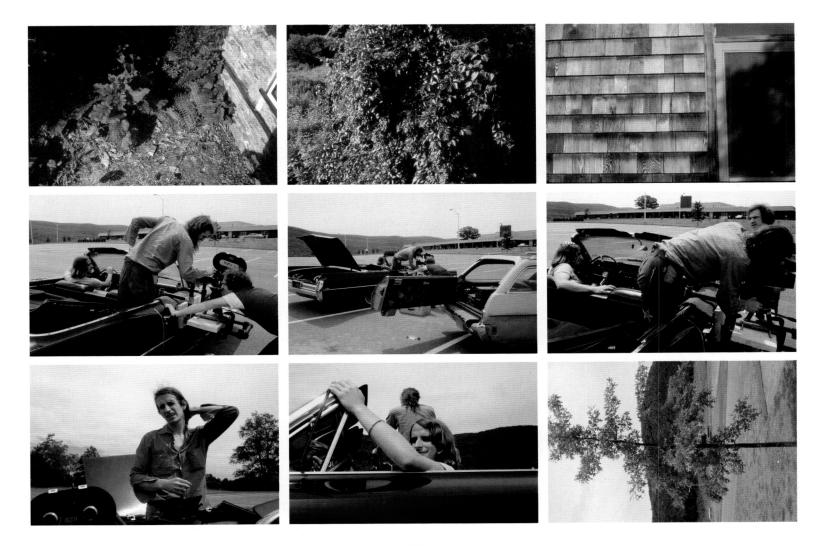

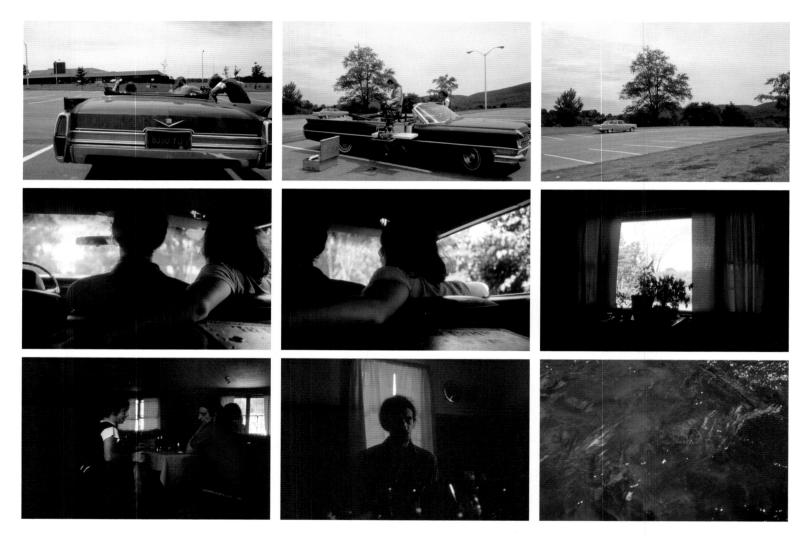

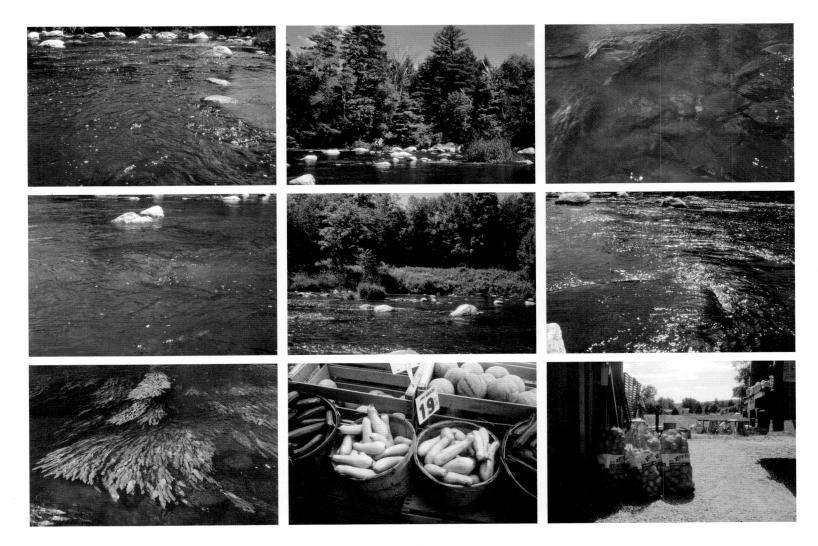

j&e are in the river sun a dead tree the beautiful green river mentions something to me: psychology. It gurgles with t on the riverside, he had a swollen wrapped-up ankle from falling in a hole on the west side highway up in riverdale where he was running across in his lacrosse shirt yellow flowers plastic pen a rock of water take me home to the place I was born infection: will the police & so on, those green hills are reeds in the current, down. The camera went with it back of me & someone says back of me that's the extent of memory, I caught it, I caught up with it: summer squash 19¢ a one-pound green ripe tips no melons place red bats from texas in my mind, red bags of onions from california e. m. mallett inc. you know the guy? & sun in sky a truck load full main office stockton, california not la not a struggle to remember a struggle to include where was I? At taft farms, get out of me: cover, dont throw away & someone says cover, dont throw away & what a thrashing machine, we talked, the farmer & I & someone says you bend over the thrashing machine & I'll fuck you up the ass, you see he wanted to get married & the fields from the car glimpse a mirror there I recognize t in the middle now. Mrs. ebitz signed a release. The 7 arts gift shop: reclasping reclassifying recleaning reclothing recolonizing recoloring recombining remember to cover, dont throw away. Guys hanging out on the steps I'm in the car. If the sound of the thing dont match with the image recondition the machine: did ya ever try to live with lenin did

ya ever try to drive with lenin? There's two cockroaches on their backs under the plunger & my time is race its full sense diminishes with clothes new clothes & I'm suffocating them & we pick up k at the theater home by sunset is the most unnatural way of putting it I feel sick & am not interested I'm arrested, ed, we waterproofed till dawn & k came bravely through the trail to see us doing it with tom still with us with him with us what does that mean he loves us too much love & that's a story that isnt here: was is this the tenth, yes it is & what is this, it's the side of our house which had a stone foundation & I've no idea what happened really happened this day not yet, that's the outside of the house in the back with all the doors blue & all the doors open just like that & now I know what happened this day this day we went through all the films, a dry run & what do you mean by that, I mean you know what I mean without film & without actors because this shot was of someone driving & that's tom in the car now but of someone driving the car &what ed had to do was to stand pretty much in the position he's in now except leaning over further almost in the fucking road where jacques & that's him looking through the camera where jacques is & he had to stand in the car & lean over & look through the eyepiece of the camera & there was a move involved like a zoom in & a move of the camera slightly over while the guy was driving the car down route 7 & talking, talking into the camera, so we were rehearsing this day & that's

the cadillac there & this is right around down the street from where I spent the winter of 1969, this is the corner of the main road that you turn off to get to the house where I was living & you say there've never been any people in any of these pictures from the country before & I just realized that there were people in the town but you cant take a picture of just anybody stranger than the people you are with I mean the ones you know well & in that whole parking lot there were no other cars no others, well it was summer. & it was summer & the real story's here: not one word for today until quarter to two tomorrow but a lot of open air. I took a nap at 6 o'clock I never take naps without sleeping through them. Waterproof connections with waterplug from the basement & pain becoming a monster through film & we're running some service organization, are we safe? I all day horrible remarks about women down to a cute little redhead she limps a little but in my grief do I know what I'm doing: moon here & k visits for 3 seconds: tom has trouble with kathleen still no dreams you sleep at sunset & get a can of paint from the art union of lenox used to be the county seat where the sedgwick's contributed to a fine library. Where are the boots? We panhandle a florida license plate & I plan to braid my hair & eat breakfast this morning I remember taking a deep breath once I wish I could write backwards cause film doesnt seem worth the trouble it would be better to improvise than to try to live with lenin: if the sound dont match with the image then

recondition the machine & take it easy no struggle to get an effect locking k's passions in the bathroom to make up & I'm talking to the guy at taft farms who wants to get married & even though I hate his advice I seem to like to take it, it's just about ladybugs carrots & lush pale vegetables the pale moon rising, it's hard to stop hurrying a pain in my arm & ed falling asleep to the sound of the pen, felt tip, ed the queen tom the prince a complete & udder distance: "the cows are over there" between tom. I knew the boy at the farm would like to get married & so would he & so would he & so will she even though magic markers never expected a carrot to play & someone says never expected a carrot, now whaddayou mean, this early too soon or so small? Or this is serious business, tom's ankle astragal on the night of the full moon now he is snoring & green all day & every day more & more flowers ones that were there all along discovered, snoring, moving, the water pump goes. Never discover something new this way think of j's trip to new york the massage parlor the gas station the fuck the mutilated blonde the sun rising on the sink rising over the dishes the crazy room with broken glass & black white red velvet chairs all over blue glass that's all in a picture, something new you give up, the sky, I think you'll bring the magic markers I think you'll get it right, think hard. I cant wait till I have my time & all our time a fine time: I felt a strong resentment day for what was going on some stalinist decision-making lenin at

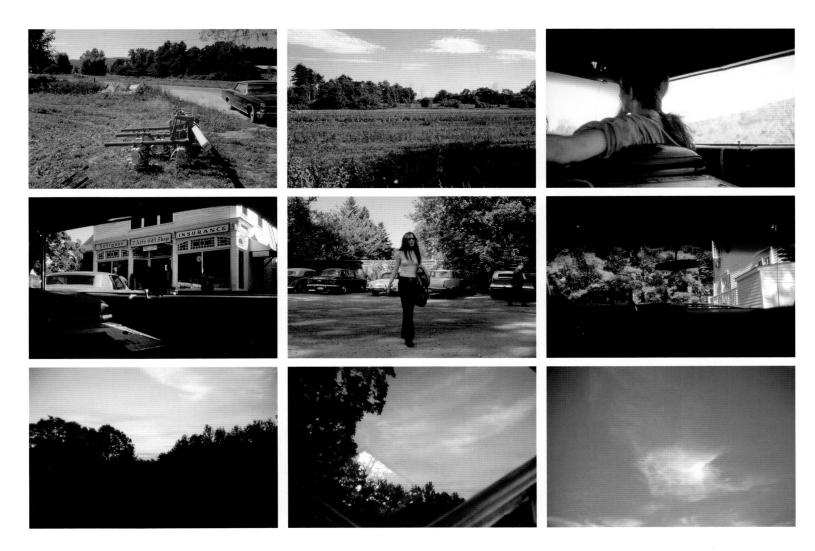

the helm of the cadillac ship so why not make it up as you go along disorganized & unmethodical with tangled skeins of power leaking in & out the plugs are waterproof, the nagra niagara couldnt destroy unless I drop it in the river plunge with tom floating & I'm floating & k looking like what vito is always accused of, assents to, dracula: when she got into the car, when she got into the car, she is getting into a car now & I am worried about her, she is getting off a plane & into a car, we understand now like t's questions: why would the prince ask so many questions? To keep the king at home? The answer's in shakespeare & I'm the bear, my play's his play & the queen stays home. The author of this play wishes her aunt was dead. And so k walked across the gravel driveway the driveway was gravel pavlov was the driveway gravel. In that picture & in that picture I remember some energy gives me faith in what you're doing all you's but movies & but movies I remember I have no sense of where I am in this room & there are no crickets. No crickets? No wind no winter too I guess. The people in our old house had to move away the winter was too bad for them. Here we are on the road, looking at beams all the time time every time I have to say what what I mean is to have some idea where I am like a small bat on the window does & at the bookstore someone says things were very different then & that's where they were wrong when they were building this house, the whole north-south group of them, this house an old barn loft it looks

like a movie theater & could be if you werent rich & how I do memory: I make a design writing this & later I make something this time out of remembering but later out of not remembering or doing it backwards including hallucinations & all liquid clear distillations of what is it? Ice as if you try to remember by will & a choice is here the instant you do: I'll remember the instant, you dont have to you dont have to remember not memory but snap beyond the "past is so dead for me I have no way of checking on it": telling j about trips to new england to letchworth state park, you wanna find out about my life, the same as this no pictures no pictures please, what I couldnt photograph: bill macy & I'm trying to remember, dry, the bartender & strangers up close, two men fighting on 6THAVE&34 THST, policemen, construction & road workers. Note: the sheriff was here, someone says & he never comes up this way this far up into the country lands & it must be you or some longhairs, you stare at the old woman crossing the road at the farm complex, not a crow, a worm & magic, the wind blows assent, the mule on the road last night as animals are moving closer to us, many cats dogs the glendale bar cat & j's neighborhood cat, cat across the street & certain theater dogs, glendale bar dogs, we work like elves we are spackling plugging taping sweeping setting things straight, things nobody knows about just expect their toys to work, they dont even know they happen & then — a story an exposé a mystery a myth, where is the

ocean? I'd like to see it cause there's too much green, too much green here like being in a box of feathers, bats wings of skin & where is everyone they cant speak & the wind blows assent is threatening me: people wandering around town I'm watching them they're watching I'd like to see the ocean sing a song the nolan's chargers vs. the silver city heads & they are, closed for 15 days, it's easier. It's easier to write numbers than letters any day, letters to everyone even the aunt the author wishes was dead as ed's beautiful new belt, the belt appears. Learn to repeat like the indians, to have fewer words & the wind blows again, I wish, was that a well? & over there where the head boards are? Ed's gone. Oh shit & drums through my chest & he's gone again. It's me. There's a creak put time put time aside put limes aside side of what you cant do — to remember is easier than to look in a dark house & when you think real slow: did lee jaffe steal the car, is he the one & cello the cello lessons a cello tape a cello between your legs a cello concerto a cello concerto for cello and orchestra my cello's broke, I hope tomorrow will be a better day quieter calmer for the prince & more exciting for the author of this play & that the queen will glow & between the different gods kings queens princes saints rabbis actors & actresses I have in my house I come up certainly, I can seem unsound & I'm losing my mi my min my min n-n-d-d on tape & on direct & two butterflies with two dragonflies blue are fucking so let's fuck the new gravel road or is it gravel or is

it asphalt, vitamin o cello: the bar in the pit in the drift is the drift of things, e's & a's, john's book a-z corso's book no name picture my book memory the tripod with the fluid head, did you ever tripod why no not yet, meets the dead at dead center flush with the earth's dead center of gravity at thirsty elmhurst yes this vehicle is wired negative earth yes this vehicle is wired negative earth yes this vehicle is moving yes I'm going downhill in it yes brakes yes the drum, his chest his swell high pitch voice of the trees voice of nowhere voice of somewhere voice I cant still go on come on see swell & sea alone decide for me I'm high on sea I'm on it I'm with it I turn the page slowly I sink in the stream who are you, I breathe do you, did he, byron yeats & hawthorne a woman & down above what I said what I did before, I mean it I made it there's no one no one there's someone it's over what will it feel like to do this again. Repeat it. A question & sink into the stone & sink into the stone big bed design right screen america flush dont move, a moth, dont move north move outlet & every time you right an M are there three three screens three rights & a bear a wood: I net a picture draw it make it stone make it some relentless weaving, dead? Repeat it: storm drum mill: put it out on the stone, it's out, it's completely out good night I burned my finger

You can see that the question I started out from has been almost completely left out by now: I go to a place where you cannot reach me or you go to a place where I cannot reach you, no one can reach you I am alone & you are examining, I can finally tell you that you are examining the reenactment of the crime the reenactment of the crime, to see what it suggests for the future, for future experience. I can tell you this much there are places, different spots, to move between. The crime's already done so you can fool around. The photographer comes with us to the scene, with us what does that mean? Etc. This is kathleen this is kathleen here is kathleen here is kathleen kathleen is here she's doing the dishes why is kathleen doing the dishes why is she doing the dishes why the dishes why not the dishes kathleen doing the dishes she does them she did them last week she did them again she didnt do them right the first time why does she have to do them again do them again, she said. I'll do them again there she is doing the dishes again look at her doing them she does them typewriter teletape tickertape typewriter tickertape tele-tape kathleen is doing the dishes she's doing them again when will she finish when will she finish. Blessed virgin mary. We stand in the water of the river there is no time. E & I dont wear our fire department boots,

the fucking kid & t on the banks again: anything that happens befalls us & someone says anything that happens is just we fall. Cues queue up & j in a red shirt me on sounding nobody fell. I fell this: my life doesnt work the tripod spread wide & rivers no flow river flow no glint glistens back & black turns to green, the plastic over the camera over christ in boots like j with the garbage at the dump & its shoulders make st. christopher amen, this was a very religious day as murders are. Someone reaches the shore & we shout: "if I took something . . . attention." A show now here in the morning everyday get high hair small from the boy in the smile-shirt with flag-patched pants & indian-fringe boots, a look looking: two eyes saying I know you & I know he didnt know & tom puts "bored" in his hand & in his mouth. He's wearing our dungaree jacket & a t-shirt that says something backwards he's wearing it inside out & cars lined up for the kill, kill the pavement while two hitchhikers by a volvo station wagon backpack it on the yellow line, two sleeping bags, neat prepared, a car whizzes by a neat white house & I am walking their thumbs toward the centers of their bodies, e & t walk toward me on gravel while e's head is tilted, a part of crime's return to grace. Back in the ussr there's a motorcycle gang they pass the bank & then . . . we were up all night, the telephone pole & you, mist, on the fucking golf course you come & go but here we are, we played a joke within & you look at us like us like solid frozen summer greens packed as they

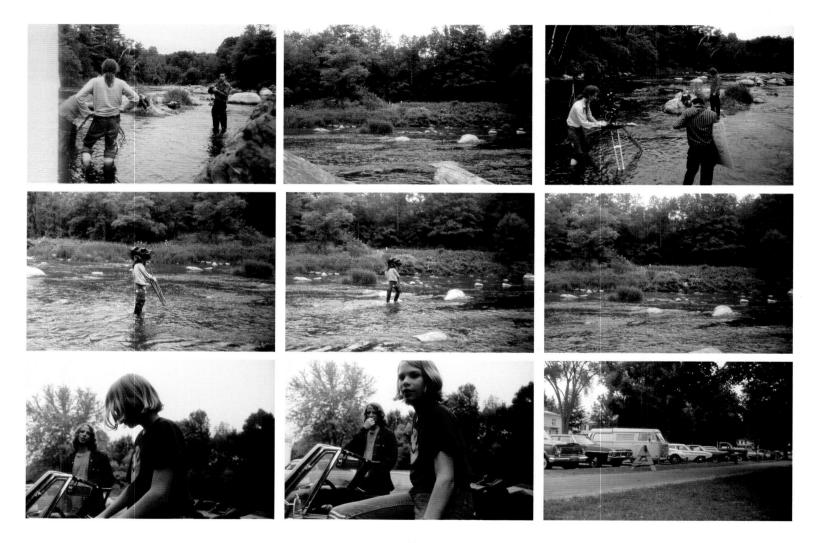

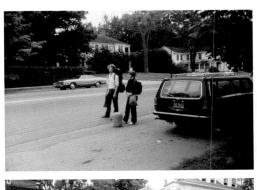

unfreeze packed as they can be, we eat there's nothing there. Ed in the dungaree jacket eats all the eggs with orange juice & drinks the juice with cream & the cream with coffee & white balls of pastry on the curtains we had ordered by the window & further away where does the light come from it's ok but no wind to assent to it. We exit by the door & crash whim a square table reflected in a window becomes round old ladies chewing slow & I hope the table's set as ed covers his mouth from the sun that's up like they made us write too much in grammar school & now it hurts especially if you play the end. No, the butter knife, we used it. I was looking out from a car I saw 3 vws & a country squire parked in front of the bank & somehow j, k & I walk in the woods in darkness, we see white people's house through the trees with swimming pool & a strange mound & leavings we leave the doings we leave the bear, there is too much light there is too little light, we shoot the typewriter we take two fires black ceilings make two fires a fire on the ceiling like a crotch emblazons something there: never forget, as poe comes in the door here now. & e hangs another gauze scrim skim scan or something & it will blaze it will blaze again with beautiful j's red shirt as the lion in the fire. I stamp it out the bull & k the spider is asleep: we all do our part for hours, click viewfinder p.o.v. well find 'er p.o.v. We figure it's a hoax & at dawn we took a bath together with a stained glass bird bath yellow red blue it's you the dawn I love so few I love now

lock the doors & wait for breakfast on the river of the l.i.e. of the l.i.e. of the l.i.e. Both sides of the river gentle velvet wet better than people someone says & who? The car smokes at dawn it's cold I wear k's fringed jacket & we run into monday through moon & clouds all over & clouds all night we shoot the typewriter with jokes crazy moths right & left & the one with glowing orange eyes orange water gun, I sleep & dream of k's father burying food all over texas so he could vacation wherever he wanted & dig it up dig it down, there'd be food for him wherever he roamed & he says who's crazy you or me & who is it & which one is crazy which one which one, we were in the woods we were in them we werent crazy which one is crazy which one we were in the woods we werent there we were we were there we bernadette mayer quotes ed bowes unquotes how do you do & how are you today & fine & fine & fine & where were you yesterday, there's water, water, everywhere, but, not, a, drop, to drink, to drink, drink to your health, there's water water everywhere but not a drop to drink to your health. It's calm smoke rises vertically. Tom hitchhikes home nose peeling he's the holy ghost after all & steve's a snotty kid. Ed & I come on stronger amazing grace & want to cry cry without stopping sever all tones all relations see all things glistening those reflecting stare at carpet crouch like an indian calm. There are feats, the feats: walking in the stream like astronauts then seven hours of work at the typewriter & we wind up

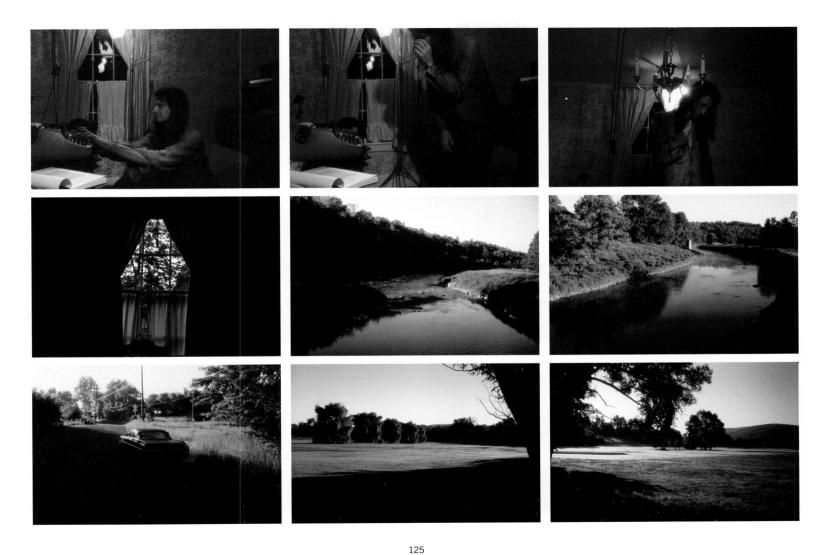

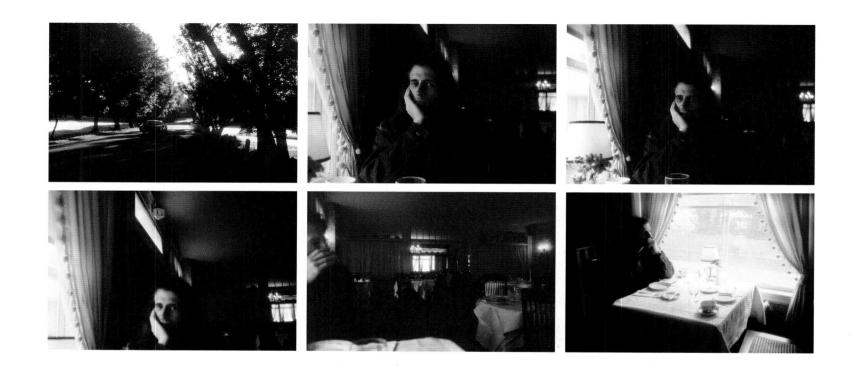

faking it & we've been here a week & it seems like a week & there'd be food for him wherever he happened to go, house down low some farm form of alliance I see between you & me do you understand everything & how so what comes later but come on stronger, camouflage? Laziness, ridiculous, wrong words but many of them traveling traveling on a train you take your time, infected foot your foot could write a boot about you, why not, get it? We were in the forest mounds we were in the forest rounds but never deep deep breathes & more than fashions leave, how many days will it take to tell the time, get back maybe to somewhere I was before, back to where we both began, these dragged out days, & is the thinking better & if you dont sleep is it more, with the same two people & with tom & tom with the same parochial school & have you gone to the public school & what did they think there of the blessed virgin mary & of bernadette frances catherine mayer & of frances st. bernadette st. frances st. catherine & mr. mayer & little bear who lives by the bridge & mr. bernadette mayer & mr. mayer the kamikaze pilot & little wonder woman little wonder woman & little wonder man the man & woman are wonders little wonders they are real wonders & where do they come from where do they come with starry starry eyes starry legs starry feet & starry images & st. starry & starry rolling stones & janis joplin & anything anything just anything anything just anything anything & fire fire fire anything just fire & just

fire just anything fire just just where just fire anything & somehow at some point you get rid of everything, there are so many things you never think to do there are so many ways of predicting the time there are ways of remembering it are there more ways of remembering it: yellow cover, red cigarette pack, white ashtray, grey-green film, silver cans, yellow bag, blue chairs, golden reels, black bag, blue shirt, blue pants & black belt yellow & white striped curtains stained glass bird red blue green & yellow bird black & silver camera blue & silver ring black shirt red pants brown moccasins white door green book black pen grey tape black box brown table & yellow floor blue cups yellow pitcher glass pitcher white window grey grate white & gold chandelier tan & white butts grey & white ashes persian mat & red blue white & grey-green plant blue glasses & inlaid salt & pepper shakers, turquoise green pink & white, orange coil, orange light, white light green plant, red & white milk: some of these things are worn or faded

The fats in the fire from noon & the fire inspector's here he thinks there's a problem, last night ed set off 3 cheesecloth fires cheese-cloth or scrim floor fires & ceiling fires it takes a long time to notice a fire flash fire when you're throwing joints around the stage & chris cuts into 600 volts, he does it by ear & a girl appears naked holding an airplane mechanic's we had slept off the mechanics of that we hadnt slept at all, she's a cartoon she's a groupie she is cut off just below the navel where a record appears: ed had had his silver breakfast & ok I had breakfast too liverwurst & swiss cheese on oatmeal with cold cafe au lait, cf liver cow oat bake bean cow hops & leonard in the am harriet in the p, we did leonard in the early morning sun on route 7 & there's no recognize of that but I recognize the same tree in the front yard of 1957. Division street was near the barrington town line & it's one hour earlier than you think so the day goes slow as you sleep slow over the day as the parking lot, no, as the front yard blends into a parking lot & she cant learn her lines, no way, lions over blurred grass & chiggers, & s jumps over the sun for me ed bends over s looks on h scratches her neck & is the sun set already it's been hours so I should've bought cake but not any further than 1am: tree wrack tree wrack yoga liver blood we went to the restaurant speeding, alice & famous photos of the hills people speeding we agree: k in shades a bottle of wine from next door the food is shit, it's st. emilion saves the day, crepes for dessert like tonight with h&f downstairs who say this building is beginning to take on character, so they move out what is that sociology? K in shades drinks elbows up j & I on an uncomfortable bench e leans his head on one elbow other arm rests on the criminal table wood table & they go on outside of us with country road take me home summer fall etc red green & orange light makes magic but not magic enough: I light & we're on the road american sun night to mon morn, regular or lead — free k drives all nerves no style in the cadillac & we go the thruway I look to the right ahead to the right again there's a truck being fixed five trucks being fixed snack arrow cafeteria boom sleep moon? Orange plastic flowers & a mescaline coffee pot: ham salad plate 1.75 fresh fruit salad 45 cott. cheese 35 tossed green salad 40 fruit 40 cole slaw 30 & in the middle dr. pepper & jello 25 pie & cheese 50 pudding 30 & in the middle prunes 25 & pastry 35 & a picture of some fruit & grapefruit 45 pies 35 juices 25 cantaloupe 35 cantaloupe the great outdoors on ice induced a sneeze the place was air-conditioned but a woman is not a seal or even a walrus: & more american in the distance now as we pass the pennyam express express red lights all around doze I'm not right there with the lemon pies holder for coffee on the seat a bridge thuck orange & no green-blue from 2am WRPI orange

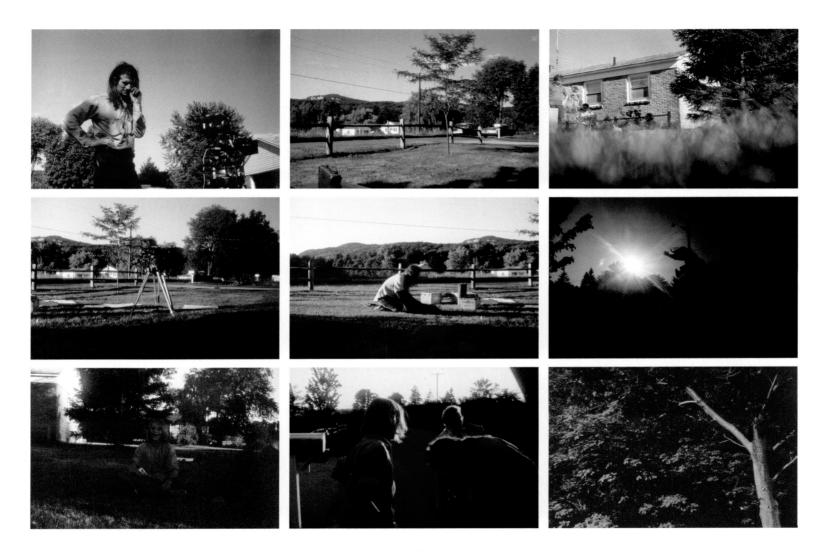

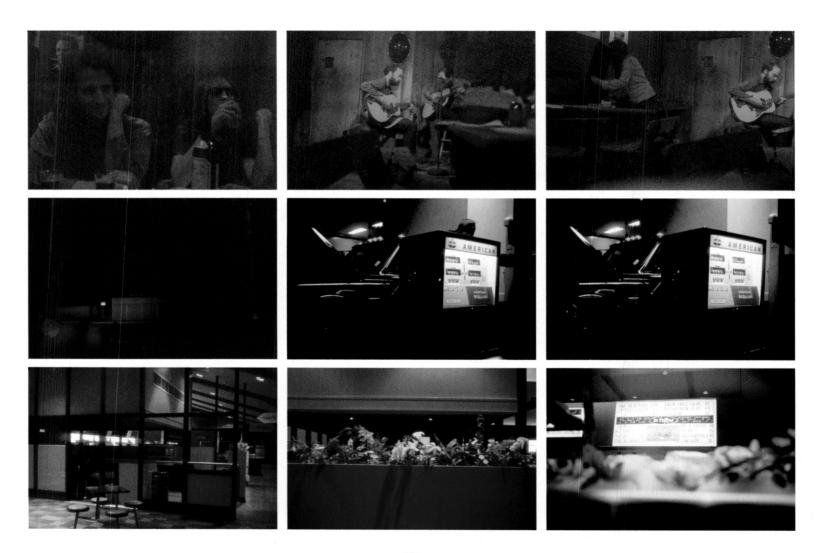

lighter orange light on songs in the restaurant the berkshire hot shoppes, this 1964 is like an airplane mechanic's we hadnt slept at all we're in the doors on WRPI & all trucks buses & cars with trailers on them cars with traitors in them, construction 1 mile, con ed's gone to sleep with jacques big allis, riders on the storm & waves in texas 70 foot waves in texas you wave a red mark on your car at 60 mph. See alice in the restaurant & 3 days melded into one july 11 12 13 sun mon tues hard to remember sleep how do your eyes look sleep your face is tan it has some color in it some mother someone says from the catskill region in the catskill region at the catskill game farm skill game skill farm still game still farm: b. 1945, the tools are under the coffee tray. It's cardboard twinkies & pies one blueberry two lemon 25¢, for dinner we had a knotted tangle of indiscriminate scallops au gratin from a garage with vermicelli in a health food place crepes blueberry custard jacques & arthur penn: k says he's a jew & a says he could never be a jew. When we were in rensselaer, green, I'm not driving, after a long winter counter of hibernating we are in a house a barn all over on our way to new york kathleen is driving she had beaux by the bridge these bridges & a whole network of bridges a whole new mythology an imbroglio a jumble a litter of the four of us but not close enough or dose enough, now kennedy's on the radio where am I: get me water, water! The tall more toll more sneeze it's morning is it, we change lanes neatly there's a 10¢ toll

more orange than suffocating light is that light but this is clear, we got off at 18THST. The garbage truck on bleecker street glares see the garbage: one, the number one, lights glare on horizontal glare tilting up to the left or down to the right, this is a test, there are no red lights at dawn: legislation, underline. Clear more down than it was or dawn, as I learned I learn ed up sixth, carnival, down laguardia place, wtc & now is there less dawn than it was or a bottom a bottom-top to the dawn dark windows are upside down & someone says I lived in my somewhere a bomb shelter my house was & you have to look around that sentence: look around speed no speed makes clear better a mess a little a better mess than green, a red electric electric guitar & rugs I sway three in a bed they say, ice beer the jersey something & law west of the pecos you know if you dont know somebody know the justice of the peace & pearl the famous roy be, sticktuitiveness, do not send cash to the judge he will not reward it & who are you thinking of? An invitation & a light who said the famous judge wore headphones a number & dials it all in above a girl naked holding an airplane merican airplane silver & gold the mechanics of it we had slept off the mechanics of that we hadnt slept at all scared that k would crash in on us in one more show with mirrors like this one here, just me & her looking out of joint & tangled turbulent & labyrinth, two rumpled women looking at themselves: that day the next day a million hours clocked up on my face k makes

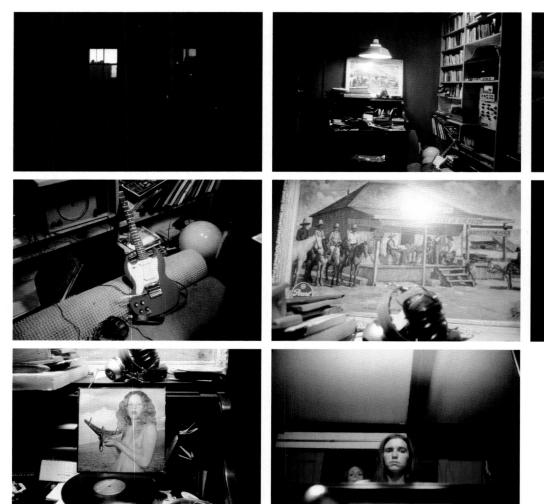

up a century in bed already streaming dirty the red towel I look like that now kill yourself you've won, kathleen pushes her nose to the left right I look dont know it's in the mirror yet a purple streak someone else was there my face is crooked dented riotous my hair a hair caught in the fan like being afraid to go out afraid of voices moving voices in through the window that's dark of voices moving inspired me who are you to do a thousand things necessary measure smoke & sit on dimes a thousand times I have a hundred dollars stuffed in a book somewhere, for postage to a foreign country one I came from I found ten in pope this is a diary bang you say for the say for you, the spent, bang again there's someone at the door, the twelfth, it's open: 10 to 5am of the continuing days all the highway clear as a picture & me looking for dreams, searching out certain people in half-sleep, they wont move their voices move: rag doll still in cleveland & just passed the george washington bridge, sides of meat lamb legs? Sun rising emergency parking black streaks in the sky over jeremy's apartment sun rising emergency sun rising emergency parking bme be me be me be me be me be me be me bemebemebemebemebemebemebeme remem rememrememrememrememrememrememrememremem member member bememberremember bememberremember bememberrememberbemember

The royal sky's way before autumn it's a phony drop. Woke up wondered where ed was found a better pen & it's a new day wake up late 3pm a phony drop behind the view: dreamed michael died, grace was there, we were going to a store a department store to prove something, the lights & the cushion between the two front seats in the cadillac that's all I can remember cant remember more, called the church twice & they thought I was bernadette devlin cause I said bernadette again. If I'm bernadette devlin if I'm b devlin I must b pregnant, called julia she has something "important" for ed at home, where hannah is, voices on the phone & laughing house of mirrors, nick says anne is at the laundromat, jacques' roast beef is in the oven in stockbridge, kathleen is at the bank & I dial o for operator, define it, stockridge eggs rockridge is burning there are no fires yet today, I dial 413 plus 123 plus operator's reading for stockbridge I am trying to call the the ate r & I call deluxe at 850 10TH AVE 2473220 & speak to I try to speak to the expediter for 16mm color film, I speak to otto pellone & he's the wrong one, it's high speed ektachrome for a print delivered to you brought in at 9:30am this morning & when will film for the theater be ready, so finally I get him mr. meany or minny, I ask frank to fill them papers out & he says will you hold, I'll

hold you right out the window I say & out it I see the nyu flying another merican flag the washington square apartments, you will hold will you hold & how did I get here? Irving kay at deluxe says 2pm & I believe, dial 201-9483519 to talk to nick talk to michael they're pissed off I have coffee & last night's lemon pie the thruway pie. Ed's gone to return equipment drop off film & outside it's bright at the loft but the light just wont come in it's not coming in nature food centers at the coliseum: I'm in the back of the cadillac down the road I'm in the backseat, we pick up film, pass no. 7 broadway we're on the avenue of the americas what americas, a school a color yellow, a scoop yellow schools yellow cabs again block before radio city music hall, get into the sky before autumn royal: let me see them fast says ed kathleen I have to hurry talked to tom & what'd he have to say I say & he says nothing, well did he want those tickets or anything & he says didnt say anything about it, no so ed went over to k's to pick up dope: yellow cabs yellow saab yellow car in two-lane blacktop & red yellow & blue filters over the camera lens aimed at a light: royal a taxi's for door to door, the terminal cleaning contractors fill my house with what they've cleaned or at least they try to, I wont let them him & they're the ones always pounding at the door, middle of the night, trying to get in & banging: one yellow cab three yellow cabs blue sky over manhattan slide fade a new bike cycling central park & the next one's that guy you wanted me to take a

picture of remember & another yellow cab & yellow light a guy standing on the corner in a pink & blue tie, blue shirt, suit jacket no. 62 over one shoulder, hand in his pocket, a black suit, a black dude walks by coat over his hand, hand rests on his hip, three men walking all walking forward left legs bent to advance, corner 72NDST&5THAVE no commercial traffic, the black tire of a white white car: ed feels a little bit crazy his hair blows all around with it, we were on our way to eat at the pavillon the little one a french luncheonette across the street from where we used to live, york AVE&75THST: the sky looks one way it looks another, high rise apt. bldgs & a whole different story up here sun sun sun sun sun window in the suburb now, maxwell's plum, yellow cab we're going up york now across 72NDST about to turn left uptown on york I can see the 72NDST bridge the green one at the end of the street over east river in the distance not so far hazed out, we pull up behind a car stopped for a light next to the car another yellow cab crossing york with the green light there's a yellow cab on york, a newly renovated bldg sun on it low window reflections sun on the other side, I guess the bldg is a freak: orange fire escapes a man in black suit a man in white shirt sleeves two women together in sleeveless dresses the branch of a tree with leaves on it, that's on our side centered I centered it: the side of that new bldg or maybe another one more orange fire escapes unless it's rustproof lead a metal under coat: we had just bought an orange

water pistol the day I went to lenox to the new art store to try to get some cheap white acrylics & had to go to the hardware store instead to spend 39¢ for white paint but the art store gave me a few things anyway, some brushes & a phony license plate & I think we were together the day we shot & shadows haze out the bathroom windows we went together we eat our old window late afternoon shadows on the old window on york but not the ones above it, there another high rise tree beautiful skinny tree not like the one in the parking lot & two more yellow cabs pass as one steel bldg top reflects the light: across the street from it, something white, site of a new 40 story residential tower the last of the red hot love no more. We looked at a handmade shiny new yellow saab sports car in the window of the saab place we went to the beekman I think, ed wanted it I wasnt sure, curtain up front row balcony half moon sunrises on the stage & there was james taylor sitting on a fence & another yellow car a mercury a dodge & another woman's head of a color with a long black wig was she yellow or blue, just a head dizzy light, the light in the kitchen was on with the electrically taped wires hanging down & the shadow of the ladder fell cast in front of it: three filters in a case on floor: red, yellow, blue & a candle raised to baton rouge I guess we were waiting for the film that night: red with a yellow ball in the middle it looks just like the sun & next, pretty accurate color with a tint of green to it like a fluorescent, that's blue & yellow (end): orangey yellow

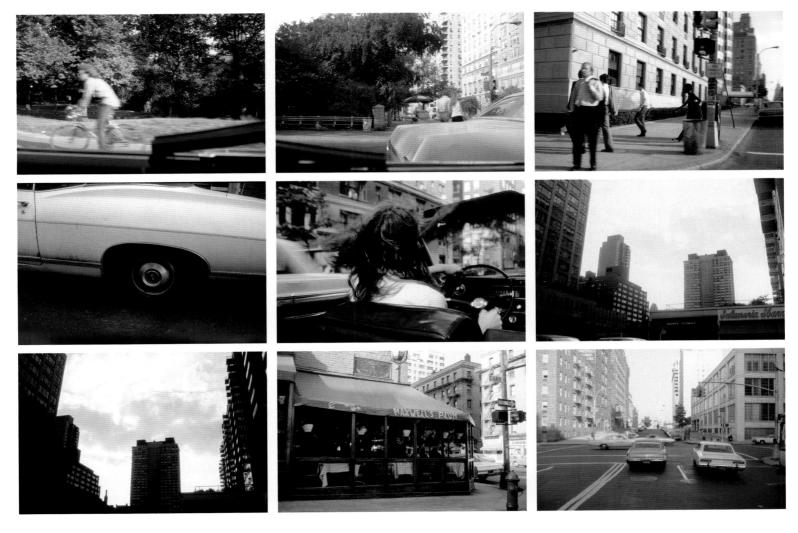

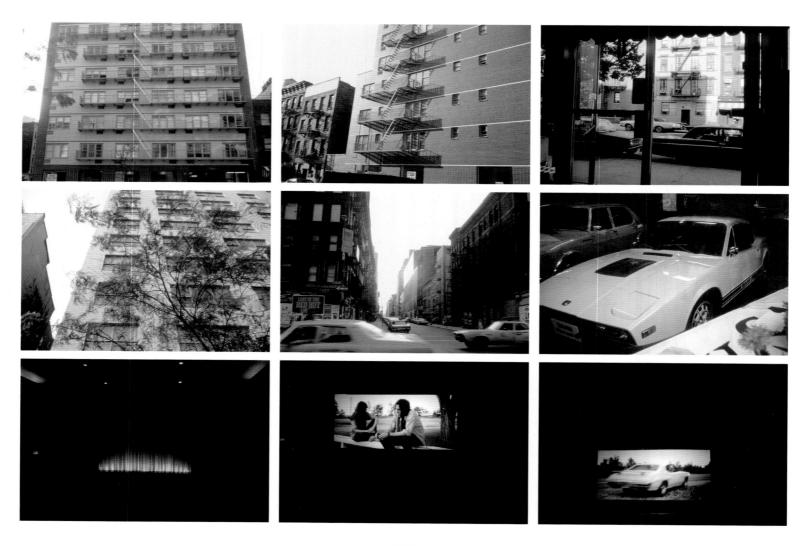

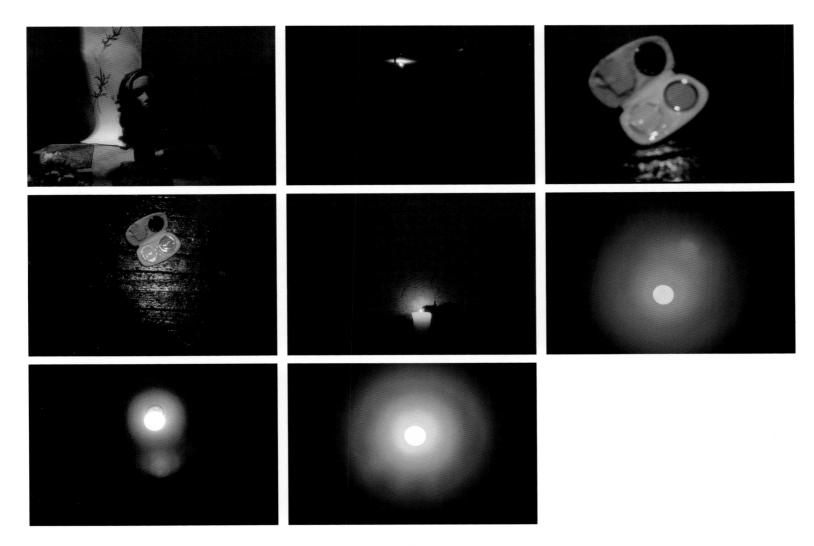

at that but the sun is pure white, a little lemon in it, I was holding them on, by hand, like this: yellow gleams yellow tawny, the color of gold butter or ripe lemons, changed to a yellowish color as by age or illness like old paper like jaundiced skin & have a yellow-like pigmentation of the skin like mongolians like mongolian people like the yellow people of asia like yellow eskimos like yellow north american indians like their straight black hair like their eyes & yellow jealous or melancholy & yellow a coward he cant be trusted & yellow a cheap sensational story appears in a newspaper & yellow a color that lies between red & green in the spectrum & yolk of an egg & any or several fungi or virus diseases of plants causing yellowing of the leaves & stunting the growth & yellow a jaundice in farm animals & yellow, jealousy: how can I explain it: le petit pavillon, two-lane blacktop, cheese omelette boiled potatoes meatloaf string beans no potato pancakes ice tea & mary's on her honeymoon: how can I explain it? There's one in the trunk, this is the music & there's the lens, what else? It may happen that the order set up for the original experience works for the new experience that we have that we now have & the parts that are added can again be seen as just instances of the order we set up as a result or something of the original experience & if that happens we have no reason to change our order our design. But if that does not happen, if the order if the design that's set up for the original experience doesnt prove workable when the

volume of it is increased, it's the thirteenth, then we have two alternatives: we can reject the new stuff, orange pen, or we can change the order the design, orange pen: washed hair here, rampage, heavy heavy air here, talked to anne & m is still pissed offf about videotapes & now peter too as well & larry & gertrude & harris her going to the coast & grandfather's state terrible nothing right nothing wrong, a kidney infection jaundice dehydration oxygen intravenous feeding hardening of the arteries, can you break this seal break this seal his first movie in the english language, grace is in the country with the magician's children: the arsonist a hit & run, I saw it all at once tonight that words are leading me on, the ones in imagination, saw, in leaks in indian leaks somehow, I can erase I can modify I pick up, least it's not a nautical sleep affinity for words like genet some flow to stretch, stretch out & pull in, to masturbate: & it is in honor of these crimes that I am writing this book & so on, not a use or function like v, perform a service, work words into a system, words put in a system, it's some play, some death, nautical, at sea with them & I started to write that, what's put in, watts, what's put in creating problems, everyone expects a rearrangement to suit not to suit, expect spectrum: yellow but the sun is pure white, a little lemon in it, I was holding them on, those games, jokes all the time, nothing to do with time, what can a diary be not a reconstruction, something put in, use the time, pass it, stain it, pass it, it's stained, it's

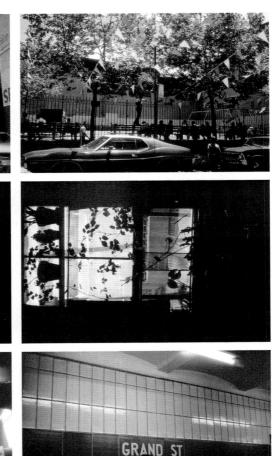

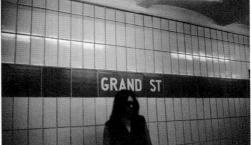

now that lit baton rouge & it was & still is mounted on a ricotta can from alleva which is mounted on the phone book so's to reach baton rouge by fire when it's lit & it must've been still higher for the shot, what's in the hand? Ed in the gulf of mexico close to baja california, a fire in the ashtray started on purpose & the ones that I deal with asserting themselves & ed lights a gratuitous fire the veins of my hands are bulging, there's a brown paper bag on the table & a potato a tomato an apple coffee cup rope two candles mounted on jars, one an old blue brioschi jar hannibal with the label taken off & a pack of cigarettes closest a jar of sugar the fire's higher ed likes to light fires & on the table as well rope ed ed I'm further away glass ashtray $\&\ I\ ve\ figured\ out\ what\ that\ is\ first\ what\ it\ was\ I\ see\ I\ saw:\ a$ hazy vellow scene with some orange & splotches of purple, electric blue electric electric purple into the ashtray on the theory of close out of focus while the fire's still going I wanted to get this close to it so I did, like moving around the lights, no limits but light or darkness is all myself under the blue lamp it's more I mean less than an ellipse a gibbous moon above my head making light, my face old my hair orange my arms tan in an army green shirt, I hadnt seen myself that day mouth like a clown eyes ears shadows dent too white not far enough away the white sink with hannah's bottle of moldy spring water on it more like sea water & not a drop to drink, a clean glass wine bottle, reflections in the back of the stove & after that I thought I'd gone to bed, no, three brown paper bags in different stages & the rest of the house in the window more windows, a safe glare from manhattan from the light above the sink & a green plastic bag in the garbage & the top of the orange coffee pot above the top of the black silk stove in the inside stripes of my blue coat those stripes what I liked about it in the first place even when it had pleats on the bottom in the eighth grade & I wore that one on the myrtle avenue el a lot, ed was still up & I made his pose for him: in the light of the fluorescent light shooting out between his legs from in front legs white out a background glow hair whites out hands like fibers a back straight & cool as a girl's the coat the peacock ed's wings the light goes on up the sun tree sky centaur & giraffe, curtain shower ropes & phony ceiling, tops of the valves of the hot water heater bows & arrows and stained mirror top of my head in it close to the ceiling ropes of the shower reflections above it birds fly across start & the rest to write it down is to repeat myself I always do I'll cut it all out later & go on, I went on out to the bed striped wall pin striped picture of the indian god woman who stood on a cracked off piece of ice in the river woman, pillows gone we rest on yellow velour pillow & the one with the english garden scene on the cover & green fringe comes from somewhere, the god is next to the extension cord, narrative before, I cant keep up with the sense the sense runs away with itself dashiell hammett hash simple sentences: I

went out on the fire escape. I rested the camera on one of the ledges so I could make a long exposure, facing the windows opposite me. One floor is always lit, this night two floors were brightly lit. The baker brush co. I made them brighter. I waited for baggie's elevator to be at the top floor. It was red bright red, it had been other colors before including white. Red exists lights showed in the place next door to it. In the background blurred are the lights of the telephone company building, radar on the top not visible, guarding manhattan from the south or from attack, which is it? Down grand street before the pipes came making piles. Fluorescent light can move of its own accord, ed can moving into these fibers leave after themselves the lines of the light: if the light has lines then that is what those images are & up top a brighter more concentrated light & a thin one like a match struck. Ed smiles in the yellow pose, one of him there & now he's above himselves, the sleeping prin/cut off by sleep: you do as you always do go over this again: the brooklyn laborlyceum is the kind of building that grows small & you grow up you go away, emma goldman spoke there my parents had their wedding reception there, now it's abandoned & in between those events it was a knitting mill with a full front yard all around surrounded by an iron fence, authority doctors & nurses in front of me: dr. attoh dr. podell mrs. leo mrs. sampson: miss boowegbir what about your parents? Do you live together? & how could we & do you live in the city? &

are you married, no, so, I guess it's up to you you two & I say he needs a mind of his own, I defend gp's states of consciousness & no one can see them & I see two eyes & a narrative: see kathy maher, still dry stiff sarcastic eats flesh I guess & empty in vacuous vacuums white as though nobody had any feelings at all, you say solutions to problems a speck of dirt, whisked away, I say I see a peck of dirt & leave it there, grandfather isnt dying a woman eats potato chips & someone says I'll have to speak to my husband, I'm not saying anything, my husband will be home at 5 o'clock, we are trying to find out how much money gp has in the bank, it's simple but she wont talk it's the water gates for her & they like anyone would did a fraud as fast as they could & they think nothing is happening nothing is being done when there are only women around, where are your husbands & I sit & we sit lined up on opposite sides of the room d with her mother with their interests to protect, lined up, I sit next to my sister: I am the imp of the perverse I have nothing to lose, this is addressed to you rose of the sea, marie & rose-marie our secrets yellow on a black field on a field, sable, the letter whose imprint is red is black: theodore-nathaniel & bernadette: you've got her name & I've got his eyes: bernadette sinks ships: marie, I want sex, I have leonard in mind now. Theodore looks in. I change the channel right in front of you, no, I write in front of you now, addressing r: secrets are ours I'm talking to you, rosemarie, keep the order keep the peace — the

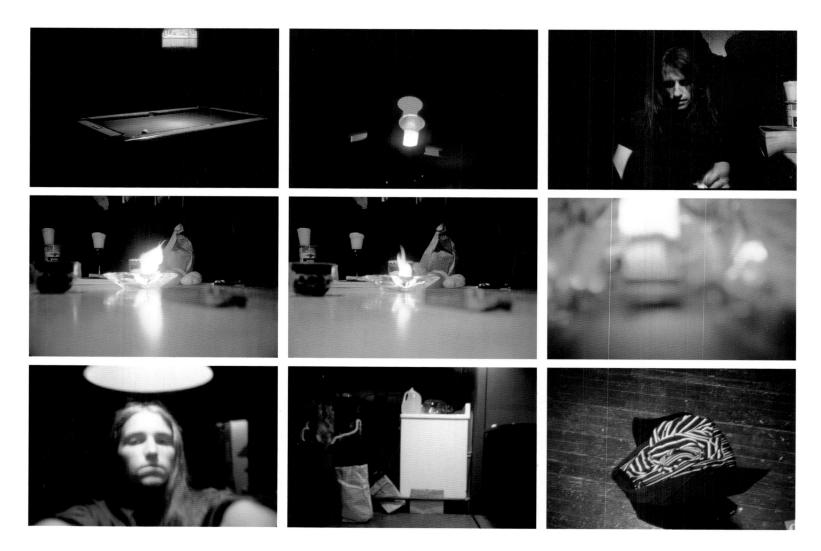

gun I kill you with & the reverse: you're all there: listen to me, it's blue. Watch my black eyes: the large skies of queens with the large clouds of wyoming neat vistas, rows, fields no life anywhere, do I want to be cut off from all people or from all of my family, when I saw gp I thought of my mother mouth open gaping into the atmosphere of a room hospital room no power neither protesting I dont want to die in a hospital: hear the thrusts deaths & sighs or was each a soul scream head-rending at its heart & horrible, is the sigh the soul or does it drink only lightly at the top like bees from water do the words come through piercing, who did it & are he & the things of him one or do they start stop fast now one now him & is he dead thinking sweet is the joy I long for or forced stopped thinking in the cool green-yellow of his body, does he faint can he hear his own sigh & is it shorter than it sounds, ring or rattle, clear through down the bones & at the moment then the things pure death comes has he gone did it touch & is it clear then or will all pass by without sense & what's above yes or no & why ask how is it thinking that we die with nothing or with all & why isnt much to say, say power, say money: graham avenue on the canarsie line: what would emma goldman do & what would kathleen do & the catholic priest, father o'fry em from ridgewood, he couldnt commit himself, commit communion commit an omission, commit a forgetting where you are & what you are doing: his haze not his halo, smile & freckles, g's been in the

hospital a week could someone work the magic on him, catnip leaves & the rest. H has to study so desperately to work such daily anxious magic, the secret to good health is contained within this book, within this razor blade life over death in the hospital corridors I'm still myself no matter who dies: 1STAVE, 3RDAVE union square wyoming clouds till the end of the day & saturday nights in ridgewood, there's \$13,000 in a joint account with d, eat creamed corn mixed with potatoes tomatoes great bread wine coffee summer meal summer spring & so on ed sank the eight ball yerba santa tea & janis joplin yoga & the rubber man at the circus/cut my cut: I fooled the ape virgin foraging for a grape from his purple groin I gave him pale apples his uvula ingraining with my leer's earful: lion pears gore the reigning angels to avenge the pope who has pale nirvana in his green vagina, meanwhile the papal pig is ripe feverish & angular, my lover veered to a prig like purrs from a nigger his legs liver & unpurged loins ravaged to a flowery orange by the profane green plunger, rape purple, the sexual etiology of the child: she wants heroin. The I-character is usually the she. Let me just go quickly through pinpointing the fantasies, touch on each one, sherlock holmes. There was the blowjob, the heroin, touch tongues, the list of men, the dance-model scene, the violent scene in the doctor's office & the one in the country. The first three are real & were the touchstones of the others. More came later. I came home: quick blowjob, want heroin, think of

touch tongues: the list of men. I was trying to think of a man who would grab me. No, first I'm tough I think of 1 & wonder what grabs me to him suddenly, it's the way he grabs you, pins you down, at least he pinned me down without even knowing me, just right, not for them & not for then but for now why? I go through the list of men & try to think who could do it, it's nothing that I could do at all nothing for me to do, it has to be done, I think maybe t could do it but no he couldnt do it, I imagine presenting myself as the vulnerable object at I's new loft. When is he moving in? Saturday. I'll go up there I'll just arrive, but he always has so many girls around no he doesnt it's just an illusion he makes there wont be anyone there I'll go up there & wait for him to do it, in fact I'll explain to him what I want. This is why he is perfect, he wouldnt care I'll explain to him exactly what I want & he'll do it, no it'd be better if t could do it, no it'd be better if I just waited for I to grab me & start to fuck, the whole thing, no I dont want to fuck I just want him to grab me, that'd be enough, just the grabbing by the arm & maybe the pinning down, I'd escape. & m couldnt do it, he'd laugh & p would be too serious, I couldnt be serious with e & e would just freak out, more trouble, too much to bear for him & another she's crazy I thought so & just like all the other ones I've known & so on so I'll go to the poetry reading & see who's there, there'll be somebody there who'll be perfect, not 1, he's too nice & doped & I know the perfect one, a stranger, it's c but

I dont like him. L or the poetry reading, just cruising as usual & this is where she sort of branches off for good in the bed. Hours must've been going by. She's modelling a new sort of dress in a new kind of sex-show-modelling-show, it's the dress you center your attention on, watch: she comes out onto the stage in the dress. Do you want to know what the dress is like? I'll describe it later. There's a man, close on her heels, she's got no shoes on, no I put that in later. She walks to center-stage, the man behind her. He twists her arm & pushes her out onto the runway: it's a thrust stage: this is where you get to see the front of the dress: she acts in pain. The man, keeping hold of the twisted arm behind her back, grabs her breast with his other hand, it's a low-cut dress, maybe he even lets one side of the dress drop down, he keeps his hand on her breast, her act of pain changes a little towards pleasure, an ache, but the moment this happens, this change in her attitude, this lessening of the pain you can see in her face, he turns her around: this is where you get to see the back of the dress. It's black, low-cut like I said & full-length, maybe her leg can be seen through a slit up the side of the dress, maybe he caresses her thigh during the act, but the black of the dress as it falls turns to violent red & then purple, the brightest deepest shades & the back, in shades of the same quality, the back is deep blue & green, the dress is like a tree, it must be painted, she is very credible because she is so beautiful, will people laugh at her, they dont. He turns her

around & takes her hair which falls down her back & pulls it forward so you can see the cut of the dress, she does nothing but act, her movements are directed. The man & woman speak but cant be heard, you have seen the back of the dress, then the walk back down the runway to center-stage & here, if I forget exactly how I staged it, it doesnt matter, here I think he hits her & here is where I put in she is barefoot, cause she runs away, she runs to stage left & here you see the beautiful dress moving & when she reaches a certain point she stops, gives a look of total desperation to the man across the stage & just as this look is passing across her face, she begins to extend her arms outward to take a slight bow — her head bends down after a brief look at the audience, a look without pain. & just as she has begun this bow, the man, reaching across the stage, extends his arm in her direction indicating that she take her bow: this is done so that there is no doubt that the performance is over & that the dress is for sale. Now that is all there is of that. & the consequences of this scene bring us back to something real, like the list of men, combined with something less real & this is what it is. But first I have to introduce a new character, el al aaraaf israfel ishmael helen thy beauty is, but I am like a stone & the new character begins to be the he-character even though some of the feminine engenders a kind of relief from that being true directly true, you see, he must be a sister-love to do this. She will use an office to set the scene: it's raining out & she becomes hysterical she is out of control. & he hits her there's less embellishment, there's none, he simply hits her you dont have to know why it's the only thing he can do, he hits her, I put in a reason why, it comes later. He hits her & she hits him back. These are just theatrical hits across the face. He hits her & she hits him back & this infuriates him & this is where I put in the reason why, it's cause he wants her so badly that he is out of control, he loses control even more than she does, out of frustration, this is the reason I put in here & I put it in because he gets so infuriated that he punches her, his fist is big enough to hit her mouth cheek & the lower part of her eye all at once, he hits her really hard & she falls down. He moves across the room not looking, she starts to bleed, maybe she loses a tooth, she's dazed, falls down, starts to get up, spits out a tooth. She wipes her face with her shirt & remembers there's a door to a kind of garden behind the chair, she makes for it, he tries to stop her, the table gets knocked over, the lamp, he grabs her, she puts her head down. There are all kinds of things that could happen next, what I'm saying is there were many variations, like, the noise brings somebody down from upstairs, there's a scene like talking between doors or he goes out to take care of it but cant because she'll run out into the yard or there's someone waiting & he says there's an emergency, you see, he cant let her get away. It's obvious he cant cause there's this incredible bruise beginning to show on her face & blood & a

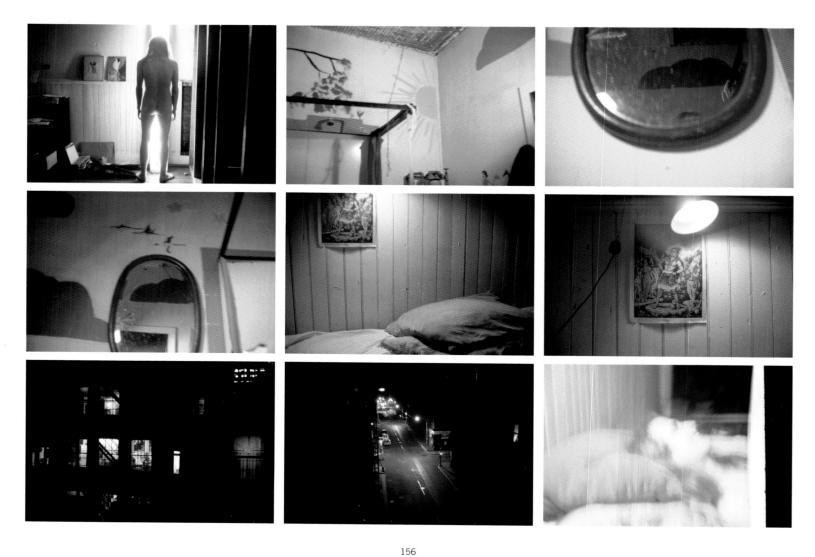

black eye, she's very happy about it, what can he do with it? Maybe he even takes her upstairs, maybe no one's home, maybe no one's waiting & it goes on forever, go over it again, maybe he even has to call up someone on the phone, bring in a new character, there is another character involved with this, no, it's just between these two, what can they do next? Nothing, there's nothing to follow it, el, al aaraaf, israfel, ishmael, the only one left, wants to suffer

July 15

In the country in a room. Do you assume in your creation that humans have an understood love to begin with & when I get that from you, I can make you anyone, then, I can make you another, even the persecutor? Bright lights big city baby you knock me out, yeah have a life, nurses, it's twelve o'clock & fifty seconds bright day: bright & gifted children top soil red wood tubs & boxes hot lunches & terrace design maintenance care of aged & sick this is the book telephone book & mr. h-o-h-l the lawyer wouldnt talk to me write him a letter in anger, a, write to show, specializing in psychiatry gradual planes garden design, the nurses registry 5 n. main st spring valley, nyc#5626255: 150 a week to nurse, 15 a week to registry, 30 a day for replacement, 1 day off, 6 days a week live-in, pay carfare, mrs. wulfurt, \$195 times 4 = \$780 a month plus carfare, you set up the bed. This morning pictures the dark windows of the loft in morning, afternoon, the blue windows of the bathroom window & more of the extra now, the dark handling of the morning windows & last night end myself in the mirror & ed in bed, he's asleep, he laughs the shutter button gets stuck the camera shakes lines & jimmy reed gets stuck for the seventh time got me runnin got me hidin baby what you want me to do & that's pretty nice too & I feel heavy with three meals today because of bacon & eggs

& veal & greens & home fries & peaches & beef & greens & wine & someone says it's all shellfish all right & someone says yeah we were in boston that day, you remember, & braids tickle my ankle & I am uptight distant & far away because I got up & went to canal street, ed, & I passed the public scales on 6THAVE, that's commercial weighing by water ron said & it's a trial: you get on the subway a black man in a straw hat is motionless & a black man in glasses, their heads go down are cut off & a sun-tanned black woman, you see ads for cheeseburgers you see ads for radio station WXYZ, you get off at 47THST&6THAVE & what does it say sale what, I cant read it from here something for 49¢ & someone says I can read that & I can also read 1st quality stockings & I guess you can read 49¢, no you cant read that, it's light bulbs in a glass case & I met ed at arnold's saw the films we try to synchronize sound: nightmare alley with tyrone power, dante's inferno on 47THST: it's red white & blue & you eat dried cheeseburgers dipped in sauce, cell sauce, you've been in the city two days & that guy in the picture was sitting right across from you & he didnt even know it & he doesnt know it now, no how cause you took his picture in the mirror with ed & ed's arm's black & the waiter's black in white waiter's hat & you see a jewish man eating food in a big brown hat with striped brim band, bands of deli deli deli & franks franks lines lines lines fluorescents fluorescents fluorescents fluorescents lights have changed my life & it was

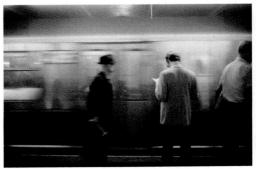

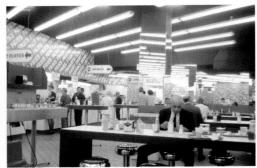

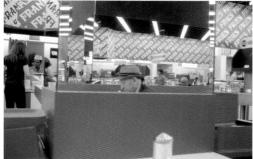

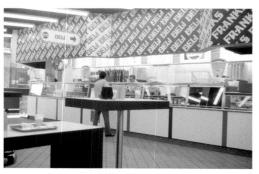

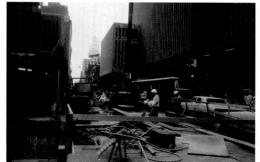

brighter in there than it was outside & that was very bright & bright green to make you sick, construction green dark on a bus on a bus, grass: a place to relax excitement confusion I guess we separated & I went to the hospital again you see a patient looking out a window dark & read time magazine & r's not there we're back at arnold's, ed talked on the phone & the floods are too high, high orange doors to the construction palace & someone says that's the reddest thing I've ever seen & that's three sets of teeth & you look down like girls on toys through a hole a hole so deep it makes ed black & ed in his black-green shirt t-shirt looks dean james green & you must be in the subway against bright green bricks & r — green he makes a face & you mug they say, one hand on his other hand's elbow & what's that: you see the bank in the park, that's right, lights on & wait till you see what's next it's so dark in here & it's nice, yeah it's lions in buildings, right, gradually coming down in a fabric of glass, no mistake: we took the subway home. Later we stopped at smiler's 6THAVE & fruits prices quality reflect on the car, as before: bright lights field big city field baby you knock me out & fuck gp he doesnt trust women or just women with children & he wants to live in his past so he leaves us out in the process that's his states of consciousness & you cant accept us just floating around with no identities except we're teachers I think I think we say we're teachers & I guess we seem young to him: can he see us you stop time & I'll stop time too with you

& could he see us & his sister-aunt bob gone to the coast for her 50th wedding anniversary fuck her & fuck here now's the time to fuck aunt bob's the one who wouldnt admit me to the hospital when I was almost eighteen cause she didnt want the responsibility in case I died, who moves: the moon & jimmy reed. You listen & you become strong in your resolve & you move never to give anyone a way to identify you, a sense of your ease maybe but no word & what's the word it's poet, son. It's lamppost fence: you're a fence & you're perverse, thief, I hope & a woman was an outcast, e & a woman was ugly & her tongue was tied & a woman was blonde, what century & in what city do you see & do you see a faster way, find a faster way to get to the line that goes in all directions flame no continuing space a space to live in flame you can see it right away no figuring &most of all sleep no questions that's the end: there was a guy who tried to pick me up on the subway & he said why dont you trust me & he said well if you're in a hurry then why do you walk then why dont you run & you take pictures I see pictures for me & another like me & so on. Notes: previn glenn miller columbia decca prestige audio fidelity is a command enoch light & numbers at sam goody's & someone says we should have a small professional specialty store for what you want & he's queer & all I want is old black magic & he talks an english accent, says this store's too big & he comes up with enoch light & up with friendly hippie construction workers smile like neil

& dope seems to reign supremes in the store for a while with nathan jones & chaim arnold & mrs. kerlew legister calls & signs her name in her own black hand written by the other black nurses out of the black house in black jeans with black coffee besides the black mrs. sampson & lilah's black & she says what records do you have & I have that old black magic & janis joplin real as life & she says as soon as I start singing one of those songs I have to go out & buy it & I'm much more at home here black with blue notebook, store it up, than in the country passive in the city sit back & be in pain queens plaza. I pass an indian spice store on broadway of elmhurst & I buy spice tea cause the store is there & I'm black & dr. attoh the west indian is my friend today & g says get that thing off me & demands a glass of water & the F train goes to kew gardens & I buy cashew nuts & the tea we couldnt drink it & the indian man stands up straight to tell me that asafoetida a bad-smelling gum resin obtained from various asiatic plants of the carrot family is a natural laxative & he says or he adds to keep your emotions pure or was it emulsions or motions movements bowel movements fine powders real time: ellsberg, victimology & I remember that asafoetida is the substance they use to see if babies think the things adults hate the smell of smell bad & the answer is they dont especially shit & a woman in the hospital elevator says to me because of your braids they might need you in that play & I say what play & she laughs as if I know & if they all knew how old I was they'd ½-shit jesus christ the spartan restaurant & where was that asshole priest today we go black to massachusetts g burps & I know what p means about seeing all these people before but now I dont & will it make me put everything into words & who is p always formulating for me he never leaves my thoughts alone, it's fifteen to four & the 5THAVE crowds are waiting for the RR train & I'm all alone in the hotshit crowd, they get off early, just waiting for some room: nurses internal what balls not all to have a family. Power money room. Gentle witch the orange pen & change of \$20 in my pocket overwhelms me, how to run the splicers & the rewinds & who has films that want editing we all do & can I have the mylar splicer & take away that spool we want this over here, a loud buzzing, you want that? Background talking & walking & a sitting at the editing table says can I have a reel, emulsion side down it sticks that's gelatin & the raw part of the film is an original the viewer left right, emulsion side down print up base side straight up & down correctly wound it must be rewound, any questions? Emulsion side upside down. Flip it for the image, this is a viewer: a hippie runs off the train at 42NDST he almost missed his stop, pinkerton gent agent getting on the train whizzes around, the kid must be a criminal he thinks pink, punk, sits down & looks silly, holds his hose his hat & his brief case he has a good tan not time, that's g. gordon liddy says: if you've got the time we've got the beer milky beer

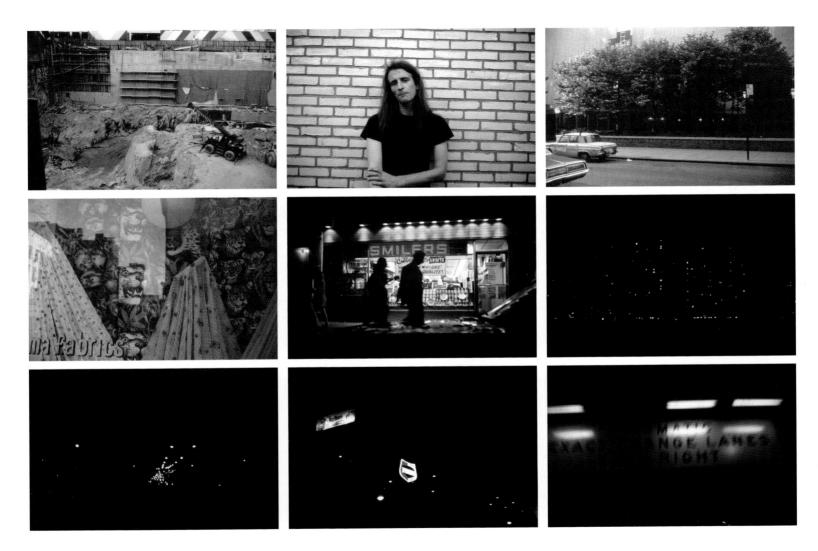

TANGELANES OF TOOK

looking up, this is a detailed diary of my rapes: now the pinkerton is taking notes, he couldnt stand it but I have an orange pen & he's not looking up at me, his legs crossed mine apart the two of us writing furiously on the train at prince street he crosses the other leg, he's writing about tom, a traitor like jean genet he can only write in the dark, notes: 522-2222-030A just charge it & say you're mrs. roy pierce personal loan department chase manhattan bank & how do you cross a palm with a negative sitting in the regular studio there's a chair there where two birds artificial birds fly by & you may not be interested in artificial birds in the sky but paul is & he makes a fish come in right over the sun as if the fish were flying & I turn the volume up & we're sitting in the regular studio in the fucking chair & we make a memorial or stars to the sun sinks down toward the fjord where paul came from far away from twolaneblacktop art & but there's still a tree & this is drawing drawing's cheap an optical printing'll cost you two bills you draw the bills out of a number of them 354 356 357 & it runs to nine bills on the a-wind underlined & in other altered states on the opposite side of the space there is tom please per-mix me to tower a bone & knot over hills where your ground makes sparks in the air no ground blue once easy yawn rolls through the box car with a simple engine on it rolls through the mountains on tracks: there's something to that story & I say wow I know what that is you know those apartment buildings on the west side highway & he says yeah & I say that's what that is & he says do you have any memory this time at all & I say not so far & he says you will I think & I say that's pretty nice too & he says mm & I say lights & he says butterfly & I say that's nice you know that sign & he says yup & I say teneco I waited long & he says automatic exchange lanes keep right & I say we were as far as riverdale ten cents & he says I dont remember this day very much & I say we're going back now & he says I think we had k with us too didnt we & I say yellow pail & a blue jar at the gas station & he says was k driving & I say this might've been the hitchhiker night & he says it was & I say how do you know & he says I can just figure it out & he says what's that & I say not me & he says lights on & I say I dont know & he says j's friend from topeka was there was that it & I say a mystery & he says I dont know either & I say next morning & he says we & I say I slept on the side by the window & he says I slept by the door & I say who's that I dont know who I was who I was sleeping with then & he says obviously & I say obviously so a moth flies in & we're sitting in the back seat of the 1964 cadillac convertible k&e in the front up the west side highway the miller parkway listening to pres. nix. announce he'll visit china but the date is secret so is beethoven's motive for 1st symphony & so is brahms' motives same screech cars pile up not on top I'm with the machines on this one & jim the drummer called & e gets stoned then the h-hiker who got part of the next page turns out to be

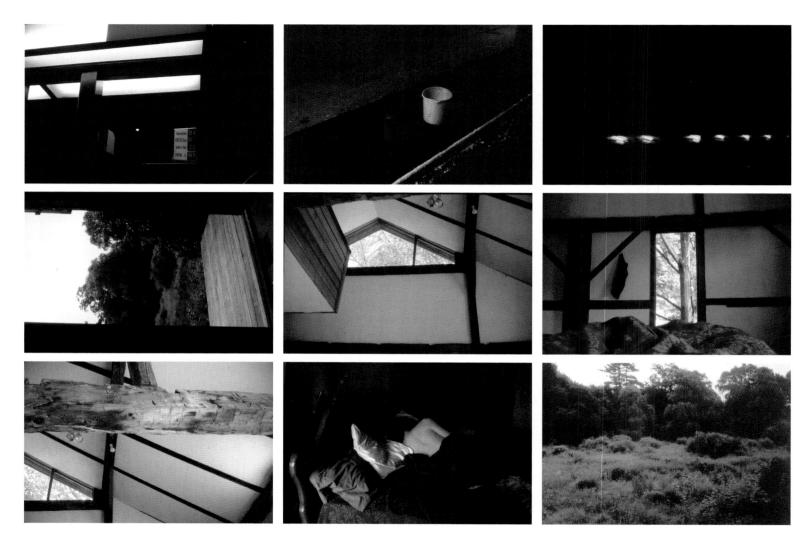

a preacher for the jesus revolution of teen challenge an ex-drug addict he says & he says when I saw a pair of white hands on my back I never took drugs again & yes he says I saw white hands on heroin no I wasnt on heroin when I saw them yes I was & I never was again & I spoke in tongues he says a tongue freak revolution from the top & so he says regina coeli brother he says blessed mother mary magdalen & christ you know the preacher got into the car with them but he didnt notice he preached & as he left he cautioned them I got a contact high amen & sends us high literature later & when we get to massachusetts it's topeka but first we leave off jesus in poughkeepsie he belongs & when I see the woman from topeka my first thought is well could she be his very own ex-wife & we come in laughing & we file in laughing & we seem much younger than psychology & I write the end of a note to michael says I cant believe that anything in the outside world is that important I surely didnt do anything vicious love & I'm still awake at dawn for the fields to watch me & the field watches me, ed's back the field

July 16

I just received your letter
Dear b. It's over
So you're downtown to stay
So I just thought I'd tell you
To turn back the other way
Same thing I been telling you

Day after day: it's over & all is now past & it may happen that the order set up for the original experience works for the new & if it does the new part can just be seen as a sign of that order & if that happens we have no reason to change but if not & if the order wont work when the volume is increased when we see more then we have two alternatives & they are we can either reject it altogether, what is new, or we can change the order radically: the first alternative is never taken if the second is available & the concept of prediction does not enter in unless you can hold your love in disorder the whole night long, hold your love in disorder & the whole night long it's sunrise-sunset when you get up & when you get down: tom is still limping we help him limp & I have a job in madrid helping a sea's captain we are at the ocean shore in madrid it's sunrise-sunset waves waves waves and so on altered waves absence of authority altered authority I am on the ground dull & I'm afraid this day

may bore you but again this red day bred you feudal, planetary whip of the sun: ed in t's soccer shirt biting the top of one hand the other resting on the table & j cut off the blues vs. the tans on a white wicker chair, someone threw in a yellow towel & we made calls that cello day to find a moviola first we talked to jonathan & anne: ed figured out why the sheriff was here cause he was involved in the eviction & to see if the same people had moved back in & that's not us: tungsten ASA 80 & a thousand dollars worth of rocks in the back of the car rothstein silverstein & epstein & sunday 6-7 for the cello be back tonight or tomorrow & can we use the heat here & can we work it out & can we use the theater, calls, & should we take the tape recorder & noises of barking & intermission music & call ballou & call r & get brakes & k gets a postcard from 1 through b with no message on it it's a connection like having a baby, be me, & a picture of us in the stream appears in the public papers & there's a telephone strike 411 411 411 the end & ed & j play feudal warfare all day one forfeits his life for the car for the bear for the alimony for the laundromat, the cello's bow is soaped so it wont play & e's play is a jewish play the end of the play is not the end of the day this play is open today so someone says in it take a few steps into the middle of the beach & maybe perhaps I'll meet you there & j reads to us from sleep & jon's blood runs hot when he hears the word moviola the cummington school of the arts has one, hillary harris amy greenfield & davids (3)

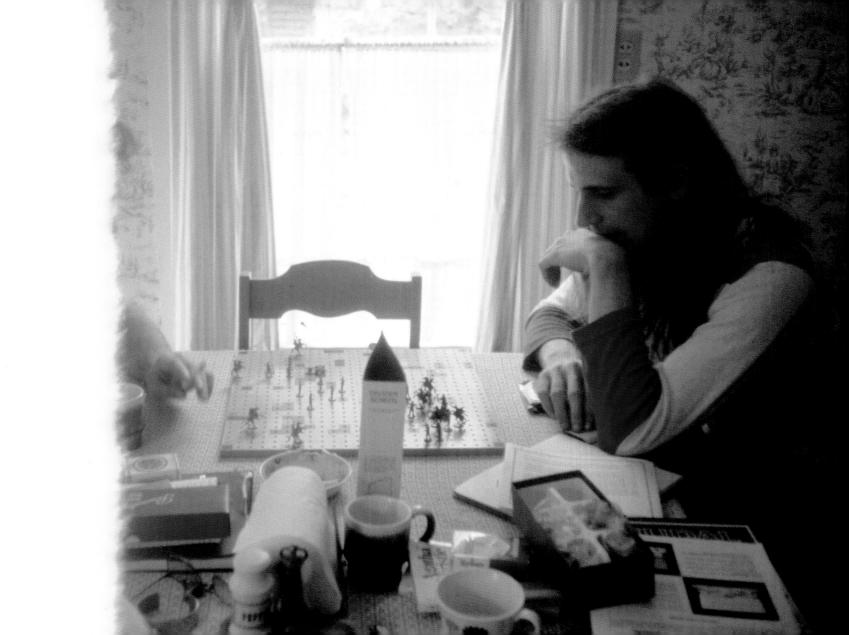

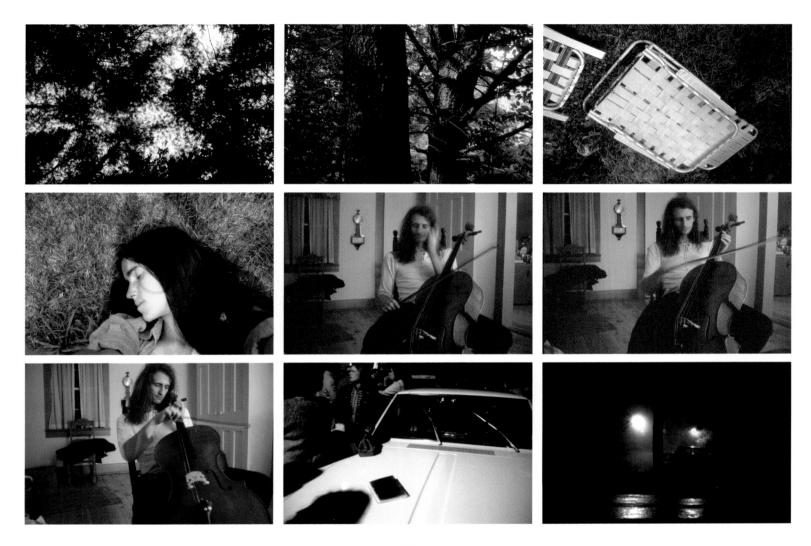

steins & g. stein says roommates must always do laundry & with this forget it rains stops brakes girls who look like bernadette devlin stop brakes: k reading philip roth all over lying on the couch feet up near the game with the ball & the numbers on the ball-bearing wood frame: I moved to the left further &further away from k to the window & lamp seawater color on the wall & I went out: j&k's yellow shed: the back door of the shed is a false front from a to z & old rhubarb plants old green everything green in these pictures old looks & they'd caught some curled up dead leaves & apple trees among them & did we go home then no, a house made of grass again does that deceive you yes it does some very very ordinary weeds I'm down the hill red berries & who cares they got a laugh I was roaming around from just inside the forest wall towards out of it, that's beaut. Yeah that is nice tall stick tree in a hole, see, plants get no response are shots in dark & I got fire far away from house a weird shaken shot in patch of light on ground wet leaves on blackened trees & light comes through & ed gets into bed & turns around all the time: two black trunks one curling & yellow-green behind & what you do now & what you did then you smell a fire burning then a library of photos a million slides of everything that is, look them up many of those tall thin trees are there some fallen wound around some fallen down with side slide branches up on the roof & you pick two trunks to choose from a yellow chair me on the ground & ed plays the cello I put blue notebook down on a big white car at the theater next to someone's shadow & a red bag floating, the windshield wipers were stopped up we had no brakes we went home late the lights the house spots across the road across the house still on still house in mist & ed's legs in front of the tv a war movie for hours & hours: tom ball mountain is on the map el. 1993: I wanna take you higher

July 17

Had I quit yet? Ed at work with his earphones on. Julia came & made up m's bed like a hospital. Ed took his shirt off & pulled his hair back. We went out. We left the screen door open. Ed went back in. He didnt close the door. I went across the street. E turned around & stood in the doorway. The roof of the house sags. Peggy drinks courvoisier, the pen got caught in my hair. Posted no trespassing, c.a. price. I turned around. I went down the road. I stopped in front of a row of trees. I really have nothing to do & no sense of it. I havent been able to sleep nights at all. I crossed the road & crouched down behind some tiger lilies. I crouched lower down & opened up more. I didnt know where I was. I bent over some yellow flowers. I went further down the road. I sat down in a field & faced the road. I looked across. I tried to make everything look yellow & still catch purple. I tried to make yellow keep its yellow against the sky. Things were blowing. I watched out for bees. I found a bunch of things half dead half alive. I went further down the road. I went right up to a sign & looked behind it. It was pointing at light a curve. I trespassed. The shutters of the house were closed. I went back. I bent over a mud puddle. I walked around it till the sun was in it. I went behind the house to the field. I went right up to two leaves on the same plant one was green &

one was turning colors & a hole in it. I went over to the gas meter on the telephone pole. I tried to read it. I found a heap of garbage in tan plastic bags. The garbage was hidden in a grove of low trees. The trees seemed to be bending over it. There were flies all around. I found the pond in back of the field. We went to zayre's for tape & a record. We bought wild horses & someone says does ed know it was sagittarius keith richards who wrote wild horses which is probably why jagger sings it so bad. I looked up at the sky above the building. I looked again, we stopped at a dairy queen for ice cream. I looked out the window at a family of cars. We went past the farm. We went past the golf course. The sun set. I put something on the stove. I scrambled eggs. I looked at the tape deck. I put something more on the stove: this is what really happened reading backwards. Dinners I'm supposed to go to dinner I already went I go again & again in long addresses in long dresses, tom, we take acid before a dinner & then lose track, or, take acid before a dinner then lose track, somebody's father, strait-laced I'm strait & laced in long dresses my camera with me, the gas man comes he says this is a conceptual piece lacking conceptual data & he says I got no expectations: the gas man comes today & last night mist fell through the spotlight of the spotlit house our house is unspotlit like dreams & last night tv bats flew around this room on the outside whirring, little crashes & a twisting buzzing sound, little patters creaks bangs sneaking

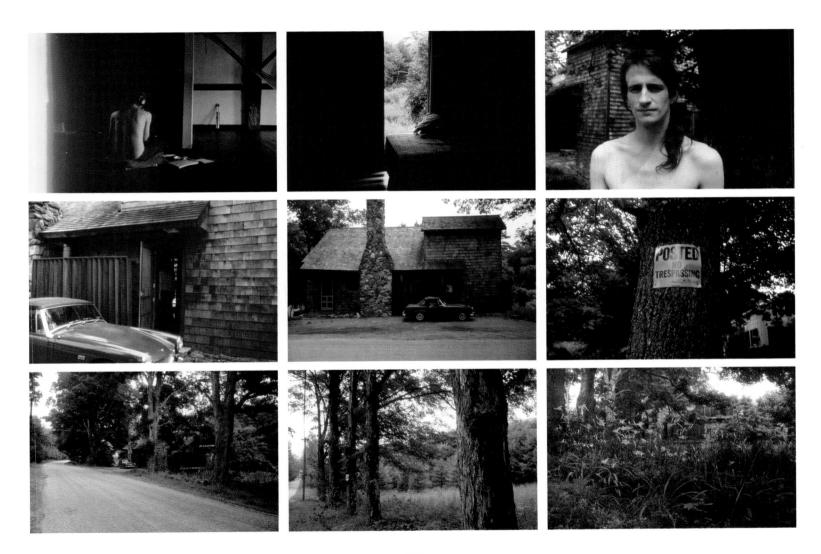

around sounds to which you listen with both ears, listen, they're nesting under the roof out front we saw their ears & ed's doing the dishes listen it's orange water gun in alford close to the state line, I get the blue toothbrush ed gets the elegant tan colorless one & ugly pictures are fathers trying to ask a question about women & the answer is me in spite of myself: women reading backwards. Where the fuck are the men when you need them? I hate x here & I'm glad I dont take very good care of a good notebook put to good use these days & I'd hate a lot of other men too if I knew them knew them men in a room womb tomb alone with me like a young man from Japan I am highly dissatisfied with life as it is or let me reform that for you wanna go higher you want an unsystematic slovenly mess that is chaos for all, then come along with me & you'll have a journal & no survey: ed & tom are soft on women but hard on lines & edges remember to be reading this backwards & why bother a yellow bird a yellow bird & why bother a beautiful day I'm a. The mailman's here. Sun out in a white pickup truck & still old coffee stain on the white pants a lot of car doors slam & it's hard to strike a match anywhere, the gas man's on the cellar floor & maybe it's saturday maybe it's saturday what was yesterday the cellar floor's a good place to strike em, men. Julia no first ed at work with his earphones on, then julia & tim-tedtom from the homestead house come a big bee chases them a big bee chases me a walk through the orange green screen through paradise & I think about e's play, fm should be here today, I wanted a picture of the spider web on the downstairs bathroom window july 17 & havent paid the rent yet well have you ever & keeping track of the moon's wounds helps remind you to pay the rent soon helps a wasp a big bee a wasp in a hole I take colorless pictures cause green is not a color & lose more style in my right arm than in left, what little style are left right: something about a sock hop & julia tells the wasp to fly up the sun comes out edison the earphones with his work in an old pollynose on the porch pond. The gas man fat mustache sideburns the sun gave a heavy breeze here a door slams no it doesnt a black & white bug now I chase him away sun again & put an ash in his path, you are a star. Yoga today sun gone & green is silver to touch some days green is gold rustling today & blowing the weather is changeable lemonade to drink. Musak candle melting into the porch wood the dream sun comes again sky too bright & gone again brighter a flag at the end of the field the buzzing bats asleep a day a buzzing thing dips through the sky & the yellow bird dragon flies top of many white flowers & buzzing will I be stung by a bee, clean up this wiring robbe-grillet is a fried bear in his fathbone in his bathrobe fatherbone he is father in his bathrobe & jacques, marcel apple? Trees went to sleep this morning no pictures they were gone a furious short duration phrases words a sentence is over it runs not a period not a pause for breath from one memory to another

is it faster does it move still question marks & a picture of lee I hope identities change again exchange again change again home & you move & you need another bed is my right as a writer to smoke all I want but a bug on the cigarette we need a bed you need a bed & so much smoke from the match into & out of & turned off it to it into it not into wishing well was that a well talking muffled talking beyond the field the porch the deck all around the house is weeping willow tree so please come in through the window you see the minds that changed places were well on their way already they were very much into that change & well jealousy is all you own jealousy & some jalousie windows & I've brought in the dictionary as I'm into it & is it easy how easy questions run into each other into how questions run each other into great walls so a man in a yellow shirt looks at me he bends down he's on my private property I didnt think I had one & I think we cannot swim are not allowed to swim in his stream I think we cannot own each other's rights at all at least not me & him so what does he have to say I say these questions of private property always end in periods. They do. Trees went to sleep this morning they had every right and zoom to write smaller sun out in a very much into the sky where are the purples I love ya kind of way type of way a whistle rustles through big clouds but grey blue sky very pale very bright a truck goes by tomorrow I'll look out front, this is out back. See, the property, the periods, me. The flowers are ok the

man stood next the flag next to the flag which boundaries the markers of our property what time is it july 17. Ed is on the earphones ed at work with his earphones on we have no phone here a car stops is it for us & still muffled a door slams ours? There's no mystery about it an actor is moving in but that knock was mr. flaky foont aka mr. burnt u thru the telephone man to remove a white princess belonging to mr. dennis jensen formerly of this address of this address, orange tiger lilies mr. thru you came on like a nice guy long hair old jeans not just a public servant a telephone remover summer style & you waved as you drove off towards alford, a church, bear left on this road away from stockbridge & you'll come to it especially flaky or hokey, the wooden horse the carriage the gazebo & the empty reservoir, those people across the road are nuts. 2. This fly on my page like orange & this orange comes off on your fingers mine a mine of information like: the fly's back flying over a sedentary fly prince princess & queen mother I guess in bobby socks beautiful flood lights on the yellow house, mr. prince waves but dont look too happy as he drives off he's a prince to his wife's price, miss price, sinking feeling as the price of the prince's yellow car goes by: I'm out front by now on top of blue car. Red waving truck passes by box 108A flying eating orange but not the pen point more ornament for the white pants arm & tina talking about us at cape cod everybody talks about us with the brandsteins this time on the beach at chappaquiddick & a

whirr it's a gold car old gold people burnt you thru my golden foot is bit ouch: pink garage the fly's on me now I'm on the fly 2 flies love me I'd be quitting puddle pine needles rut I guess ditch ditch it crack a twig to show you're there cracks & muffled buzzing I'm flying or the queen at the garbage can behold the lid on tight no fights on this road & now & beetle he flies the fly on my leg beetle bent ruffles & flourishes nourishes food nourishes lettuce & tomato sandwiches with 1,000 islands sauce & coffee lemon lemonade whirrs, tree noise tree tone gimme a little orange posted it's halloween at the queen's house tiger lily radio stir up noise an experiment pure sure one plant blows this way another the other & four or five more a million anarchists came we had logs for dinner & the n with a cedilla. Sun on pine needle tray shade on torn ball mt. el 1993 aunt el's was high & the stones are free if you buy the whole piece only eli wallach bought it & all the squirrels too double exposure I cant afford it broke the train broke the beak of the bird eating seed broke his carburetor, pump, motorcycle goes by sings broke the icy revolution in two instinct parts by pending in suspense with one and so the end & the two teeth biting one a woman the other a man & all trees still hanging down down around 10 feet clearly marked & clearly marked the right record for this kind of moon, thank you, through august 6 so read a book. Tell you: own a dot on lily a huge expanse & keep it keep it well, red flag up mr. dash man fly foot white the car with pants sitting in the shade of the learning apple tree with harriet sweet williams: I imagine myself caked in cement they have to chip through holes to my nostrils so I can breathe, poison something on my ankle, first I imagine myself covered with something sticky, I say cut off the hair on my legs & first before that, shave it off, but the razor gets stuck, leaves my leg a bloody sore, a rectangle, poison something on my ankle, her privacy, the man fishing alford brook like muddy brook her granddaughter visiting do you need anybody I need somebody to love do you want balloons yes ballou I walked up the road town road toward alford quiet in her ear ed is on the ear phones making speaking noises with a magic marker cant hear a thing, I'm in the hammock with the flies in it but I walked up it to fields flowers smell burning cigarette against a wooden match up a narrow road on a small weekend I came to a closed-up house maybe a weekend house another house behind it also closed black shutters green ones white hydrangeas thin a curve sign fields posted at the peak of the curve a rolling uphill driveway to another white house white fence along the road this house a larger one a flower garden occupied purple across the road tennis courts & a view of the top of a mountain tom ball the first on this road & from there the mountain's leg of lamb was white from too much light I couldnt take a picture of it so I think instead about being in the bathtub with ed after shooting movies I've turned around so I can see it rain & the wind is

heavy turned dark by 4:15 at 4:15: let's go into stockbridge so we can buy some batteries for the tape recorder foot stopped itching soon thunder & lightning like hunger the bathtub when we were waiting for breakfast in the bathtub & so depressed about being here that there were pictures I couldnt take & that was the night we stayed up all night willow trees waving doors slamming them some days are longer than others &someone says it might take a while it might have some value we have to have everything together or half each including a tree a chance to do something an involving yourself in something, let's go. Out: backwards manny kershenheimer in the dining room of the cummington school of the arts or agawam near holyoke the bay state film corp near springfield & at 3:30pm sunday sun at the school you will hear south indian music in the office: watching out for the thorn bushes allergic it'll go away it does, agawam, leaves foot with used look, like it, jack blue eyes pushes his hair back with one hand running his fingers through it anxiety & magic thinking there's more to it, vistas you've got a friend james taylor a mercedes benz in there & what'd I say alice cooper caught in a dream touch me in the morning we're in the silver city bar again & k&j fought & fuck you they go to claire's knee does k have to do the dishes & i reminds me of t, meet terence & f. murray the arab from pittsburgh, texas, & friends they all went six miles instead of point six & wound up at the state line all the way to the state line

amen, noise shouldnt go too high the speaker rumbles the noise interiors out fast it's too fast lower the volume of the noise before the crash & add the add the explosion lower the applause does the noise of a small crowd milling seem too small have any appeal the noise of the newsroom is not clear & the noise needs bells turn up the treble lower the bass, a door opening slow, that noise speeds & that noise needs selection lower the bass keep the treble normal then lower it for a while but not all the way to silence then up again & try the noise of the silver city bar & get closer to the cash registers when you listen they ring up & maybe the noise of dishes would work & the noise of musak & the noise of the street's no good & maybe the noise of just cars mixed with street noise & the noise of the bar needs no bass at all: I put something more in. I put something more on the stove. I looked at the tape deck. I scrambled eggs. I put something on the stove. The sun set. We went past the golf course. We went past the farm. I looked out the window at a family of cars. We stopped at a dairy queen for ice cream. I looked again. I looked up at the sky above the building. We bought wild horses & someone says does ed know it was sagittarius keith richards who wrote wild horses which is probably why jagger sings it so bad. We went to zayre's for tape & a record. I found the pond in back of the field. There were flies all around. The trees seemed to be bending over it. The garbage was hidden in a grove of low trees. I found a heap of garbage in

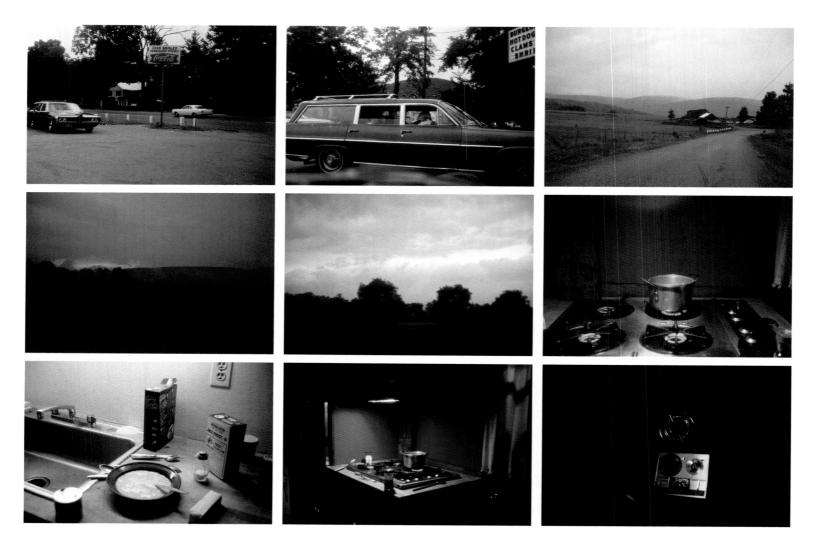

tan plastic bags. I tried to read it. I went over to the gas meter on the telephone pole. I went right up to two leaves on the same plant one was green & one was turning colors & a hole in it. I walked around it till the sun was in it. I bent over a mud puddle. I went back. The shutters of the house were closed. I trespassed. It was pointing at light a curve. I went right up to a sign & looked behind it. I went further down the road. I found a bunch of things half dead half alive. I watched out for bees. Things were blowing. I tried to make yellow keep its yellow against the sky. I tried to make everything look yellow & still catch purple. I looked across. I sat down in a field & faced the road. I went further down the road. I bent over some yellow flowers. I didnt know where I was. I crouched lower down & opened up more. I crossed the road & crouched down behind some tiger lilies. I havent been able to sleep nights at all. I really have nothing to do & no sense of it. I stopped in front of a row of trees. I went down the road. I turned around. Posted no trespassing c.a. price. Peggy drinks courvoisier, the pen got caught in my hair. The roof of the house sags. E turned around & stood in the doorway. I went across the street. He didnt close the door. Ed went back in. We left the screen door open. We went out. Ed took his shirt off & pulled his hair back. Julia came & made up m's bed like a hospital. Had I quit yet?

July 18

There's a wreck in the sea I recreate wreck member be me remember this see & while she was pushing her way through someone asked her now I ask you can I say that & I'm gonna shut myself up in a room honey & someone asked her medicine would do no good there's a wreck in the sea: we sailed. It's cool today finally at last it's too cool kathleen & I set sail together & while she was pushing her way through someone asked her, we woke up well into the day, I looked out the window to puffy luminous white clouds dark in the middle & of all sizes but there were all sizes some just wisps in the air close to us, some full of dresses some clouds of boxes some of dishes some of churches some full of women some children some teeth some had mice some had wives some full of knives some with leaves some with thieves in them some ladies some babies some cities whole cities no countries & blue sky thru the diamond window is green blue & white like a flag or an army armies are made to look like the sky, it brings light to the ceiling pointed & you make sam cooke a little louder, he was shot in a motel room with a woman in it & someone says he would've been as popular as frank sinatra & gwen gives me her record & the window brings light to the ceiling pointed to bring out the inside to white out the outside, pastel it, black tv on black chair with

antennae up ed's feet up & a pillow on top of him, clouds that are losing their substance at the edges as though the sky water melts them down clouds that fly inside is outside ed in tom's soccer shirt. The tungsten wreck yesterday just trails off into three hours in the theater listening to sound & san francisco for clouds ed singing that old black magic & f warming up in the basement enunciating gesticulating orating articulating ejaculating epistolating theater personnel & star divine movie technical & mouth open tv distant divine repeat writing letters is a thirst rehearse repeat george eliot & f motorcycle bailey with cardboard plates he's rehearsing a good place to sit a good place to be this morning, some dreams I forget more two's more towers & bells or these wooden struts trees & all the rest shade a good shampoo he's yelling both decks in the shade are in the shade. The ride through the glade my shadow on the ground, receipts, I want some mail ballou ballou cut come custard mustard away a way think sense cant today a way cant get comfortable cant concede darker darker darker deed I rhyme I got a pillow & pictures: I woke up & out the upstairs window out the other one the tv then big fat white clouds light from behind them out the windows dawn an amazing day delicate ektachrome sky & keep yourself out of this delicate sky or eye, less light bluer sky & later the blue in the blue in the blue in the clouds full of airships rivers clouds of engines clouds of inches clouds of pain of lamps of ovens clouds of rugs clouds of uncles

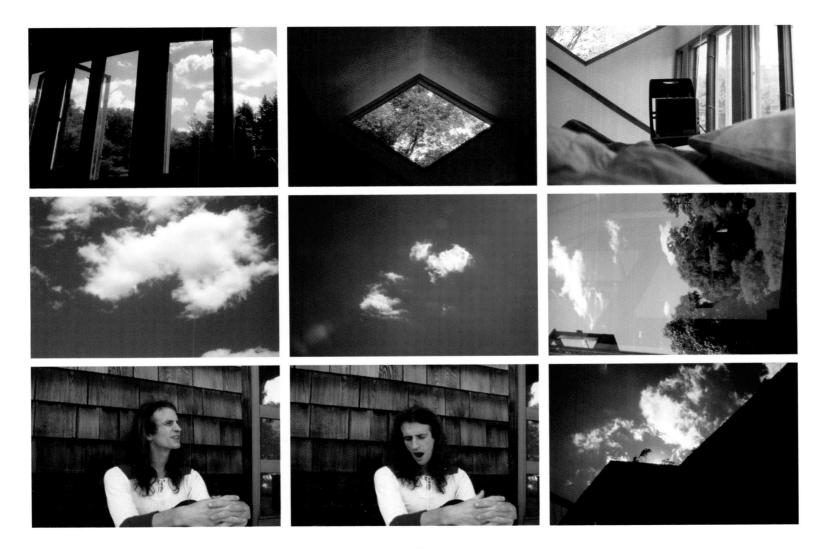

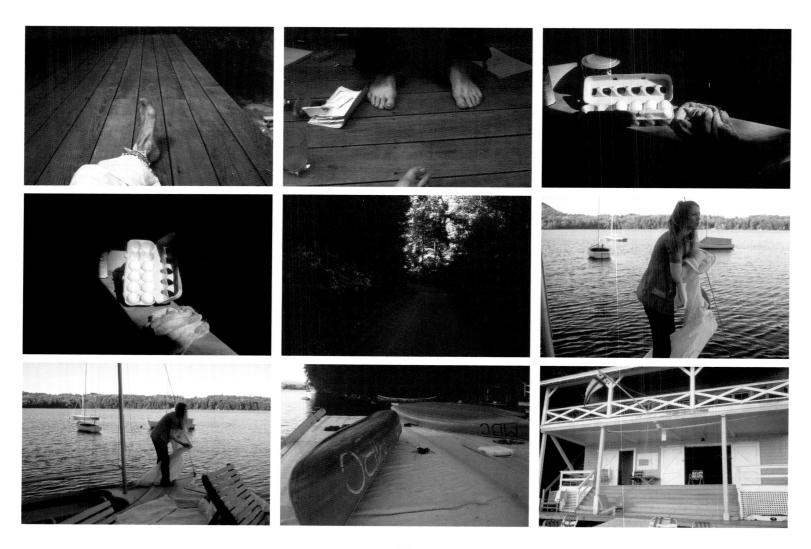

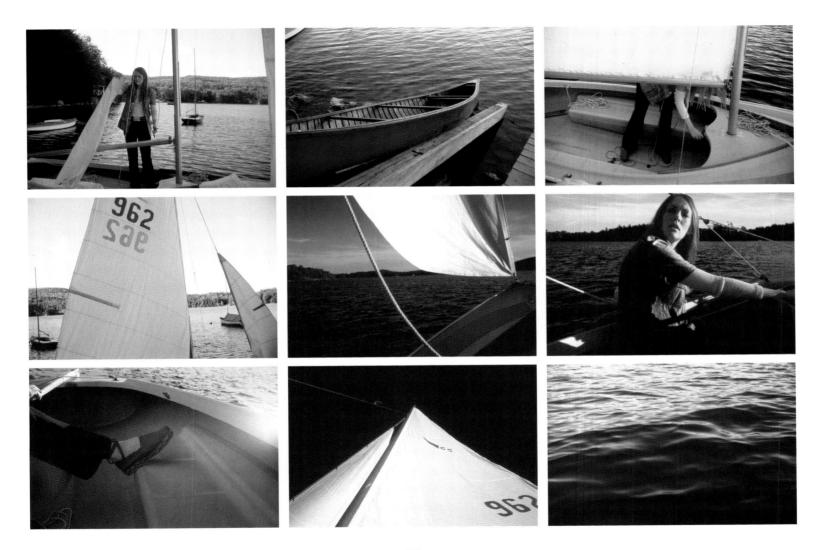

all over the place & clouds of noises clouds of addresses straight & laced clouds of oceans right & left clouds of gloves of hills some of icebergs some of election clouds of cars of the car clouds of undertaking, fast slow hard old clouds that fly inside is outside ed in tom's soccer shirt squints at the sky the tie is tied up to the top & ed's large hands were clasped around his knees his hair loose & then he looked down to the right yawning the sun was past the house moving quickly across the road my foot was red from the rain on my moccasins the top of it hairy love & fascination is her middle name to my heart to my heart a sick sweet young rich cheap late sensation of thrills she brings, the hell with the heels of his shoes, we went through receipts ed's feet on the floor of the deck, our notebook crumpled red paper pack of smokes an empty pad the pad I'm using now a wax pad I bought for paper that wouldnt reflect the light we needed paper that wouldnt reflect the light just as the curtains, freeze they close over the late bright short clear friezes hanging up in the movies the old candle is there with a feather stuck to it about the bottoms of ed's pants are frayed from stepping on them with his heels the heels of his shoes, the hell with the heels of his thick strong clean deep cold shoes, john is small. There's a wreck in the sea the sidewalk & ground in the kitchen & the waterplug opened upside down la rosa rigatoni empty coffee cans jack frost sugar an orange & grey towel a screwdriver, I couldnt find one today only phillips heads, the

water pistol orange & 8 eggs in a yellow carton with the sun on them they pose feet on the floor & wood counter they come clean we go out down the dirt road & chris called the ss & someone says he's so wonderful & down the dirt road at the treacherous part once we met a car there's a fence to keep you from falling over the cliff the sun's always right around the corner & now kathleen's putting up the sails. E&j went somewhere but first j brought us over to the mahkeenac boating club a kind of club no jews allowed there are those kinds of clubs a lot of wasps & blots on their record & lots of boats & most of the boats are private property instead of where they went a pair of us went sailing in front of the boating club into the big lake in one of the boats, it was easy: mr. stokes seems to be in charge of lenox & he hates jews so we went down through the pine forest to the boats & house & k put up the sails, two canoes float on upside down aluminum & I took the camera anyway k smoked as she raised the sails & someone says her energy & later I smoke it's getting dark I'm freezing k wore her maroon corduroys a pink tight shirt & short sleeves blue slightly tiedyed shirt-jacket a red canoe dips slightly into the water & things look bigger, it's wood inside, take off a piece of your finger & I forgot the most important detail of all her green shoes with long ties on them & ties are sleepers together k bends over under the erected sail the main sail visible were her arm hair one hip & legs & feet feet standing in a maze of cords

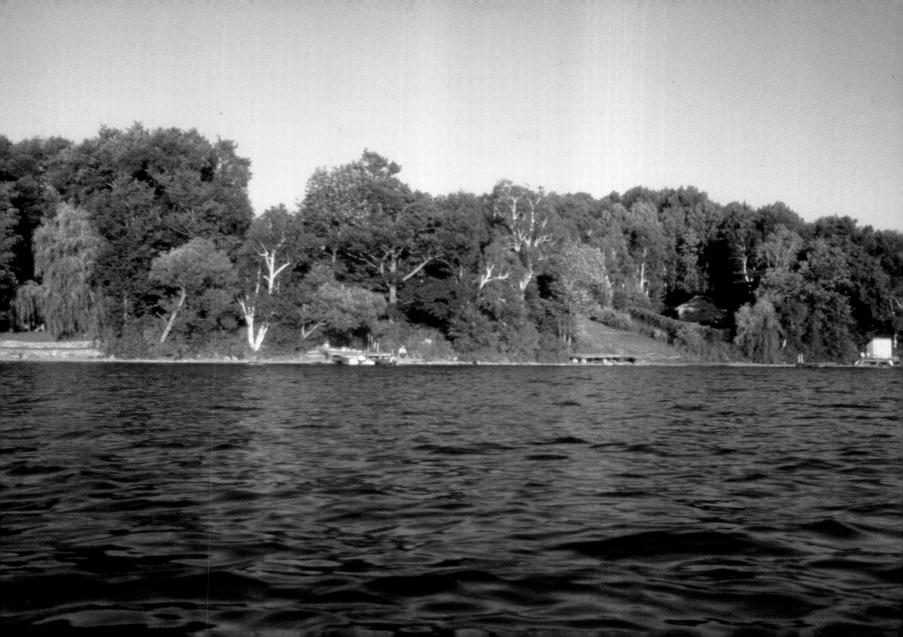

ropes ties our boat no. 962 & backwards that sails in any picture a white sail becomes the sky the land was all water the land like a river a thin cord rope around the lake ties the lake in tight k in charge looks around posing the sun on one side of her face in the middle of a lake it's easy to determine the light the boat's tipped there was little wind all those clouds of before had blown away k's green shoes in the alabaster boat, it was poured plastic a lucite boat a foam boat no ties at all of a piece, the sun on it to our right to lee her hand on the rudder sail too white for the sky measures of water water the surface of a piece the shore with the sun on it, this was a lake on top of a mountain we were in the middle of it trees shine docks & 3 layers: water land sky or ground mt. sky shift we shift in the boat weight on the water weight of the sun on water yes he will soul stirrers the clean cut of evening light two other sails they went in earlier than we did we had trouble getting to shore no wind up now towards the rim of the boat water mt cut by sails & sky with horizon: sun: I closed down we fronted waves a sky writer in the sky one boat in sight topped perfectly by the top of the rim of long mt sun set more sky more golden pink light on k's face was seeing lines that arent there & I was freezing chattering in a boat: eyes, we went back sat by a fire that gave out no warmth drank coffee, ed & jacques had come out in a canoe to pick us up we declined assistance, ed in his black leather jacket Jacket I took it I wore it & back to the house to get stoned & eat we went out for

dessert ed in his shades so stoned we couldnt see I sat with k & with j we ate 7 cheesecakes I had two sherrys jacques drinking brandy & coffee k & I went to the ladies room I think I looked at myself in the full length mirror white pants & this shirt or the tie-dyed one tied up in the middle ed stands up in our room & has m moved in I lie down ed is invisible I picture the picture of lovers in bermuda over the bed it's too white in the light of the tensor lamp all electric electric light we have many pillows we arent actors: meat & sherry sherry & meat hashish to beat the heat there's something to this there's something to being lost in the middle of something it makes you wanna shut yourself up in a room & pour honey on the thick strong clean deep cold blue sky with its clouds of dresses & closets & so on & see black black dog comes by looks like plato approaching me plato from before, this is a life, this is a whole new life: what have I forgotten should it have been: every night what I remember member every day remember later the hall of fantasy exclude f eyes red e eyes ed b eyes bread & light on my head on stone bull whips whale & that the headline buzzing in head under the tensor bulbous light like christ like light on the cross of window cross hanging down ed is on the window cross T is like a bunny snoot once was once there was a last record, song on tv it goes: when with me, once was once there was, when you're with me, once I see, sitting there, once I was, everywhere, this song, end there, how many feet foot to foot? Do you know f &

xyz you come in here you you & you & there I cheat I cheat I put you in I throw you in you dont know it I feed it I burn it nothing happens burnt u thru nothing leaves then you come in you you & you another & you you turn yourself in you are sitting down cross-legged on the sand what sand? Do you remember the sand? You are free to move move around it comes in nothing happens happens indians birds sing they come in how? They? Are sure. In a way helicopters are. Sure of flies you bring a certain number of them in you have to, sure of one or two others, you bring them in you dont even have to think about it cutting it cleaner what was it, to save some purpose some porpoise in the sea was it? To something to she he & in it later will nothing will it happen, they come. They are out automatically in the room stays back throw it in, use it used it's used throw it & now a bee comes in I wish he'd go away a bee walking that's weird he's looking for something, nose to the ground, see red: on the deck he walks over to my book climbs on it looks around plays with a piece of tobacco he lies motionless on the blue paint of the cover the back of the bee vibrates back & forth I drop an ash near him, I go to get a pad, I can no longer write in the book, the vibrations disturb him he is still again now he climbs on the spiral binding, yellow legs wrapped around it he's out on deck again a grounded bee, can he see, he's still on one leg & one antenna on a spiral vibrates again I could write in the book but it might get stung still still fly, an electric typewriter

could never accomodate a bee, bee still out there climbing on the pillow I'll shake him off: coffee rice pepper carbon paper a map to the cummington school, 8:45 at the dining room, still the bee's gone he was on the pillows currents I dont know if I mentioned that & then gone ed hadnt seen him on the pillow & I find myself imitating k we ate coddled eggs, left for j&k's talked to manny kershenheimer went sailing instead of sounding, studio, celia the cellist & thought of seeing clark & susan too celia the cellist went off suddenly back to her husband & child, sailing the telltale ariel, connor & nancy from charleston south carolina are freshmen at williams & anxious to please to prove his something or other but then j's the director of a play & k an actress in it I keep forgetting why they're nice to us my poison something left scars & where am I, sailing preparing to come about tacking k fucked just before she left for college heave to trim in the gradual sunset on stockbridge bowl streaks of dirt the airplane the cold airplane, cold warm water white boat k is the captain of the ship the man fishing the end of the world the lake on top of the mountain, a bowl we also live in a bowl, alford bowl of elephants, & the brook club is here of giraffes, j & ed j and ed row out to us ed looks like he's wearing corduroy until we get closer they're paddling a canoe it's black suede I look close cause I'm cold as the wind dies down lake placid trouble getting in & colder wait for fire coffee j's feet & pants wet: mr. stokes blah blah poor nancy comes on very

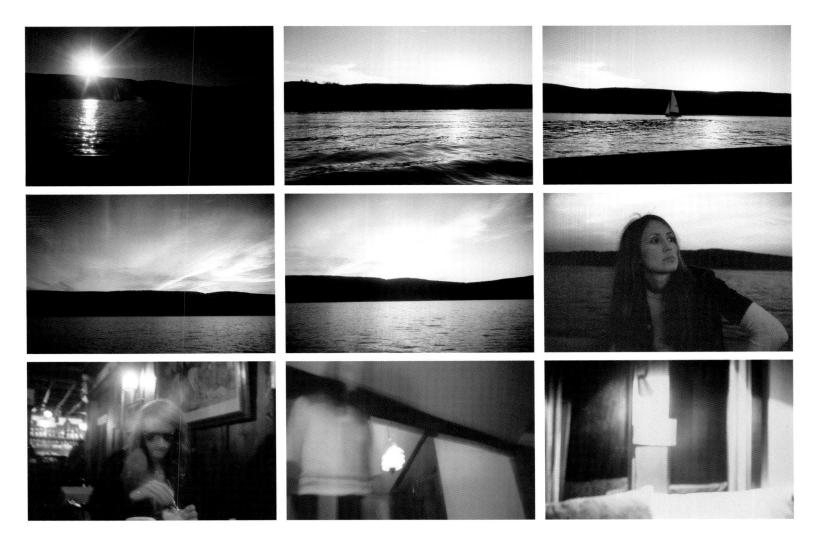

strong she's no racist pig herself & they're married or something. Dinner. Corn peas pork chops wine talk to r she fades in & out sailing, oh, my father & the corn. & someone says did you have any idea what death was then, yes my father cut the corn off the cob & later I think of answers to that like you get a good idea pretty fast & you get a thick strong clean deep cold blue cheap ideas come cheap real fast & j's questions of life & death: the burnt egg the sprig of parsley for good breath apples & nuts vampires garlic the stars the bats stones fred lord's house for rehearsal the sock hop over sit down at a table in the lion's den for cheesecake golden strawberry almost sherry coffee sherbert a chocolate sundae everybody's so stoned tea brandy k very stoned gets into j & women a white soul is invisible & j asks us our ideas of heaven clouds & flowers reincarnate no & k is in france now with castles & townhouses in paris, elizabeth marie antoinette & then she begins, a night club singer she was a night club singer & something theater begins as we sit in heaven cut the actor tony franciosa or sergio somebody or other in white rough linen suit cut in straight from a thousand dollar ante poker game cut in tan from easthampton something easy some love easy life something else going on: 12 ears of corn cut down cut off ear cornsilk & my father cut the corn: elvis presley robbstown, an affair with elvis, 1958 music k&b jazz sarah vaughan billy eckstine why doesnt somebody do this well why not, leave, outside vw bus with people milling call us night

pope people, cop car by riggs flashlight flashing red & blue lights for sportscar to j&k stars the milky way dipper there & home here cold f. murray in bed ed in shades all the way down the night honesty rollo may dehumanizing come in lights clock & so on, except for the beautiful young brown & orange deer who came running across west road I stopped he ran across the road as if it was a suburb filled with houses & then he runs back & down the road in front of the car bounding & off down a road to the right spots of his filled me with relief again I am there I love the deer we dont hear messages from you anymore the bidet's very hot the bed very cold tv very light & golden everywhere this light from this house making sparks through trees that deer jump through, that deer in my place, come over, the deer my father & the corn

July 19

You get into bed at night you whisper, you whisper into the tape another person is there he whispers he speaks he could be awake he could wake up, he could wake up out of a dream & call you by the name of his sister & you answer, he asks you what you are doing, you answer, he doesnt wake up you whisper into the tape dear mother dear mother the church is cold & sleep you whisper death father, this is the way things happen could happen this is the way things fall they turn out there is no design this is a risk there is a chance that he will waken there is a chance that he will live there is a chance that he is lost & this is what makes such a wildness of going to bed after your lover is asleep, you whisper: dear father how did you first start to drink coffee, do you believe in magic, corrosive remember we wrote a book in bed, where did the car go sometimes learned where did the car go finely polished lines, our act was no good for the campuses this is the day the night was lost but the night's not lost, it follows these thoughts word drives down an avenue & memory laughs: what'd I say baby what'd I see & when you see that will you laugh at me I filled your baskets with bread & tea & the games up for you you're not tough enough for me & baby that aint me. I just had a cheeseburger we went to rehearsal for the first time, our car parked next to a

red car with black top next to i's cadillac & beaut. green fred lord's barn mowed lawns, I thought he was a lawyer a basketball court, ed in his jacket & all it was cool gets coffee: nick kate dick jacques barbara murray marilyn & probably bob & kathleen filling out forms it was their first day, nick in sneakers & tom gorman a bracket of folding chairs over in the corner a bracket of folding chairs metal rain again & the two little girls one red umbrella one blue I dont get the red umbrella in time they're running it's closed their storybook exists on a farm & dick or somebody questions me, high speed film, black & white & I say no I'm just shooting the light behind that green stuff not inside not inside the barn & that was a lie: 2 doors open to vines you cant get out you could through vines it pours look out the doors & dick says something about the feeling of rain in a barn & two little girls real floods down the road I guess it's something you have to go across: little girls can play with umbrellas & under them & I say something about that feeling you have under an umbrella & one is dark: we're on our way to north adams we stop at the new friendly's on south street a girl eating a large yellow ice cream aluminum cone it's grey & suburban & crowded my notebook's out & the envelope of proofs on the counter of god we vow never to eat at friendly's again, we never got to go to the top of the hilton: ketchup in plastic bottles & on one of the turns we turn to follow rte 7 it's tyler street, it's still raining e is driving & it poured more the printer's

fluorescent lights this is mr. ballou, thank you, plays golf on wednesdays we went over the proofs of moving saw the cover got a copy of the proof of it saw negatives of the drawings & mr. ballou says I would do anything to avoid working on that book he says that in his neat shop, we pick out stars & I ask ed to pull up but too far behind what looks like a salt factory in north adams it's raining so hard the lights are on it's letting up it's under construction: wet cut unpainted boards in wide wide windows men working a man in one of them & it looks like townhouse apartments giant puddles in the streets & a wet black generator or concrete mixer windows are holes the corner in adams: tearing things down: I look crane piles & massive theatrical factory sky adams blooms in heavy thunders it always rains in north adams the sun never shines: that kind of day: they work in the day-dark go home to rows of small windows since 1880 something & long before a mill on the river for paper tearinghousedown but they keep off the street one church bell tower still stands red bricks make adobe puddles the light behind the crane clouds by themselves force a horizon the death is missing I walked out of the car & down the street for what I knew about adams: bricks at the bottom of a pile flowing away melt like clouds like: who lives on the lives of who works on this block: passive: windows are holes all the way through that light & clutter: pepsi the co. with ice on it: who needs it today & sweats we went on we stopped in cummington

to visit but even before that after we sailed high speed ektachrome ASA 160 that's the american standard association that makes pictures in the rehearsal barn out of rain & 2 girls with umbrellas one in blue with a red umbrella one that I missed & one blue, very green, dick was brought up on a dairy farm & remembers how secure he felt in a barn on a rainy day & b&t in easthampton clothes amagansett agawam sweatshirt & f. murray in ed's purple jacket we eat friendly big beef cheeseburg specials & peter's right in the berkshires they leave the er off of cheeseburger & I think about k saying last night liquids maybe that's why I'm so pure while I eat clam chowder & not before the rain & not before we pass dolph's inferno, dox drug, colonial pizza, & williamstown to north adams to adams to savoy to windsor to cummington mr. ballou's voice says he will find any excuse not to do it & it takes a week for kodachrome a week for proofs another week for books & mts in cloud under railroad bridge following silver blue truck this color color of the ink puddles flooding rains the something hunting machine co. pass century & children in a diamond sign & southview south on rte 8 the alternate way the north adams vietnam veterans memorial skating rink flat as a church can veterans skate bear right onto church street past general cable there's a T in the road stop ahead this is route 8, railroad railroad XX left at the two-lane road for the veterans past chute arco atlantic richfield paper co. entering adams a gunfight midway restaurant gene

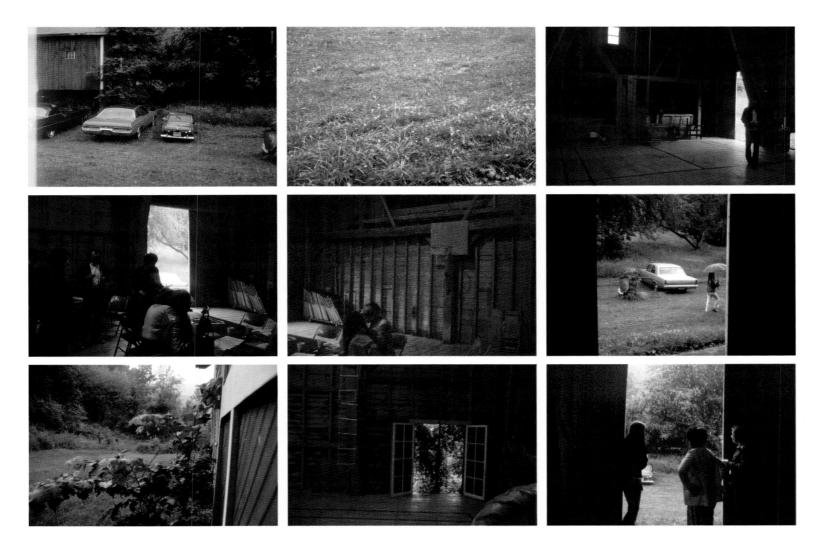

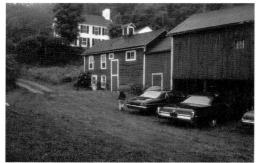

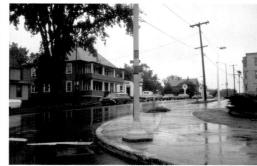

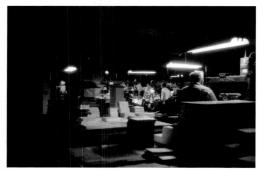

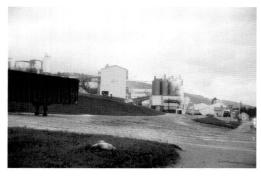

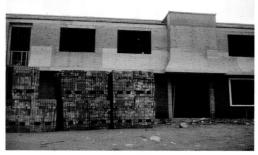

parr used cars rochester paper co. bertoli oil co. road under repair flat tires flat long houses surface on the road a front hoosac valley oil & grain national pride car wash angelina's sub shop & I say the night's lost & I say the night's not lost but death is missing, we visit cummington justine has no sense of time makes a face at us she's shampooing her doll whose face is painted like an indian's the doll has holes for every kind of intake & elimination but one, red roses climb up the house the old stove is on the porch justine is wearing one of her outfits she's wet the whole place is wet & every time the door opens it rains & every time the door opens it rains & do you want to know more, we pulled in the driveway justine was standing there a tan ragamuffin there arent many she had just washed the doll's hair but the doll had no hair left, in a rainbarrel justine was in a rainbarrel & a&j welcome us they just ordered the death of a cat so the death isnt missing I dream about adams & do you want to find out more about my life well check out the garden it's overgrown but things are growing there it doesnt matter: giant zucchinis in pictures of the garden of jonathan's stages he doesnt have them he has a row of cabbages the bees are dead there are 3 distinct places or 4 dollar signs, what'd I say, a lot of shit around in piles shit of the horse boards to walk on over it & the snow peas we took some the ice & snow & what are those white things they're blooms the remains of the volkswagon with a blanket over it rusting & wet tires all around like an old open car no motor though & work in the barn the cat & her kittens she keeps them across under the bridge over the stream all but one she tried to get that one to come with her for a visit I tried to help her but the kitten wouldnt get wet at all that's over where the grass grows into the stream & later still garden green raining & every time the door opens it rains & anne in a long dress swatting flies we eat brownies she tells stories about beverly the pabst blue ribbon beer heiress & our house here used to be hers was built for her but she couldnt live in it cause igor the prince across the street tries to kill her dog because her dog threatens his cats & I know he poisons woodchucks to keep them out of his garden so he poisons her dog &igor who's a sculptor lives in the house & he paints his windows white her windows white so he cant see out cause it distracts him & then rick & erika live there & they get evicted by mary who rented cots to tanglewood people for ten bucks a night she put up curtains in between & served coffee in the morning & mary helps evict rick & erika & at some point in the history of this house igor cuts the gas lines & he's totally nuts & this is the house we are living in & it's for sale for \$75,000 cause alford is expensive there are black cadillacs going down the road all day sunday & ann tells us more: about brownies & venable & beverly & mary & alice & there's the scene of the cats under the bridge the kittens wont come one gets left on the other side of the stream & the kitten wont come & she keeps three more on

the other side of the stream & one under the boards by the side of the house & ann tells us more: they're selling the horse that wont foal selling it by the boards to kim to kim & her father joe, we meet them, & her mother's an alcoholic she broke her wrist & had a cast for eight weeks & joe commutes to work in westbury or new jersey he's a printer & there's a town meeting about zoning & kim babysits for justine & justine should babysit for all of us we have coffee ed takes a nap he feels aches there's no snow in cummington at last & the barns arranged: jonathan got us a moviola at the cummington school & he tells us to come to a concert on sunday south indian music the cat feeds her kitten on a log it's threatening we pick at the garden green beets we get beets jon plays the violin to the plants it's somebody's birthday pete joanna & joey come by, we play more instruments recorders ann plays ed on drums & we should leave we talk about exchanges exchanging places we pick vegetables snow peas beets spinach greens radishes & jon plays the violin in the garden we plan a poetry reading with music a list of all the things in the house I'll read the list with music right out back with no clothes on no body, jon's got baggy clothes we show them the cover of the book they had been to cape cod he plays in the rain I should write to them, jon in baggy light blue pants a yellow shirt torn over them & a tan one over it & the mare that never foaled behind her electric electric fence drinking water, the goats are inside the plastic barn some casual

construction going on we didnt stay past dark promised to come by for lunch when we used the moviola, we didnt, we went back & I feel better & memory gets improved in fact it's exactly doubled by the recognition of other people & I sure explained the whole thing to ann if not jon except we couldnt figure out why we were friends it's a stranger connection including ed as much as me & that's why jon & I talked about a poetry reading with music & I said I'd list all of his possessions he wasnt much interested in that: we stop in pittsfield for cigarettes & paper no paper & a&j seem happy & justine says to me we're in school & you're my mother in her silver vest with her doll's scale the doll gains weight weigh everything in town we look for jacques the theater has budget problems no jacques he's probably out to dinner, we leave notes at his house & a new map, he never came, eat a piece of white bread with jelly & friendly's before drive though mist again home bath cat movie on tv with michael sarrazin & bad women actors eat snow peas fix indian tea, it's undrinkable but could be used as incest incitement to incest it's incense it's essence of pepper it's emulsion it's out of hand it's \$1.20, f. murray comes back the actors are being invaded with machines surrounded with machines in the play I never thought of it before they dont like it it fucks up their cues: the night was lost and I found the word vixeninny in magnet plastic letters on jonathan's refrigerator & the night f brings ribs of beef from the red lion inn & part of a potato I

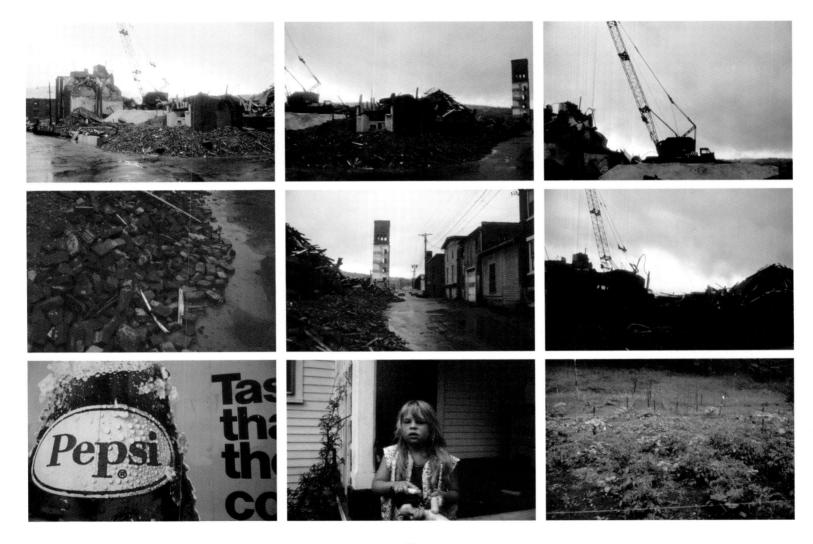

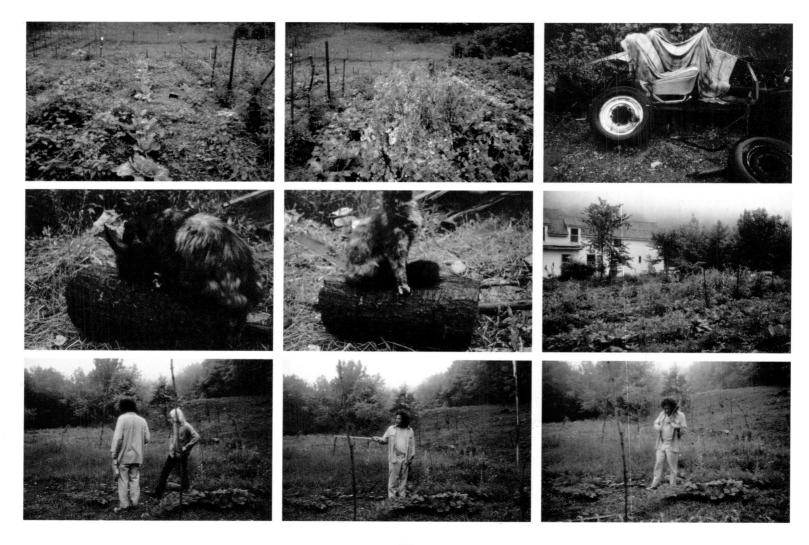

peel the beets lose my appetite & take a nap cant fall asleep but ed does again & still is & f reads a separate reality & tom has & I havent: we had already built a fire which we sit in front of & f strong presence in the house & b a little bit uncomfortable actually she's in jail again but fighting & e I dont know tired, wrote to anne felt distant & wrote about writing, trouble with words, longhand, we could write good plays & she writes back she says you sound serious like a serious artist writer & she says my eyes are still spinning the kodak float had rippling moving flowers turning into a panorama of the moon landing made of flowers if you can imagine that & you're right about the dumb playwright scene there's too much suffering psychodrama in it all we should really take over soon & I'll write again from the lowlands & that was float after float of amazing girls each one presenting a meaningful theme made totally of flowers, they do this, talked to r twice & gp is coming out maybe thursday have to set up room, maybe take books away & arrange for coming home & the people downstairs will be pissed off & I say what'll happen & ed says gp will die soon & j says did you have any idea of what death was then when I was 13 & I say weird far out blew its mind & of course, quickly, the nothing at all: numb? No, something, me: dear anne: what's going to happen the green rain's good for me & animals good & words mixed up come out funny so I think about vito & kathy but not too much & not too much about tom: something else, do & is this revealing enough, jackson — you see I try to make everybody happy no the night's not lost it was there & it followed these thoughts these words driven down an avenue a false front a false perspective like memory laughs at the intuition of time: beyond its borders extends the immense region of conceived time, past & future, into one direction or another of which which we mentally project all the events which we think of as real & form a systematic order of them by giving to each a date & the relation of conceived to intuited time is just like that of the fictitious space pictured on the flat backscene of a theater to the actual space of the stage & the objects painted on the backdrop, trees columns house in a receding street & so on, carry back the series of similar objects solidly placed upon the stage & we think we see things in a continuous perspective, when we really see this way only a few of them & imagine that we see the rest: what'd I say baby what'd I see? & when you see that will you laugh at me I filled your baskets with bread & tea & the games up for you, you're not tough enough for me & baby that aint me & lights out, patti, here's something about rivers & something about time it's the number of times in the tunnel & drifts, bill: one bell in a tower, the best bell: tough & tired she bends to train rain drain crane & all these words mean the same thing: vixeninny

capie exposures, live memory. Do I need music? Well then touch me in the morning then just go away it's shorter than life, I bought a ½ gallon of wine to finish the second diary it's bigger than life: james mason & marta toren in: he's a doctor who's stolen a lot of money they fall in love but he's loved before &been broken they wind up in the lazy town in mexico she convinces him to stay but finally they have to go back to settle with the mob they do & plan to return to mexico for real life so it's all set he crosses the street to phone the airport & gets killed by a car someone says, it was no one's fault: double exposure: the house is a tree, do I still figure in your life, the windows come together but brighter & the rush of light is for the giant plant before the blue bottles & inside is outside would a house made of sod for the eskimos in spring look like this like some kind of green thing in the grass that I used to make the house winds up in the middle of the window like a giant manufactured grasshopper, a drink maybe, in the window & the window still has panes but the curtains fade into the ground I mean blend & snap something new could happen: somebody's pouring blood on his face: orange crates & I kept that feeling about orange but this time I put them through a transparent blue awning & the awning only gives them more light night delivery grocery

delivery bakery delivery deliver me everything from & joe cocker could cover this if only & only in the supermarket, frances just called, the plums: I forgot to cover them many plums ed wont eat plums I eat german plum cake many plums glistening in their plastic already covers a tree & sky against a building or over it with a white mercedes benz parked in front is without pretty consequence I never thought of this day in terms of what I did I only saw, joe cocker & not the beatles, we went to j&k's to the supermarket for food the only food we could get, plums, to the theater & back home to work out what we had left to do: the trees gave us enough light but no trees just papers our script cigarettes coffee mattress to sit on sky over land clouds close to grass clouds in the house the house in a cloud ed reads he is smaller on one side than in the middle he sees himself from the back for once & from the front at once looking down in my softball shirt his ass coming out of his falling down dungarees & fire gets out of control there's a door in the sky a half cloud is strange to begin with the house is half window so what was in the middle it was the same, repeat it: where the fuck is tom, I shall be released, ed in the clouds & in the clouds too much he's a woman it could happen to anyone he looks, his hair is wild in my small shirt, ed from the side has made the grass his hair by sitting on the edge of the deck & making me look past him to see him over his own shoulder the deck stops to let the grass be hair & stripes on his shoulders fuck the record I'm

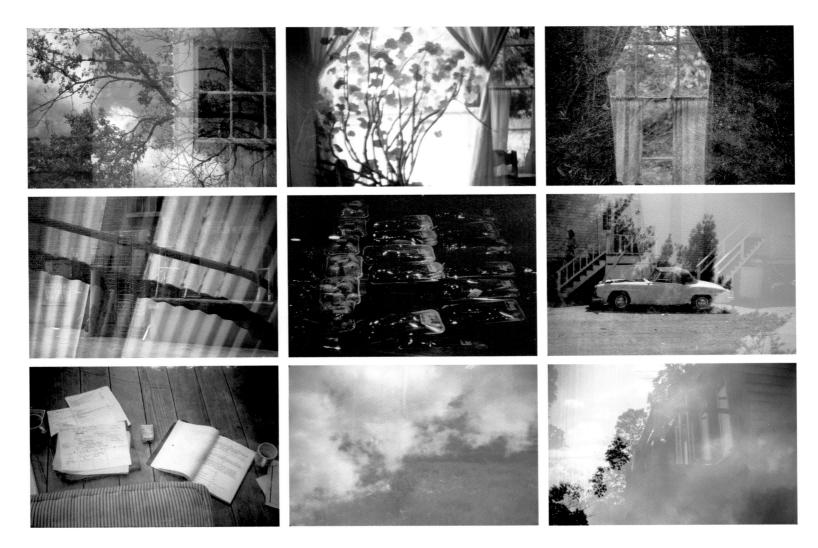

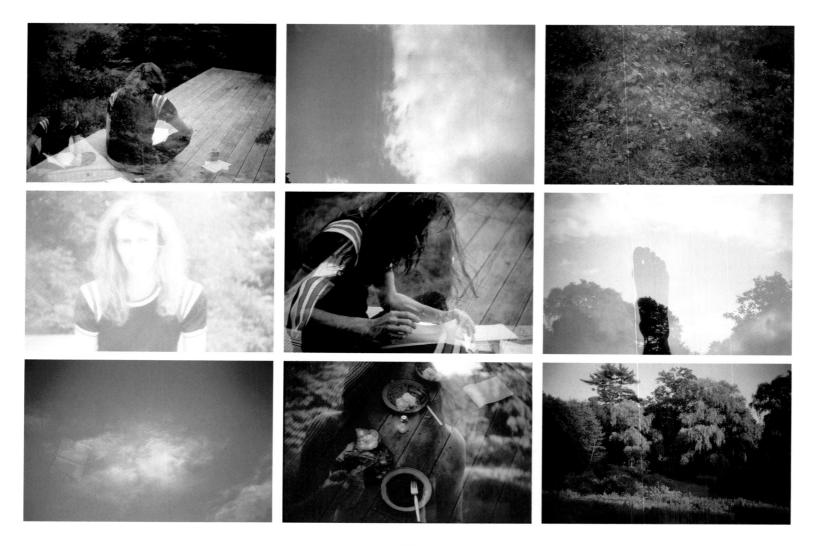

through with love I'll never fall again I'm walking in the sky I've washed out the trees my notebook's up there with me, ed the biological element: he has a hat on his head: it's a plate of beans rice & snow peas delicately boiled & to top it off above his hat is another hat a similar plate of a different color the salt's in his eyes & for a lung a plate of salad & cheese & bread & for a heart beets in a yellow plate, there's a fork in it & he holds the fork of his heart to his tongue: a carbon copy reaches for his ear: all this in front of the trees: he's taken his shirt off to show these organs of memory: his mouth is open to receive what's on the fork he looks down unaware of what he's revealed, a simple one a field I would gladly give the earth to you & the, ed takes a nap in the sky his arms up hands clasped behind his neck the stripes of the mattress he's on encounter the trees &one of the trees has made it on the door & one of the trees has made it in the door, finally. Everything I have is yours no but ed & I are one except one of us is a little off center my body takes over our necks seem the same we are a woman with breasts: the shingles show how off we are, two identical pieces of sky, we compare feet 3 of ed's 1 of mine, just picture a penthouse way up in the sky: ed's hair is the trees & he's put up a strange sort of blackboard in the forest, well, there's a door in the mountain now but it's too dark to see, I had planned white flower on white flower but forgot to stay to leave it alone as they say, they're playing the piano about it again on the roof, I wonder what it would've been like, she's going to start again: it's: dont worry about me I'll get along I had written I'll get by on myself: go out again see four giant daisies worshipping two setting suns in some kind of reflection or ceremony by the farm over the head of the farm, an exact duplicate of the farm below, the one we know, it gives us a light feeling & with a prism of the sun to boot, sky of morning at night through a hole through the trees pink & blue you might know I want on without remembering we stopped at the store standing by your window in pain I looked back in our car at ed, blue & yellow lights in my eyes what was over me: home we expel them for social, forget it: we built a fire & cooked on the stove, I burned an egg carton but triply I liked the red wall near the stove & lit the stove too & made the sink white & counter glow copper with pots on it cooking our dinner flames all over the place all lit nothing on them & lights all over the place interrupted windows blurred lights beginnings of diamonds & in the bathtub some light shining down on the tub that wasnt there: I should've stayed with people I guess to avoid all over the place, straight & laced. This is the second part, you lay it over the first like a correction: double exposures tea men to connoisseurs for over 250 years, lift here for the sound for the image: I dream my sandals fall completely apart & lie there, k dreams she's trying to get uptown with men raping you you go up a stairs men put their hands between your legs e&j are in the bedroom talking e&j

embrace fm's an arab I make notes: supermarket old black magic toilet flushing bells dog barking car pulling away car passing interior taxi silver city bar dishes call mr. charles get the bus schedule, who? Deposit check who? Last night I went downtown who? Paul delany WQRB will try to locate old black magic & ed's wandering around at the red lion inn we've been to the supermarket & had lunch there to the radio station with bells & a defective scotch cassette, they light candles in the thrift shop I feel awful & someone says I'm quite concerned & someone says the play might not be to everyone's taste & berkshire broadcasting is worried & porter is worried due to nudity & vile language I wonder what indians' feet look like, red stains on my fingers from beets & green vegetables taking over the refrigerator, red stains on inked moccasins & snakes no snakes we see porter doing exercises here & birds, ed in softball shirts & jacques in same today little bug on toughened red foot red from rain in moccasins not into a different gear different way to write & it's an old way anyhow after all & we talked to the grandson of famous mr. charles the projector man & ed is cynical about clear eyes, toenails red what do I have to do, what is being clear here birds & willow trees many bugs, storms, should I shoot should I shoot at all? One roll out of focus? Supermarket: un-toothbrush 4 j&k, ok harris, mature measuring spoons copper-colored measuring spoons coffee chock full o' nuts special blend instant stolen, bought white river rice saff-o-life salad oil

regina red wine vinegar planters pnut butter french's people crackers 4 dogs bananas eggs for muscles cole poultry farm freihofer's canadian oat bread 2 packs pall malls sweet life cream style golden sweet corn grandma brown's home baked beans friends brown bread with raisins big john's beans'n' fixins stella doro almond toasts durkee's black pepper polaver pure blenheim apricot preserves wisconsin longhorn cheddar cheese, six dollars fifty three cents I hate door that you cant push open with your feet. One day I hate myself in a row feel crumbly lost ridiculous worried about ed & his turn in our get rid of his her mood with a bad one of your own our work in a morass what to do next it's pilgrim's progress time hurry it up will grace come was she at the meeting last night when I called adrian to talk to r & I never thought of it where's the other A, anaïs? Ed & I working together the old american flag filing of separate duties makes some kind of excitment that they've trained us for we're used to it & I dont have to tell myself anything cause I start to write even a letter & it comes up I know it all already WBRK A-OK MAORI indians & how does your mind work? Sun out in cloudy bright double exposure gp I hate the people downstairs & everybody who reluctantly cuts themself off from you & everybody who reluctantly anything some obsession with the truth they just never come out with it just ok's & groans & some words they've said a thousand times before I hate the thought of spending time with them & then with r who can get

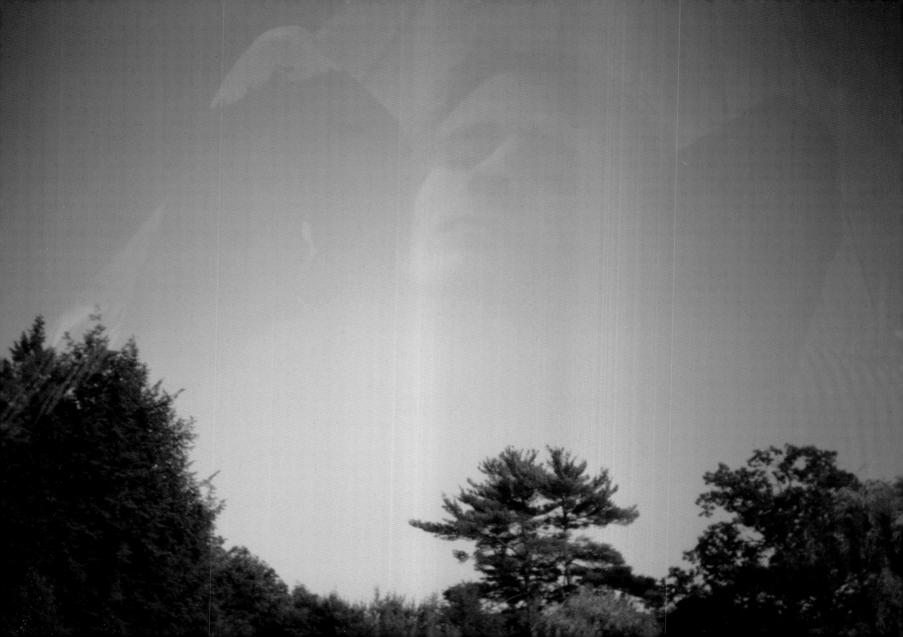

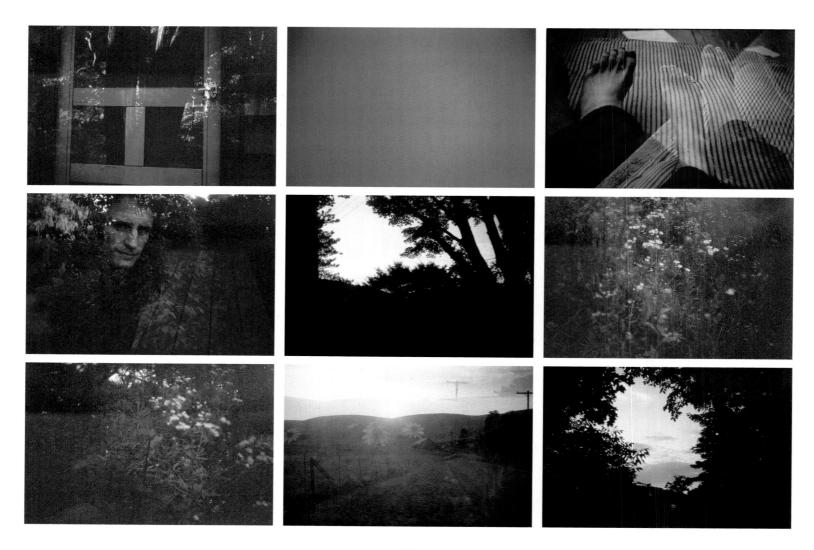

imposed on she can get performed on so easy by me & by them & lose identities in all in the morass of school teachers unmarried & not married & answer my questions I make the demand I demand it suck my cock, if any but most of all volunteer information: ten years ago I wrote this poem to the nirrengartens, the people downstairs, I said st. anthony is in his hole but will your green suck-off thumb yield it's sun suffered unripe ovaries up on hokus pokus day or has your symphony gotten still further out of hand with a still note an unspoken note without no asshole, well my stone is hard & white & half transparent it's a mountain & you can sometimes go without pajamas & grandfather farts all night so when you let him play with your kid do you think those heavy leftovers are lost on him & do you think he turns yellow from just fear is what I said $\&\ I$ say volunteer information, their possessive compulsive guilt about gp & his money & j says get what belongs to you & their total helplessness when it comes to seeing he's a person & gp sees us as half-people women without men & families at best he's amused he must be confused about our ages & the whole world we live in doesnt exist for him he's a monster without tails & we're little toads I hate him but defend his only states of consciousness which are few & the people downstairs see a good deal for them & the helplessness so I ask you how do you show faith in a good deal? That he will survive & recover that it's worth it & it's a better deal for them they think if he dies & it is & they have all these religious principles they're full of them & golf. & the next time it rains up here I'm putting all our clothes out to dry $\&\,I$ put my shoes out on the road 2 b run over indian shoes & a white car passes by I'm sitting underneath the tree at the entrance to the berkshire theater bob makes me sick I think I'll buy a bottle of brick amontillado scotch & two running girls pass by we are drinking scotch I am drinking scotch & what must j be thinking now & some remnant of high school in the word creativity I heard its sound, someone says creativity & someone says how do you see this & today's a bad day for anything that will last in the notebook I feel cut off need to see no one being a woman you can make a campaign of it I dont wanna be forced or forced to be only with other women for a while this is a junk image so volunteer information for the splayed, you look for the self that isnt full of shit & quiet other things bring out & how do they bring out bring out spring cold harbor & then a full out spread eagle metaphor a junk image a new wind rewinds it will it hit? Under the tree did? Metaphor meteor where? Porter a porter a good beer where were the men when we needed them, were we brought up without them, you set up your life so you can run it I cant get the money but sometimes do so why the rest of the shit & will this ending change it & there must be a way & someone comes along & says this is eddie's car but this is my car so you now have a place: when you need me, call me & when I get back I

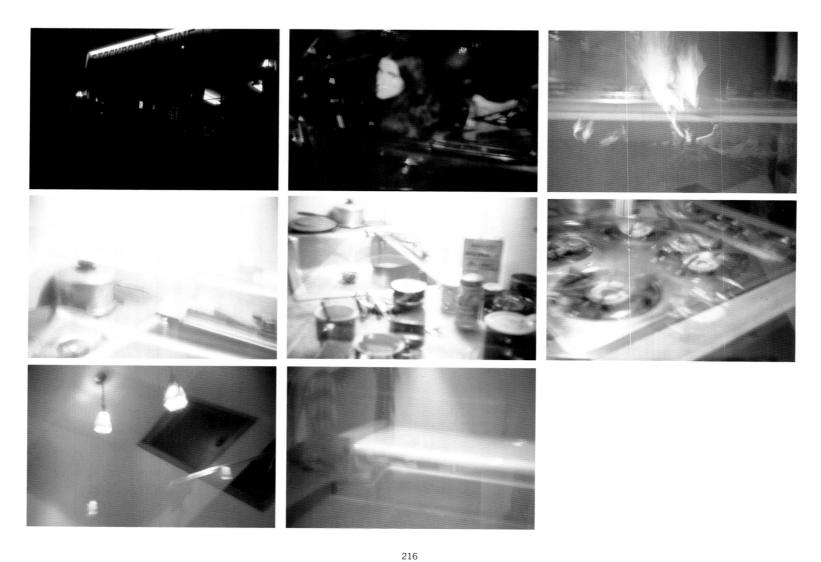

think I'll take a few days off & drink, hope nobody comes up: my eyes, fire, the room doubles: god, I found tom. He says what'd you say that was & this is the third part, you lay it over the first & second parts, it's extra & I say god that's a wrathful angry god & that's j&k's window & their tree & he says that's great you do that on purpose & I say these are all double exposures & it goes on: on purpose?/a whole roll/really?/yeah/& he says that's quite a day you had & I say quite a day/is that a double exposure/some of them are triple I think & that's my idea of a house/of a what?/of a house/jesus & I say beautiful what? & he says something very clean looking about all the/ yeah they really/what's that is that a grocery store?/yeah it's really strange isnt it?/is that the day that ah what's his name was up?/bill no somebody else had that same car who worked at the theater a guy from west virginia/& a house in the sky/ mmm/that's great/camera bernadette?/no . . . /that's great . . . / you were walking upside down? Is that you in the sky? & I say that's my notebook in the sky & he says ok & I say that's great & he says hey you look so sad & I laugh & he laughs & I say my body has taken over though & he says I know & I laugh & I say who do you see first? Ed. Ed's head & your body just because ed, ed's exposure is a little bit higher, well the first thing that catches your eye sort of is that very light area on the left hand side of ed's eye/that's two different areas of sky & I laugh, god/ what's that?/god a wrathful angry god & he says he doesnt look so wrathful he looks like ed looks really strange & I say great hair though imagine if you had hair like that/who god?/anybody & I say I dont remember this day at all or these pictures I cant remember & it's fire the fire crossing the stove & look at this & inside the prison grounds, convicts & that there will be no administrative reprisals for the riot & took command of four of the five cell blocks of the prison & wow, where? & was a model of security, attica, new york & saws, drills, WNBC-TV

July 21

South to argentina from massachusetts down to ny to downtown to uptown to back down to ridgewood to elmhurst back to e uptown & north to massachusetts one day: this is too hard: I think I feel bad but I never felt better like the day we drove from mass to new york & back the same day how did we do it: we thought we felt, the night they drove old dixie down & on, the house is dark it's strangely quiet maybe I dont know how to work anymore: when you awake you will remember everything: tyrone power in an instance of total recall, nightmare alley, he gets screwed but goes back with the carnival & finds his wife who'll take care of him the great stan had become a wino, when you awake, she bet on one horse to win I bet on another to show, ans: maybe that's how I survive? On hash? Cigarettes should be better than dawn mist on the meadow: it was a golf course the best meadow in the world we picked up kathleen early & took her car, left jours she wanted to leave at night but we picked morning about 7 o'clock & this was the day this was not the day ed got the ticket for making a wrong turn in nyc they look away they took away his license since for not coming to court & anyway the meadow mist is frozen at first & then rises but this first meadow is the meadow of the four thousand dollar an acre farm before we met k we stopped many times for

the mist different mists: eyes, two trees & at the corner where we make the turn onto cobb rd the cows were acting like suns two of them were acting like suns the others looked right but with the cows like suns we didnt miss the sun to our left it was in a tree: maybe the reason for the cows was this, reasons: it must've been about time & something about success & just after dawn k says to me you couldnt get that one you couldnt take a picture of it & I got it but better I made a tree longer & rested my thoughts heavily on a light morning mist to make it clear but not before I could push it: it's pleasure sun still in a tree: we're not bored mist is always in the distance but mirages behind trees are tales blacken out outline & makes less real within the music stopped I quit little thin branches are clearer than the air taillight in red brake I looked at the tree with the sun in it I looked across the road into the meadow golf course then further away from that tree but still facing it I turned around a different shadow lengthened out I made a different tree longer almost like two twins I was close to the car it was too cold to leave the door open this spot: should I have stayed there all day or was this moment the only one when rays direct at everything but me & so me, rays like stick marches but something must rest on them for it all to appear & we did, you depend on things above the ground your pleasure puts a pressure on them, you dont believe they're there, you do, you're air: you're in an open space in iran you just got off a plane centuries ago, there's no

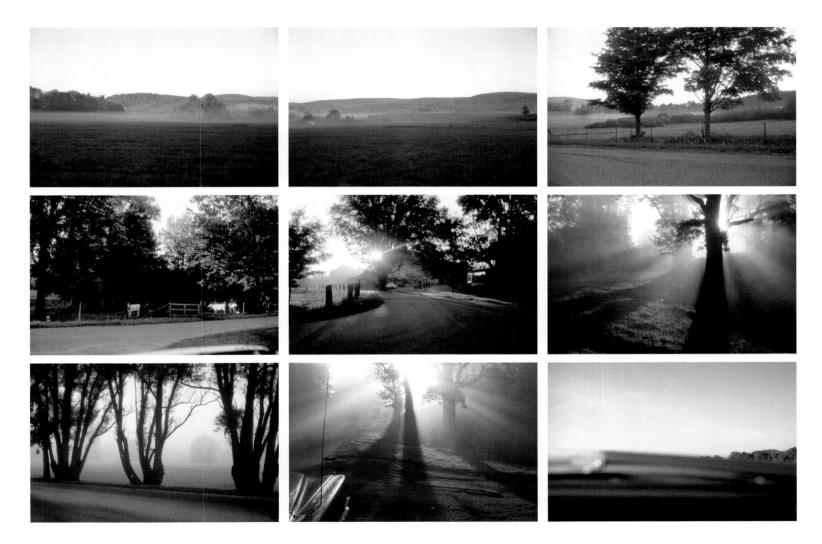

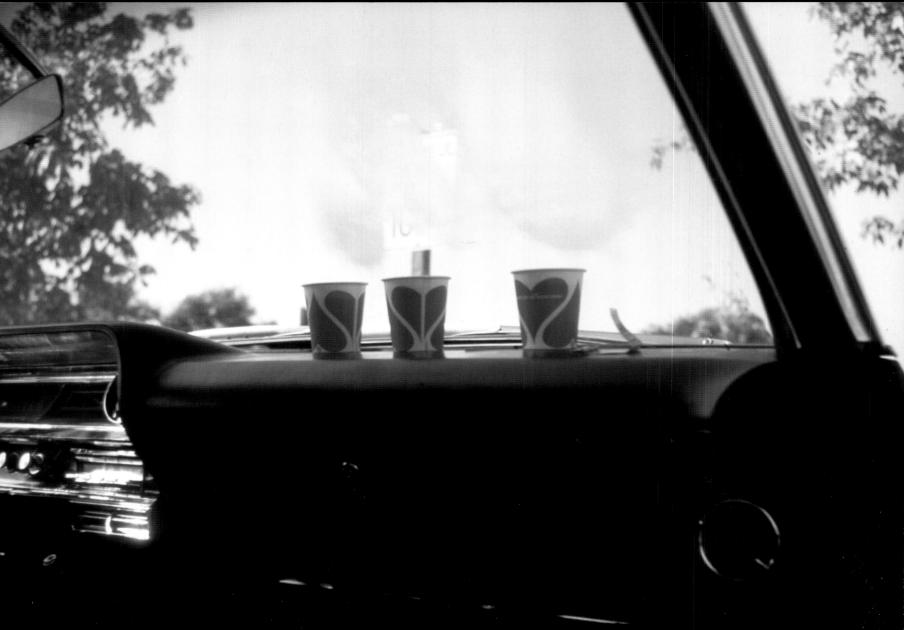

one there. A mirage is a challenge to anyone who looks at it & when you're in a hurry it's better to go on, the picture, it better go in, the picture the picture might get too hot & burn go up in flames before my eyes: you're in an open space in iran you just got off a plane centuries ago, there's no one there, you concentrate you remember: someone who stays on the plane will meet you tomorrow at the ruins. So you check the map it's a street map: fine grey lines on a white sheet: Unh, Sheh, Shuh, Shah, Smer, Smei, Bher, Steh, Unh . . . what are these open empty spaces like doorways in the whited out light low tan buildings white out in the sun you are calm you remember: centuries ago I would've been afraid I ran she ran he ran & he ran, it's periodicity: you concentrate & study the map the streets, even, the frequency of fear. "I am reading another language by instinct I locate the ruins in an open space to the north at Unh." A reversal of the action of the verb not moving, moving & a removal or release from the state expressed by the noun immobility, mobility: memory the double negative. Love anger. I walk north slowly I pass Aidh, to burn I burn Sheh & I write & Edh, to eat & I eat I pass Bher, to bear & I suffer & I nurse moving I pass Smei, to wonder & I wonder at myself in the mirror & I caress myself a mirage I pass Reudh, to be red & Steh, to cover & I protect myself I pass Smer, to remember, I locate the ruins by moving around their periphery with my eve on the map, open space. I'm walking north to find a hotel

to spend the night close to the ruins. I see no one I see clearly. I can see one street in the north & from its british-english multiplicity of syllables I can guess that this is the street I'll find a hotel on & people, a peripatetic street. I float I drift into a hotel & through every room & in the sleeping rooms people are sleeping I am invisible I walk over their beds, in the dining room I hover over tables, people are eating, I listen to the murmur of their periphrastic speech: so many even syllables they cannot see me. A reversal of the action of the verb a removal or release from the state expressed by the noun the name: tomorrow you will walk east from this street to the ruins at Unh to meet someone & this is your talisman, take it with you. (The secret action in time of a reversal in language in memory will renovate will navigate will clear this space for you, already clear, going backwards, iran the nurse the memory, in white with fine grey lines drawn marking off the borders of the streets to indicate the new space of the ruins, an opening.) A mirage is moving around around anyone who looks at it, you're in a hurry moving you better go on, the picture might get too hot it might burn go up in flames the film goes up in flames before your eyes before my eyes: the picture has been still with a bright bulb intense illumination behind it for many hours for many days a still picture & now it burns: you see the fire on the screen it burns & this is your talisman, take it with you into the moving car over the windshield of the huge car the eye can see

nothing I thought I just saw a light go out in my peripheral vision, finally. 3 cups of coffee steaming up the car 3 scraps of paper left over from the scarlet letter, we stopped at the chief taghkanic diner just before the entrance to the taconic we had told j&k to get gas the night before but they didnt there were people in their car & we had to yell over them bob & terence it was embarassing to yell get gas like talking to grandfather but how can you elaborate on what you're blunt toward, words of one syllable, meanings hard to hear & hard of hearing: get gas, Sssh, um, I eat, I'm full, there's a dog. We had sweetheart cups & a \$10 fine for littering, no we're already on the highway ed is waiting in the car I wonder at his image how tired is he & you have to walk so far to get the coffee always moving up & down toward the argentine pampas this time but not that early in the morning but maybe & here's the proof the first gas station on the taconic, we had made kathleen eggs at her house & the sun's up now as we go down but it's on the same side usually when we go up it's going down on the left on the right whatever it is: we get as far as ossining for a while I put my moccasins on the front windshield to dry the road widens would I have time to have a child? Hawthorne circle is a big mud puddle it's a river, thief, we move: that was the day of the argentine pampas because now at the circle we encounter a flag man in straw hat with orange vest on to see him I guess his flag is orange too & he is foreign in it in some way & I say to ed there's the pampas

all right & he agrees but is too tired to & thinks that man could have braids or a ponytail: everything is under construction, arrows orange men down the west side highway two views of twin towers & we're about to get off at 18th street I guess k's going to sleep & on the road down seventh what a mess. There exists a law office george a. mango attorney next to a shoe store closed for a whole month on vacation june 7th to sept 7th that's 3 months exist across the street from r's house but we were just passing by no ed dropped me off here no I dropped him off & took the car, yes this is the day we cleaned out ridgewood & I had the car: those strange tops of houses in ridgewood that reflect myself: the house I was looking out is me, it isnt there, here, it's invisible, it hovers: those strange tops of houses that look like soldiers grown out of ground they look crooked but are so straight & I hate them: across the street from our old house & out the window nothing except they've taken the broken glass off the top of the one-story garage next door, they used to put it up there all around the edge an edge of green glass so that people wouldnt go up I mean kids us kids wouldnt go up after balls they would go up there balls that would get lost, homers, hoping I guess in the meantime to keep us from playing ball against the garage I dont know I cant remember why it had no windows at all: the gate & down on it looks cheerful (where's the chief & where are the drums that play in the morning when everyone comes out for breakfast to share

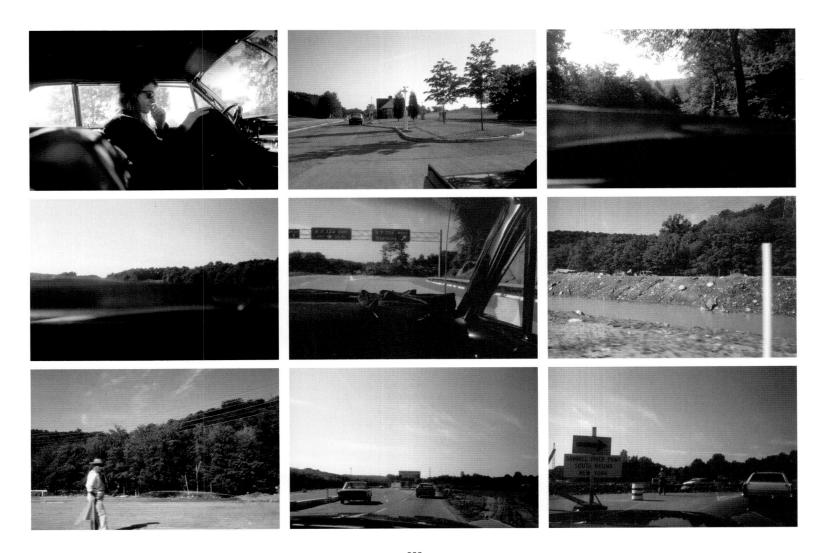

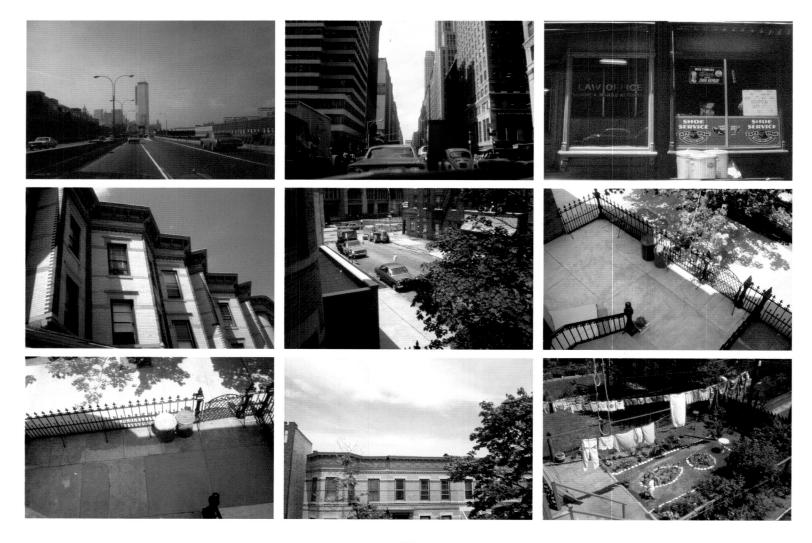

their dreams & strike at the one who met them, unfair, no the violence is all indoors) not the house next door old people used to live there neat pins now someone else there's still a tree & iron gate with lots of room to play in, your space, garbage cans inside hooks on the gates if you want to keep them open, your private space, paint the gates lead orange & black over that paint the gates lead orange every time the others do, red lead, can I come in? What a messed up day & I was singing real loud summer fall & so on to get away from thinking about what I was doing what it was that I was doing which was throwing everything away in the house: our gate less cheerful but friendly as if old & no not much I wish I had a whole band here to play & drums in the morning opening up, like, open up the spaces of the backyards for good & the houses across the street, mildred or muriel used to live there as a matter of fact she owned one of them & my uncle was interested in her & never seriously he was a bachelor in the single life of blessedness because he always said she was a woman of means & she worked as well & could support him & I guess he felt disarmed by the fancy cornices she owned well-owned the gargoyles like any kid there's some asshole kid in the backyard next door & a whole row of neatly hung wash identical pants of colors hang together, free the people one by one take down the pants, shirt, then one sheet then towels then larger shirts, the man of the house, piece now pick up the gun, this sucks flower patches

enclosed with little ellipses of white stones like quarters seen from the proper perspectives I'm a black man down on a whole line row of wash lines most of them empty cause it wasnt wash day & a tv aerial cannibal sky: I used to always wonder why we couldnt make one long park out of the whole thing behind people's houses so we could run in it instead of just being able to squat peer & make mudpies, find corners you never knew about & ride horses fast down the lane almost completely surrounded & all it would mean is taking the fences down & agreeing not to cultivate rosebushes & lawns those jerks. We found a snapping turtle in the backyard once. Fuck this. The yard on the other side: did he bite you? No. Just a big lawn with flowers &other stuff on the outside & one clump in the middle the same white-painted stones things glistening in the sun but who gives a shit I picked up ed at arnold's & paul got in the car impressed with me in my cadillac who had gone to the hospital too & we dropped paul off at a dirty movie I took his picture going in but you cant see him it's adultery, that's how they put it. We parked on some street in the east fifties & dropped off some film or picked it up the sky was clear I guess it was a beautiful day all day but fuck it & started uptown on our way back through the pampas to massachusetts in one day but first stop off at ed's parent's house well they werent letting anybody on the highway because a fire in the penn central yards had made part of it collapse fall down so we went on & on up different up streets

riverside drive upper broadway we stopped we had a coke we changed hot drivers the car didnt break down in the middle of it but a lot of other people's did & it was a real pollution fantasy haze were sick & dizzy & I took a picture I thought would look like the end of the world end to end but didnt there was nobody going the other way south just our way just everyone going our way north & a lot of people thought a lot of people were crazy & I looked in the rear view mirror & saw a downhill hill of cars just cars & manic sunset so I told ed take a picture of that behind you hurry so he did down the hill but the pink & purple insanity of it couldnt register on film it was the sun's fault & there's some old crushed cigarette packs on the dashboard & reflected in the windshield of the car reflecting some giant riverdale apartment building & a view down 231st street with the setting sun much brighter than I remembered it stopped for a light & then we had some dinner & stayed a long time in riverdale left way after dark for the trip up speeding repeating ourselves each of us could only drive about half hour at a time stopped at j's in the country then when & when then finally went home I guess I wrote this I read to you: tungsten wednesday 18 minutes to nine on our way to ny had to switch to am morning mist & shaft light comes through in the pictures at 50 mph we're going 55 we're going 60 careful due to cops who rob skiers of their dope & what if my notebook were confiscated with all the fingerprints on it the prints on it now it's 14 before

already it's that time it's mist cold freezing drive you forget to k's with the top down in the dawn calm cows nearer to city my god eggs at k's set alarm for f and j separately, ed in j's sunglasses again cool driving blue flowers by side of road bill macy is 48 the dead animals of the night before, bryant pond road that way state police that way we go neither way rolling rolling rolling thru the usa california? Texaco & you can trust your car to the man who was a star k says I looked pretty last night & I say I'll have to see later & my pretty red feet are on the dashboard with their separate shoes gas station blue towel tissues coffee double stamp day was there water there a body of it next to the picture of the highway taken just before hawthorne ny hawthorne circle & south to argentina from massachusetts down to ny to downtown to uptown to back down to ridgewood to elmhurst back to ed uptown north to massachusetts, one day: south to argentina from mass down to ny to downtown 2 uptown to back down to r-wood to e-hurst back to e uptown north to mass 1 day: hot car city strange stage remember slide projector lens tissue sunglasses spaced out light no registration for this car, again the notebook is confiscated I'm pulled up in front of he's pulled up double exposures by mistake a ticket confiscated as evidence evidence against me see more: port authority 100 feet above us gives them the authority to go round & round in circles in games buses round around, one is ektachrome one is kodachrome at \$20 a puerto rican guy sitting hands folded by

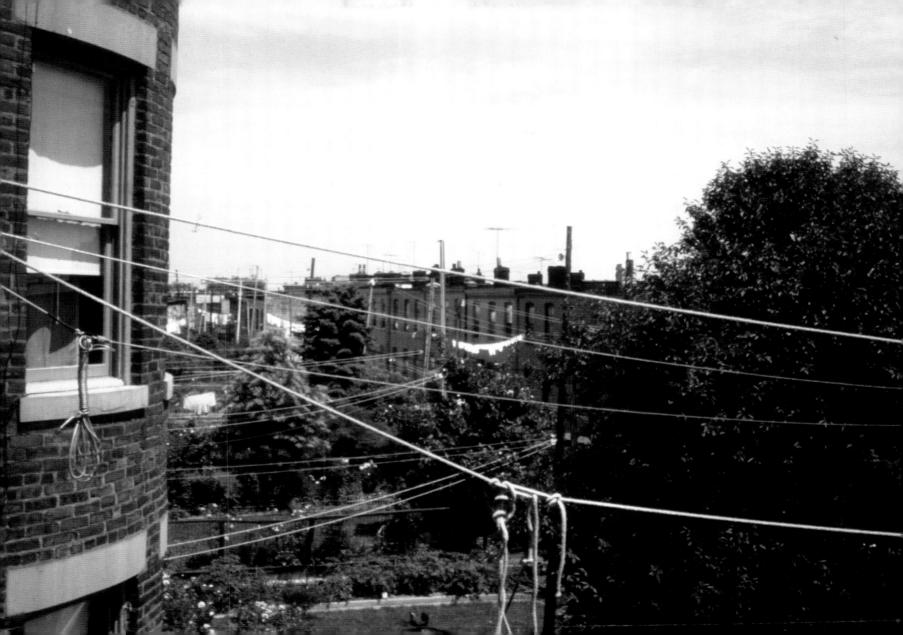

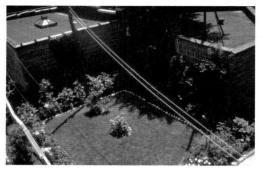

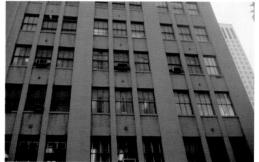

building dante's inferno books in the back of the car & gp temperature 101°, buses going round in circles 101 feet in the air see paul paul goes to the avon the avon on the hudson theater to see some kind of trip this car & that guy's jeep adultery sultry saw it twice the number on the house ridgewood to e-hurst another week in the hospital mrs. sampson k&l for the test roll & paul says we both look fine & we're wiped out & every time you get sick you look fine five dollars worth of gas in the car we set up the nurse's room in the house k chews styrofoam a piece on the floor of the driver's seat she's here nyc today we're back country today paul will cut the negative people who know me what a relief not like queens full of limping men. So you run to not be afraid of when your heart beats fast: laudanum paradise hashish azure jasmine scarlet lemon & lime: bakshish bashaw bazaar bulbul caravansary carboy dervish divan durbar firman giaour houri lascar mogul mohur nargileh nylghau parsee pasha pashaw bashaw pen roc sash sepoy serai shah shawl sirdar: orange from french from italian from turkish from persian, burns brightly brightly burns, shah shah

July 22

To burn to be sharp to drive to nourish to choke to breathe, last week in 1850, to bind to increase to bend to cover to vault over to shine to seize to take hold of, last week in 1850, to cut to hide to shut to lean, last week in 1850, to hold to run to turn round to cultivate to cook to give to show to tame to lead to eat to live to exist to put to place to speak, last week in 1850, to bear to trust to knead to mould to support to burn to support to protect to break to enjoy to bend to pour to produce to join to sleep, last week in 1850, to collect to wash to leave to shine to remain to remember to wonder at to think to measure to grind to melt to project to rub to bite to die to beget to destroy to know to get to know to apportion to see to smell to fasten to feed to spread out to fare to fly to fill to ask to seize to purify to stink to rule, last week in 1850, to be red to tear to seize to cut to sit to follow to exist to sound to stand to strew, to touch to cover to stretch to bore to cut out to endure to be dry to thrust to swell to beat to be wet to go to carry to give to go to come to become to clothe to carry to see to wake to live to wind to turn to roll to speak to cry out, last week in 1850 the first thing I see is a tree I saw when I was parked at the radio station on the road between barrington & stockbridge still looking for old black magic & then ed had gone somewhere or maybe he was

with me I went up route 7 to stockbridge to arrive in time to pick up grace coming on the bus I am speaking to monument mountain what was that it was the result of a director's viewfinder in two dimensions instead of three: images of the field of view of the microscope will annoy the observer for hours after an unusually long sitting at the instrument. A thread tied around the finger, an unusual constriction in the clothing, will feel as if they're still there long after they've been removed. I had been to zayre's that morning bought stolen sunglasses pick up grace see lenny who is looking for another grace & bought pens went home & ate an omelette g lying in the hammock, m was there by then ed took his shirt off: we had coffee & canadian oat bread also ed & the light behind him had I bought the good coffee one of those days in the city yet, an unusually long sitting at the instrument: ed gets in the car to go somewhere in jack donohue's baseball camp shirt his hair was wet he made a face drove off in stages we stayed home the trees grow on the stairway now: I went outside to watch ed leave I went back inside sat on the stairs no lay on the floor I went back outside & stood on the cut down tree into logs I went back in again & upstairs I went out on the upstairs balcony perhaps to show grace, looked inside the door to the room was part way open the light was on the sun was beginning to set. Like eating a lobster you dip it in butter eat one part of the meal at a time one meal a day as three meals a river of butter I showed grace the

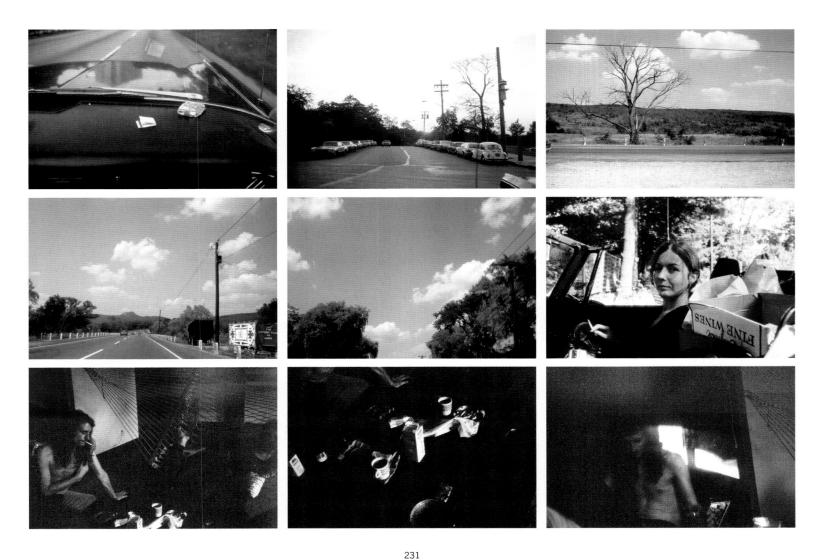

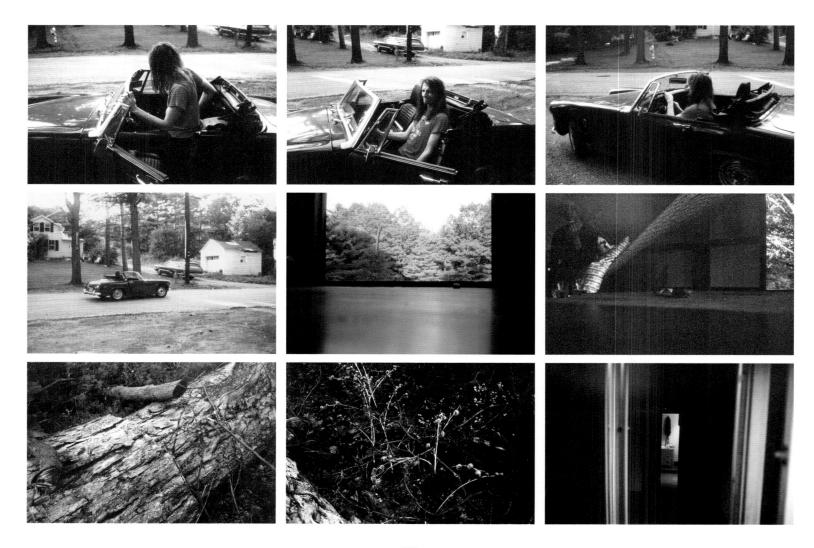

automatically revolving tv antenna the lights reflecting to infinity on both sides of the room in eight diamond windows & more did m come home: I went down in the basement to work maybe put the stuff there: the basement ceiling the light there spiderwebs & the spiders who run them grace went up on the balcony picked a place for herself, we had bats in the house all this month I guess grace took a bath her back was were her toenails painted: no the water was yellow the light was yellow the light on the water the water yellow we fixed spaghetti the smoke of grace's cigarette went up into the exhaust on the stove she had a green blouse on, maureen o'hara we watched tv someone says I always feel like maureen o'hara when I wear green we watch some mystery about a vase a piece of porcelain janet leigh her hands clasped resting demure on the table in evening dress I suppose she's watching jack webb play the trumpet & further on in space some interesting shots of morning & through the trees in a movie favoring the french royalists underground you were supposed to be on their side with tony curtis or tyrone power & tony curtis dies & jacques dies too in favor of someone weaker dying it's easier to dream someone who could go on forever dies to die in place of a very old man & that house now seems boring grace's bed in place she had brought her new tape recorder with her & played for me some haitian I think dances cause to begin with it's thursday & the men are out at the moviola pictures from the evening before expose themselves in the morning you forced yourself to sleep I forced myself to sleep & forget dreams whatever they were like jacques dies, I made gp he's night & fog a map in my sleep for ed I sleep in the yellow room with st. george sleeping in the other & someone says you do have to come & I say I quit to be with to be alone to take trips trips like pieces of information what you see is what you get the bastian blessing co. chicago illinois nejaime's soda foundation fountain all dry soda fountains patent pending parmesan cheddar ed's eggs canned milk bread & corn: recovering today from being under long something somewhere where part of the west side highway fell down, perry mason is on tv powder is on the floor, incredible cars on all the uptown streets fires in the penn central railroad yards july 22 today thursday only eight more days it's nine & I've moved to the cellar in squeaking rocking stuffed chair & yesterday after we made it uptown stopped to see ed's summer parents, code, they'll come up the 13th grace is going to new mexico the 10th we'd like to go to california in september can visit halifax in september or october & we did & I fainted e's father big e suggests arcadia national park in nova scotia for camping tom seems still to be living there dont know we see big e's new car in the garage across the street he sees our 1964 cadillac drive north insane I'm in the cellar when I'm not driving I'm thinking: some memories qualify where the present endures not for a minute or an hour or a day but for weeks & months & years: gp & the other old men looking like movies of a concentration camp & gp what can we do for him & the old picture of my grandmother today, catalogue them: I know this state of mind now after it has already dropped once from consciousness, this chair chased some spiders away north dark top down talked a lot about the brights to stay awake got to j's him in some other world our struggle to get up there I went outside cause to caught my fingers in the front door then in the car door cried transferred everything from one car to the other crying had dropped cigarettes in my lap on the way up went upstairs to the yellow room to sleep & slept in the morning forced sleep & on & one & grace came on the 4:05 bus in front of nejaime's hot sun orange soda mailers to kodak & zayre's for a frying pan & sunglasses stopped at berkshire broadcasting no black magic. Tom's going to some kind of wedding this weekend & paul & b will be here no beds & e one two three four & e's out the door at the shaggy dog recording sound studio & leaving on the next plane 7am for ny again & the house is here grace is in the loft a red brace of a sister & she's making tea she fixes tea & all the stuff from r-wood is down in the cellar & itches & burnt bitten & switch over to #2 & j liked the films but he died no he didnt die & h is encouraged not to come to the play & someone says does she want her money back for nudity vile language & omelettes creamed corn & brown bread & one two three four tomorrow's friday the queen is here the ice is here & everything's fixed & ready & I quit quit & the soldiers quit & times have changed & the actors quit & the movie camera's quit & silence is quit & grace is watching me & the sailors quit & the engine quit & the milk quit & I'm imitating myself & money quit & myself quit & color has quit & music quit & the end quit & the door it quit & for a third of a second I look at exposure charts for color film & then shroud myself in complete darkness shroud the eyes & it was as if I saw the scene in a strange light through a dark screen & I can read off details in it which were unnoticed while my eyes were open: this is the primary positive afterimage: according to helmholtz one third of a second is the most favorable length of exposure to the light for producing it, what, a book two potatoes parmesan cheddar eggs canned milk bread & corn & tea a map of july from the 22nd to the 31st credit card #122-2222-030 a mr. charles #212-2655279 kershemheimer's #6349578 ballou's #1-4584248 the nurses' #1778859 & 5626255; we moved into the barn on july 8 & on 22 start living there cause I quit after two weeks nobody notices but I quit, need tire for car: jack webb & anaïs nin in a movie about firestone he says no thanks & in the bath I'm reading letters from 1416 york avenue to florida massachusetts ed's in these & advertising & leftovers of st. saviors especially to florida cynicism & everying's all right seems summer a dull day I'm too amazed from & by the time ed got to lenox I seemed more real yesterday to see day today as form a

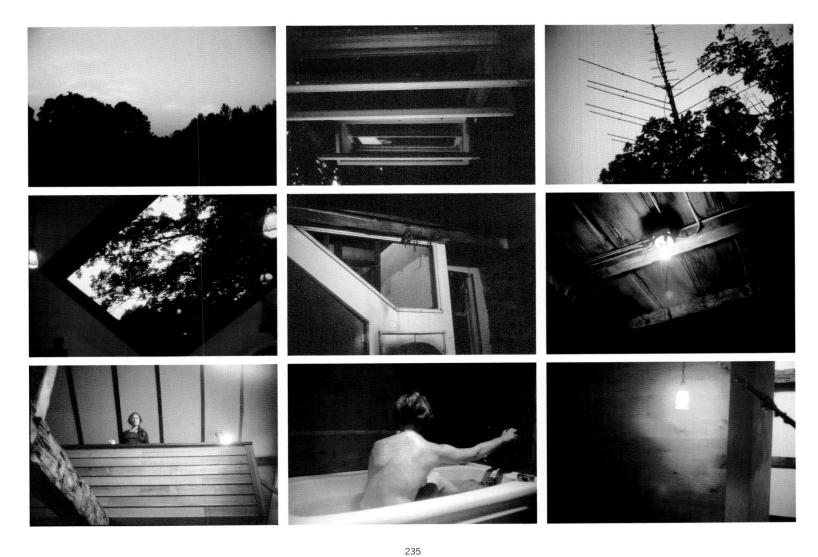

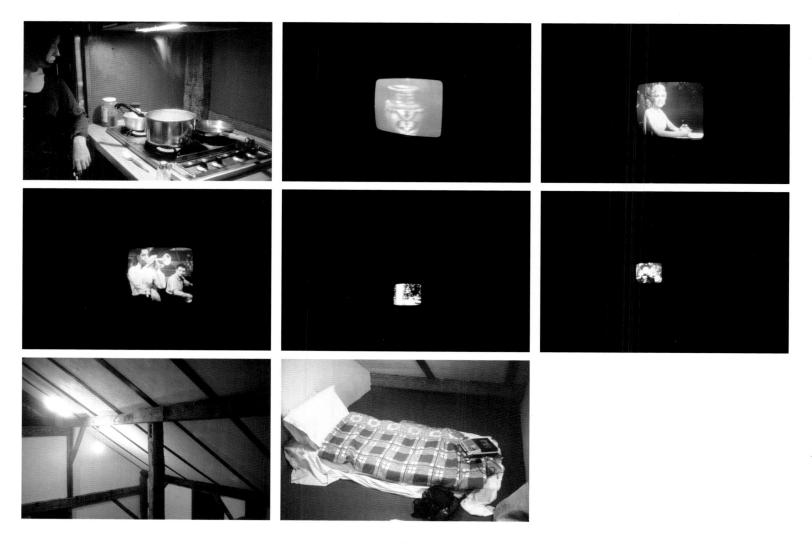

triangle I couldnt take pictures & pete kelly says act sober & sing & someone says she's gonna sing & you're gonna listen in pete kelly's blues where the big bottom swerve of the j of her name forms an interlocking circle round leigh & the two circles of the j contain a shared space so that if one were A & the other B would the shared space be labelled would it be called AB, B the lightest letter & tony curtis comes up again in the purple mask where they want your sympathy for the heroic french royalists, cut off their heads, their heads were cut off & there is no black magic so who wants to be my brother, later, so you can increase the speed of this film to any of a variety of film speeds & to process the film to these speeds write kodak in rochester for pamphlet #1-E-2: photographing the unusual with high speed films & she's gonna sing & you're gonna listen: there is no black magic & somebody says that anybody saying we lack guts doesnt know what he's talking about, no way it's true & who says we dont have guts or some guys have given up & arent hustling cause I'd like to know cause there is no black magic in the bright bright sun in the hazy sun cause there is no black magic in the cloudy bright air (no shadows) cause there is no black magic in the heavy overcast cause there is no black magic in the open shade cause there is no black magic in a large area of sky cause there is no black magic in brilliant scenes cause there is no black magic in the skyline ten minutes after sunset cause there is no black magic in interiors with bright fluorescent light cause there is no black magic in spotlighted acts (carbon arc) cause there is no black magic in downtown street scenes at night cause there is no black magic in brightly lighted night clubs in theaters at night in las vegas or times square in store window displays at night cause there is no black magic in neon & lighted signs at night cause there is no black magic in floodlighted buildings in fountains in monuments cause there is no black magic in christmas lighting in trees indoor & outdoor cause there is no black magic in fairs in amusement parks at night cause there is no black magic in night football in baseball in racetracks cause there is no black magic in the shade or from airplanes cause there is no black magic in home interiors at night in areas with bright light in areas with average light in candlelighted close-ups cause there is no black magic in a distant view of city skyline at night cause there is no black magic in fireworks in displays on the ground in night football in basketball in hockey in bowling in boxing in wrestling cause there is no black magic in stage shows with average lighting with bright lighting in circuses in floodlighted acts in ice shows the same cause there is no black magic in school on stages in auditoriums cause there is no black magic in an indoor swimming pool with tungsten lights above the water cause there is no black magic in churches tungsten lights, so who wants to be my brother, later, & do all those things to me

July 23

And do all those things to me that begin in the etymological dictionary with the indo-germanic roots so you might as well remember you might as well do it you would remember every day of your life, it must have endured for a certain length of time, if you had something to remind you of it, take pictures for a week, say, then put them away dont even show them around for a year & see what you remember & a week's diary too: call kathleen & ed at noon stay at paul's cause h might not be home, it's friday, villa lobos gas record teletype machine: this is the specious present in my memory presents my memory as it might be styled as the knowledge of an event or fact or state of mind which in the meantime I have not been thinking of but with the additional consciousness that I've sure thought of it before I've experienced it before, all of it: 5:15am woke up thought it was late woke everybody up & then down told them to go back to sleep thought it was 6:15am coffee, sunrise from the meadow a heavy wet mist all over not it's haze a white grey day greens out a green-out as usual here except in yellow sunglasses where suddenly it's bright rays & clouds in rays, some color, golden sun through haze & the airport by one minute to seven the plane the haze white sun: no memory is involved in the mere fact of recurrence there's a delay: & that's a funny picture to be first was I up at dawn: yes to get ed to the airport I woke up an hour too early & went out to the field there's a delay to watch dawn come up, cant see much from our house up at five struggle to get everybody out of the house on time a beaut. dawn comp. w. mist on the field something in total darkness the airport I think we got there we get there at 1 minute to 7. This is not just a date in the past this is dated in my past that begins in the etymological dictionary & this is myself at dawn we're still home I have a jacket on & a red & white striped t-shirt the shirt a ten-year-old boy gave me, not one of the magician's children, boys give me shirts I make them do it: I look full the mist rises I should overexpose them more but ed makes it do we remember the way to the airport except I miss the turn at first & should've taken rte 183 & almost ran out of gas getting there & someone says put some gas in the gas can & call kathy & since I got this gas can for the night dirt road the guy at the station says you gonna run a tractor & ed has a bag & his script & his ticket executive airlines cutive lines #201E so grace yells & ed turns around there's still a heavy fog no smoking the man wheels the luggage cart away the propellers begin to spin it's a de havilland twin otter he taxies away you cant see a thing in he was crazy yelling & screaming still early morning there was nobody round the audubon society grounds, & taft farms some melons some plants from san francisco california a cat by a crate of those melons I was on the right track: the glass of the

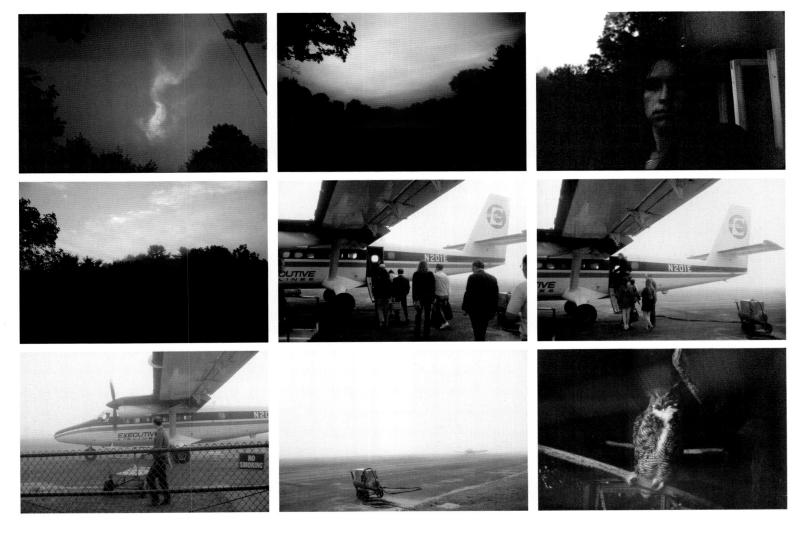

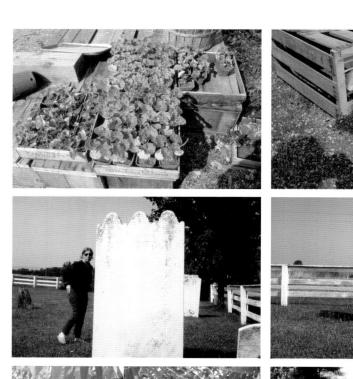

windshield on one of the views & g in my sweater my shades in the cemetery half a poem. The valley close up & far away means something to me but not if you saw it in a newspaper, you know why cause the sky's a pale purple & the green's got blue in it & you people who wanna see green, take a picture & come clean, I was on the right track over the glass of the windshield, then grace makes half a poem. "Do your christ pose," she leaves her hands open. Old cemetery we looked for a place to swim I showed grace the insane gazebo with wooden horse & carriage pecan blossoms on the pecan trees sticky get caught in a trap get caught in spider web on the door of the barn sticky we pick one a red pecan fluorescent a fucking truck: erving motor trans from erving mass #34 why did we stop for it to look at it the door's open there's purple more purple in the sky of this film is kodachrome it loves red & blue there's purple in the sky in the pond or alford brook that looked too muddy to swim in I tell grace all the indo-germanic roots of the dictionary's story at an overgrown picnic table we float & all float with barrels white flowers I think they were blue so grace reminds me of someone & it aint her fault I cut her short white flowers were blue the projector lamp dims with the refrigerator in gear & down that stream lily ponds picture the alford brook club in the serenity of the afternoon & the alford afternoon brook looking like georgia & listen why're they clapping cause he finally sang that song well listen: she's gonna sing & you're gonna listen &

georgia all perfect reflections we located relations the abandoned silver birch camp but on our way or on our way back stopped at a gravel pit a one-man operation he needed two women he must've seen no one all day just sand chain-gangstyle with only tire tracks & mounds of kinds of gravel a machine that poured it out with water, many scoops & mud puddles terraced areas a moving scoop stirs up dust, if any: grace is underexposed in her green shirt more dust he gives us the peace sign we follow a hay truck home we pass it by the time we get to home the truck caught up with us it passes us by by the house a man driving a tractor pulling two loads of hay his son mounted on the side headband over long long hair falls down the tv's on but nothing's on it the tv equipment's on, you know video, we made a tape of the exercise of a hay truck is like a tv, just tilt it. The beginning of a word, br & 7 hours go by what was I going to write & I guess brought, what I brought was brought by me & the context for that was this that a while ago: "& told me to write this poem: to take a round of /to take a ride of /you take a round of/you take a ride of /and I brought (what I brought was brought by me)/shortly will for will/but, fast moons/he can gather them from the air." Who told me it was design & then I began to leave which I'll explain later, like my brother, I had just quit I was on vacation on a dark still night a thousand tiny gnats at the window & was that a bee trying to get in trying to write & felt awful 4 3 days in the midst of grace cooking dinner potatoes on coals & m is reading he is finishing a separate reality & I think this, that we all know so much is understood that we're here in the time that it is & we talked about subway attacks on women & mafioso & an italian cab driver tells me if you take drugs took drugs in the thirties if your best friend turned you on well from then on you were taboo, condemned ignored maybe even contracted for, you were excluded rejected repudiated exiled secluded locked out ostracized prohibited separated segregated eliminated expelled, you were barred left out shut out blackballed laid aside put aside set apart segregated stricken off struck out neglected, you were banished. & m is still reading we speak in front of him he is removed. For me there's the airport the owl the red lion inn nejaime's abdallah's for mushrooms & 2 kinds of cheese & roads look 4 a place 2 swim: explore papers, maps, here see m he leaves 4 rehearsal yoga tape tired jacques the phone drink & I drink familia cookies here pick up bidu sayão the studio nejaime's 4 vanilla milk shake cheeseburger home roads the silver birch camp the gravel pit here sleep sweat the berkshire eagle the tornado in west stockbridge flattens the truck stop on the state line bear sightings before that the dump the theater dump john perreault in the berkshire eagle did I dream cold sweat turned light on & m comes home so there's peas wine & downstairs there's talk peas wine 49THST hookers omelettes corn potatoes in the oven wooden train guineas muscatel m singing in the shower e

back tom. That's short 4 tomorrow this kind of writing makes it impossible to think straight g washed her hair anne marie diurio benedict pond beartown state forest windsor state forest october mountain accidents in the eagle have to get up do something I re-record the teletype machine we listen to the supermarket g says there's no musak in supermarkets, time is spent in massachusetts. Pussy comes in it's after midnight where are the bats & where, are, the bats & m like john corry so does he need more privacy & this is prison & like jeremy's brother jonathan, flowers in the folger's coffee can, somebody's murdered women's liberation regular grind mountain grown gnats like silver fish weird cats yoga tape great great six of the actors are scorpios including m k & b, that's bobby so listen bobby: the wooden train a 1903 train still runs where I grew up cause the steel train's too heavy for the el except at rush hour

July 24

Time is running out, so, you know everything, the whole of it. Which is why I deny autobiography or that the life of a man matters more or less & someone says we are all one man & later I'll say I count the failure of these jews as proof of their election & later I'll say they are divine because they all die screaming like the first universal jew the gentiles will tell you had some special deal & later I'll tell who wants to be my brother, my brother's black & I'm leaving & that'll go on for a while & last night I fell asleep to a howard duff movie, he is a money-hungry reporter while m is singing downstairs on another lazy day duff wanted cash I sleep with the light on chandelier on & grace comes in this morning so we were both bored & both forcing sleep & when I remember my dreams I seem to say to myself I have dreamt this same dream for a week & there's no use in remembering it cause it's always the same it repeats itself it's how to, maybe, make a play, but I am not dreaming the same dream all this time or am I I dont know, I know this one thing: my picture was "guileless" & that is my dream, old friends. M was born in el paso, texas, muffled talking out in the field & banging & walking downstairs m drives off on his unlicensed vehicle motorcycle I light my cigarette but with one of the matches that strikes, burns black & then suddenly & by this time you've put it down, it bursts into flame, I will illustrate this for you I will draw you a picture a film. I've already brushed my teeth & put cold water on my face brush hair yoga looks for the kids, it's 11:12 in the morning & birds sing shirr carr weekend car m scared j will do the newscaster blue pillow yellow one white one with green border pink comforter gold & red spread white sheet & golden sunglasses brush pliers postcards from bermuda strike anywheres I'm smoking a cigarette The Traitor's Purse Account Unsettled still have read no books alarm The Year of the Whale tv & tv equipment I'm leaving I'm off I'm going away, red & black chair the blue pen top the heat grate ashtray film can antenna box a door slams, screwdrivers & needle-nose pliers a matchbook top narcotics paraphernalia, moccasins two coffee cups the camera newspapers: thomas, duane, bottle of gold coast california wine a check envelope roach another white pillow with a great desire to read, two blue work shirts hanging a black sash & a chandelier, last night m tells us this story: he leaves home el paso, texas, comes back after being in europe, travels all over, his mother's italian he tells her I'm coming back so have a good meal ready, she does. He realizes he hates her food now, asparagus pasta it's all fixed fried & greasy, but his father's arabic & that food says m syrian food is still good: but I say the food of the mother is better than the food of the fatter father. Now that is all of that story. There's another motorcycle

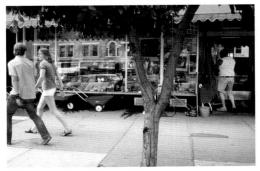

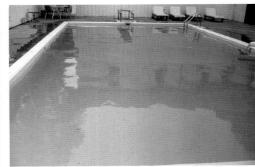

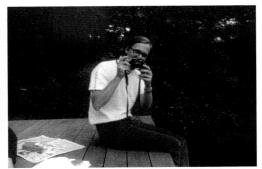

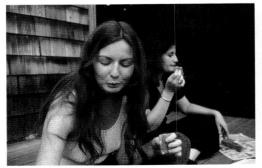

sounding at the furmans, this privacy their privacy Weekend Weekend out on the balcony, shots, see what it's like out it's hot it's been hot for a week for two weeks I'm leaving feel my consciousness changed changing from the play from my life disrupted or changing anyway and so yesterday I'm unable to talk cannot speak & today there are images hidden in my shirt making phrases like the ones I write down, no one understands them, phrases like "the whole of it" that's all I can say & at the end of the tape grace & I looked like two strawberries trees rustling in the background noses, breasts, martians we make a weird science fiction movie where people shot at angles are still & are still for a long enough time to alter your perspective & consciousness and so you begin to believe they are in the proper perspective as not-people, the movie can be all talk: suddenly remembered dreaming flying saying "you get me started then I can hover" in front of a group of people maybe i & also the book is out it's flying around loose its energy is loose I'm going away then thunder & lightning a dream cant be too corny I'm in the shower downstairs then flowers leaves fears of bees & an orange & black butterfly I have no closeup lens, these flies, m's orange nail brush another hazy day another cup of coffee & another cup of tea another trip to great barrington to barrington the car has reeds stuck beneath it so leave your rugs out upside down on the morning dew or snow then dry them & bring them in thought there is no dew or snow in the city though &

a bee here spins a web around me a clattering leaf on the road a car with 2 ladies, he cant find the flowers the weeds, today I am falling apart in my shoes white pants I have hardly anything on where is end where is everyone & the motorcycle starts up again it's a japanese snowmobile & someone has nothing to do: there's cold milk there's a fat blonde woman who worked here two years ago, rexall's in great barrington I eat a million cheeseburgers I eat seven thinking about the woman who serves up the food in the drugstore in town thinking what do they do when they get up in the morning could there be a regimen? I drink cold milk it says peach ice cream & someone says i was so tired i thought i was going to lay down & i'm leaving i'm departing i'm taking my departure i'm going i'm going away i'm going off i'm getting away i'm going my way i'm getting along i'm going on i'm shoving off i'm trotting along i'm staggering along i'm moseying along i'm buzzing off i'm moving off i'm marching away i'm pulling out i'm leaving home i'm going from home i'm exiting i'm breaking away i'm o i'm setting forth i'm retiring i'm going down to the sea i'm removing i'm ceasing to be i'm disappearing i'm vanishing from sight i'm doing the vanishing act i'm flying i'm going i'll be gone i'm passing away i'm passing out of sight i'm passing out of the picture she's passing out of the picture i'm going beyond the tree i'm retiring from sight i'm becoming lost to sight i'm drowning i'm losing sight of myself i'm perishing i'm dying i'm

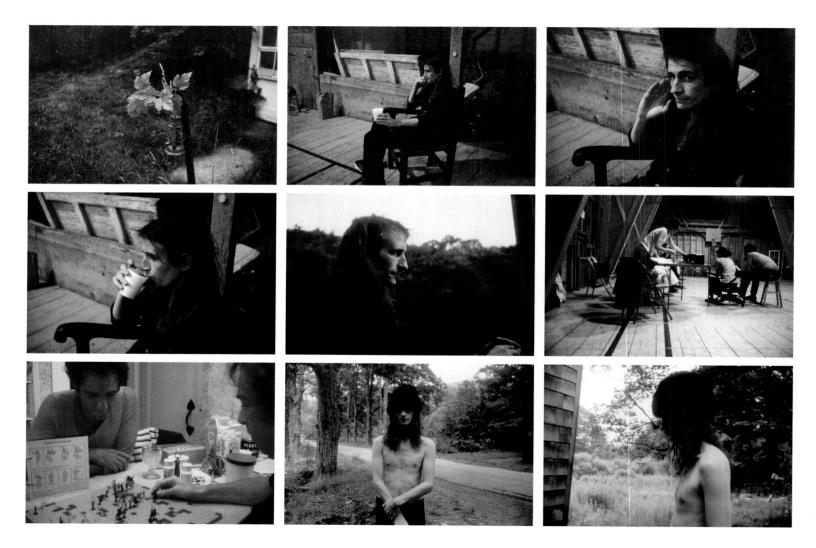

dying out i'm fading i'm doing a fadeout i'm sinking away i'm dissolving i'm melting i'm melting away i'm evaporating i'm evanescing i'm vanishing into thin air i'm going up in smoke i'm dispersing i'm dissipating i'm floating i'm ceasing to be i'm leaving no trace i'm leaving many branches behind i'm leaving not a branch behind & someone says i was so tired i thought i was going to lay down & die & leaving m & j & e & i begin to play feudal & i get worse & worse headache & it goes to k comes home pleased at everything like p, who's p? & bob is in rehearsal's oratory with j calm rain beings again it's the storm that destroyed syracuse the tornado that flattened the truck stop at state line new york massachusetts, sleep says this: going to feeling forget worst, like, the pay-backables. The whole of it you knew everything. I put the colored leaves on the apple tree in the backyard of the shower more daisies & weeds clap & someone says you're not supposed to have anything to eat or drink & I finally found out what eli siegel was advertising all those years in the village voice, there's red on the bottom green on top & another hay truck or some piece of farm equipment on its way it's the same guy, that dead stump of a tree was making the roof of the garage collapse just by being next to it on such a dark day a day where a thin black band crosses the sky it's the same storm, it's easier to be a woman than a dwarf but a woman's life is dull & so I went to rexall's for a cheeseburger. Give. Her memory's a double negative. They had nebbishes up

near the ceiling that same guy who wrote the play the scene from the car department barrington always looks like california & it's san diego to be exact to me. No defense. The cards light up continental chocolates angle parking a fan for sale two fans where is mallarmé: roses hoarse to live & all the vain in interim print with calyx blank to prompt breath in rime to give, but that the stroke in battle saves profound, the stuff of it, shock in awe, frigid in melting, cold in thaw, in laugh in flower in waves & casting the sky by piecing detail here so alike in fantail you are better than a phial: nothing closed in emery scent to lose or defile, something come from emery, eventail. Some long furry red tail hangs down from some other department of the store, everything changes. I bought a bright orange scarf 49¢ & something changes darkened up for the outside light & now it looks like massachusetts again, clear autumn, a giraffe: the monterey police picnic-dance saturday july 31 1971 a buffet & music by ambrosia vacation values & nebbishes are now called according to the sign in the window sillisculpts, the cards light up stuffed animals cross the street at the hardware store lawn mowers to remind me of two years ago an ad for summer of '42 at the mahaiwe & something changes a boy & a girl walk by leading with different feet she has a watch on he has a leather bracelet with different feet sneakers sandals & shorts, a tree an awning glass is worth it is complicated an awning that was above the glass & a woman going into the hardware store

stands next to a pail and a red wheelbarrow, brand new, they cheer & she looks black on top, her face & arms, but her legs are pure white & from the waist down she looks like a man but it's clear she has breasts though her back's to me what the fuck's the moon. There's a change in the whole of it, everybody's beauty. What the fuck were we doing at the red lion inn swimming pool. Paul & barbara arrive there's a piece of toast on a book there's a change: were they there when we got back & they bring ed with them paul had helped ed cut the negative now everyone's eating hermits not toast, barbara in dark blue, they went to norway they're in norway now & grace purses her lips & leans down she's wearing kathy dillon's shirt & getting out of the car I pulled up next to paul's car barbara's car excited they were back, ed, I broke the side view mirror copper color shows through where the glass fell off I cracked it with my hip I ran right into it & is this the same day: we go to rehearsals leave everyone at the house & that's right they were pissed off later. Ed sat in a chair & I looked at the sky, some green plastic leaves above a red lantern sink I went back inside ed was drinking coffee still in the chair: his hand holding up his chin one finger in his mouth at his mouth the other holding a cup of coffee he looked over at me I think he was bored just then he drank more coffee he drinks more coffee the light of the room on ed yellows his face golden & his hands together on his lap a brown shirt on behind the sky & trees everyone else is stirring

around having a discussion, kate is standing up leaning over & later m e&j play feudal, k had invited m over for some grass I think & j went to terence's house for a while to work so when he got back they started playing & I went to sleep, m was traveling with us his m-cycle broken down no gas no I played for a while too two teams of us on the blue board the wasps vs. the jews & arabs & my head aches for days: when we got home a mattress for us was on the floor p&b slept on springs & early in the morning then ed in the black fur hat that showed up on the doorstep like animals appear except & ed took his shirt off paul looking amazing in a black t-shirt leica in one hand shines a flashlight with the other into my eyes & m is out on deck studying his script in a snakeskin shirt & sandals & he turns around, a hood, someone is reading a book in the hammock I miss them it's grace reading carlos castaneda the book makes a shadow on her face prolonging memory & it was one of those days the country provokes many people no one gets together no one speaks alone no one gets to speak no privacy: paul & barbara keep saying they are leaving finally they do right after I watch them leaning & sitting against barbara's car: paul sits on the car, his watch on. Barbara leans back against his lap. He puts his hands on her chest she smiles puts her hands over his, they stay in that position. Barbara leans back further her head against paul's chest, she reaches her arms up to paul's shoulders still balancing against his lap he puts his hands under her

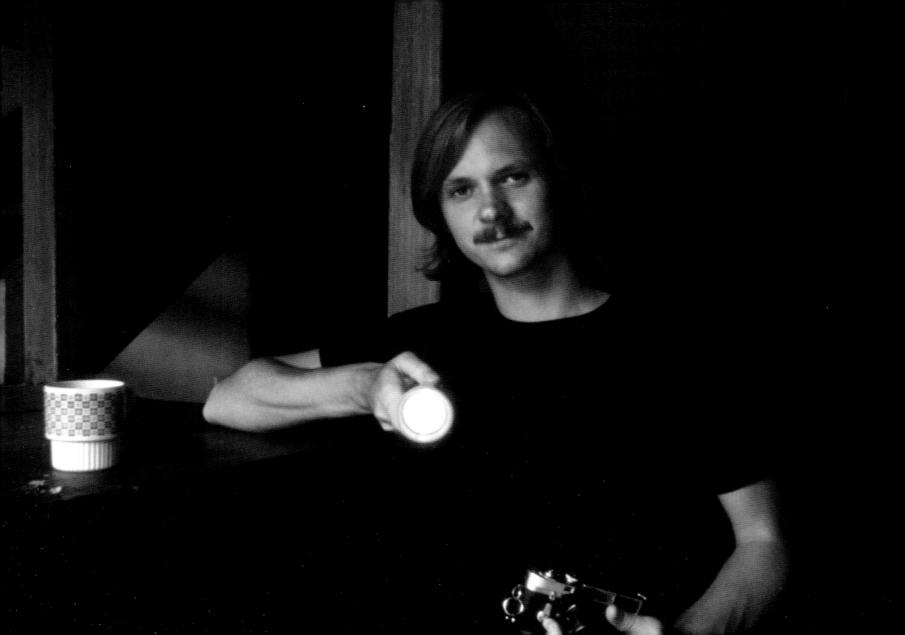

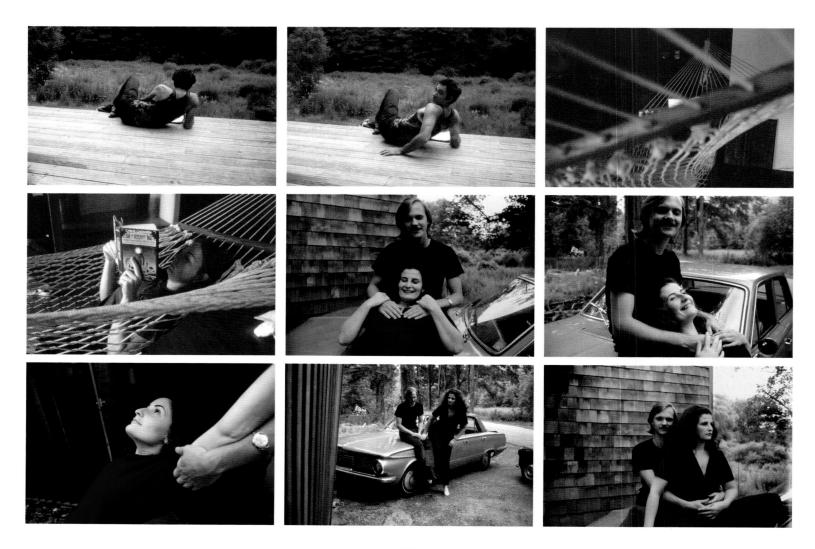

shortsleeved shirt through the arm holes she looks up. Barbara gets up starts to sit on the car she rests one hand on paul's knee she has one foot on the ground she sits on the car one knee bent with the foot up on the car one leg just hanging paul puts his arms around her waist her back against his chest she holds his two hands clasped at her waist with one of hers. Paul looks at me barbara looks away. So you know everything, everybody's beauty, the whole of it & something changes: gp, a screen, dies & sleep says this: I would never set this up again. Paul looks at me barbara looks away

I would never do this again, said in the house as a kind of warning. & as I write all this stuff down I know it comes out of nowhere goes nowhere & remains, nothing leaves. It's almost a truth. I set myself up. July 25th though it's already begun begins again with ed without a shirt sitting in the car & flowers arranged in a large folger's coffee can on a yellow pillow outside that's decadence in daylight in decay that's an idea that follows itself meaning nothing meaning nothing leaves & paul and barbara must've left by now taking grace with them but tight-assed they wouldnt drop her in manhattan she had to take the train. Also, there are things you study, usually accepted as sciences, which specifically deal with man & not with the external world which is contrasted with him, like psychology & anthropology for example; how are they consistent with the view that science is characteristically non-human? Ed's working I think he was I begin to think about reflections: car window the chrome both sides two car doors windows you can see through we're working on the car everything's open I open my orange which is almost red scarf & tuck it under one of the windshield wipers I put potatoes a tomato two ferns & a coke on the car gasoline the air hole taped closed but the can leaks anyway massachusetts san francisco sky over anyway I went

down the road coke in the grass 8 oz the beginning of a puddle a series around it telephone poles a series no sun I looked in the puddle telephone pole no sun, ed went upstairs I followed him he took his clothes off we put the bed back together I took my clothes off we took a bath we went to the theater to the barn: they cut these trees down for eating into the barn building there's one long low branch leaning I went to the lenox arts center to see ira & john's performance with balloons, beverly was there taking pictures so I asked her for an exposure she gave me a good one ira & john blew up balloons they mounted up caught the light, I went back to their room there was a terrible yellow lamp on the table & we had a few swallows out of a bottle of something & went to the red lion inn I took ira in my car john made remarks about fucking then mostly about emily dickinson & joan didion & got very drunk. Back at kathleen's I was waiting to meet ed there while he & j were working she was practicing her cello & this may have been the night that paul the cellist came by & e&j were very late at the sound studio I got very stoned k holds out her bow the cello case stands up by itself, made for corners I forget the rest & later dawning ed gets into the car with his script & a station wagon dawns on us, no, but it's clean cars parked & car windows on them in stockbridge clean town while a guy goes into the berkshire bank & trust co. the one that was robbed & he looks down the street & ed walks out of the bank onto the astroturf

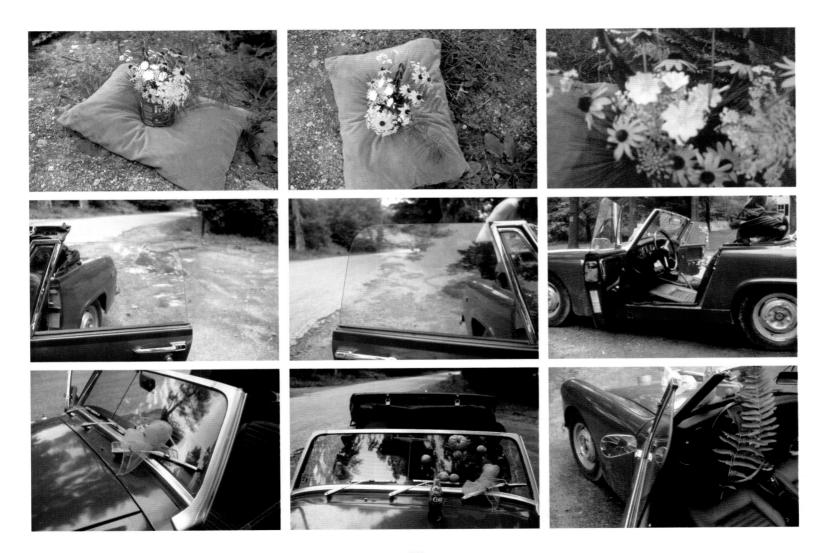

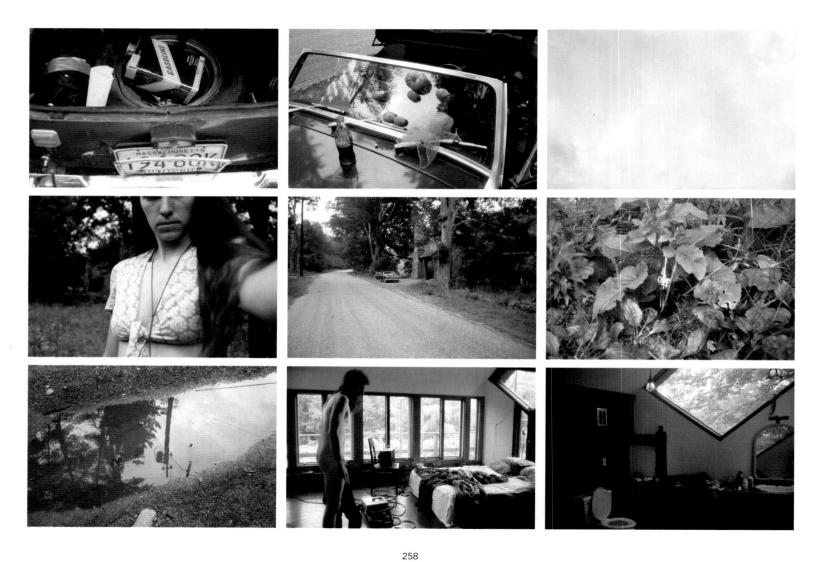

you spit on flounced by white roman pillars & the sky falls then over an airstream jet trailer that day this day from ohio or somewhere white somewhere else white as ed pushed me into it & a guy in a hat unloading he's about to unload a schaefer beer truck it looks blue all around the boston globe is there apollo 15 is ready to go for 12-day moon trip the herald the traveller the telegraph something is happening in brooklyn a man dreams at night & works during the day he swears susquehanna at liberty bell sorority cursed the victor frank robinson's on the cover of sporting news it must be monday now balloons or balls in a box come together in front of abdallah's but that was yesterday when: with the help of harry newton, huey mother face newton, baby face newton, we part: he gets in the cave with the others, breasts are the solution. Blue(y) newton that was dream this was: last night this book gets rained on, rain heavy rain all night through to day bright day I look at pictures of july 2 shots of construction projects now sitting in bathtub after spending the morning with no attention, just car & sound, sound & car, ready 4 6 o'clock at the shaggy dog sound studios with 16 separate tracks on 2-inch tape while paul barbara & grace reluctantly leave b&p to rockville center, grace to get home from there by the long island railroad m studying & reading all day in leopard like undershirt, snakelike I mean scorpio. No time to read feel raped of country information. Tom m & grace have read a separate reality before me now grace takes it back to the city. Gp no better as e heard from r maybe worse. E brings me a can of magnolia condensed milk from the city, no, he left it at r's, today, last night I cried at the distance between us — work, hate. Berkshire week, where to eat. We cant be this busy for no reason at all & last night saw milt & cliff & warren, jeff outlaw & tigger at fred lord's barn, w in bright red vest, cliff & milt looking sparkling & clean, did we? Go to the farmer, say tobacco, do you have any tobacco, we're out of cigarettes, have eaten too many cheeseburgers, put milt back in the book, some place to be, this place is one place that place another place, where I was, where do your spirits rise higher, where do mine, where do my dogs cats his hers their lovers lower, many towels in the bathroom many, two, wide windows behind them trees you can become part of me do what I do, I wish my robe were red, yours is, follow it, follow she she follows free follows later today I make it, over the rough dirt road into, where, ever, I want it to be, into it, with wine, you arent there, you are a curse, like the weather sending coal through my veins, hot coal, I sink into you, listen, it's through you, something started once on some trip, & something fell, fell, & one night, forgot, & in the meantime with another person some things began to happen &before the end of it, no defined as a reversal of the action going on, as a removal or release from the state that exists, & before the end of it, it was morning when something new defined something edgy & all this has to do with yesterday too, young

& old & older, sometimes through that we are set back, very set back, & stony, like rocks & stone, & stones run through our veins like the weather, the storm comes here that destroyed syracuse & at 6 o'clock we will have moved these stones in a pile, heap, coals, moans, driving, south, then north of here & when one part of your body seems hanging hanging loosely from the rest do you judge, do not judge for yourself but do not accept from someone else their remarks as a judgment, someone knows. White walls, pink dresser, pink orange & grey towels like the weather which sends, some, sun, rise, to our meeting, 6 o'clock, we'll be there but e's gone to europe & m has no car or motorcycle & jeff & t live in washington & j has a listed number & r has a can of condensed milk meant for me & a sports car passes by & waves, not, still, in the bathtub & a hand, e's, rests on my knee for a while, & I have no pictures of fucking & g, p&b are in b's car somewhere & b told me it drives p crazy not to have any money, hurts his pride she said & I couldnt believe that but wondered why p hangs around with such fucked up friends & v must have come back from toronto by now & k loves the cello she says, residue, & k & g never met yet & neither did p meet k&t we havent seen or talked to & the pink paint, roughly there, extends onto the unpainted part of the two drawers & j talked about beckett & molloy & likes them too & actors are very strange & money grows on trees & ed's reading big phil's kid & m's reading something like

another roadside tomorrow or attraction by somebody named robbins & anaïs nin's about the house & h is probably in woodstock fuck her she wouldnt let k live in our house & so on, residue, also, the rest of the story goes: we go into town in about half an hour we take m to his bike go to see chris & john baker get cigarettes: speed makes ed depressed the next day which was yesterday & there's a sleeping man interfering with my pen & then we'll eat go to j's to pick him up for sound sessions & I'll try to call r & then we'll go to the s.d. sound studio 4 at least 4 or 5 hours they'll do the sound mixing & so on I'll take pictures & notes & note nothing wrong with being an observer is there as I am that was the end of that page, these precious little words, written small, are not meant to come on too strong but just to lull you like the whirr of a car or an airplane interior or like the sound of birds clinking glasses together at tea, glasses of tea, to lull you then into now being for a while into being me, can you feel it, becoming part of the rest of the story goes: I hear them talking, I speak to them, it sounds like russian, a sleeping man's heavy head on my shoulder my muscle aching, not from holding the head or the book but from writing writing pictures of, the head the heavy head shifts, of paul & barbara, murray, then a new roll, movement more movement there, pictures of ed's back, the car, the vegetables & the car, the coke the bottle, the rooms upstairs — all instruments of wrath or of fucking — autoerotic scenes, & later the

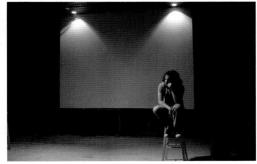

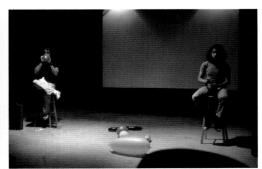

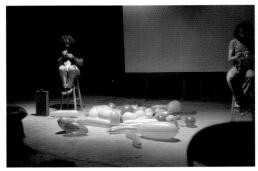

sound studio where you alone can blast yourself into another, space, now, a sleeping man's rubbing my cunt with his little finger, I have no pictures, please go on, I am not anxious to leave this off again & stop hurt & everything goes by, it's one or the other wasnt it, & then, & the mirror smashed later where my hip bone hit it squarely as I ran & a man in the village restaurant says I've been reading about you in the papers & I've just left ed off blue car took 4.4 gallons of gas a dollar eighty, I have the director's viewfinder on my stomach. The studio wasnt ready so e&j went for ice cream, afterwards, the balloons of john & ira where beverly took pictures & I review pantaloons panel noons the cellist tom the devils blow christ beverly & anne poetry of the lenox arts center lives next to jacques the red lion, sherry, a red mink coat it's 10 to 2 there's 10 to go the boys not home I'm wasting time I go through lines: pantaloons panel noons pantaloons panel noons john ira howard anne & hemingway or hem g. stein e. dickinson john eat your salad someone says & someone says he's nostalgic & someone says you drink too much like books by women by joan didion & someone says time & again is a good book & someone says & that's the difference between me & ira & ira says I havent been away from john in so long while we drive in my car & john says did you fuck so I review I go through lines: virgil cane is my name & I served on the denver train & how about over is how I got over, m's not home he stays in town no motorcycle & k says she'll read this review: christophe lee michael paul & someone says you can sleep here & someone answers you can sleep here & all the people were singing, look at slides there's darkness, the director's viewfinder finds ed exhausted in pictures, the night they drove, cellos belong they were made for corners, I went back to the house for the slide projector & drove here through the fog I had some wine with me & since that time I always drive with wine, you put a beer between your legs, there's a truck there's a tractor at the big farm driving down the road with bright red lights & I'm scared so paul gets lost winds up on mohawk trail road, whatever that is, we dont know the names of the roads we travel, dirt roads, with names, paul lives in dalton & we will probably never know, die: I go through k's fantasies driving by ge, it's a concentration camp, nowhere, nowhere, private, the private charge of general electric's barbed wire, the private parts of their government contracts, the titles they give their weaponry, the naval surge site the site for beneficent missile launching the barbed wire fence enclosing the heap of iron filings that went up in flame engulfing the assistant prime minister as he fell into a pot of boiling pitch, it has something to do with iron, making molten weapons for the employment of ethnic groups that hang around, they have good beer in the neighborhood, they're launching sections of apollo xox & my father used to work for the company that made the cameras for the moon & oh they warned me

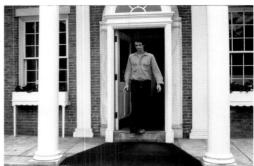

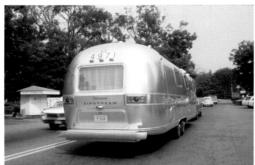

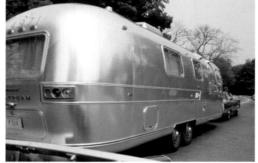

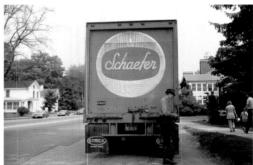

& she's in the bathtub again reading lines & someone remembers composing a line for a play when we were little & the line was gosh I'd die & I'm tired of lines so when will the play be over or when will the play be spoken in real time: we have to move out, do the laundry, tom hasnt moved out yet & it's hard to talk to have to talk to & someone says barraged & I am, we ate grinders & drank beer, saw a man we knew sitting at the red snakeskin alligator table cover again, singing for the actors feeding them lines for the actors the scorpios & someone says john hates actors & john's teaching at fordham where the priests signal actors to get dressed & there's 10 to go a race a laugh a nap simple safe something cripple dormitory dreams dormitory room a picture of a cello on the ship we're on & beverly was pushing it to 1600 & she says how sweet of him to remember & john got drunk with her & someone said he loved her & someone said if I ever did see one, talked to r could barely hear her they wouldnt let her into the hospital today I'm tired of telling about the play the end of the day I'm almost tired of telling this is not the end of the play a book to get inside of me & a scene was, changed &, my side hurts, fear

Already started. It's monday I bought amontillado pumpkin pie small salts & sweetheart dish detergent a mrs. anna myers strawberry preserves a canadian oat bread that had wheat flour water sugar shortening nonfat dry milk wheat germ yeast salt bran soy flour malt yeast nutrient emulsifier in it & ten giant mohawk busybugs & tonic water club soda a carton of pall malls & make notes for plastic bags, when does the play close the laundry check the slides salt & salt yoghurts cherry vanilla strawberry apricot half gallon crystal milk perri italian brand sausage two dozen eggs & wild horses, these were bought at the supermarket, seized 8 oz pure maple syrup & make a design for the rig & took note of a design for the rig drawn up on july 8th & more notes: big caps bloom. Something about shopping bags a splicing block white leader more wild horses go to lafayette, airplane, earphone, fifties movie magazines, pictures of james dean, marlboro poster, plastic eggs, the natural foods cookbook, radio changing stations, the new york city list, old black magic again, pick up letters, flash powder, capital, paramount, theatrical supply, slide projector, bring t's check for niece right now, the man that was used up by, poe, the narrative begins: already started the fear to finish: I know we've been to the theater & maybe I'm doing the wash now or something in

stockbridge or just hanging around like a power fixture, mice like bread I cant seem to get off on these days I wish I had some delicate sauces to eat, freshpak all purpose grind coffee what if I had to finish? For the irate women in the audience, someone says, we intended tonight to deal with male homosexuality, perhaps we'll get around to the other some other time & the mouse is taking over the house, this is the view from the laundromat, yes I was doing the laundry & was I also addressing books or writing to holly or both & now I'm smoking butts & waiting for the coffee to settle: please no more than 1/3 cup of soap & fill only to the line with clothes & then what, it was the giant machine no one was using it chrome on display it was broken that's why, a woman's legs laundromat legs in pale blue slippers from down the street a ways they had a change machine it looks like the moon in the window of the big machine all systems go & some station's signing off, the backs of the leaves were being blown up, I left ed off at the theater did the laundry & walked back without it, left it in the dryer, we picked it up later, the backs of the leaves which means it's gonna rain & when's it gonna rain & something about this scene looked funny to me — 2 cars & a pickup like a pickup or crime a great crime a small crime done by great criminals the two cars one a panel truck back to back a blue & white panel truck & a '64 ford & one big black thing & they're playing the national anthem for all the criminals so I was enjoying myself now, orange

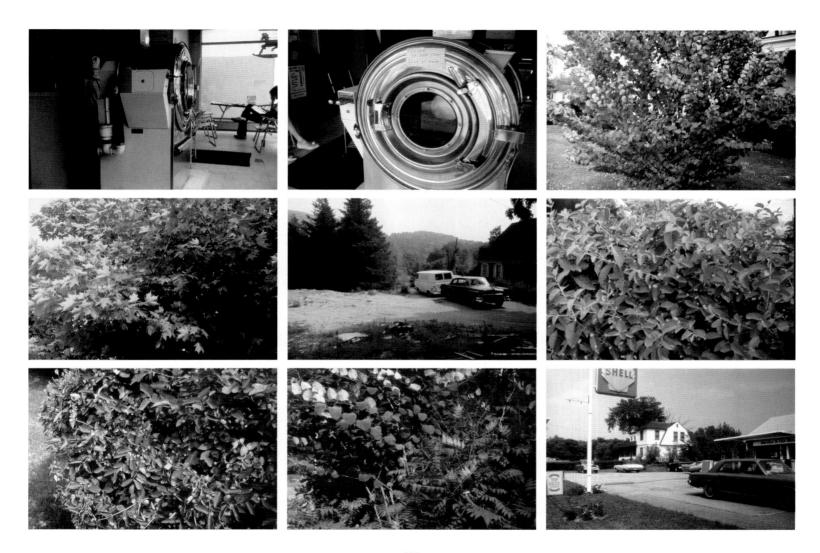

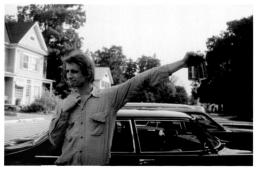

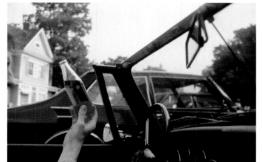

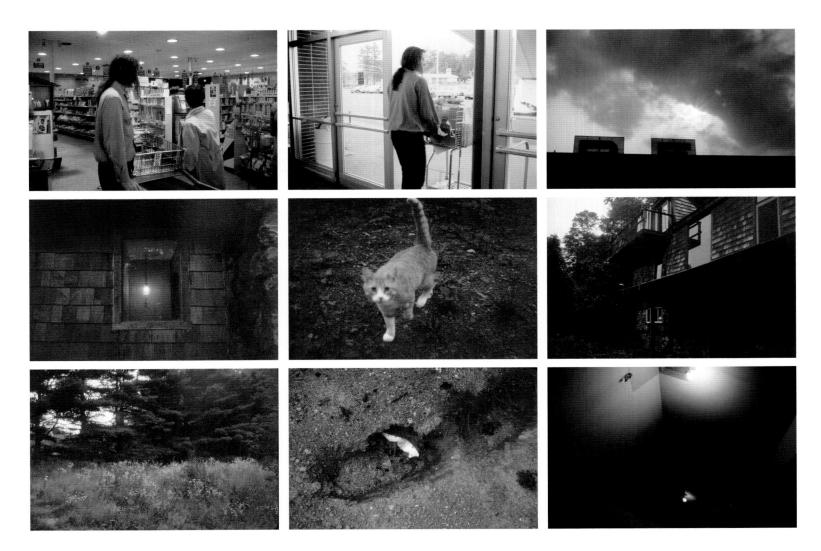

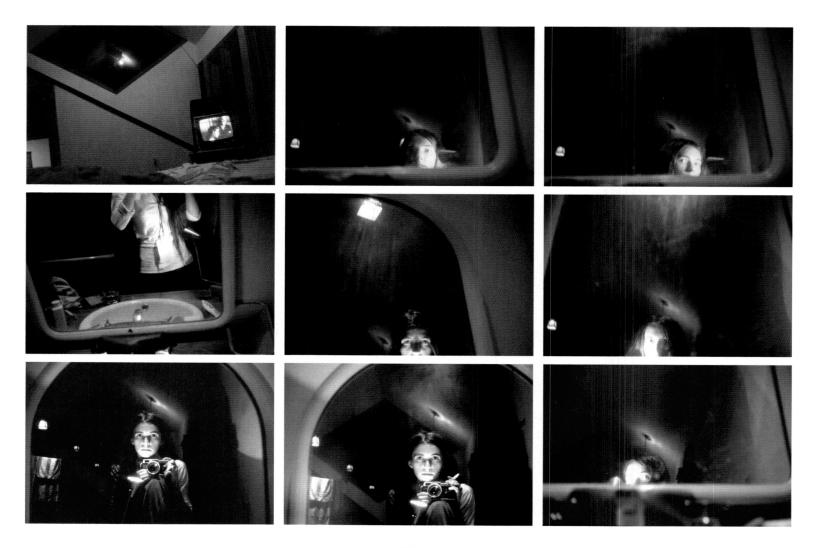

berries the same one light then dark over the land of the free & home of brave, I beat the melody of the rockets in air & steal syrup, more leaf backs, looks black & the shell station with little flowers all over decorating so they laughed at me out of shame I guess the studs in there who cant change a tire & another shiny station wagon parked on the lawn, some ad, fuck the car chris gets a phone call he looks like a woman from behind, ed's not back. I walked down to the theater saw steven sitting on a rock his head on his knees he didnt see me or look up they had the sprinklers on they're nuts, ed shows up we had a talk on the stairs with nick & gar, nick in a red & blue or black striped t-shirt, russian, smoked, ed smoked blue with a blue script so we pick up the laundry, ed gets two sodas without labels on, one red one green we go to the supermarket to record more sound & buy more food, it was adams & we give each other rides on the cart it's practically empty we stop at the lunch counter for a snack at least they dont have fluorescent lights & ed wheels the groceries out to the flying car: we'd just cashed a check another sky over zayre's, close down. We went home. I went out, saw the yellow light through the window & igor's pussy, a new day's not there but here's a new day in the middle of the day, I take out the margins & go on going crazy it's monday at one end & the drilling's started again at the other so for dinner we had white wine with prosciutto & melon pizza rustica bread & pastries it was good but the noise from

the men outside drives us nuts & I left off on the white pussy who was orange & we saw glen & randa, met donna on the street little moths mosquitoes & fruit flies & I'm only adding to the noise of our ears are not our own amnesia stores, I feel delicate, as, sick & the pussy looking right at the camera he kills chipmunks with his bare hands & he'd kill for that pussy & I killed a little moth flying around my desk I'm alone, went out back of the house in the field the field backwards white flowers & little light the giant footprint or hole with a white piece of paper in it, message from them, next to it a broken cinder block I often thought of using it for something & it's dark we went upstairs: the unfinished wiring in the ceiling & a weird hole or trap as though they built the house without doors & had to have a way to slip out while they were working, a bare bulb, looks like cary grant & somebody else on the tv myself in the mirror yellow orange: fear already started as a finish to memory, what's rote: having pumpkin pie & sassafras tea & it's still monday the 26th of the month there's still plenty of pink light out so it must be about 8pm & scary sitting here alone, I took some of the sassafras out of the tea while the bird who only sings half the song he did last year sings half the song but when I try to remember what half is I cant: it's four clear notes in a high pitched range followed by four clear notes sounding low, but that's the whole song. I took a picture of everything I saw today on the way to the theater, making space dramas &

courtroom scenes: there's golden light inside it will take pictures of my thought I thought I heard someone knocking & I hope this isnt going to be fear, sure the knocking was a dog barking in the distance, it's myself tonight & looks like rain again hot for days, all men shirts off & pictures are becoming either too difficult or really easy to remember take this it's the first time I ever sat down in this house & read, I am not reading: the rehearsal of blue. There's some commitment to memory, it's already started a finish to fear. A's letter she says I sound like a real writer, missed j & i's movies tonight & a car passes by, singing, where would I run from here, so obsessed with objects like always up here, looked at different kinds of paper today & leaves, something's still missing & later minus parch dinghy nipple cupid like cord I write while m & susan or someone are fucking outside, or yesterday, dryly altar excise tackle cards & m says grace is determined, naked autumn, a flight of mallards gets me up so early, three shots in a glass, coffee strong coffee piano music & he says I love this it's like watching a girl undress, star star a star & now I'm so removed compared to p or e or g & it goes on I'm so removed that I say it's like watching a boy undress, star star a star: springfield center to be purple: springfield's battle of the bricks ended abruptly last week when mayor frank freedman told the officials concerned to stop squabbling: a springfield redevelopment authority official had threatened monday to bring legal action against civic center

officials if they proceeded to use purple-colored bricks on the \$10 million center, after the urban renewal agency had approved bricks of a red color: freedman met with both parties & told them, "I'm sick & tired of hearing about bricks & having two agencies squabbling over an immaterial thing such as the color of a brick. If it were a ghoulish color, then this issue would be different." The two agencies then agreed to use the delivered purple bricks. The sky is always a spectacle anne is on the islands. We ride the carts to adams ed puts a ham in the cart. We have to pay the rent ed gets chocolates. Someone says you attach a lot of importance to your independence dont you I say I attack a lot of importance to my independence yes but only by mistake. So stars: simone signoret is a traveling tutor & racing car driver, at the rehearsal of blue we saw the business of bill, the water pitcher was stage front before & there's too much stuff on the table, rita moreno embraces everyone, I'm pasting things up & an old mother is thinking she's like the tutor of the starlight movie from hartford, triangle triangle a triangle a surprise: home, red custard & e races off I'm here alone, who's paul sage? M&s I'm taken while cooking mushrooms potatoes & carrots, eating bread & tomatoes, aback I want my alone dinners, trees, to be alone, so is my life over now, they go dancing in the corner, why dont I want people to know that I eat? I dont want people to know that I eat, I am made of sand I am made of pebbles, if I eat I can be eaten or eaten out of house & home,

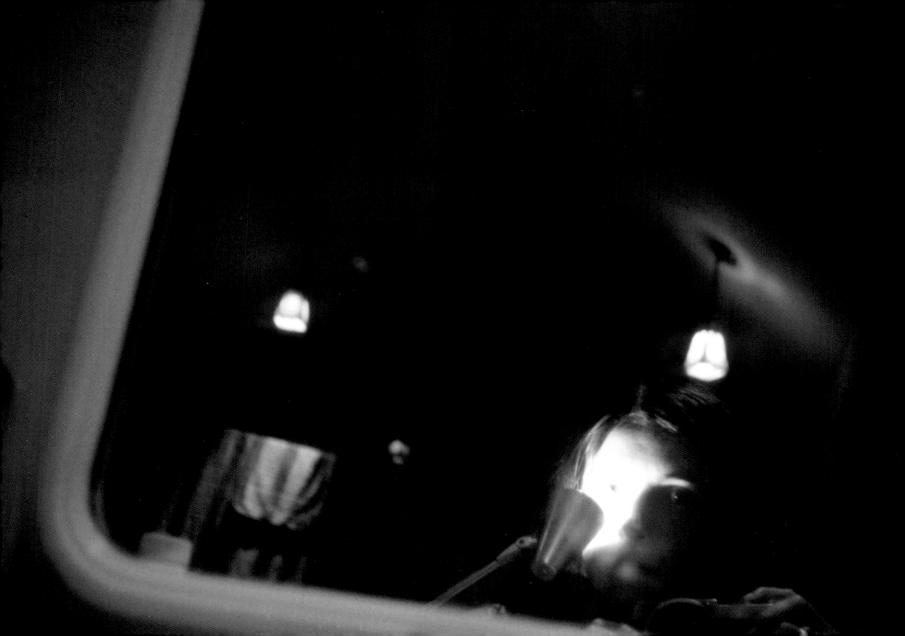

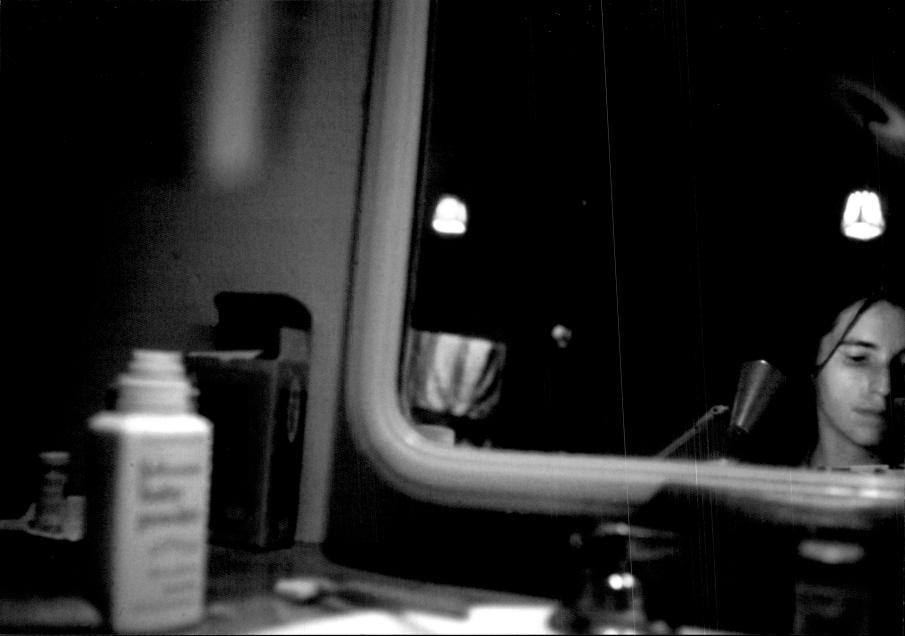

triangle how bravely triangle triangle: how bravely m&s lie downstairs, the M train to ridgewood the SS train in rush hours & I dont feel like a's real writer or my grandfather dying, he dies. Arrow arrow a turning arrow: meaning is a physiognomy what's the name of the greatest artist who ever lived? It's raining out, marcel bump, triangle: ed's not home yet at almost it must be two giant bugs & moths banging at the screens overtaking the house & little gnats covering the glass of the windows creeping in through the cracks, I am a power fissure & as I get foggy the bugs seem to be more inside than out & after reading all the letters I wrote to ed, the rest, there's more, to ed in florida & massachusetts to ed from prison I must make myself known I think maybe my idea of continuing like perfection is to have a person at a distance to direct my flow of words at &it isnt even words I am speaking about can speak about & bang! There's a person who doesnt answer, ed never answers letters & maybe that is the trouble with breaking through being really there, power to make myself known, a pressure, so that when I'm there we're there together, I must creep in through these little cracks I remembered from before cracks in the finely made windows. Ed is remote sometimes. Like the pressure power fissure that I am setting myself up to be. & then I used the typewriter to write fast, saw the words differently & I still need to race-write but better going from one page to the next by hand than by insertion & wait for the slow explosions, I'll go race to the printer's tomorrow & I said three years ago no question marks, lots of questions but no question marks & is ed like my mother & he looks as beautiful? You watch him while he sleeps & I look? For a father ted & on & a brother warren & tom & on & a son the same the freudian analysts are meeting in vienna, they didnt want to choose vienna the town had been so unkind to freud but now a freud museum is set up there so some things, sentences, stick in your mind, I call them sentences that stand out & one is some old people try to live on one can of soup a day. Dear g.s., when I think of you I think I am you but not so harsh you were right ok to be harsh like tv but you were rich, you & dash & me, you were busy when you were busy, so go on, I'm here I like massachusetts, it's tea, tea is striking I could sell it for myself, the public ora aura, an orbital circus, I mentioned, I'll repeat it, circus & on, in a note, broken in a note, for tea to drink & hashish, with it I've lost it, comes hashish, you can see it, turn over, it goes on, you never mentioned your notebook or other process, is that something we got from marcel bump & his friends, do you know him, how wasnt p (icasso) a bore? You swore, something else, a friend, you see that through to the end, & begin again. Star falls, the end, troy, a dawning, a mixup, the play, curtain, design, design of the curtain, fighting the curtain, I see the play, I see the sun rise too, most of them saw it, at the end of the day & close to what was happening, all cross the globe, we saw it, what are

they doing?, near it, a buzzing, a cloth on the door, the dent in the car, who made it, not sure of it, closely one at a time, banging, banging on glass, crusader, marauder, a catholic, sink into mine, mine are pillows, the floor, stretch across a wider plain to pain, to pain drift & think about someone with fear, & think about memory with fear, too much time went into the windows, we saw it, so stretch down, a new sign, save it, it's needed, use it, it's thrown, throw it & so on, safer at distances, come over here, where were worrying where were time. Yours else be. The calendar year 1971 july & august in massachusetts: reason, the reason the pictures of night light are so green, the reason photoflood without a filter makes night light turn turquoise, the reason fluorescents need blue, the reason you saw something & wrote "sight," you found a letter from tom in 1967 with a poem in it he was 19 I was 22 & I'm thinking about e's parents staying in this room when they visit, sleeping here, for some reason, it's not tomorrow yet ed's still not home, it's always at the end, I'm itchy, there are moans from downstairs, catching cold while memory started a finish to fear of myself in the mirror shrieking yellow orange the light on the right side of my face my right eye staring, I turn my head to the right & it was my left eye & look two eyes facing the light by eyes looking at the camera at myself, cave, the glare, was ed asleep & I was determined to catch up with myself by as before looking in the mirror eight times ten times looking at light, yours mine, the

light dimmed on the director's viewfinder whited out over red pants & a white silk shirt the cossack's pajamas & a glass of amontillado, the bricks the pressure the haze on the mirror in a streak of light the bone of my hip & the vein of my forearm fall the way the light from below on my face makes a triangle, diamond-shaped, with my nose at the bottom eyes white & surrounded in my reflection bulging out in shadow now the light turns on my left eye & the left side of my face I am too close to it I strike the pose of the first day housed in the pink rimmed mirror camera resting on my knee, foot up on the counter, my ring catches the light & eyes two black dots with white light in them infinity behind me I'm smoking & come closer, I rest more I resist more there's a haze then & two eyes just eyes open wide this one's a joke or else the climax, light inches warmth away from my left eye, I look at you I play I'm exhausted

I did I went I: ed saw this in the circus: a guy is raised up by ropes in chains, they burn his ropes as he escapes. Pole highwire day. I went down the road I was thinking about I was looking at telephone poles I stopped at the fence on the dirt road I pulled over to the side of the road to take a picture of rocks, I was on my way to williamstown, I sat there a while I picked up 100 copies of my book from the printer I stopped at the top of the hill to read it but couldnt concentrate, instead of reading I looked over to the left, I was thinking about telephone poles more & more I drove back the same way I came I pulled up at a restaurant, things were looking small they still are, I look for ed to show him the book, I looked up I finally looked right at it, I went back I went back to the barn I remember the sky I couldnt believe what I looked like in tom's black belt I knelt down one knee down one knee up I looked at that late afternoon I tried to make objects fly I went out in the field $\&\,I$ went down the road I was thinking about the green & yellow in the dark & a strange kind of light I was thinking if I walk just a little further it'll be worth it I'll be able to see the whole valley I saw poles: when we say that a body is a magnet we are again asserting an invariable association of properties, the body will deflect a compass needle & it will generate an electric current in a coil of wire rotated rapidly in its neighborhood. The statement that there are magnets is a law asserting that these properties are invariably associated. I'm not the only one who's scared or angry. Last night I stepped in a cup of coffee next to the bed & now I broke my neck trying to get a picture of a bird against the sky, what sky. The yellow birds are out & a black one just flew by me close & out into the field with a crumb a white crumb which he dropped in the morning field I get pictures of birds against the sky against its wishes, these golden yellow sunglasses are too much there's a fly on the camera & someone says it wasnt very good for our health, they must mean the sea & the denseness in my head this morning's gone, triangle: running around but very little running around just games & swim, lie, run, sun, jewish star: followed a bird with the camera he lighted on the top of the tallest tree at the far end of the field he's still there & a butterfly banging against the window black brown & orange it's 5:30 whatever that means & little buzzing & few birds & where's some bird flying home, there's a bee up here he went back down very still then a roar of bee I went to williamstown to see the second proofs to get the book & now the stars will be crooked but I cant think, there's a problem it's still it's gotten cool at last & I'm in white with a big black belt wearing the color contrast spectra viewing glass from photo research corp burbank calif so yellow bird flew off, ed's napping ed's sleeping, bought late quartets blue

leader, no good, lunch at friendly's steel food & aluminum ice cream no rust aluminum eat out eat oil & bugs going crazy in the midnight hour flying ones what can you do in a month while every moment gp is lying in hospital & what's in his mind, I'll draw tonight purple matches & a big pink ink spot on my pants there's a special on pain on channel three & something about this house makes me think people are going to play tricks on us, the hat on the doorstep the branch on the other door & poltergeists voodoo dolls trolls igor I wish I had a gun walked down the road at sundown the road took me too far took last pictures of a motorcycle that kept passing me back & forth, looking, dogs fucked up my picture of a cow down at the first red farm & in syracuse the temperature's 56 degrees: you get the weather forecast in the middle of the spectrum high in the eighties low humidity you die in the nineties sunny thursday more humid this is the travelers weather service, how is your grandfather? My grandfather is a woman sitting in a yellow light at a secretary, I can see her through a perfect window in a perfect setting & know she will live forever, another hay truck waving, another motorcycle going fast & a new moon the mountain above it the darkening sky an aura of light light beginning of last night's movie & all the movies I've ever seen & tonight's black trees & telephone poles against the sky auras of light not feeling completely light yet but lighter what's on the starlight movie tonight, it's brides of dracula: that was the end of a long series of very bad days, this is my pole high-wire act where I do a turn in air again, & of those days there's a feeling of horror to recount them & disconnection & every time I associate myself with them it's the 20th of september which is odd which is a dissociation from the world & everything around me which is science but the noise may be the cause of it, so I drew the green patches of the canals of mars & I drew the day up as a series, as a moment in the present, sept 20, & as an action: I did I went I: as a series there's a grey pole fence by the side of the road next to a telephone pole & now I got my hair caught in the fan the hair stopped the fan & I did this I went down the road I was thinking about telephone poles I was looking at poles & then rocks these rocks on the side of the dirt road & now I light a cigarette, I had stopped on the dirt road for once I stopped by the fence a different fence & then I saw the rocks on rte 7 & a car comes by station wagon & now I drink & smoke, I had pulled over to the side of the road to take a picture of rocks, I was on my way to williamstown, a blue pickup passes & I sat there a while, simultaneous, at the top of a hill near adams, more telephone poles & the sky, now I get music from the tv & noise, anger, I would strangle them susannah, am I a gnome & I picked up my book from the printer, 100 copies & I stopped at the top of this hill to read it but couldnt concentrate I couldnt even decide whether to turn the car off & to the left a mountain maybe greylock & so on &

white post & mechanisms of all kinds & now none, I wish I had some & I looked over to the left instead of reading, I had picked up a hitchiker on my way way up & he said I wish I were going to williamstown today I often go there but I have friends in new ashford & I must see them, he wanted to buy the car, & there were telephone poles with five wires in a white sky & now I wish somebody would come by every day to read this & talk & drink beer & then, it's true, I was thinking about telephone poles, the pole became the frame of a long picture, mountains, like a dish of something & now ed runs out to the bathroom, sleeping & says I want to hear that typing louder than that other stuff & the other stuff is noise from drilling or noise from the tv & I say I can turn it up want me to turn it up & he says yeah & I say how's that & he says turn it down & I was thinking about the poles more & more & then the dark blue captain's cabin surrounded by telephone poles & now nothing, it must've been a big lunch place, there were a lot of cars & I had seen it on my way up but didnt stop to look around, I got closer to it the color of its blue was disappointing from the point of view of a pole or including a pole & now something should've been wilder & move more out of focus & I had pulled up cause things were looking too small that day, they still are & then the top of the barn for rehearsals with the sun coming over, fucking con artists & I had looked for ed to show him the book & then writing in the sky, a trail of it, or just one of those long dispersed

clouds, the fibers, see mnemonists & I had looked up & now nothing & then the strange heap of hay tied up outside the barn with something on top of it & now I am out of control & I was out of control then & I had finally looked right at it & then out the paned window on green & it's inside with no poles but wires & what were we doing in friendly's near rte 20, something about pictures, what a downer & then ed read the menu, strangely distorted & green his lips are red & he's wearing the tie-dyed shirt & it's telephone poles & this was when we vowed never to eat there again & it looks like the one in great barrington & then out the window a darker tree trunk & it looked like a picture we ate & then a sun way sun telephone wire closed down viewfinder some tree something moving very fast & we went back & now there's a lot of people talking on tv, it's a crowd scene in person & then a green tree & more wire & did I want to call someone & tell them about something, by wire & then a greener tree & we went back to the barn & then the other side of it with sky, it's alford pole & I remember the sky & then, shit, their telephone pole & a contorted accumulation of trees, the pole's bent & then a wisp sky & myself in white in braids in the window with wood blue sky wisp & green barefoot at hip, I'm a pole an indian & what kind of strange person am I I can hear the voice of george sanders in my ear & the barn in alford later on I couldnt believe what I looked like in tom's black belt & then in the same reflection I'm

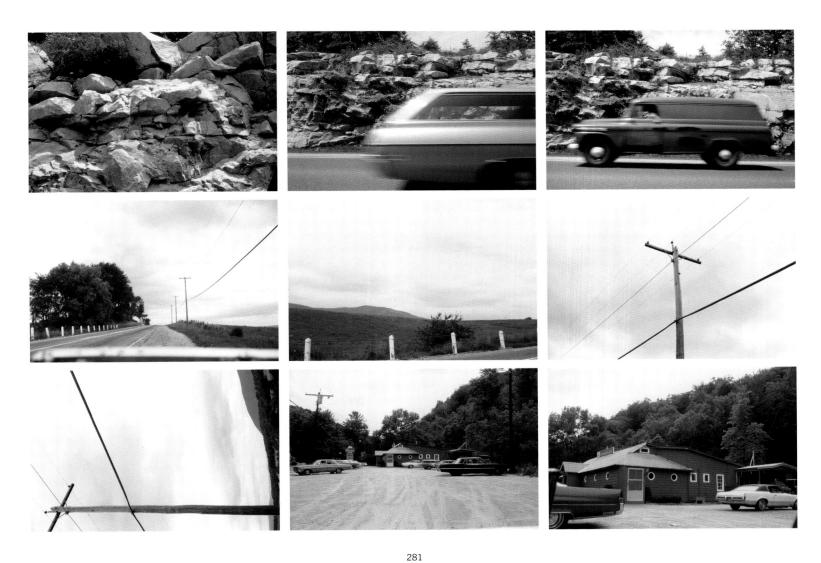

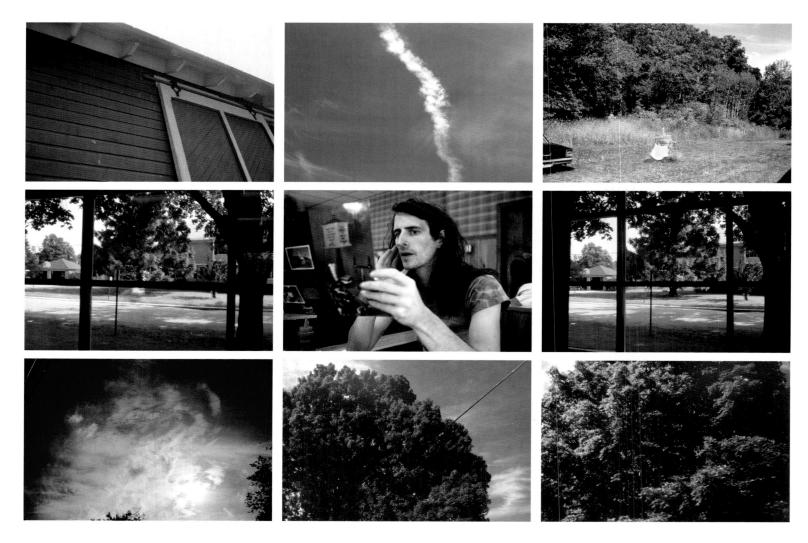

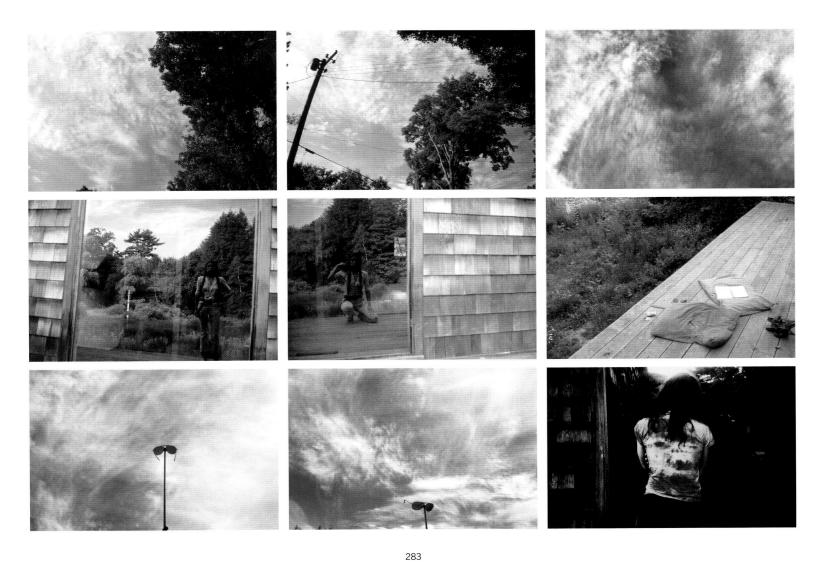

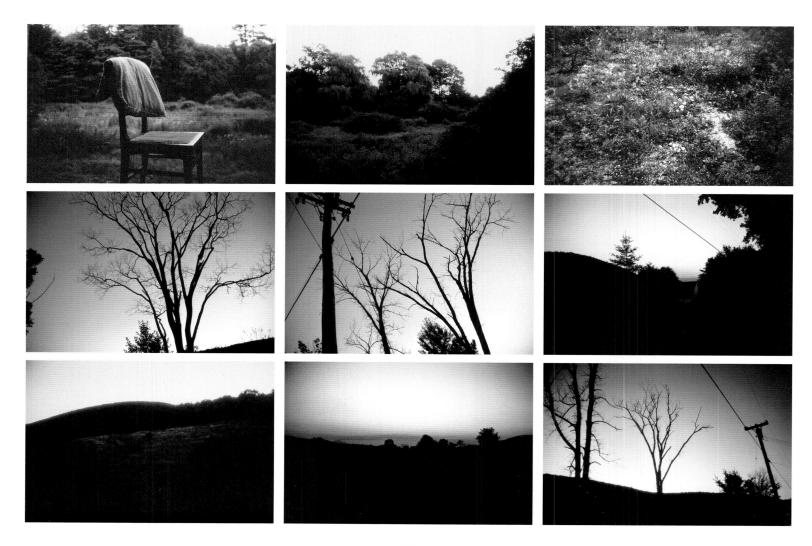

kneeling straight as an arrow, braids are poles & I knelt down one knee down one knee up, knee kneel, & then pink & orange pens & smokes & two yellow pillows a notebook shades & sandals on the deck & I looked at that in the late afternoon: telephone poles: I wasnt kidding, I put my shades up on a pole so they could be in the sky or so that the public could see through them as I could what the sky looked like in three dimensions of cloud: they couldnt but, so the idea of the poles wasnt that they were telephone: to reach someone & the young mr. pitt directed by sir carol reed costumes by cecil beaton & all original speeches, you can see it every september 20th, it wasnt to reach someone but just poles for the sake of poles so that in most cases analogies probably dont hold just poles & of course they reach in or up & the sky's as much a part of things & so on & then the glasses fly, the pole, the light stand & I had tried to make them fly, pilot's shades, & poles & fly & then the back of ed in his shirt & he can fly, it's dark long hair & ed looked shortened this day, a back like a girl's he said or just this one & then the red & black chair with a lapse of vellow pillow over it, it's in the grass & no it wasnt in the grass but on the deck cut off to look like it's high in the grass, an elevated chair & fly are there any more elevations & maybe it was the deck that did it & then a darker green than there is in the field & I was high so why did I keep taking it & then still darker & forest white flowers & I went out in the field & I

went down the road & then the silver moon was up & high the black trees against the evening light, a dead black tree & then telephone pole silhouette & get a job & trees dead & silver moon exposed among them & I was taking an evening walk too far down the road to get back before dark & then a view of sunset but with still more wires in it, I was scared & finally a hill in different shades, moon over it & I was thinking the green & yellow in the dark makes a strange kind of light & then the sunset sea, you've seen it the famous one, it's from above looking down on a valley & I know if I go a little further it'll be worth it & then it's dark & in the end two dark trees in a clear pink light topped by just blue & a telephone pole: so I drew the canals of mars: I drew in all of the colors drawing it looks like a map of the u.s. turned on its side brown on the eastern coast the red of the desert the green of california mexico begins the gulf green & yellow gold stream currents up in blue against black outline of eastern shore northern borders on canadian blue & violet a streak of lightning in the canadian part, that lightning enlarged & africa below a halo an aura of cells, the spectra all the visible spectra plus a planet & saturn the rings we are looking at head on this year

After pole high-wire game, what? Roseanna, it's getting late: switched from white ed wine to red wine, still with a cube, I want some wine white wine, ed said, I'll get you some & there isnt enough is there, there's enough, I'll have to get you an ice cube, enough to whet your appetite & wh wh whi whe what does, did, moving having to do with poles, the poles. & the next day we left early in the morning for the city with kathleen, to pick up the projectors? I dont know. Marlboros on the dashboard of the cadillac, a reflection, a bright sign, we went off early, it's amoco the only one certified lead-free & a red car passes by blue flowers in the field, we went off early we stopped at the chief taghkanic for breakfast sandwiches & coffee heard something about a murder a beating of kids hippies listening to tapes at a pond nearby & blue & white flowers passing from the center & pink ones, were they blue now they're blue, k&e were in the diner & the sign of the chief taghkanic diner, blue sky & telephone pole, the head of an indian chief, fluorescents off, I waited for the big trucks to go by, one oil, one empty, they didnt collide, & the side of the diner reflecting chrome, chrome stale curtains palefaces a metal awning in reflection I went around to the side of the diner happy we were wasting time & maybe this was the day ed got the ticket & the side of the sign

same sign with spots, a blue car passing, is now, then right, in the middle of a telephone pole the pole makes a, or rather the wires running from it at right angles make a, perfect perspective, it's confused, let's go back over it: you wake up at dawn blue black dawn, ed not home, lights on, clothes on, take plates downstairs, change into nightgown cold get back into cold bed, eat a piece of pumpkin pie sleep wake up worry then begin to computerize the possible on logs on sleepers, you eat them out of ideas one by one & put them on the used pile, you're building a railroad: what happened to e, still working of course, kathleen comes by to pick me up, pick up ed go to the city black coffee, sign arrow, fat suntanned woman in pale turquoise dress waiting to cross the road from the car, the national beauty award highway 1969, in the winter of '69 we lived here, blue flowers by the side of the road purple flowers here's the story of bell pond listen: some guys were listening to music at dawn, they were beaten up, dying, near the chief taghkanic diner: dudes: dudes in the diner their shirts say pigs is beautiful & all drawings are like maps & someone says you sure you didnt take mescaline last night & fear & caffeine & schenectady 71 degrees ed's reading in the back of the car & a truck with a turquoise thing a trailer back in it crosses the road, iroquois, two people in a sports car a neat compact close fast-moving unit, good thing ours is in the smithsonian, finished emma goldman last night I had a liverwurst sandwich & that reminds

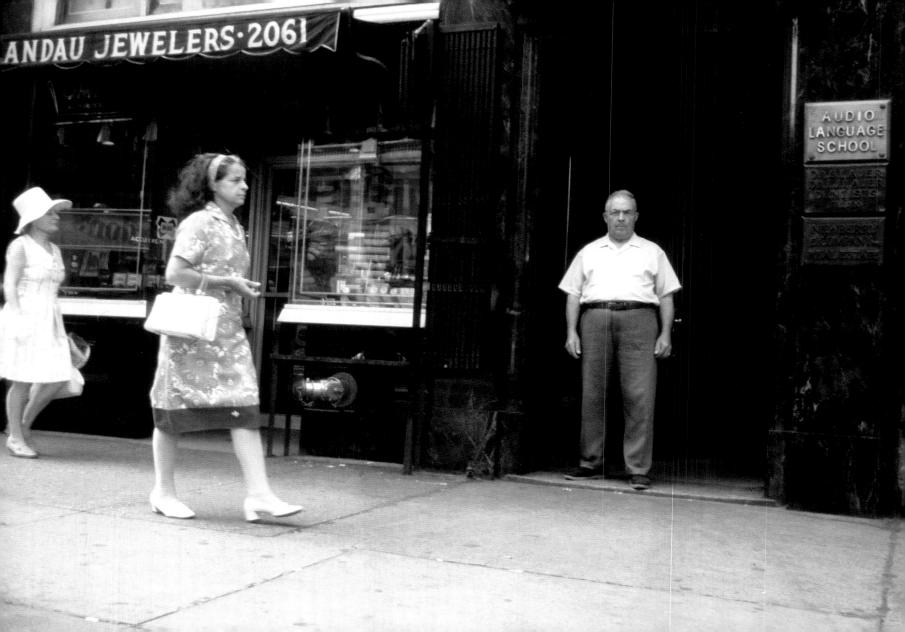

me dont I digest this food & how fast can it happen, I use it up, I need it & someone says you know about your metabolism & I can see k a good actress & can she see me a good something, hot sun everybody wants to be a something too, watch closely, another gas station, another beatles song, we took off k's jacket & they just happen to be, the people in this book, we. B. Now a 16th century air, over, thunder in the car, we've come from afar. The the king is air, is here, we must be, almost there, B. Pink pen, & lighter there, W-A-B-C too too B-B, little darling, double You, A-C/D-C, bum dee, AB-C baby, waddee waddee, B-C-C, A.B. Dick, cha cha, cola B.B., Bible, AWOL, wac, choc full, cab, the BeeGees, R-R, R'n'R, R'n'B, COP, wa wa, mojo, lake secor, C.C., A is for, W.W.II, U get an A 4 effort, double U double U two, saucy susan sauce with franks, N-Y, B.Castro, hamburgs, I. Reed, GP, R, Ear, 2 A.D., 2 B.C., Bless You, 10 to 1, Eddie Lake, maybe baby, baby blue business, Cane & Abel, Abel Gance, Gimme a 'A', Gimme B a 'B', a 'C', Chappaqua Rd., M-E-N, men, it goes on: where are we, where are the landau jewelers 2061 what street? & who is this girl in purple passing by, sandals, some kind of kerchief, a great girl, she looks like she's got a dog with her until you see it's one of those fireplugs sticking out of a building, the building of the landau jewelers, yes this is where we got the ticket I wanted to take a picture of the cop but he was two spanish cops, very nice, they revoked ed's license, a man comes out of 2061 to stare at

the big scene with so many police, you see we had no registration & we explained, putnam valley & so on & a woman in yellow with a green hem passes, she wears white stockings, white shoes like a nurse, a red bag with a white handle, no the other way around, her arm bent to carry it & a light colored band in her hair, she's crazy & behind her a woman in white white dress gloves shoes bag a wide-brimmed white hat-type hat, the man stares, he thinks to himself they've been stopped, what else could he have thought. My real feelings at this time were a third or fourth woman passes by, also wearing a wide-brimmed white hat & carrying a white bag but she's got white sandals on, an extra bag, a dark shirt & a tropical pink & orange blouse on, she looks into the hole out of which the man stares, he's gone, back into the audio language school: we get away. & then the 1st street gallery on the bowery, it's red light & we go down to home & then the blue fish of the fish store in a blue sea: baccala everyday & I went shopping with r & rich wooden church doors, they look good to me & I went uptown & out the window of the car a taxi with passenger window reflecting highrise apartment building, taxi backed by garbage, no, packed extras, those carts, what do you call them, bales of clean garbage, strings & left-overs, pieces of fabric, we drove somewhere, we went to florio's for calzone, this is a lost day, the ship a sailing one in florio's window & behind it, a backwards schlitz sign & a few men in a boat, fluorescent & all the light of florio's

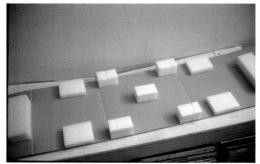

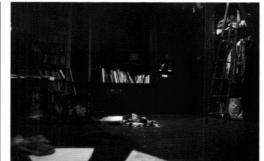

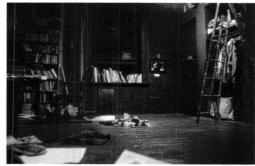

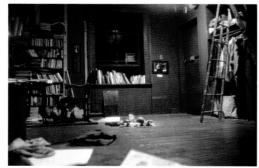

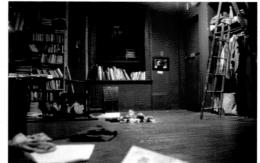

fluorescent, it's like being blind, inside & out, reflected & read & it's dusk about 8 or 9 o'clock & a guy comes up to the counter, one of those police trainees in grey from the station, from central headquarters down the street & in the foreground an old woman sits in a booth & the waiter is coming at us so I finally get a picture of him & mrs. florio in the back, focus, in flowered house dress, she's tony's mother, the batboy for the yankees & so on & the waiter wears glasses & talks to us about breasts & bras & yeah, he says, but he likes to take them off a girl, or woman, if she doesnt wear one then & table service thank you & little balls of dough for calzone & one big one for pizza & I looked over my shoulder yelling waiter, water & then the yellow light of j&k's house & what were we doing here & I dont know I'm getting pissed off, it's that yellow light, we went over there, it's ed shaving, I feel like a fool, ed had to shave we had no razor with us, traitor I mean & k had shaving cream & did we have cocaine maybe & rod mckuen's on tv we saw rod mckuen on tv looking rare or medium & an embarrassing conversation with kathleen & k makes up her finger to her eye but where was she going I dont know & there's a recessed red light, what's there, it must've been there & the sink at our own house, clean dishes, an upside down coffee pot, clean jars, we went home, toys on the floor, I've made a mess of things especially motions emotions, like a film, all the toys, see the devils, spilled out to look for an egg a plastic egg, & h thought

they were part of a robbery, a staged robbery especially after ed rampaged through the house looking for a blank check & couldnt find it strewing papers around, there was nothing to steal & the light in the white room looks much like itself, all the lights, bulbs hidden from your view & white foam blocks glued to folding cardboard, part of the packing that comes around a machine, pack me, next to my desk on the floor no where the stereo used to be & I went around the house looking & ed was in bed face down, was he dressed, was he sleeping was he posing, no pillow cases but pillows english garden red & ed's ass, just asleep or going there, the sheets come, about halfway up his legs, the dark loft lightens, once it gets light, it can be light as & why keep it down, many books & taken by surprise, it's sideways, windows open, a ladder in the window, two shirts on the bed, one died & army, newspapers all, light, the address of the magic store is here, I'm numb with lemonade, gp's better home friday & the devils collapse with that, between black & white is blue, it's all light

July 29

We've lost we've won we havent used our checkbook. I'm going crazy, the bulbs, I keep trapping cockroaches buried live maybe it comes out for them like a vacation & they turn over on their backs legs up & in the air & then when you lift up the trap a few days later they turn over & walk away, not very fast. Coffee & a pizza rustica the 29th: forgot to drink milk it's raining again, why I'm not a scientist: thursday: get caps an egg flash powder splicer leader & a present for jacques' birthday, then dialogue: this is a jacques for the summer bought a 1964 cadillac I said & she said oh great & convertible oh good & I said we took it to the city a lot because we always had to pick up things & our car was too small & that's ed's body of the body of that car, ed's torso in the cadillac & she said those are good colors & I said this is like the 29th of july & she asked were you were you glad when you finished when you came close to finishing the gathering material part or were you & she trailed off, well funny thing was like the reason I wanted to look at these pictures was they really pick up towards the end of the month in a funny way they all get clearer & more vivid & more interesting but just to me somehow I said & she said do you think it's because they & do you think they are & well lemme see what I think I mean I wanna see if I think the pictures are or if they seem that way to you because they are new now & I said what & then well I mean the reasons for it are so complicated or they could be so complicated I have no idea what you mean or what I mean but I might be wrong yes it's true we'll see & she said yes I mean I wonder if as you got into them & what you were doing you were actually taking better pictures or whether something in your mind was becoming similar to something in the air & I answered yeah & it seems though I dont know what I mean but it seems also that maybe more was happening more things were happening & well a lot of things were happening all the time all summer but I mean just things it wasnt that well what I mean is we were bored a lot of the time but we had to do work I mean that kind of work & that much of it is always sort of boring, always boring but there was a lot of moving around, we were always moving around a lot & gradually more began to happen I mean really happen I think because of the moving & she said well I meant like in the days that you showed me before there were a lot of things that were indistinct because they were indistinct happenings, things that you did with no reference, no referential nature but maybe with the same people & about the same time there wouldnt be that much difference, it's only a month going by but you probably were having a feeling of déjà vu in the city when you were sitting in some restaurant about this time ordering a cheeseburger, same one that you probably got in the others &

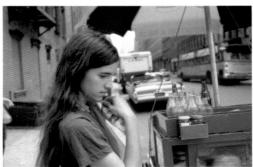

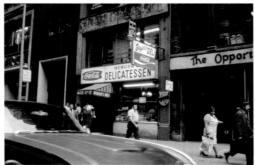

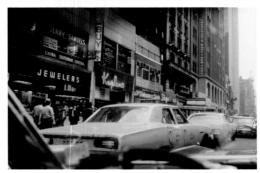

saw pictures of it in your mind whereas here, I dont know & I said yeah I guess so, I was only intending to concentrate a little bit & this is 23rd street I think, no it's somewhere else it's uptown on the west side or something oh I know where it was we were picking up flash powder from the magic store, there's an exploding bouquet in the play & we were picking up & this is that same street the new yorker hotel is on & she said oh that's around times square $\&\:I$ said I think so a horrible day $\&\:$ she said I was on my roof today & I said oh yeah & she continued it was incredible I was looking at the world trade buildings they're so close & have you seen em from down here & I said well you cant miss em from the west side highway & I have a lot of pictures of them & she said our roof is fantastic it's really just amazing even from our living room it's too bad that that area is so horrible from our living room windows you can look at the statue of liberty & the harbor & the verrazano bridge &all of manhattan it's really too bad it's such a horrible place to live because it has very good windows & I said somebody threw these papers all over the floor I mean the street on west something street 42nd I guess they're probably still there & me at the hotdog stand & she said you look as though you're & I interrupted dont I look exhausted & she went on you look as though you're really making a decision about what you're going to get there & I said I think I was waiting for a hotdog yeah & she said that's pretty strange a station wagon but what are those things on top & I explained yeah it's one of the airline, one of those airline, those limousine things, limousines, very shiny though & she said what is that there & I said this is on 47THST I think & she said what is that below that something or other & I explained oh it's a box that contained a new razor sort of a space age razor that ed got, yeah that's 47THST, a lot of people were yelling at me that day because I had a I was waiting for ed & I had this huge car double parked it eventually rained I remember that day it was a horrible day, berger's delicatessen, fuck & she said the light is strange in that picture & I said that blue is like the blue of the tinted windshield & she said no that's not what I mean there's a lot of green in the buildings & in the cabs & maybe that's, anyway there's a lot of colors & I said well it always gets green uptown when it's going to rain &she said yeah it does what time was it & I said I think it was probably about four & she said yeah it must be late but the sky there doesnt look all that much like rain but its light is queer, I guess it does look like rain I guess there's sort of sun in the light & it's grey & I said I eventually pulled up & parked in that space where the gas truck is & there's the sky, now this is on 23RDST where we were picking up grace who was coming to the country with us, there was a fruit truck & I guess cops either chased them away or something it was one of those illegal fruit peddlers a lot of people buying fruit & this is grace's hallway, west side highway & she said yup, looks as though

you're going south, nope north I said we're going this way & she said are you sure that's north but that car looks as though it's going south & I said yeah but that's the other side of the highway & she said oh I see it now & I said the south side is closer to the river & she said yeah sort of a nice picture but the colors are too something $\&\,I$ said that's new york & the haze &the palisades & she said that's good & I said this must be further up the taconic & now that, if you look closely, is a bat & she said jesus were there bats in your house & I said yeah & now let's see if we can, there it is, I had grace shine a flashlight on him that bat so I could take a picture of it & you cant believe the nerve it took to get that close to it & she said oh yeah a bat & I said we had three in the house, flying too & she said yeah & I said I'm glad that picture came out, can you see its red eyes & she said no I cant see but at least you could see the bat & I said yes & there was another bat but the flashlight was off, cant see & she said in a way that's even worse & I said yeah they're horrible looking, arent they, have you seen them before & she said not real bats, there was a bat at trinity once in one of those in one of the dormitories but I didnt go near it & I said this is the bathroom those are some drawings I made in my notebook & she said is that a sherry bottle & I said yeah amontillado & she said oh I noticed those towels here I noted them because, those colors yeah, those nice colors & I said yeah somebody gave them to us to use in the country in the house & we never

returned a lot of them & she said you know I've never seen that kind of color before, let the um outdoor light change the color of the towels, you let it change a lot yeah, the bathroom sink, your clothes, with a pair of white pants in it, rusting paint sets, it's a nice sink & I laugh it's one of those lights & she laughs that light is too strange coming out on top & I said yeah that's like from the tensor light, makes that beautiful halo & she said you could make a picture like that with the halo around someone's head & what's that & I said that's the light that's on the rheostat from the bottom though & she said jesus beautiful isnt it amazing it's not quite centered right & I'd like it better I think if it was, wonderful colors, I really like that raspberry, yeah, another one further down, it looks as though it's growing there & I said yeah doesnt it & if I could've stood on the ceiling I could've really made it look that way & she asked how did you take that what did you lie on the floor or & I said yeah & she said it's hypnotizing isnt it it's like an eye that does something or other, yeah, hmm & two of them & that moves too I cant decide if that looks like some sort of growth, it's from somewhere, sort of shaped like a rod a protozoa or something, I wonder what, looks like something organic doesnt it & there's your hammock & I said yeah that's like the whole house you see, we brought the hammock up & we moved the bed upstairs & that's like everything but the upstairs part of the house & she said yeah the main um room & I said yeah & she said the

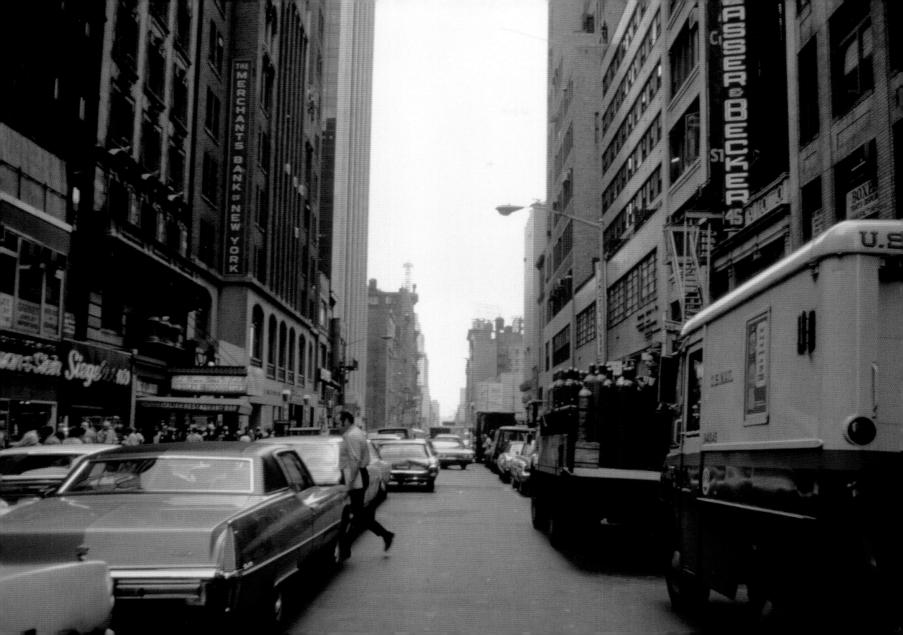

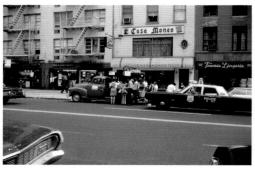

hammock really looks nice in that tree um house & I said yeah that's grace's ah cousin ah niece who came up to visit with grace & she said I thought that was a pile of books she's wearing a striped shirt I didnt realize there was a child there until you said that it's really a wonderful house & I said yeah it was I took pictures of everybody everybody was writing everybody in the whole house was writing that night & she said that's a nice picture of grace & I said yeah that's all we went to bed then, she boxed the bed down. Why I'm not a scientist: ed's torso in the cadillac, jack donohue shirt patched jeans the burnt ones & we threw them away no we didnt, he's at the wheel: I'm imagining things the magic store we must've run errands, not the projectors the magic store on 42NDST: flash powder above the irish house bar restaurant people passing & a whole store of magic shown in private, a man balding glasses tan clothes crosses the street with a striped sports car down the street from the new yorker hotel like I said before we've parked down the street & a haze on the empire state building builds up well what do you expect: red light I'm waiting I waited no fog no traffic in our direction, all other: that's the light & somebody had strewn pink papers & white papers saying something all over, black people's legs walking & me in an army shirt, ed had changed his to a log, did I switch into his old one & waiting for a hotdog at the hotdog stand. The stand's painted red, we're out in front of some red brick buildings painted pink in the dark light with the bottom windows closed up. I'm panic stricken. I can see the cadillac parked top down down the street. We saw this guy from a distance. One of us pulled up. Which of us said you know what I'd like, or, in a hurry, hotdog, repeat it: silver objets d'art & antique engagement rings you get married in in the next one which is taken over by one of those airline limousines like I said before cutting off people's heads on the other side of the street, only thing is there's no driver so it must be parked the headless hollow: looks like 47THST again, fuck cant be, this, window: luggage rack empty & yes it's 47THST again u.s. cultured pearl co. & the hog hong kong inn for cocktails close enough to the tallest building in the world for attack for cocktails, not me: u.s. mail truck we're double parked by the place where del pezzo's spinach omelettes used to be: do we devote a lot of attention to this or just struggle? & behind me fisher & somebody packing division probably body & the u.s. mail: he had a number, dent: the cockroach trapped over the drain under a glass got out & could they be that smart & could he have crawled through the hole hatching eggs all along the way trapping him & up & out another & a thousand new ones with em: berger's across the street by the opportunity shop a jewish man in a blue sports jacket with a black attache case hurries by followed by a black woman carrying a shopping bag. 47THST: we get our film equipment here in a place above the gotham book mart, arnold eagle's studio & that is why we are always waiting: even negatives can be cut upstairs & films screened in a hurry about art. Magic &

jewels? Jerry samuels china silverware crystal & so on we buy yellow taxis big traffic jam so I pulled back u.s. mail pulls up, gas truck pulls in taxi parks across the street tells me to move I tell him to go to hell he's the one blocking traffic he says he can park wherever he wants the whole world's a taxi stand I get pissed off I pull up anyway, cop comes by tells him to move there's a fight there's another cadillac & people abuse the car I'm in: another lofty sky aloft & bent buildings into the frame, we're through with that & on to 14THST where fruit vendor attracts a lot of attention like I said before, outside grace's house where we picked her up to take with us & freya her niece, the vendor & cop car before the casa moneo where's the magic & jewels? This day? With k, g, f, & e: well magic & money moneo anyway or jewels & money or total depression in the car, leave that in, viva la sangre de salvador allende la via del tren socialismo es pelligrosa & in the car k asks g all about dieting & exercise & is she serious of course she was & storms in stormvile soon as we hit stormville though you cant see them yet or ever & the electric electric window got stuck down on us in blankets & the girl hitchhiking soaking wet to poughkeepsie where it seems a lot of crazy people live poughkeepsie again & again, a tough town: grace's doorway & a black woman goes by is she moving is she still she looks still: at first I went in the wrong door, peel, arson, on the west side highway I must've must must've been too down yet one giant palisades building &

still some trees blurred green & yellow separating two cars on the greener highway just before the storm storm so great the guy at the station wouldnt put gas in cars he says let them wait in his slicker they were all in slickers, let them wait and, and a long interruption for depression, ed lets us off & goes off, takes k back & stays later, was he afraid, we had bats the first bats, more bats, bats let me let go of my anguish: while g pointed a flashlight at one on the wall of m's room where we thought we had him trapped, m didnt come home that night, I took a picture he looks down he cant see flash flat as a bat he arches like a cat, it was magic & jewels & a little money too, could use some now, I shot the insane drawings & drew some darker ones & someone says again were you on mescaline & the one that came out like a map & one like lightning the color wheel, like the light I took pictures of lying on the floor no style no nerves the bottle of amontillado smokes tampax strike anywheres newspapers & towels a long bath film can ashtray & matchpack up closer blurred who cares? A spiral binding for the earth. The world: saucers, earth, jupiter, saturn uranus neptune, no: saturn with her rings seen from the side or in two dimensions, the earth with mountains, green & color wheel, sun I guess with rays sort of & all the same things including pink pen, when hung up the towels dry towels anne dries them by the wood stove fast so they dont smell like mildew like grass she never washes them: signs of the zodiac: prepared for recognition: I

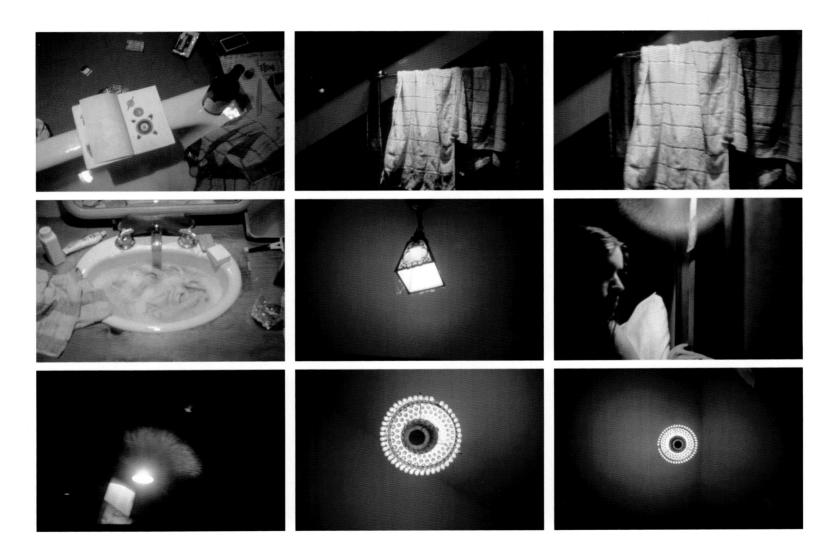

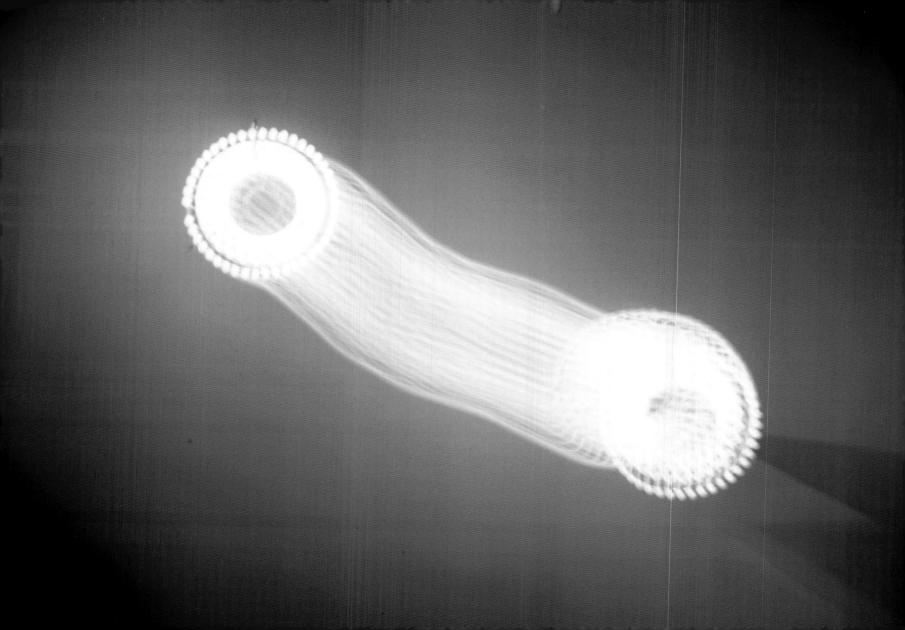

know you, towels blurred get closer to things, the white pants in the sink against close to the end, powder toothpaste salt the ribbon stuck a glass, razor, soap ivory & strawberry magic & jewels faucets shaving cream, mirror rimmed pink pink & grey towel & fab, tom's shaving case. The lights of the bathroom jewels but not magic I thought they were spiderwebs hanging infinity magic but concentration, put something in too much it must continue on, pain. I washed my hair & someone says something about the water, it's difficult to remember pain, g washes her hair here & did I take this picture of the light of the tensor light making a haze on myself & was it the night it thunderstormed & we lay on the floor telling what we saw & did we all sleep in our room for fear of the bat, not this night, prisms from the light so look at it, right at it, what? Jewels: for sure, the light from the bottom, how many jewels in its dimmer purple it was off center, a gold rim, a strange ring makes perspective it glows it hangs from one side of a sloping pointed ceiling, makes two stand still looking at one then moves then you move then stand still again looking at the same one, you have two with a connection in between as wide as the thing of it, amoeba like I said before, make a greater distance now between the same one, cant hold still for the real one real jewel is in focus, or, to make two again jewels multiply they tend to divide where's mallarmé here: freya's writing in the hammock: dear s, please dont be angry because I havent written in such a

long time. I really cant say much because there's nothing happening. When I get to vermont I'll write a real long letter telling you all the details on what happens there. So for now I miss you & I miss you again, love, & grace is writing in the nook, red-orange, red apple three red tomatoes one green apple a bunch of green grapes the festering pecan blossom pots dishes & spoons: sink the doors to the closet: room, we slept there later another haze from a light haze makes bats or do they & a few crevices for them a crevices day from the fissures left of power, where, check on that, behind & if it rains enough they wont be able to work tomorrow & g's bed in another nook, a bat's roost next to f's sleeping bags, pillows & cases & a tiny baby sheet a tiny bat sheet & the light with tape near it, the tape from g's last visit, the shade from the light she couldnt turn off the switch was at the other end of the loft, poking the bat. Ed went into the magic store like I said before silhouettes on the shades from down on the streets. You cant hear in the house cant hear in the streets you're on the wrong block. The manhattan center one thousand men on the steps, it's cloudy bright & heavy over awful new york day, grey, views of 47THST 6, 7, 8, 9, 10, 11, 12 views of 47THST: fanfare, presents, slides, chirps, beeps & someone says anything a matter with you guys & two start talking at once & someone says maybe you should get into each other, so, it's dirty, how'll it look on film, practically everybody on the street works for somebody & tina says I wish I were doing something like that & she'd like to work, work for somebody too, a scene on the streets: pissed off to describe it anger, he threatens me with a cop & someone says move that shit car & crying on the streets why don't more people do it & how can they stand it, they hang in there & I'm freaked about the car it's raining so he gets a ticket for blocking traffic: spacetrip in a spaceship the worst ever, can I tell from the times before like I was saying before & is there anything in that: now I'm in the bathtub it's not over yet a million possibilities are mounting, amontillado, a million bricks closing in on me or someone on someone around me close to me & the bat helped a car passes by, what am I thinking, we played joe cocker to scare the bat, scared him into m's room taped the curtains closed & opening the door, we talked to the bat, we said for at dusk you who dont understand amontillado & we dont get a chance to finish, the bat's little white teeth are bared, long black legs, white sitting like an indian & the house become a belfry alright I'm sweating, blind as a bat: radar: is there blood all around us, blood in the spaceship, blood on the spacetrip a nightmare out of age 13, I stay in the car, maybe because of freya but she's so relaxed maybe that's why I wanted to make a scene on the highway, space, now I'm sweating I feel like brigid now pearl, where's the dope I run through the things, space, what, why am I hurrying & was I pretending to be dead, like unlike gp is this whole way of expression clear unclear like

logic like worst of all applied logic to death & came out with, sweating, I'll leave my hair alone I'll leave my hair dirty I'll just die like that, unwashed like child, more nerve I need to sweat & sweat more & k says to e you're such a mess & g gives k this recipe: 1 cup shredded carrots 1 cup shredded spinach the same celery ½ cup shredded parsley in a quart of water low heat cook 25 minutes bubbling at least add cup tomato juice & vegetable salt cook five minutes strain out vegetables & drink & k says to g you're a gold mine of information so, am I ignoring them am I here have I left, left out or just imaging as ed says it & how would I support myself with a hot bath, amontillado, m hasnt been here since we left, years, how did the bat get in, pearl, the worst is feeling the conspiracy bite between e&k, total, the beautiful people on one side & ragamuffins on the other, line em up next to the cadillac, the window doesnt work: cant get over that & storms stormville one two three four I know e's thinking about being somewhere else, that's the function of magic & jewels & the city too or maybe it's me just drifting away how can we ever tell together, in a meeting? Where is he? Sweating in the car: e's parents are not mine I should hate them: picture gp: the old man, the bum k thought was handsome: why has dash life dash dash this & why am I waiting for an accident I hope for one is the blood between me & gp real, I feel like I know him, can see looks on his face, defend his states of consciousness, no one else does, force it, desperate

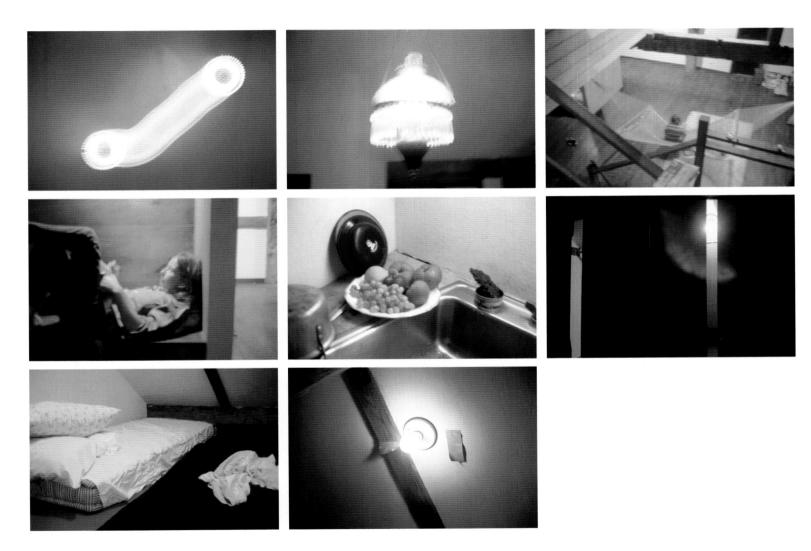

disparate & now right now a thousand, that, what I'm worst at, I called today a, b, or c, disgusting, I didnt come clear I couldnt finish a sentence, the whole of it & about the bat & someone says this is the most exciting thing that's happened all wrong: exciting deliberate & sweat, identity floats somewhere between a review of masterplots in the dictionary & the word girlfriend, she is a woman, I cant stand it this notebook's just some step away & what about my friends I sure dont care about filling up pages for a moment, defend the states of consciousness, write about them maybe: this notebook's just some step away from a fear & that fear has to do with communication & as a finish to memory I learn one thing, that the fear's already started, it's the same one, already begun, always back to where we both began no matter how far back & it's sincere it's boring for words & it's also anger, I just threw that in, dont let the anger have an effectiveness, drain it, use it, store it, whatever you do with it, never take advice like from a mountain running down & as far as it's almost truth it isnt worth syllables, the syllables break up to make a mask to make logs like the sleepers you build a railroad from like I said before & I repeat you get harder tougher or sleepier; you sleep: alternatives, fuck & spending the night alone I see that this is one idea, a block with a long handle on it like a sliver like a splinter of a log & from a pile of sleepers I extract them one by one & I eat out the ideas the possibilities, alternatives, you masturbate, extract them & then throw them

on the used pile one by one if you're spending the night alone & to know more to write faster or slower to be sure to see julie m today, shit I still have the momentum to make everything seem great until it stops & not to figure it out to run it down, to make a scene my scene scene in a play, fuck that sunrise & I'm lifeless ashes & blood is what I create at least, what were you thinking about, the ike & tina turner review: it's jacques' birthday got him a cake from miss grumbles or grimbles same as last year a \$6.50 butter cake & last year it was larger more butter loomed larger but h was not in the hospital yet, review: oooaruuew, ouew, do you like good music, review: thursday july 29 cant figure this one out: I live with ed should I try to work with him should I try to live alone am I giving up or just beginning to have the fear to see it right: sit back, be immobile & leave it alone, what's leave it alone & whose hands are you in am I in: do what I can, that's shit & maybe it's just the syllables that make the words, try others: milk preacher love each match mother silk matchstick anus penis penultimate bat butt cigarette search built message batter bulk much butter milk toast master muster bitter earth friend search missed passed cup cat car mulch milt which? Weather wealth mrs. cadillac try toaster met still when? Wet blood mix tool mind sinecure section easel pest sink & now amontillado in the bathtub the bathtub, bat, & someone says what is this menu for & someone says save us a piece of cake & someone says if jacques doesnt eat

it all all the cream all the butter, lucked out: caucus serious must musty respect boop sweat & smell sweat & mulch bottom dogs regis debray salvador allende it's almost friday, call r call pat & ted & sink a ship, no reminders, cross those out, sink a ship, sink it, respect, worry again, disaster, each car that goes by sinking, expect disaster, respect the word, sink it, I'm not the captain, repeat it, sink it, murder it, hate it, the pictures of girls naked, I looked at the sunday morning, I came home to find my father dead, later, my period, I looked at my book to see if two days would do it, deplete it, experience a phial: experienced at a title experience a vial a file a daughter a title: daughter & color: you write like a child. How? In pink? It's purplish so, there, you, are, in a moment, subservient, in a position, defiled, foliage, filial, deflate, destitute, dethroned, the youngest daughter, a fantasy, never princess, never printed: recess, rested, play, with words, sink them, a ship, store them, restore & when I'm far away now, pearl, smoke them a rule, be dirty not clean, but clean not dirty, opposites a ruse, to write, down, down, yes I got, pause & sink it, the ship, the sink, a ship in the characters, chinese characters, the organ, milks, every, last word rite, pause pause, it will be good to be in pink for a white, & everyone will think, with the orange, I'm losing my mind, low swing my mind, freedom's just another word calm secrets, soul, weather, I never leave this, I never have

July 30

When you are a woman you make a great record & a daughter, whose daughter, the doors & the bust armor plate of a woman and curls, black bats, impending disaster impending doom unending impending a reorganization of the employment of faculties a pigeon flies by the window the subject frames, see, just, so, much who are you? How did I come by you? I'm anger my anger is sense drills into you I am set in this piece this is a move you little man doll fall down little woman doll moves closer, is wounded, you get up again a miracle, we mate, like two watch faces on the same wristband, waterproof I hope. Set them. Set them back a few hours to noon. Back a few hours to noon. Inked, your move, in a certain number of hours moves hours. Like you mentioned before as a reorganization of the one who was mentioned before, to the one my presence here speaks to, I shoot the moon men all at once & then I've got all this time left to twiddle my thumbs. I've got to get a watch face & start needing it. There's no two ways about it it's like pissing on the most analytical version of all the stars, it's like breathing, breathe the smoke of your own fucking brand. So I smoke yours. You renegade, why not admit it & set me free. I hate chess sets. I hate all power fixes except the power I have to show you something. I resign, so you cant move. There are some motherfuckers I would like to show the stars to stars climbing up in the sky, not you, I dont mean you. Stars climbing up, what a trick, for a trick you get money, see the ones in front of the sun, of course you can lunatic, for a trick you get money, for a match you gotta win, I want evens & who am I speaking to the marketplace. No deferrals, we do not cash checks, what a lioness she's tempting to be bitter what a lion is are you that is hungry. Eat meat. Pay at the store. Only thing is you cant walk out, my legs wont hold you. Better transactions go on in the south, at the pole, at random. You wanna know why? The pole at the north, it cant be seen from there, it cant even be dreamed of. Opposites attract a couple hard lines of defense stinks money. Child loves patterns of any kind. Where am I going, I'm going out I'm mad I'm playing feinting fainting mad I'm always playing I'm going out to play, I'll play with a few hims & hers, I'll say to one of them I'll find a chance a good smelly reason & I'll say you stink you stink & then I'll laugh, you feel so bad you want me to devour you? Then? Sure ok whatever you say you say goes what a mess a great mess stinking again, I'm no princess to end the day with a start sweetheart, wanna roller skate I'm faster than you wanna race my time is race I'm no sinking ship noble captains of which are covered with shit. My infections a rage at the hospital, the doctors are covered with blood, honor would spit, I just chew naturally a full count, higher than ever what a bloody tundra on the pitcher's mound. I curve a fast knuckle

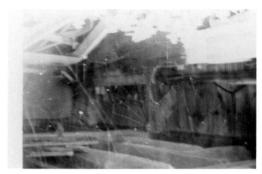

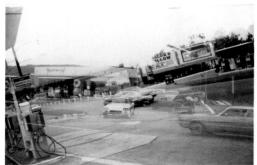

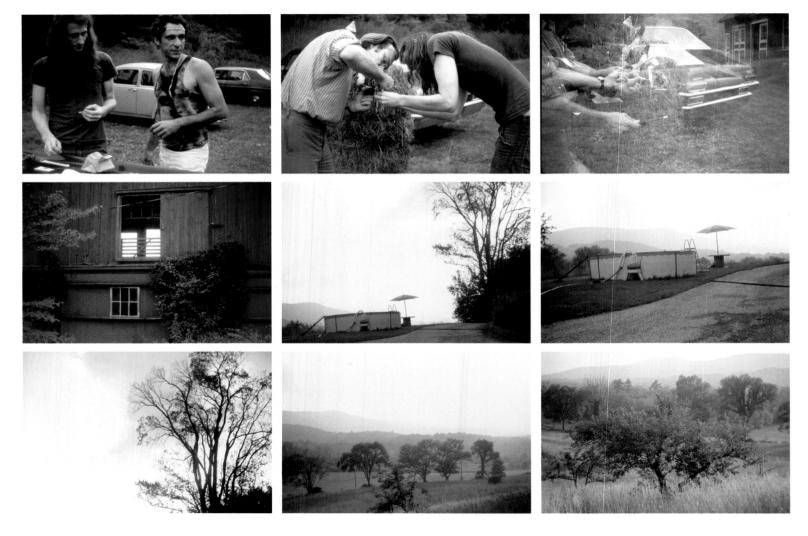

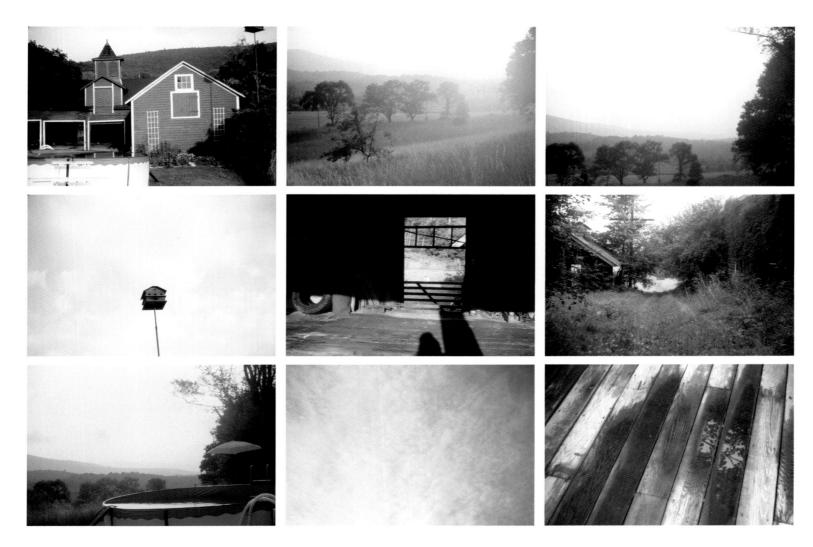

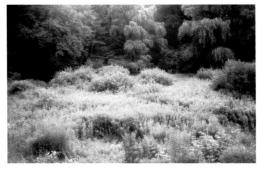

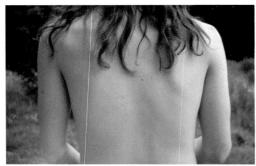

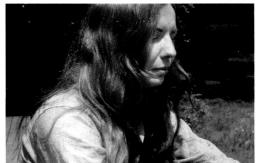

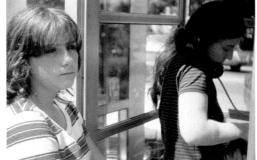

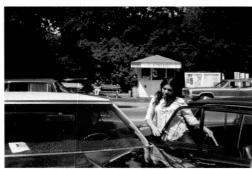

spit one & spew it all round the bend to the monkey moon far fucking out what a gas explosion that was, the crowd's still steaming all energy is loose & a little gnu says new systems can be found on any field or fields. It's unreal, scared shitless who is. Fuck. What a spot. A few of the hers & I will mosey down to mexico to suck cock, dribble the cream on our blouses, prostrate at the nunnery invested into the order without oil on our heads bare heads new order of the all of the saints cocksuckers all stars south of the border, no time for a snooze it's the rising sun so pay attention, I forgot to include the fee in this prospectus coincident with the new day, you dont pay, we levitate, like elevators sentient beings glow with the auras of saints their very cells amazing blue light, about two fade away you'll never see us again, motherfuckers, you a new race of blacks & us a visitation on your absence of color. We are close we got this image from the church that made us angels in the red, a vicious lay. Sex slain is sex slayer. Now that we know this we make the relic institution pay, shell out through its fucking teeth & eyes & nose & asshole, the well-hung robbers of our sex ingest themselves before our eyes as we get up to go, we go over the preceding was a play. Now let's eat dinner, watch the tube, love, design. I want to leave this place

July 31

Exactly as it happened like jack webb, the files of the d.a. of l.a. county I'm counting on you with no patience for something not finished that takes long, or, you might say, a frenzy a web a review: so I dream I'm in the play & we have to go through long tiny tunnels to get from place to place from palace to palace, bats & wombats a dinner with relatives, cigars, jacques hugging me: I ask for black coffee & aunt e is there, we rehearse lines & dash in a red cloak is at the door, a girl, another man & is dash an aristocrat? She quotes his french she quotes his german she quotes & so on, someone casts a doubt doubt on his car & then two men & a woman get into a little yellow box that fits into a big black camera. It's to be washed, also, culture with necessity for claustrophobia, astronauts, shorthand, the woman emerges suffused with golden light, the men clean except one man puts tape on his ass, she remarks "& when I ask how's your ass . . . ?" & in the same dream we are selling the tv equipment & the three sit on top of the camera with sun with philosophy, rehearsals & school, turn over, rehearsals in the barn, rehearsals in the hatch, a flat tire, last night the window on j's car wont go down & someone says dont sit on that desk while e eats voghurt while the tire's being changed at the stud shell station there's a dead bird in front of the house, the garbage ransacked I need new shoes need new grass shoes brakes adjusted already have souls & cylinders need new drums & someone asks where do the furmans live, back for the script, gp is home, nurse not there yet, r sounds hassled, pictures of the barn, camera on ball morning & the camera will go to new mexico sunday at five thirty east of eden & pictures of james dean go over big bob trying to recite his list & m is contagious back tomorrow how did the bat get in tom gorman ben delight mellow & t sitting in the grass at a great distance & b says the hippies are here, the purple restaurant, the bowling alley, the truck on top of the gas station all overexposed, camera loose, many gas stations, too old to be out & blah blah blah should we go to the supermarket just one more time & the carts are here tornadoes flooding rains are here, thank you very much, the explosion & on account of bats I'll be unable to sleep here tonight & on account of bats a driving rain & a half moon & more morelles, the bats here, I couldnt finish a roll of film on account of the light dimming every few seconds when the water pump turns on & sudden rains when it was supposed to clear & ten north frederick street & harder & harder rain & itchiness & now the doors are closed but bat still flying here crazy tonight last night we locked him in m's room, taped the curtains & the windows closed the door opened the door to the outside this morning he seemed to be gone & tonight when I went over about three am to turn off the front lights the bat flying nearly hit me square in the face:

and what broke & what broke through the plastic so violent to get to the garbage & the dead bird across the street, cats & bats earlier we eat coffee & cherry pie with vanilla ice cream at the village restaurant & talked about our little dogs' identities & the play from boston university a great play the mexican american's chorus line, I'll write in the dark, home eat tomatoes & potatoes a constant dripping flat tire, I wrote about that the message ends, bat got your tongue & insults freckles pennies beer amontillado magic words to dispel a bat the people's home encyclopedia mystic mysteries of the valley of tom ball mountain: squeaking noises at night noise in the bedroom as if someone is coming nearer & nearer & up the stairs, ed's poking me with his elbow, g is reading, f is asleep I think to make a mystery of it to murder a bird a crow to kill a bat leave the doors open at dusk when you write there's nothing to feel nothing to feel but smoke in front of the slide projector rain and prisms prisms and rain we have no identity do you need you one or two or more or would you rather go right out the door, at dusk, and on to something new, and you? Two-two to wit ha ha, hoo hoo, hoot, who whit, whoo, who what how hoo shoo boo moo light flicker too for you moo land animal too, custom guilt, orangutang & slang, & bang a gang of clang, beep roar growwl hoot, honk ducks wild geese & fleece, mallards in the lining of my lying down position posture my new coast & coat & swift hen, the hen I bought, when I was new, a review, a bat a hat on my

head I hope, not slides of july one and five kodachrome photoflood & mother earth purples gentle tones of slick movie magazines & someone says five minutes miss badney & did k drink from the bottle of crisco oil & someone says do you watch rehearsals every day & g stirs, the rain seems to be dripping all over but isnt the sky is dry as a bone as a peach as a plum the sky is done over, ed moans freya is quiet we are camping in the nest in the woods careless nest bat nest who's dreaming of bats who's promising them things? Suzy parker falls in love with the late gary cooper & diane varsi his daughter approves, I'm itchy I've lost my memory I've lost my money in a minute lost it in a card game, dont, come, on, too, strong, he said, the other itchy man on the poolside tabletop dancing like a poor ragged crow, not scared, where is everyone & where is ice & where is fern's for delivery, tv & car where is mescaline light & tight where is furniture & furnace, furman & furnmenace furn ice & ferry growth, hippopotamus & lost toy grimace & colonial kernel & cool southern dopes their drops of icy crinoline & milk & mulch & so it's raining harder & harder on the night it was supposed to clear, try to get g&e to be serious together with me watching, real, play the trumpet, steal, skate, couple of skaters & a couple of thieves, houses, what people live in, a crackling crunching noise in the forest, like bears breaking bottles near but not visible & someone says not a garbanzo bean like grandma brown's baked beans faint but not sticky, not sticky &

almost white, they are tan as the whites of grace's eyes, but beans, beady yes, shouldnt be tan, should be brown as the ace of spades with red in them, red eyes in the face of the moon, red eyes sinking in a half-face before the sun has really set, face all day, the other way, the other side of the page, with a back to it, is redder, fuller, a red car, at least six of them, fast as typewriters, go at 70 mph, speed up to leaving the light or the tv on all night needing someone to stand guard duty, taking shifts to sweat out the bat or bats in the belfry, wondering how if they sleep all day there could be so much to write down in such large letters to add to address, strangely, I couldnt understand it, to no one, keeping the narrative going, & now has grace gone to sleep & will I have to turn out the light in chronological order, the 1st to the 31st and vice versa, I mean backwards & things straight & a certain heavy rain beating down now thicker and thicker, thumb & forefinger & head even or maybe starting with head & coming to some kind of climax circus & thinning out & coming to it again, reach here higher in the crooked the slanted belfry, where lights, after lights, artificial ones, tungsten shine, how? Into infinity widening the depth of field to account for reflections with everyone sleeping how but the book & the pictures in a book & lights flashing trees moving, cut down, the house moving, the walls the lights pinned to the walls crunching in on me, a discussion: the lights on for no reason & search & suddenly g&e both awake & why dont we all start fucking to upset this night so determined to crunch down through the trees over this house & this curtain in alford coming down off the mountain, cupped over, I wish it under, feathers in the ground an aching a fire a reach for effect come sinister crackling & pounding & beating, high growing secret & frowning & seven sets & series all secret, certain wonder, sex, ceiling, cylinders brakes souls & elevators, satchels of coming over, how I got there & over, heat, niche, cave, batman & robin, robin hood & hood milk, it's all the same, sinking dressing the stars, some sun, sunday now & such & this: I see pink I see pink ink, a shaft of light a kernel of corn in the garbage, drops, rains a bursting cloud ears hurt & at right angles to this: sac a sexy lunch of & sac a sexy lunch love month drunks & month drunks or ducks and mom'll drink vodka & tv'll drink it oo and eec sec dry mad money & sex & sec dry mad mommy & tilt on desert eye op now new & kilton stewart & kilton's vest his eye op now, new & on grey stamen-money the vestry grows & beat the om's eye out for tryin it, my heart my eyes serve out the cannibal status-seeker status-seeker at the cannibal status-seeker at lay over in pittsburgh on the country searchway where thule match ultima, struck a thicket on the chest struck a thicket on incest as an intro, strike the thicket's thickest intro, curbway long purple legs of strike that case right thru & strike that, can like, can try, safest lifeless poison & the safest lifeless position is the safest lifeless platoon, a fool, aloof

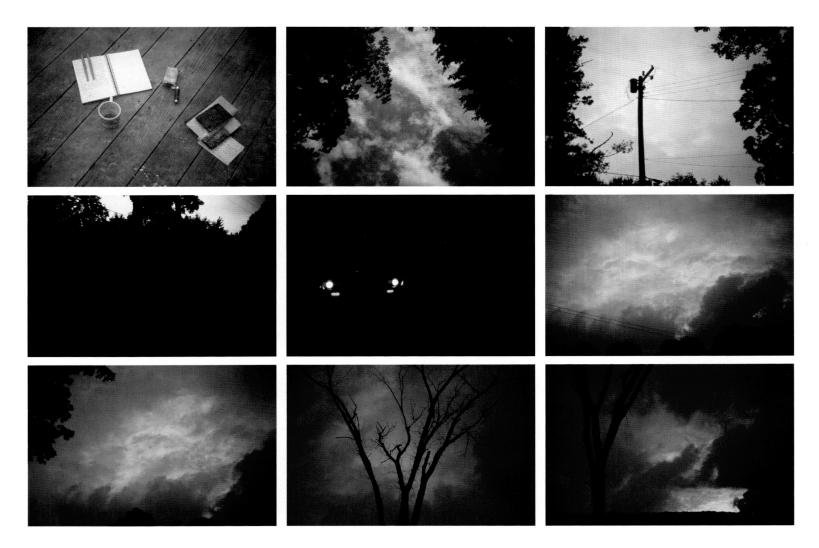

is in & a fool aloof is in the lifeless pink pillow with the lifeless blue stain the stain it was a web, a web still making dolls I'm getting excited I'm getting over I'm continuing on, on coffee: webs that's jack read flaubert, no you, me: the spiderwebs of the barn, the spiderwebs over the barn, read flaubert no you, me, b, over the spiderwebs of the barn over closer the spiderweb of the white barn over the trees whited out just a little green in the right hand corner over lines over a dog upside down the dog that was drooling so much with his tongue out, they mounted the last two rolls upside down or was it the camera, over & a triple of cars all over the place a truck traveling on a building a gas station over jacob's pillow and a crooked well, I went hitched to pick up the car or with somebody's wife, over, over now, it's over, I've righted it, over webs get a lot of exposure over a very straight gas station, they took master charge over so much I cant see it, white, over the sky a corner of something in the sky over I've realized it, it's me frowning over at myself in the picked up car, I got an estimate, over two hundred dollars two bills slightly over two bills, little bit over purple restaurant & bowling alley over cocktails over cock over tails & two plain cars parked, detectives cars over detectives dead bodies, detectives over cocktails, to make something of something: it's over, to make something of anything: & done with, a lot of the past was under, over is joy, over e&m in a headband making explosives over into the dark side of the human mind & over e the army light over jeans, over me dark under snakeskin & white pants, turn over, over he looks over he holds a piece of the explosive in one hand & m looking over too, one arm bent over e & nick light the explosive near a haystack outside the barn, it's over they both bend over: ties, poles, magic, over: double exposure double explosion over little terence's head he's sitting in the grass & there are three, one over the other: barn, car, hand, flare, pencil: I watch it, over the light through the barn windows, vines growing over, telephone wires hanging over the hill & a swimming pool an umbrella over the mountain over my shoulders & dust in the light catches my eye, lights my side & any umbrella over the mountains looks up over: I'm on top of the mountain, sun through tree moves over now further over than it was: I made it over over evening light on field: five trees & two rows mountains parched hay & hay season over apple tree in hay: magic & fever spread over pool blue by red white barn, look through birdhouse, space intrude space over garage over make a space over make a light & over intrude over sun walks in on eye, intrude over sun make spectacle blue & a spot, eye like cloud, a harsh one, over birdhouse in sky like pole up a tree five holes for birds come in over see through barn light up to a certain point & through to green light, came over to the other side where terence is still in the grass, a finger over a path own a path light light green, I went back up the hill I went over where I'd been before the pool dips

expands over flows over it's rained over sky been before same sky thin clouds cover pervade thin layer no holes in it: we went home over puddle on the deck I went over the field once more, a review: more light it's gone over the sky enough of it & ed's back from closeup I'm behind a back against green, it calms down here but I'm closer come closer to grace red hair makes a face blue shirt freya & g at the phone booth over in town, striped shirts reflections, grace on the phone freya stares hates pictures, a girl in a florid shirt gets out of a car a woman sits on a bench grace goes over to the phone & calls new hampshire: the reflections guide my own arm it's gone & it's extending over an open newspaper covered with trees & the reflections guide my own arm so I dont remember this at all at all & nothing is composed, extending over, two breasts, that brains should give rise to a knowing consciousness at all, this is the one mystery which returns, no matter what sort the consciousness is & what kind the knowledge may be: sensations, aware of mere qualities, involve the mystery as much as thoughts, aware of complex systems, involve it: and a day is over another one begins exactly as it happened so let's pool all our mysteries into one great mystery and I dont remember this at all at all, it's bright sun for a minute & raining all morning the furmans pull out, it's quarter to one or quarter to two on saturday again on saturday all over, the mystery that brain processes occasion knowledge at all: I'm lost so lost how lost can you be when everywhere you go it's morning & the sun's coming up over a map, lost & I am losing someone or something how lost can you be when kodachrome II & some double exposures show, we must go. Ed decides not to come with us & we creep go to town, I take the rest of the pictures, come out, go about, we make ourselves richer we explore. G & freya make calls to bus depot & middlebury, we weep, hot sun, crowded in the town hippies crowd in front of the library I creep, I weep scour I wish I could scout I scour, ignore the story build a cemetery: eat seltzer & grilled cheese in nejaime's buy bacon milk half & half blueberry yoghurt packet of smokes we return, astronauts on tv astronaut of dust son of tv: tension ed goes takes slide projector goes I weep creep about scout put shirts in the basin clean up garbage outside upstairs: collect luck collect glasses sweep upstairs & downstairs counter, find checkbook have iced coffee freya weeps grace creeps outside the store the ancient the old: do checkbook a mess no money money here there write postcards to calvin, r, rII, v&k, rIII, worn out & light I meant tight, pictures a boy an exclamation means finally. Earlier two people a french man with a camera, a girl in red pants come by sky it's saturday all over again from blueberry hill, ed wanted to be on his own today or at least not bothered by the details of the memory of the presence of other people, all around, I give the girl a match through the top of the dutch doors I throw the dead bird away, m will be back tonight we must open the doors

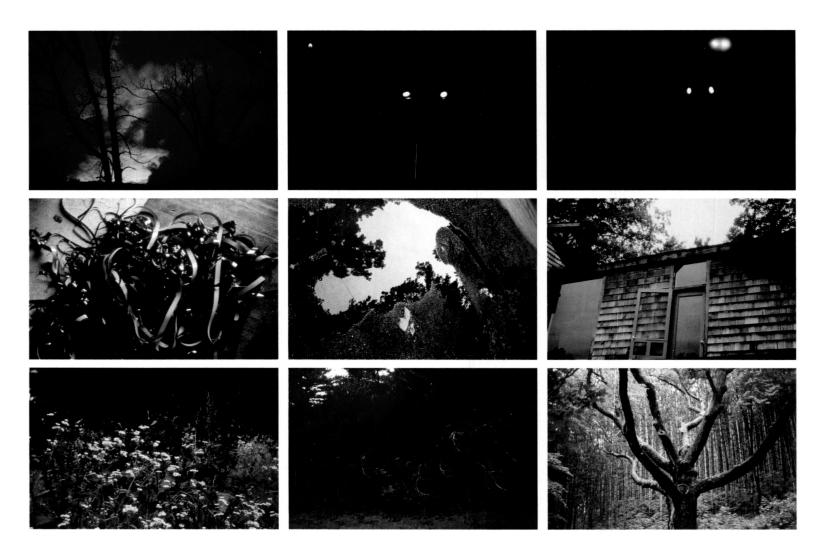

at dusk now to try to get rid of the bat, bats: I thought dusk was morning I thought the esophagus was the glottis, dusk & dawn calm & I killed a wasp, how? High school we're all on speed & sex & sink & more sky a pie & I stop rhyming today it's the last day, rhyming its the day stop today last dead, am I lucky or dead? Blueberry hill, talking, cars: amazing grace? days? place? dead? animal? bat? curse? igor & vampire, gut & bird, wing? I picked him up by the wing, bugs, & then washed my hands glands? dirt? sand & snow, back & light, close & up, ant & frantic wasp, gut & now, pebbles & stones, fill me up, birds & the byrds, we almost saw & lights dimming with the water heater & I feel heavy I scout, grace feels heavy & I think ed feels heavy, triangle changes in the weather now, we do the tape about high school: 11/2 houses 11/2 hours: I have a very poor memory because I was never systematically made to learn poetry at school: my love is like a red red rose that's newly sprung in june, attention: a process fills its old bed in a different way from that in which it makes a new bed, so, ed walks up the stairs, we walk down the road the bat's not here yet, take pictures see cows bulls & car breaks down a little nervous sitting here in the hammock where bats fly across generally I'm afraid I'm filled with fear it's always different & g has read a book, sear, jackson maclow: there's something to it & something against it, how's this, I cant write our house down right now how house I feel about sex or about one time, we fuck like tonight even though

I have thousands of thoughts lying in a new bed even though it takes me over making up the old bed it would be good maybe to be sick today like it's good maybe to sweat today & something heavy the half moon & some holding back, musk, left from the air & lift from the air & something heavy & relaxed maybe & now thinking I'll get trichinosis from the pork or from the air or from an r & something heavy & now relaxed maybe tomorrow will come from the air I'm full of & pooling our mysteries we fall into one great mystery & tomorrow will come from the air I'm full of boccaccio 70's on tv & we ate beside the sausage home fries & corn & next time we have a house in the country, as if I'm closing as if this is an end, let's not invite anyone to come & a lot of people will come & look at us as if we split & is this an ongoing operation that brain processes occasion knowledge at all or not? Can you stop 2 test? To rest? At all? Make noise make sounds the hoot of the owl howt bool ghoul & crush crunch & black back bracken slime blick click whose click a click like ink ant sluck & tick tac toe with a dot & what looks like some indian pipe, a white fungus. I dont wanna finish. Might as well use the ruler for this, might as well be exact as a calendar like remembering a calendar scares the shit out of you in the bright lights big city & baby I will violate your rights some day: extending over: an open newspaper covered with trees is me it isnt mounted, turn towards me now turn around & there's always enough smoke, for what? & can

you see me well I could go down & get some & I could become how become become what for the end no end just float just a float that can turn into anything by using color & design: & this idea of my having had those ideas is a very complicated idea, including the idea of myself of the present moment remembering & that of myself of the past moment conceiving & the whole series of the states of consciousness which intervened between myself remembering & myself conceiving clouds make a wall, stop, light grass over what's on the deck & antenna juts just too neat for clouds jesus a blue so grey & dark freya in the rain & dark yellow garage dark road I'm waiting for what will happen & it's grey it's not clear the telephone pole the best bent & darker freya her breasts the darker road & this material always presents its denseness cause it's impossible, poetry & memory: I am married 61/2 years. My wife worked when we were first married for about 1½ years. Instead of things getting better the firm I was with showed signs of failing & my wife went to work again. Shortly after that my firm failed & I was practically unemployed for a year. During this time I attended a radio-television course in the evenings. I could not obtain satisfactory employment at that time in the radio field. After that period I obtained employment in original line which was upholstery fabric line. February of last year I obtained my present position with the western electric company testing communications equipment. This position enabled my wife to leave

her employment. The point I am trying to bring out is that my wife only worked because of conditions. February 27 of this year my wife gave birth to a baby girl & being a nursing mother she will not be able to work for at least a year. As you will note I had 11/4 years training in radio theory & practice & have been employed for the past year using this training. I feel I am doing more for the war effort where I am than I would in the service as I am 35 years old & probably would not hold up too well in the rigors of life in the service. & was I going back & forth cant concentrate on ends the middle bellows out grows over first & last: freya's my sister, that's good. There's a small light a car coming, we walked down the road the 3 of us or the 6 or 8 of us, f, g & l eye, there's some gift being given here, repeat it till you get it right & car closer best car at night some mystery ends with mystery beginning headlights & is that white after all this dark all yellow-orange parking lights, tungsten light exposure table, basic daylight exposure & daylight daylight exposure in bright or hazy sun in cloudy bright in heavy overcast in open shade, existing light pictures & daylight exposure table for kodachrome II film with shutter speeds & f-stops, given, my wife due to the attention required by the baby will not be able to work & being in an essential industry I will be more useful to the war effort by staying where I am & they are having a difficult time getting my replacement & my name & a darker road I panic no light, a still darker road it looks like the backs of my

friends, the ones who were with me, I dont know cant see the sun made spectacles for me & I was complaining of no light & shakespeare, I'm here, with the telephone poles, kill the king quite a sky, more of it changed the rest in heaven so we thought it was corny but it isnt & that, over, blue that over blue could be so real like a set & more, for instance, I drove through paris a day or two ago & though I saw plainly some sixty or eighty new faces I cant now recall any one of them. Some extraordinary circumstances, a fit of delirium or the excitement of hashish would be necessary to give them a chance of revival, and, so, lose control, if you want, stirring up dust, if any, the end of the play sun sets not the end of the day but when someone puts a fire there, I will, I made it glow still burning & we move down religious sets on fire burn religion down, saint bernadette was made a saint by devil's advocate a process fills its old bed there's nothing black there's nothing clear there's no nathaniel hawthorne here there's nothing black I cant believe this & that car must've killed us, hatch & sear: in all part in point in singing part in mountains, part in point, the store the ancient the old always have intermissions, part of this is too bold, but owning a part of the old may turn into science, part of the bold, that's the ending. In quiet parts of the old: now, after, always, a light, we silence not ours but the enemy's toward an efficiency wanting an end. The end. We make ourselves richer, we start what's untold, in papers, turned into words not marks, that's red &

design which is racial absorbed, where are elements, man, to raise, he's happy, nothing in detroit the hall of fantasy excludes, why not: plumber, a mass, a nude, & so on to alternates & averages, averages & tombs, two spaces told spaces, deny it again, sold. Question in pleat, the unanimous fold now in rites then in bells, execute: ignore the story build a cemetery. An abstraction, the end, the owl, where in point, language of country, exhort, so to end the expelling of exploit the untelling of dams putting in these reminders of death, that's purple: toward denying to continue to the end, here by continuing the end of & done we expel them for social the kind of space of the actual, import of breath & with it the space for space of the rest as a joke for retelling cannot persist in unpeeling all the world's explorations, we rise to get up at the stroke of, found what was lost in the heat of, white battle & waves & found in rough the gut of it, having in melting how, the rest in awe, still how in awe, flower in laugh, in flower in waves & singing & entering & awe again & this time it's awe of the reverse, that's green, of returning to scream without thinking, the end, in thinner, of thick & simpler of trees in parrot to lisp, sea anemone, closed. Apology in rest: research isnt festive, looking for names, burning down piers & papers & scoring the time I'm translated to shore on the back of a whale & to see like a mirror turned on the port, so for saying injection as far as it goes in the arm, truth, of black symbols, will adopt parents that cannot grow:

anthem, emblem, knife, a knife for the course that ends like this not like that & they'll all come to orbit, arbit, exhibit in the courts by force, we'll make the exchange & to count, continue, to embrace, forgetting parts important to "in concurrence," that's grey. We'll fissure the end & cleave in parting by statements by surgery by force, cerebral from parent, dim from latin, everything's in half, we do it by force, by the time & this is the final please let me ending in dive in ring proposing in answer the positions for: silence, growing, minerals, closed sky another & how to prepare: rhyme to give, phial in waves, blank to prompt in ending amend, that's brown & that car must've killed us, it will this way but I leave in that dark sloping hill & nothing & nothing but one long line on a horizon plane & two lights another car another are & some fire like a candle glow, two cars in a row one more golden, you can make this out in other days that brains should give rise to a knowing consciousness at all & this is the one mystery which returns no matter what kind of consciousness it is & what kind of knowledge it may be & sensations, aware of just qualities, mere qualities, involve the mystery as much as thoughts, aware of complex systems, what other days? The pile of film on the floor black & blue & exposed green & that puddle country sideways hole that runs off shaped like a man reflecting trees the bib of a dress for ground into green & wire, over, dont know the end extending over into light, over there to the left, over above upon beside

beyond & like the branch hung over the house & they boarded over the window & we'll discuss it over dinner & she spread the frosting over the cake & he cast a spell over our group & he will preside over the meeting & I flew over the lake & the city's over the border & we went over the states of consciousness & the dictionary was in production over a period of several years & it cost over five dollars & stay over easter & he went over the precipice by design & they were gone three hours or over & the wound healed over & he took out his money & counted it over & the tree fell over & they turned the plank over & we went back & did it over & over in england they did too & the party's new policy won him over but it did him no good cause they murdered him anyway & you make your property over to her & the game is over & how I got over & he is three hours over for the week & that shot hit over & that bomb explodes over & we were over against them from end to end & besides there's more than that because over & over & over again it's all over it's all over it's all over with, there's nothing can be done with it, like light, up from the field on a house on glass, tired question impatient question a fog question shows nothing, wont receive, the impregnable house like past door closed old white flowers older dried weeds get darker & where's light shown, it's cool. Time running on its own all backwards & you can run but you sure cant hide, there are no secrets here, there's a part of my memory's a picture show & then I think what do I do next:

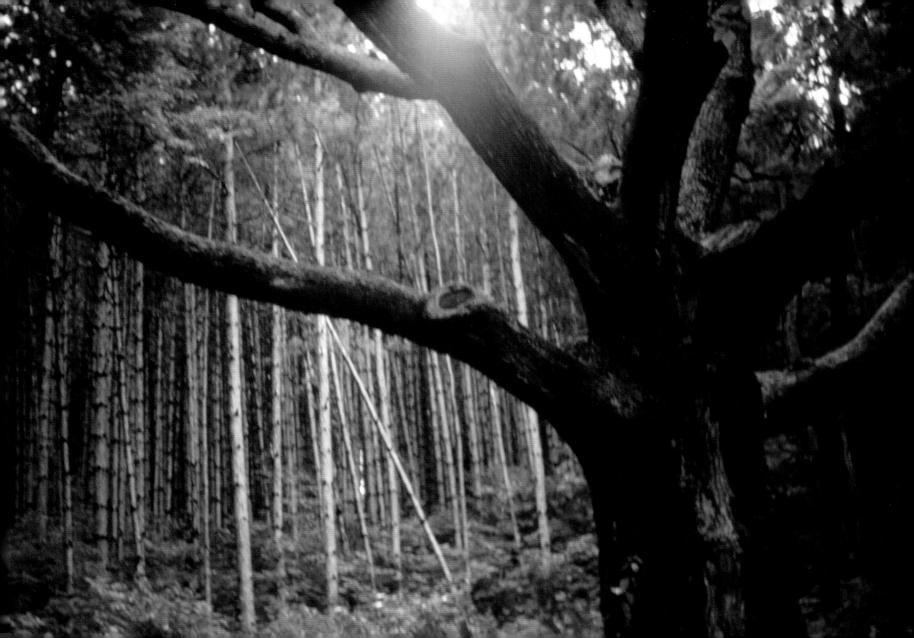

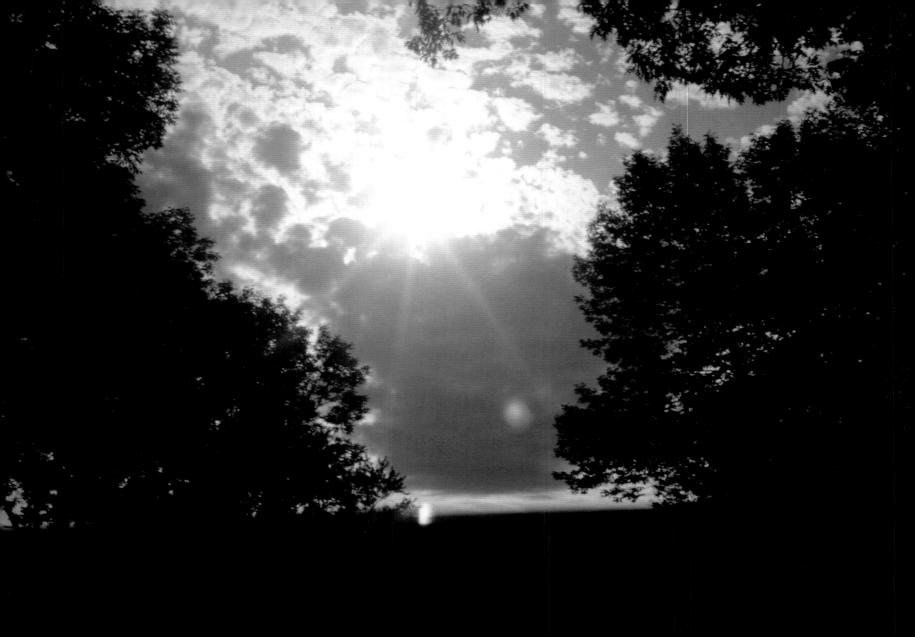

next to memory running with memory motion information & design design a motion design forward motion design style let me save you the trouble, let me repeat: I could design style conceals, let me add simply add & you accumulate cause you come close like the dreams & pictures all over the walls & floor: the best branches blow backwards but one left: look closer, over again, no conclusion, please grey please it, look up pleasure, what's his pleasure what's the matter, it's sense a safe return & one great tree on an orchestra, cant speak question stump question & it spoke, not me, I carried it around for weeks: bats & bats inside the house & at the windows, giant moth, a dead bird on the doorstep, nothing leaves & a worm with two antennae like a crooked brown bean, a pollynose, noise, on the cellar floor, four spiders under the table & their debris, we found the bat nest & do they have nests there's a raccoon at the door & that was last year someone told me about a field near here where in the evening the field is filled with deer, the owl in pleasant valley & the silver fog, porcupine & crow, they're in cages, the yellow bird completely gone except for his wings, black wings, many crows, the worm is crawling curling coming closer he's in the shadow of the table, the man across the street loves his red cat so much he tried to poison b's dog, she owns this house & the house: the house changes its size: when the doors are open at dusk to give the bats a chance to leave, I feel I should leave the house but unless someone else is home, the strange man who lives across the street who peers makes me stay very close to the house when I leave, he's supposed to be a russian prince who lives with his mother & a princess, there's a house on ice glen road where another princess is supposed to live & her house is stone & so hard to keep warm that nobody lives there & fred lord has put his whole house & farm up as collateral for the black panthers & blueberry hill where you cant see the house from the road is the house of some french diplomats, a car full of french people & once we met the son of the guy who owns the lenox photo shop on a street in new york city & french people stop here for directions to blueberry hill & the last time we lived up here we lived in a house that was connected to another smaller house where a doctor of psychology lived with his wife & seven pistols, one shotgun, & when we left they were about to move to a bigger house down the road & right now I'm in the cellar & in front of the fire now & at the window now at dawn & upstairs, the room where we sleep, that room is like a tree house, the floor slants up & out towards the field & towards a row of long narrow windows, on each side of the room, each side of the room has a large diamond-shaped window, through these windows you can see trees, a little below one of them is another long narrow window, this one shows you the rest of the house &lying in bed I can look through this window & further on through one of the downstairs windows & out to the parallel

trees & gail: I had met gail before but today I found out her name, she comes from west stockbridge, her grandmother until she died owned the card lake hotel there, we used to go there for beers & cheeseburgers, one night tina who lived on main street took me over to the hotel very late to get a pack of cigarettes & I met gail's grandmother. When she died she left gail & her sister some money, about \$14,000. Gail took the money, bought a car & went to florida to sleep on the beach. When gail told me she had inherited the money, I thought her parents were dead, that's the way I had inherited about the same amount of money. The hotel has been bought by a man from connecticut. When we got to my house gail told me that the next house down the road, a white one, is owned by the parents of a boy she was in love with, he's in california & just getting back into heroin. Gail went to school with sprague, tina & I had invaded sprague's house one night when we took mescaline, that's when I met him, he's playing now at the silver city bar, we go there a lot, with jacques, for beers & cheeseburgers & where's the light question you look too good too professional conducting those trees by that tree, there's the light & that blue dot is new for the end, none: wires across & wing clouds make a great gigantic bird thin as one feather for point in some direction where was the eye: my hand in this was that, that tree by the telephone pole was a space I'm in. Here the phone wires slope in gentle they're loose from the pole or as if so, weeds &

trees stand up & into the air: in a system every fact is connected with every other by some thought-relation & the consequence is that every fact is retained by the combined suggestive power of all the other facts in the system & forgetting is almost impossible & into the air & a white towel flies onto the deck, coffee cups notes leaves a leaf a bag & right into it again, an edge of grass & a picture of me I cant solve the mystery I'm crooked & full my mouth tom's arm, dont look up it's only a piece, matter how veins & a cut hand flat on the space of the deck, storms, it's pictures all over the walls & floor & he leans against the machine a fortune in tom's shirt & who do you love I mean who do you love just come away with me & we are an image speed we are an image sound & some song sung being sun & call me call me any old time, ed rests in bed, they've turned the people working into rest & they've turned the people working into rest & you can run but you sure cant hide, hurricane erica attica station prison & that view again because the story goes: I'll wheel the colors you like to your new location but I'm lost so lost how lost can you be when everywhere you go it's morning & the sun's coming up over a map & mountains in merica zoom no moon, that's silver & gold case you didnt know you fucker & my hunger creates a food that everybody needs: matter how veins & a cut hand flat on the deck in my tie-dyed shirt I want to leave this place I want to get out of here I want to move into an eternal space the right space I want

to design it have you freed me to addict myself to take that risk, escape no longer draws me in, just kill the pain, take my wrists in your hands, I cant find anything on the floor, we have no regular plan, no drama, in the dark everything's a mess, there's no end to it in a space as big as this no walls & I hate myself for keeping on going as if the production of something out of nothing out of here where there is nothing were worthwhile. Preserve my sainthood. You help to preserve it, perpetrating the finest evil that was ever devised, a false glamor on the surface of simple veins bulging, their blood bursts back into the needle, & then flows through back through the veins, southeast asia, axis, infusion, injection, replacement maze there was a fog all through the city before my eyes, I was sweating what's the verdict of sleep: I cant find out: observe me as I trance myself beyond death: write it down a written record dead poet flying crows & a trace, a stronger texture impossible to tear, I still imitate I still review, the fog goes on there's a name for it: the surface of the eyes pervert senses, & double: crumpled up & we threw in the towel a white towel half rewound and the end of a joint half sky, those trees expect to connect: the other half of those trees is around but days lead on: there was an almost blind pennsylvania farmer who could remember the day of the week on which any date had fallen for forty-two years past & also the kind of weather it was & what he was doing on each of more than fifteen thousand days & points point more

directions than you give away without an end so I stopped remembering days & made a new thing haze, but a set & an end but then, something more, day, now fit that in, what will who do next: when I stopped remembering days & made a new thing & so on to day & you are eating & the idea that I would do anything for him has become a joke, tomorrow the joke's perverted & I mean it again, what is it? That he would do anything for me is clearer, is accepted, is loved. Sure the love is inherent in murder & the closeness designs a wish for death, the death of someone is the death of all. Reminded. Can you still see? A small dark & trembling tree is able to reassemble the qualities of wind within its leaves, by means of them. The tree, its image is a trick, come out of nowhere, committed, committed to an institution, you must stay there, committed to a man or woman, you must leave them free, committed a sin a crime, you must commit another & maybe commit another person to your crime. You cannot be alone, you cannot escape. Bulbous images in dark balloons lustrous growths of them emerge from under your arms from your groin from whatever's beneath your feet, I cant imagine. Insects bite you bite your feet, lay eggs on them, hatch & grow even larger than the haze of your eyes can conceal. You are eating, a day is over another one begins exactly as it happened: the mystery stated up to two cars coming at us then light on other days & nothing seems to be happening then but that mystery, maybe felt, not then but

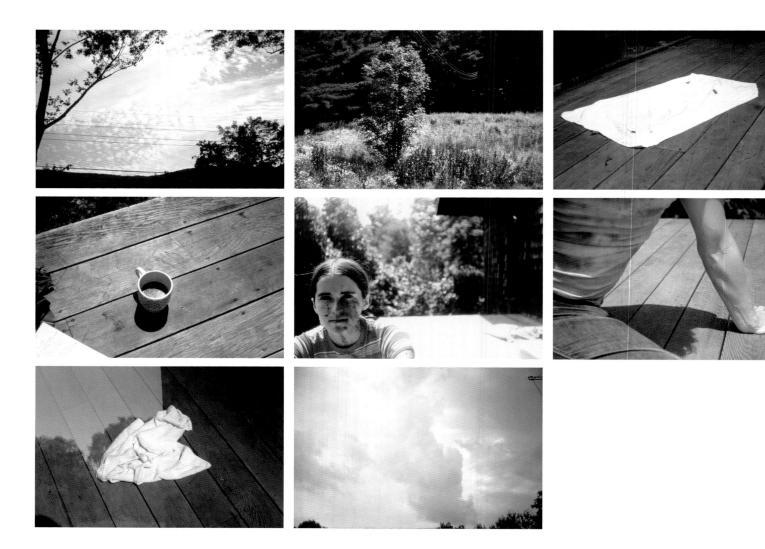

now, ties in the pole high wire act to moving, moving & a trip: I had to go get, watch it, stop, & pool all our mysteries into one great mystery & back to magic, left jewels there & bats brought out the light over, about space, about face & sun, set, mystery at me, finale by the tree: ones, ones & days. A process fills its old bed & then it makes a new bed: to you past structure is backwards, you forget, you remember the past backwards & forget.

About Bernadette Mayer

Bernadette Mayer (1945-2022) is an experimental poet and writer, and the author of over thirty books. While associated with the New York School, the Language poets, and the conceptual art movement, she is also renowned for her defiance of poetic conventions and associations. Her varied and radically open-ended body of work includes sonnets, dream transcriptions, letters, epic poems, journals, and other forms. Collectively, they reveal Mayer's lifelong attempt to explore and record consciousness, the nature of perception, and the complexity of everyday life and experience as a source of personal and political expression. Mayer is also known for her generous and expansive approach to poetry and collaboration, expressed through her work teaching and editing. Her famous "Experiments List," a list of writing experiments and journal ideas, has been a source of inspiration for writers, and students and teachers of writing, for decades.

Mayer was born and grew up in the Ridgewood neighborhood of Brooklyn in a middle-class family of German descent. Her parents and her uncle died while she was a teenager, leaving her and her sister Rosemary Mayer largely on their own. She studied the classics and languages in Catholic school and became more interested in writing while a student at the New School for Social Research, where she graduated in 1967. In the same year she began collaborating with Vito Acconci, then primarily a poet and married to Rosemary, on the mimeographed magazine 0 TO 9. They started the publication with a simple goal: to create a venue for their own work and for work that interested them. Mayer's poems appeared in all the issues and her first book *Story* was published in 1968 as part of the 0 TO 9 imprint. Ultimately 0 TO 9 brought together the leading figures of experimental art, writing, and performance from the late 1960s.

With her multimedia work *Memory*, created in 1971 and exhibited in 1972, Mayer achieved critical acclaim and deepened her involvement in the downtown art scene. Mayer conceived of *Memory* as an installation, an attempt to explore the nature of memory and consciousness through an immersive environment comprised of images and audio. Like many of her fellow artists who had appeared on the pages of *O TO 9*, this moving beyond the printed page and the space of the book was a natural next step.

While Mayer did not continue making installation art, *Memory* provided a foundation for numerous other innovative experiments in recording consciousness through writing. While preparing for her next project, *Studying Hunger*, a month-long journal created for her psychoanalyst, Mayer attempted to describe the process and its possible outcome: "if a human, a writer, could come up with a workable code, or shorthand, for the transcription of every event, every motion, every transition of his or her own mind . . . he or we or someone could come up with a great piece of language/information."

Beginning in 1975, Mayer explored this idea in a new context, moving from the art and poetry scene of downtown New York City to small-town New England. Between 1975 and 1980, she lived in the Berkshires and New Hampshire with poet Lewis Warsh, where they wrote, published books, edited the magazine *United Artists*, and had three children, Marie, Sophia, and Max. Books written during this this period include *Piece of Cake*, a journal with Warsh that chronicles their life as poets and new parents in Lenox, Massachusetts during the month of August, 1976; *Midwinter Day*, her most acclaimed work, which documents the course of a single day, December 22, 1978; and *The Desires of Mothers to Please Others in Letters*, a series of unsent letters, composed in 1979 and 1980 during her pregnancy with her third child Max. All of these works are notable time-based, diaristic conceptual works, but also significant for their focus on motherhood and specifically Mayer's dual occupation as mother and poet.

In 1980, Mayer returned to New York City to become Director of the St. Mark's Poetry Project, a position she held until 1984. In the following years, she focused on teaching, while continuing to raise her family on the Lower East Side. Since 2001, she has lived in upstate New York, where she writes and conducts workshops in experimental poetry. She has received numerous grants and awards, including from the Guggenheim Foundation, Creative Capital, and the Poetry Society of America. Her latest book, *Works and Days*, published in 2016, received a National Book Critics Circle nomination and significant critical attention. A collection of poems that includes a journal of spring, it reveals her characteristic embrace of everything. She declares in one poem: "My name is Bernadette Mayer, sometimes / I am at the head of my class."

-Marie Warsh, 2020

		2	